PICTURING THE PROLETARIAT

Joe R. and Teresa Lozano Long Series
in Latin American and Latino Art and Culture

PICTURING THE PROLETARIAT

JOHN LEAR

ARTISTS AND LABOR IN
REVOLUTIONARY MEXICO,
1908–1940

University of Texas Press

Austin

Requests for permission to reproduce material from this
work should be sent to:
 Permissions
 University of Texas Press
 P.O. Box 7819
 Austin, TX 78713-7819
 http://utpress.utexas.edu/index.php/rp-form

♾ The paper used in this book meets the minimum requirements
of ANSI/NISO Z39.48-1992 (R1997) (Permanence of Paper).

LIBRARY OF CONGRESS
CATALOGING-IN-PUBLICATION DATA

Names: Lear, John, 1959– author.
Title: Picturing the proletariat : artists and labor in revolutionary
Mexico, 1908–1940 / John Lear.
Series: Joe R. and Teresa Lozano Long series in Latin American and
Latino art and culture.
Description: First edition. Austin : University of Texas Press, 2017.
Includes bibliographical references and index.
Identifiers: LCCN 2016023738 (print) LCCN 2016024710 (ebook)
 ISBN 9781477311240 (cloth : alk. paper)
 ISBN 9781477311509 (pbk. : alk. paper)
 ISBN 9781477311257 (library e-book)
 ISBN 9781477311264 (non-library e-book)
Subjects: LCSH: Working class—Political activity—Mexico—
History—20th century. Labor movement—Mexico—History—
20th century. Politics in art—History—20th century. Arts and
revolutions—Mexico—History—20th century. Artists—Political
activity—History—20th century. Posada, José Guadalupe, 1852–
1913—Criticism and interpretation. Herrán, Saturnino, 1887–1918—
Criticism and interpretation.
Classification: LCC HD8116 .L428 2016 (print) LCC HD8116 (ebook)
DDC 322/.2097209041—dc23
LC record available at https://lccn.loc.gov/2016023738

doi:10.7560/311240

For Marisela, again and always

CONTENTS

Abbreviations ix

Acknowledgments xi

INTRODUCTION Allegories of Work 1

ONE Saturnino Herrán, José Guadalupe Posada, and the Working Class on the Eve of Revolution 17

TWO Workers and Artists in the 1910 Revolution 47

THREE *El Machete* and Cultural and Political Vanguards 69

FOUR Consuming Labor: *Revista CROM*, Art Education, and *La Lectura Preferida* 113

FIVE Cardenismo, the Popular Front, and the League of Revolutionary Artists and Writers 159

SIX The Mexican Electricians Union, the Art of the Strike, and the Spanish Civil War 211

SEVEN "Unity at All Costs!" and the End of Revolution 261

Conclusion 311

Notes 319

Selected Bibliography 341

Index 353

ABBREVIATIONS

ARM	Acción Revolucionaria Mexicana/Camisas Doradas (Mexican Revolutionary Action/Gold Shirts)
CGOCM	Confederación General de Obreros y Campesinos de México (General Confederation of Workers and Campesinos of Mexico)
CGT	Confederación General de Trabajadores (General Confederation of Workers)
CNDP	Comité Nacional de Defensa Proletaria (National Committee of Proletarian Defense)
CNTE	Confederación Nacional de Trabajadores de la Educación (National Confederation of Educational Workers)
CROM	Confederación Regional Obrera Mexicana (Regional Confederation of Mexican Workers)
CSUM	Confederación Sindical Unitaria de México (Unitary Syndical Confederation of Mexico)
CTM	Confederación de Trabajadores de México (Confederation of Mexican Workers)
FROC	Federación Regional de Obreros y Campesinos (Regional Federation of Workers and Campesinos)
FUPDM	Frente Único pro Derechos de la Mujer (Sole Front for Women's Rights)
LEAR	Liga de Escritores y Artistas Revolucionarios (League of Revolutionary Writers and Artists)
LIP	Lucha Intelectual Proletaria (Intellectual Proletariat Struggle)
PCM	Partido Comunista de México (Communist Party of Mexico)
PNR	Partido Nacional Revolucionario (Party of the National Revolution)

PRM	Partido de la Revolución Mexicana (Party of the Mexican Revolution)
SEP	Secretaría de Educación Pública (Secretariat of Public Education)
SME	Sindicato Mexicano de Electricistas (Mexican Electricians Union)
SOTPE	Sindicato de Obreros Técnicos, Pintores y Escultores (Syndicate of Technical Workers, Painters, and Sculptors)
TGP	Taller de Gráfica Popular (People's Graphic Art Workshop)
UNETE	Unión Nacional de Encauzadores Técnicos de la Enseñanza (National Union of Technical Education Workers)

ACKNOWLEDGMENTS

This book about collectives of artists and workers was very much a shared effort. Artists Arturo García Bustos and Rina Lazo, who were protégés and colleagues in the 1940s of many of the artists discussed in this book, first opened their doors to me as my landlords when I began an earlier book in 1990. They and their daughter Rina García Lazo have since offered years of inspiration and hospitality. Herzonia Yañez and Graciela Schmilchuk have provided friendship, logistical support, and guestrooms in their respective homes since my first trips to Mexico.

Four institutions in Mexico also feel like home. As a Fulbright scholar I was affiliated with the Centro Nacional de Investigación, Documentación e Información de Artes Plásticas of the Instituto Nacional de Bellas Artes during the summer of 2012 and had access to their rich document collections. I'm grateful to researchers Guillermina Guardarrama and Laura González Matute for their generous help. Jacqueline Romero Yescas was an invaluable guide to the Leopoldo Méndez archive. Nancy Arévalo and Carmen Rivera at the Centro de Estudios del Movimiento Obrero y Socialista shared the treasures of the archives of the Communist Party of Mexico. The staff of the Centro de Estudios Filosóficos, Políticos y Sociales Vicente Lombardo Toledano, and Javier Arias Velázquez and Josep Sanmartín in particular, went out of their way to facilitate access to their unique periodical collection and provide other help. I spent many hours at the Sindicato de Electricistas Mexicanos down the hall from the collective 1940 mural *Portrait of the Bourgeoisie*. Fernando Amezcua Castillo, Gerardo Avelar Flores, and their *compañeros* shared documents, insights, and meals with me in the midst of their ongoing struggle to maintain one of Mexico's oldest unions in the face of the heavy-handed liquidation in 2009 of the public electric company that employed them.

A variety of people generously facilitated access to documents, images, and permissions: Pablo Méndez, Henoc de Santiago, Aldo

Sánchez, and Evelio Alvarez of the Museo del Estanquillo; Enrique Gutiérrez de la Cruz and the archival staff of the Universidad Obrera; Maria O'Higgins and María Maricela Pérez García of the Pablo and Maria O'Higgins Foundation; Gerardo Traeger of the Fundación Santos Balmori; Jorge Ramón Alva de la Canal; Graciela Castro Arenal; collectors Daniel Mercurio López Casillas, Michael Ricker, and Peter Schneider; Dr. Marina Garone Gravier of the Hemeroteca Nacional; and John Charlot and Bronwen Solyom of the Jean Charlot Collection at the University of Hawai'i at Manoa.

I benefited from the generous support of the Hoover Institution at Stanford University and access to their extensive collections on Mexican communism in the fall of 2011. During that stay, Stephen Haber challenged me intellectually and on the bike trails. Barry Carr has been supportive of every one of my research projects since we met many years ago. The late David Craven modeled the relation of art to revolution in his work, encouraged this project, and invited me to publish an initial piece. I am grateful to Jay Oles for his related research and for two helpful conversations. Tatiana Flores, Jennifer Jolly, and Leonard Folgarait wrote exactly the books and articles I needed to read and responded to emailed questions large and small.

Colleagues at the many meetings of the Rocky Mountain Council for Latin American Studies offered feedback on annual episodes of my research. History graduate students at the University of California at Berkeley gave excellent feedback on early chapters. I am very grateful to the two readers for the University of Texas Press: Mary Kay Vaughan asked hard questions and helped me think through the answers; and John Mraz followed up great suggestions with multiple references, contacts, and second readings. Diego Armus, Deborah Caplow, Barry Carr, Margaret Chowning, Joseph Collins, Chris Fulton, Janet Marcavage, Susie Porter, Peter Schneider, Linda Williams, and Eddie Wright-Rios read all or parts of a near final draft and made invaluable comments. I am particularly indebted to Susie Porter and Eddie Wright-Rios, who each helped me think through different questions. Special thanks go to Peter Schneider for sharing his encyclopedic knowledge of the Mexican print tradition, attention to visual and grammatical details, and prints from his collection. Joseph Collins expertly applied his machete to my tangled and jargon-filled sentences and made this book more readable.

There may be no better place to conceive and nurture an interdisciplinary project than a small liberal arts college like Puget Sound. Colleagues in History and Latin American Studies endorsed my leaps in

the classroom and in my research. Fellow border crosser Doug Sackman encouraged this research in a variety of discussions. Linda Williams shared the methods of art history in a co-taught class, and Janet Marcavage taught me the basics of printmaking in a studio class. Don Share enabled this book by grading and managing much more than his share of our Cuba travel seminar. Kyle Cramer helped me manage hundreds of images click by click. I am grateful to Puget Sound for the two sabbaticals that bookended this project and for generous support for image permissions. Close to home, Deborah Caplow (UW-Bothell) and Mike Honey (UW-Tacoma) have been comrades in art and politics.

At the University of Texas Press, I thank Theresa May for her initial interest in this project, editor Kerry Webb and assistant editor Angelica Lopez for their guidance and patience, and Victoria Davis, Jon Howard, and Ellen McKie of the editorial and production teams for shepherding this book to publication.

Last and foremost, I thank my family. These acknowledgements resemble some of the images in this book, with work foregrounded and the domestic sphere in the margins. But I am very aware of the powerful women in the world and in my life. Marena and Soroa long ago stopped asking their present-but-absent father when he would finish. I hope now they will invite me along as they shake up the world. Marisela Fleites-Lear and I form our own collective of intellectual workers and (one) artist. She helped knock on many of the doors that led to this book and commented on every page. She inspires me daily as she dances across new thresholds.

PICTURING THE PROLETARIAT

INTRODUCTION

ALLEGORIES OF WORK

A central image that marks Mexico's art after the 1910 Revolution is the campesino-peasant—often depicted as the iconic Emiliano Zapata himself—fighting to restore the lands and autonomy of rural villages. Almost as ever-present is the image of the urban worker in denim overalls, fighting for his rights while building a modern progressive nation. If the first image was fundamental to Mexico's traditions, the second was essential to its modern future. A common underlying image is that of the revolutionary artist, dressed in overalls and leading the working people he portrays in art.

This book explores the relations between artists and organized labor and the competing and evolving visual narratives by which they represented the worker as a central protagonist of Mexican society during three revolutionary decades.

In Gustavo Ortiz Hernán's 1937 novel *Chimeneas* (*Smokestacks*), denim overalls project a variety of assumptions about workers that had become standard tropes for artists as well as writers on the political left. The fusion of race and class is illustrated when the novel's main character, Germán—a bookkeeper in Mexico City's La Perfeccionada textile factory on the eve of the Revolution—first imagines the dark-skinned strike leader Chicho as a naked Indian with bow and arrow. But then Germán has a revelation:

The naked Chicho with his sunken collarbones and skin [*pellejo*] as dark as brown sugar is not the same as a gringo, red like a California apple. But there is something that covers Chicho's dark skin that makes him equal to a Yankee and even a Chinaman. Chicho, who spends the whole day making sure the threads weave together in the loom; with his hidden Indian spirit and wide hands, covers his dark skin in an armature of blue denim. This is the same cotton shell that hides the bodies of weavers in England, of German miners and of men who, piece by piece, construct the little Fords of Detroit.[1]

For the bookkeeper Germán—and by extension the writer Ortiz Hernán—the factory and the denim overalls make Chicho part of a

modern, international proletariat, although his very universality is Mexicanized by his transformation from indigenous to urban mestizo. But his picture of the proletariat concealed as much as it revealed. Mexico was a primarily rural country, and factory workers were a modest minority of the urban labor force. For the radical artists of the 1920s and 1930s, the denim overalls, the uniform of the working class, symbolically reduced the divide between skilled and unskilled and urban and rural workers that characterized Mexico's industrial transformation.

Overalls also defined the worker of the 1920s and 1930s as male, with his female counterpart mostly represented in her peasant skirts and rebozo scarves and tied to domestic duties and the labor of reproduction. Women are completely absent from the textile factory in Ortiz Hernán's novel, though in reality, they formed a substantial portion of the working class on the eve of the 1910 Revolution, and the real La Perfeccionada employed 643 women out of a total of 800 workers, some of whom led various strikes during the following decade.[2]

Finally, denim overalls symbolically reduced the distance between intellectuals and workers. Germán the bookkeeper self-consciously admires Chicho and other workers for the strength they show on the shop floor, the passion and violence with which they settle their disputes, and the directness of their sexual relations with women. As his sympathy for the factory's workers grows, he fantasizes about trading his well-worn "clerk's jacket" for overalls. Eventually, he becomes an officer in the factory union, and when he is indirectly implicated in a violent workplace riot that leaves a hated Spanish overseer dead, he disguises himself in overalls, darkens his face, and escapes with Chicho to join the Zapatistas fighting the Revolution in Morelos.[3] Industrialization and the Revolution turn the Indian Chicho and the middle-class Germán into a mestizo proletariat and revolutionaries.

Ortiz Hernán's novel hints at the aspirations of many artists. If in the 1920s their visions were often allegorical, in the heady radicalization of the 1930s they seemed to come true. Indeed, Ortiz Hernán's fantasy of the bookish Germán at the head of a union partly paralleled his own life. His ties to President Lázaro Cárdenas and the official ruling party in the 1930s and his militancy in the League of Revolutionary Writers and Artists (Liga de Escritores y Artistas Revolucionarios—LEAR) facilitated his appointment as director of the government print shop, the Talleres Gráficos de la Nación, under a regime of worker self-management. The novel itself, printed by and dedicated to the printers and illustrated by LEAR artists, epitomizes the collabo-

ration of artists and workers during the Revolution. So too does the mural painted for the union of the print shop in 1936 by four LEAR artists (figs. 5.19–5.21).[4]

REPRESENTING WORKERS

On one level this book is about the artists and labor leaders who both aspired to represent workers. A study pairing artists with the organized working class in the Revolution may not be obvious. Mexico in 1910 was an overwhelmingly agrarian country, with a large peasantry and a small urban working class. With limited markets for fine art, professional artists were a tiny, urban group of middle- and upper-class origin and dependent on the state for training, patronage, and employment.

The outsized role that a handful of politicized artists and the leaders of a small organized working class played in the 1920s and 1930s had everything to do with the 1910 revolution. Recent scholarship recognizes the period 1910 to 1940 as a genuine social and cultural revolution, even as most scholars acknowledge both the gradual process of hegemonic institutionalization and the continual challenges and negotiations that shaped the new order.[5] The experiences of artists on the left and the working classes very much fit into this dynamic. The postrevolutionary state and society were made by artists with brushes and workers with tools as much as by campesinos and middle-class generals with guns. The pragmatic strongmen who won the Revolution in the battlefield needed the support of workers and artists to sustain and legitimize their rule. But bringing these radicalized elements into their ruling coalition was not an easy task.

Campesinos were far more important participants compared to workers in the decade of armed struggles beginning in 1910 and were arguably more central to the nationalist art that followed. But revolution empowered significant sectors of urban workers who, like Chicho in Ortiz Hernán's novel, gained leverage in workplace struggles and beyond and often made formal alliances with revolutionary generals and the postrevolutionary state.[6] Similarly, it gave opportunities to a new generation of artists who incorporated European avant-gardes to create uniquely Mexican visual languages, reached out to mobilize social groups with their art, and helped construct the state's ambitious project of public education and national identity.[7]

The dramatic acceleration in working-class organization on the

shop floor and in the streets not only paralleled an artistic renaissance but also intersected with it. After a century of mutual indifference, organized-labor leaders and middle-class artists repeatedly crossed and shared paths, engaging in new levels of collective organization that involved both resistance to and collaboration with the postrevolutionary state.

Like the writer Ortiz Hernán, male artists on the left in the 1920s and 1930s claimed a close affinity with the urban working class. They donned denim overalls, formed their own unions, and represented workers in their art in ways that embodied, shaped, and challenged the discursive representations labor leaders made of themselves and their constituents. In speeches, public murals, photographs, periodicals, broadsheets, and posters, artists and labor leaders agreed in their portrayal of workers as central protagonists in national and international struggles.

Their joint construction of a public image of the worker is emblematic of the organizational and creative innovations the Revolution unleashed. Artists as well as labor leaders seized the opportunity to remake themselves and society. In the process, they indeed played a fundamental role in the creation and representation of postrevolutionary Mexico.

Central to the worldview and self-conceptions of both groups were class, race, and gender. Artists were intensely aware of their own origins and privilege. They mainly came from the lighter-skinned middle class of provincial capitals. Art education expanded after 1914, but for the most part artists with advanced training continued to come from relatively privileged backgrounds.

What changed was their conception of themselves and the nature of their profession, which coincided with their incorporation of poor and working people as ideal subjects in and consumers of their art. Artists' encounters with campesinos and workers were unprecedented and frequent during the Revolution and its aftermath, but it is the workers that many encountered most directly and came to identify with personally. From 1914, critics and artists celebrated manual arts and crafts and drew analogies between craft and artists' workshops. In the 1920s, many artists organized collectives and wore overalls as their uniform and marker of the working-class identity they had assumed, distinguishing themselves as "intellectual workers." And while they took pride in the darker-skinned artists in their midst, they mostly embraced a flexible racial identity as mestizos, a version of the darker-skinned mixture they often projected on the urban workers portrayed in their art.

Labor leaders spoke on behalf of a supposedly united and homogeneous working class that in reality encompassed a wide range of realities and identities. Many stood out among the rank and file for their relatively privileged origin, education, skill level, or strategic placement within the workplace or economy. And if artists often dressed down, many labor leaders dressed up, assuming middle-class respectability in moments of leisure and formal public association. The skilled craft workers who formed and led the key labor organization in Mexico City during the Revolution, the Casa del Obrero Mundial, were mostly literate and light-skinned and were photographed wearing suits and ties in public events, even as they led a movement that incorporated a much humbler rank and file. Luis Morones, a former electrician and the predominant labor leader of the 1920s, embellished his fingers with diamond rings. The predominant labor leader of the 1930s, Vicente Lombardo Toledano, came from a wealthy Puebla family and was trained as a philosopher and lawyer at the National University. The general secretaries of the Mexican Electricians Union from 1933 to 1940 were all engineers. Aside from fashion, labor leaders had much in common with the intellectual workers whose art celebrated and sought to enlighten the manual and factory worker.

Radicalized artists and labor leaders presented themselves as vanguards responsible for enlightening and politically orientating a reluctant working class, whether as Luis Morones's "Grupo Acción" (Action Group) of the Regional Confederation of Mexican Workers (Confederación Regional Obrera Mexicana—CROM) in the 1920s, or the artist collectives of the 1920s and 1930s that reached out to the working class.

The Communist Party of Mexico (Partido Comunista de México—PCM) magnified this vanguard tendency. After its founding in 1919, this tiny party organized in isolation and militant opposition to the dominant sectors of organized labor. Its members were influenced by the example of the Soviet Union and were sometimes directed by Moscow, though they tried to engage national traditions and organizational struggles on their own terms. As a result, the PCM won considerable prestige among intellectuals, artists, and a few leaders of the working class and peasantry. With the onset of the global Depression, a progressive government in Mexico, and Moscow's Popular Front strategy of broad, antifascist alliances, the PCM entered its golden age in 1934 and extended its influence among artists and intellectuals and significant sectors of the newly mobilized working class. In turn, the PCM inevitably influenced visual representations and labor discourses about the worker.[8]

Another parallel between artists and organized labor is their relations to the postrevolutionary state. In a mostly rural society with limited industrialization and a preponderance of unskilled and informal workers, organized labor was structurally weak and divided. In spite of labor guarantees in the 1917 Constitution, only a small minority of skilled workers in strategic sectors could successfully challenge employers alone. The majority of urban workers frequently relied on support from sympathetic government officials in their organizational struggles. And those who governed often turned to organized labor as one of their most reliable and easily mobilized allies.

Similarly, in light of the limited market for art, students and established artists depended on the state for training, patronage, and employment. The commissions artists received for public murals in the early 1920s are the most obvious example. Still, the variety of artist collectives and publications, their alliances with organized social sectors, and their use of alternative artistic media like prints provided artists a considerable degree of autonomy from government control. But alternative, disposable media and their wider but poor public left unanswered the question of how to make a living from art. Even when artists' organizations thrived, they still turned to the government for commissions, subsidies, or salaries in cultural bureaucracies.

Of course, artists, workers, and sectors of the political elite often shared common goals of political reform and national transformation that made collaboration obvious. Similar to the public school teachers who spread the civilizing mission of Secretary of Public Education José Vasconcelos in the 1920s and the program of "Socialist Education" in the 1930s, artists and labor leaders were uniquely and similarly situated as intermediaries in "the dialogue between state and society" and leaders in the social and cultural changes of the Revolution.[9] They shared reformist and nationalist ideologies but often diverged over the pace and degree of reforms, issues of organizational autonomy and artistic freedom, and the conflicting class interests government officials sought to contain and balance as they legitimized their own rule. Organized labor and radical artists followed but also pushed the postrevolutionary state toward reforms, particularly in the mid-1920s and mid-1930s.

Yet in moments of national crisis or catharsis, as in the political crisis that followed the difficult 1928 presidential succession, or the nationalist ferment and political institutionalization that followed the 1938 oil nationalization, organized labor and radical artists came up sharply against the limits of their autonomy vis-à-vis the state.

What Barry Carr notes for the PCM can be extended to many labor leaders and artists on the left: "Aiming to subvert and transform the character of the capitalist state, the Mexican Communist party [PCM] in some ways acted to strengthen it, encouraging its 'revolutionary' and 'progressive' pretensions."[10] Similarly, hierarchical and implicitly authoritarian relationships within their organizations further undermined the goals of liberation and democracy advocated by artists and working-class leaders. These relationships left a problematic legacy for the labor movement and for political artists. In the narrative that follows, the year 1938 is both a high point and the end of a cycle of organization and innovation among artists on the left and organized labor.[11]

This story of artists and labor unions occurs primarily around Mexico City. This familiar pattern of centralization is reinforced by the nature and location of the sources and my own interests. A variety of vibrant regional movements simultaneously shaped and echoed trends in Mexico City, as artists from provincial capitals with lively artistic scenes were drawn to Mexico City for education at the Academy of San Carlos, and as artists in the capital regularly renewed their "Mexicanidad" with commissions or teaching appointments in the provinces. Similarly, fellowships, exile, or conferences in the United States and Europe exposed these artists to international trends and extended Mexico's influence on those trends. But Mexico City remained the main point of contact for ideas, artists' collectives, teaching jobs, and public and private patronage.

The related centralization of organized labor was as much about politics as economics. The Mexico City labor force was larger, more diverse, and for the most part more organized than that of most smaller cities. While unions with the most economic and strategic power were often industrial unions or federations based in particular regions or spread throughout the nation, proximity and access to the federal government favored the leaders of the smaller, less strategic unions and federations with their base in Mexico City. This pattern was accentuated by the creation of an official national party and a truly national labor confederation affiliated with it in the 1930s.

Finally, both art and organized labor were dominated by men who largely identified their callings and organizations as the province of males. Women were fundamental to the labor force in work that ranged from domestic service to factory and office work, but most were segregated by employers and male workers alike into poorly paid and unorganized work. Women were deliberately marginalized in the

main labor organizations of the 1920s and 1930s in the name of workplace protections and an ideal of a family wage for men that would allow women to maintain the home and raise children.[12]

Similarly, revolutionary artists represented themselves not only as workers but also as male. The expansion of art education in the 1920s increased the prerevolutionary trickle of women artists.[13] But the most talented among them, including Frida Kahlo and María Izquierdo, painted largely in the shadow of male artists. Denied mural commissions, the revolutionary medium of choice, they were often overlooked because of the medium and the small scale of their easel paintings, as well as their use of a more subtle, less directly political content. The counterpart of the denim overalls were the *huipil* blouse, rebozo scarf, and long skirt of indigenous women in which Kahlo and Izquierdo often dressed, a performance that further distanced them from proletarian modernity.[14] The exceptions were foreign women, like the Italian photographer Tina Modotti, who escaped many of the limitations imposed on Mexican women and made class struggle central to much of their art. As a corollary, revolutionary male artists portrayed artists who rejected political art as effete, homosexual, and counterrevolutionary.

The artists featured in this book include the famous (José Guadalupe Posada, Diego Rivera, José Clemente Orozco, and Davíd Alfaro Siquieros) and the lesser-known (Saturnino Herrán, Gerardo Murillo, Leopoldo Méndez, Xavier Guerrero, Tina Modotti, Santos Balmori, and others), as well as the occasional anonymous artist arising organically from the working class. Artist collectives and movements are as important to this story as are individual artists. The formation of artist collectives modeled partially on labor unions, such as the Syndicate of Technical Workers, Painters and Sculptors (Sindicato de Obreros Técnicos, Pintores y Escultores—SOTPE) in the 1920s and the previously mentioned LEAR in the 1930s facilitated artists' discussions of the function of art, their communication with the state as patron or reformist ally, and their contact with organized social sectors.

This book features two national labor confederations and a particular union because of their importance among workers and in national politics and the enthusiasm with which they collaborated with artists: in the 1920s the Regional Confederation of Mexican Workers and in the 1930s the Confederation of Mexican Workers (Confederación de Trabajadores de México—CTM) and the Mexican Electricians Union (Sindicato Mexicano de Electricistas—SME). Leadership was both crucial and problematic in these working-class organizations. Labor

leaders considered here include the corrupt but politically astute Luis Morones of the CROM, Marxist lawyer Vicente Lombardo Toledano of the CTM, and engineer Francisco Breña Alvírez of the SME.

The combined narrative of organized labor and artists over three decades allows me to trace a broad arc of organization and the competing identities of gender, class, nationalism, and internationalism that shaped postrevolutionary Mexico. In the mid-1930s labor unions and artists, mobilized by nationalist, Communist, and Popular Front ideologies and the reforms and divisions of the Mexican state, briefly situated themselves as fundamental actors in Mexican society. Even so, they ultimately found their unity and autonomy, if not their discursive importance, undermined by internal divisions, governmental centralization, and a changing international panorama by 1940.

WORKERS REPRESENTED

At another level this book is about the images by which workers were represented, or pictured. Thanks to the Revolution's social effervescence, the political needs of political leaders, and the convergence of artists inspired by avant-garde ideas, Mexico in the 1920s and 1930s moved to the forefront of international culture as never before.[15] Artists who saw themselves as "intellectual workers" pictured workers in ways that tell us something about the reality of the working class, lots about the politics of the labor movement, and more about elite discourses regarding the working class.

There is no iconic personality or image of a revolutionary worker or union leader on the order of campesino leader Emiliano Zapata. After 1917, Zapata and campesinos remained fundamental markers of nationality to officials, intellectuals, and artists in their attempts to *forjar patria* (forge the fatherland). Even so, as the urban working class grew, organized, and protested, the visual representation of the worker evolved in parallel and distinct ways, present in art from 1910, conspicuous from 1924, and prominent from 1934.

While middle-class artists exoticized campesinos and indigenous peoples as unique symbols of a deeply rooted traditional national identity, they portrayed urban workers largely in terms of a shared universal modernity. Campesinos and workers, the peasantry and the proletariat, the traditional and the modern, were fundamental symbols crucial to national identity and reform. Artistic depictions paired them but also blurred the division between them. The blurring re-

flected the constantly renewed migration of campesinos to the city, identified by their *calzón* breeches and sombrero, who remained an important part of an unskilled urban labor force distinct from the European industrial proletariat. At the same time, the blurring reflected the gradual and partial cultural process by which campesinos became proletarians, giving up the *calzón* and indigenous markers for denim overalls. The blurring also projected artists' visions of a political alliance between the working people of the city and the countryside, between the hammer and the machete, while navigating the shifting recruitment strategies of the Communist Party.

Not all images of workers were bound up in political allegories of class and nation. Artists explored other aspects of working-class culture in their art—the basic dignity of work, domestic life, and leisure activities. I consider some of these images but favor art with explicit political narratives because they were so central to the visions of artists on the left and because they reveal more about changing politics and public labor discourses. My attention to explicit political narratives unfortunately reinforces the biases of male artists.

In the history of the visual representation of the worker, the medium is as important as style or content. Visual artists engaged in a dialog between easel painting, muralism, printing, and photography. The print, cheap and rapidly reproduced and distributed, was the medium of choice for many artists who aimed to reach a working-class audience. While attentive to muralism, I feature the representation of the working class through the graphic art of selected journals, posters, and flyers. Ephemeral in form and function, this art has until recently been ignored or featured as art prints in exhibitions and catalogs with limited reference to the form or context of its circulation. It is often dismissed as propaganda or for its alleged conformity to socialist realism or official postrevolutionary nationalism. Yet it was at times censored by the state and criticized by Soviet critics for its alleged "expressionist distortions." This creative art provides insights into developing styles and iconographies as well as the organizational strategies of workers and artists. In short, it is valuable for its role in social change as well as its multiple visual influences and innovations.

These graphic media reflect and shape a different story than muralism. Printmakers shared much of the content and style of muralists and similarly aimed their art at a mass audience. But prints, photography, and the periodical endeavors that often contained them allowed artists greater autonomy from state patronage compared to murals

painted on the walls of public buildings. And the more ephemeral nature of the form bound it to the daily life, events, and organizations of the working class. The temporary, throwaway nature of prints—a product of consumer culture and advertisement—allowed for an immediacy impossible in murals. The journals produced by artist and worker collectives—*Acción Mundial, El Machete, Revista CROM, Lux, Frente a Frente*, to name a few examined in this book—served a variety of goals and functions: staking out political and aesthetic territory from other groups; asserting a claim on or independence from the state; and as bridges between union leaders and the rank and file, between artists and workers, and between cultural and political change. These publications also reflected a variety of international influences on artists, including modernist and avant-garde traditions from Europe in the 1920s and the international left culture that linked Mexico with New York, the Soviet Union, and the Spanish Republic in the 1930s.

Of course, just as there was no guarantee that workers saw public murals (much less saw themselves in them), print media by or for workers did not guarantee a wide readership or ideological congruity with that readership. These publications rarely convey what rank-and-file workers thought about any given issue or image featured in their pages. But they do reveal the ideas about labor, gender, and politics that labor leaders and artists circulated, the role of visual culture in shaping the ideas and strategies of the labor movement and artist collectives, and how these ideas and images became a part of national discussions.

This book explores the history of the visual representation of the Mexican worker over three decades as a dialog between social change, politics, and aesthetics. At the risk of overgeneralizing, I suggest here an overview of the visual narrative developed over three decades from the art of artists on the left. Regardless of my generalizations, the images in the pages that follow will ultimately speak for themselves.

The first decade roughly coincides with the military struggles of the Revolution. From the eve of the 1910 revolution, artists challenged traditional academic painting in a variety of ways, including by incorporating the figure of the worker in the national canvas. Two prerevolutionary artists model two distinct archetypes of the worker that would clash and mingle over the next thirty years.

The fine-arts painter Saturnino Herrán introduced the worker as a subject using the visual strategies of symbolism and allegory. His strong, fair-skinned construction workers labor at essential tasks,

building the monumental structures of Mexico City. They invoke the shared goals of the prerevolutionary elite and mutualist workers' associations through which workers were to assume their proper roles as citizens of and constructors of the nation. The prototype Herrán established can be called a "worker-citizen."

By contrast, the artisan printmaker José Guadalupe Posada developed a primitive style for the satirical penny press for workers that challenged dominant notions of development and highlighted conflict between the working class and its economic and political exploiters. Within that exploited class, he distinguished between the virile, oppressed, and outraged artisan classes, with whom he identified, and the victimized worker-campesino consumed by factories. But while Posada and his prints denounced abuses, they never advocated strikes. This archetype can be identified as "worker–victim."

Artists led by the painter Dr. Atl (the pseudonym for Gerardo Murillo) participated fully in the mobilizations and fighting of the Revolution but barely developed the image of the worker beyond the earlier work of Herrán and Posada. But in the reconstruction of the 1920s, artists' representations of the working class flourished against the background of intense labor organization and cultural politics. A rich variety of artistic influences and experiments shaped this representation, including Herrán and Posada, early murals, experimental rural and urban art schools, the avant-garde Estridentista movement, and the introduction of modernist photography.

I feature contrasting portrayals of the worker elaborated from earlier archetypes in two distinct publications that claimed to represent the working class. The newspaper El Machete was initiated in 1924 by a collective of artists including Rivera, Siqueiros, Orozco, and Guerrero and later became the organ of the Communist Party. These artists used woodblock prints to depict the working class as the exploited victim of foreign capitalists, the postrevolutionary elite, and the leaders of the official labor movement, themes they had first explored in more timid public murals. But unlike that of Posada, this worker was often portrayed as the instrument of his own transformation. The agency of this "worker–victim–militant" was portrayed as owing much to the enlightenment offered by the radical artists affiliated with the Communist Party, although the image of the militant worker was gradually incorporated in other publications after 1924 to show support for regional and national political leaders.

As the original artists of El Machete were dispersed after 1925 and the newspaper became the official organ of the Communist Party of

Mexico, the image of this "worker–victim–militant" was further refined in its pages by photographer Tina Modotti, who combined the modernist aesthetic of her former partner Edward Weston with many of the political themes pioneered by muralists and graphic artists. While these *El Machete* images joined influential political and artistic avant-gardes, the style and themes they used to picture the proletariat were hardly dominant in the 1920s.

By contrast, the official CROM labor federation published *Revista CROM*, illustrated by commercial artists whose drawings blended the earlier style of Herrán with the reformist politics of the federation itself. Multiple covers and illustrations depicted attractive, muscular, Europeanized workers who, together with industrialists and government leaders, constructed the postrevolutionary nation with their tools and the national flag in hand. This image was also bound up in middle-class consumer aspirations featured in articles and advertisements, a "worker–citizen–consumer" with an explicit and unprecedented political role.

After a period of repression and marginalization at the turn of the decade, artistic and labor movements in the mid-1930s were revitalized and radicalized. The left's Popular Front strategy, international cultural movements, and an alliance of working-class leaders and artists behind the reforms of Cárdenas made the worker–victim–militant the dominant representation of the worker. These images were most fully elaborated by LEAR artists in public murals, posters, and pamphlets, their own journal, *Frente a Frente*, and their collaborations with *El Machete* and labor union publications like the electricians' *Lux*.

The worker of the 1930s was more fully elaborated visually and ideologically than his predecessor. He was often depicted collectively, and the blurring of the campesino and worker from the 1920s largely disappears in the face of repeated representations of the proletarian masses or of a single, often colossal, worker representing the exploitation, protest, or victory of his entire industry or class. In murals, prints, and photomontages, he is embedded in the economic infrastructure of factories, or the production of primary resources like oil, and confronts the global forces of imperialism, capitalism, and fascism. He is also the fundamental actor in the creation of a democratic and socialist order in Mexico that seemed by 1936 to be very much in the making. In short, heroic individual workers and the proletarian masses confronted the forces of reaction at home and abroad.

In many of these images and for much of the decade, patriotic nationalism was subordinate to a national and international class con-

sciousness. International struggles around European fascism were often reflected in representations of domestic politics, with working-class conflicts linked especially to the Spanish Civil War. While the worker's primary uniform was still the overalls, in many images he was also joined by his Popular Front allies, professionals, and office workers in suits.

In another variation, the mass of workers communes with its own enlightened leadership, particularly when facing its class enemies or offering its conditional political support, as equals, to the political project of Cárdenas. And somewhere in the print or photograph—among the banners held in the crowd or the credit in the corner—is written the word "LEAR," pointing to the close collaboration of the artist collective with labor leaders and rank and file.

The print medium, featured in publications, posters, and flyers, remained the privileged form of political art in the 1930s, though it competed with and was influenced by other media. LEAR artists collectively painted a second wave of murals in schools, public markets, and union headquarters, and photographs and photomontages aimed at a more sophisticated working-class audience seeking an ultramodern form of representation. Stylistically, the international left culture that linked Mexico with New York, the Soviet Union, and the Spanish Republic in the 1930s influenced representations of the worker in all media. Most notable are the incorporation of elements of Soviet Constructivism in geometric compositions of powerful male workers and the use of the photomontage. Complex visual narratives and avant-garde styles belie any facile categorization of this art as socialist realism.

In the idealized visions of male artists and labor leaders, the worker, whether citizen or militant, is almost invariably represented as male. As noted, women were a significant part of the unorganized and organized workforce, and their numbers among teachers and office workers grew considerably from the 1920s. The middle-class press was more likely to include illustrations with women workers, in part because it often explored women's work as a problem. By contrast, in the visual world of artists on the left and illustrated labor journals, powerful men dominate the workplace; their wives occupy the domestic sphere or, at best, an expanded public sphere of consumption or protest. In Herrán's allegories of work and construction, a wife feeds her husband and children on the margin of the worksite. In the later prints of Posada, women are mostly homemakers protected by their artisan husbands or are the doubly victimized wives

of exploited male factory workers. Orozco repeats the latter trope of victimized housewife and contrasts it with "modern" prostitutes with bobbed hair who service the bourgeoisie. And the rough virility with which the heroic workers and their artist mentors are portrayed in *El Machete* has its counterpart in the Posada-inspired portrayal of effete, nonrevolutionary intellectuals.

By contrast, women played a prominent visual role in the text and illustrations of *Revista CROM*—not as workers, but rather as modern homemakers or as public, fair-skinned women with the latest flapper haircuts and fashions. Women were also the obvious audience for abundant ads that promoted middle-class modes of consumption.

An important exception are Tina Modotti's photographs of working-class women in the late 1920s. And in the 1930s, in conjunction with an increase in women's organizations and changes in the orientation of the PCM, artists gave workingwomen more prominence in their images. The campesino remains the male worker's essential ally, but his wife, usually with long braids and rebozo, often marches at his side, albeit with their child in her arms.

The visual narrative of the working class shifted around 1938 as the Cárdenas government moved toward moderation and the institutionalization of its coalition in a new party; as the PCM, the CTM, and its constituent labor unions underwent internal and external crises around that institutionalization; and as the LEAR itself succumbed to internal and external pressures.

Artists on the left hardly surrendered in the face of a dramatically different political climate, one that would shift further right in the context of World War II and the Cold War. The extraordinary visual aesthetic they had created in the 1920s and 1930s continued to hold sway in the realm of political art and still featured the worker as a fundamental national actor. LEAR artists visually narrated many of the conflicts between and within unions in the late 1930s, and after 1938 their successor organization, the People's Graphic Art Workshop (Taller de Gráfica Popular—TGP), tried to defend workers, campesinos, and students who challenged the post-1940s institutional order. But many of the portrayals by the TGP and independent artists after 1938, especially those done for the CTM and the official state party, reflected a fundamental shift in the association of the worker with the state. The colossal symbolic worker who earlier took on capital now defended national resources and industry from imperialism, with a constant background of the Mexican flag or its colors. The masses communed less with their own enlightened leadership and more

with Cárdenas and his successors as president. The worker–victim–militant, rendered in the powerful aesthetic derived from Posada and the artists of *El Machete* and the LEAR, became gradually fused with the patriotic colors and nationalist message of the worker-citizen derived from Herrán and *Revista CROM*, a worker-militant-citizen with militant modifying citizen. Nonetheless, as argued in the Conclusion of this book, the traditions of working-class militancy and the visual vocabularies developed between 1920 and 1938 continued as points of reference and as oppositional tools used by veteran artists and the younger generations of artists inspired by them.

The chapters that follow weave together a chronological narrative about the artists and the labor leaders who aspired to represent workers and the images by which workers were pictured. Chapter 1 considers the situation of artists and the working class on the eve of the Revolution. Chapter 2 follows the participation of artists and the organized working class in the decade of the military revolution. Chapters 3 and 4 survey the variety of organizational and aesthetic strategies of unions and artists during the 1920s, centered on a comparison of *El Machete* and *Revista CROM*. Chapters 5 and 6 explore the revitalization and radicalization of artists' and labor movements in the mid-1930s, with a focus on the LEAR, the electricians union, and the Spanish Civil War. Chapter 7 traces the divisions, conservative shifts, and institutionalization of labor after 1938, as well as the demise of the LEAR and the birth of TGP. The Conclusion reflects on the legacies of these representations of the worker.

SATURNINO HERRÁN, JOSÉ GUADALUPE POSADA, AND THE WORKING CLASS ON THE EVE OF REVOLUTION

I f the characters depicted in a painting by Saturnino Herrán and in relief prints by José Guadalupe Posada could talk, they might share their experiences as I imagine them below. My stories of two working-class sisters reflect the distinct visions of two artists who were almost alone in portraying the working class on the eve of the 1910 Revolution.

Maria happily brought lunch to Juan at his worksite; happily because her Juan, God providing, had steady employment for the duration of the construction project, the new Teatro Nacional; because she could care for their two children without taking in sewing in their tiny tenement room; and because lunch included meat leftover from Sunday she bought with money other husbands might have spent on pulque. As Juan ate distractedly amidst dozens of half-naked laboring men, Maria nursed their youngest, looking down modestly while watching the wandering steps of their toddler. Juanito could get hurt, crawling amongst the workers, but this worksite was his future. He would grow up to be a skilled carpenter like his father, or better yet, a stonecutter, like the one carving the fancy column that he was getting a little too close to. Maria was happy to be a small part of a nation, almost a hundred years old, that could build such a palace with her husband's strong arms, a nation where her son would surely grow up to build bigger things than his father had.

Maria was also happy to not share the bitterness of her sister Guadalupe, who let her children roam wild while she took in sewing, and rarely had more than tortillas and beans to send with her Jesús. Her husband was exploited—crucified daily he insisted—by the Spaniards who owned and ran the textile factory where he worked, where they both had worked until they met and Lupe got pregnant. "Let them just cut the pound of flesh from him directly" Lupe complained at family gatherings. "Tell your great president with his fine palaces about the factory where my Jesús works for charity and a glass of pulque" she would tell Juan. But when Jesús started talking about strikes, or even voting for that rich presidential candidate, "el loco Pancho Madero," nobody got angrier than Lupe.

This chapter examines the representations of class and gender by the painter Saturnino Herrán and the engraver José Guadalupe

Posada, who together pioneered the modern visual representation of the worker in the last years before the Revolution, developing different media, styles, and ideologies that would project well beyond their untimely deaths in the decade of the Revolution.

Herrán's was the elite world of the Academy of San Carlos and finely turned salon paintings, while Posada's was the lower-class world of craft shops and rough relief prints for the penny press. Their visions of labor differed beyond their distinct training, media, and style. Herrán portrayed the physical exertion of labor, workers' transformation of the surrounding urban world, and workers' traditional role providing sustenance for their families. He projected classical poses and eroticized European bodies onto Mexican workers and celebrated their nascent citizenship, even as he avoided addressing the social contradictions inherent in their labor. By contrast, Posada produced hundreds of engravings that articulated a working-class consciousness by "Mexicanizing" workers as a proletariat with rural roots, victimized by the abuses of bosses and foreigners, even as he rejected strikes and condemned revolutionary opposition to the dictator Porfirio Díaz.

Together they occupied and imagined different spheres of art and labor, of elite and working-class cultures, at a time when these worlds were only beginning to become aware of each other. The two artists' styles and visions would serve as distinct models for decades.

HERRÁN AND THE MODERN MEXICAN CITY

Saturnino Herrán was born into an accomplished middle-class family in Aguascalientes in 1887, just as that central Mexican city was undergoing dramatic growth as the site of the Guggenheim copper smelter and the largest railroad machine shops in the country. The industrial environment there may have captured his imagination from a young age. When he moved to Mexico City in 1903 to study at the Academy of San Carlos, his teachers included Antonio Fabrés, a Catalán artist known for his realist drawing techniques, and Gerardo Murillo, who harangued students to paint their own national and monumental art.[1] For Herrán, the city and its labor force became obvious subjects, made more pressing by a series of strikes and a range of monumental projects to remake the city in anticipation of the 1910 Independence Centennial. His earliest paintings evoke the daily life and effort of work in an urban society in the process of transformation.

This transformation raises the question: What *was* the urban reality

that working people encountered and that artists like Herrán sought to portray? The liberal, export-driven economic project under strong-man Porfirio Díaz fundamentally changed land ownership and labor relations in the countryside during his long reign (1876–1910), known as the Porfiriato. The transformations of the countryside are essential to understanding the Revolution and the prominent role of campesinos in shaping its struggles. But "Porfirian progress" also transformed the urban working classes and their environs, creating significant groups of workers in export sectors, like the miners of Cananea and the oil workers of Tampico, as well as workers in domestic industries, such as the steel workers of Monterrey, the textile workers of Orizaba, and railroad workers at transport hubs like Aquascalientes. Mexico City played a particular significant role because of the numbers and diversity of workers, their level of organization and political involvement, and their physical proximity to a central axis of transport, markets, and bureaucracy. Many of the reasons that made Mexico City central to the organization of workers made it the source of training and employment for artists, even those raised in vibrant provincial artistic communities like Guadalajara and Aguascalientes.

An overview of the Mexico City working class in 1910 and of the lives of several working people who rose to varying degrees of prominence in the labor movement during the Revolution helps set the stage for examining the visions of Herrán and Posada as well as eventual forms of working-class organization. In spite of the presence of new and traditional elites, and a significant rise of middle-class professionals, bureaucrats, and merchants, the capital on the eve of the Revolution was a city of workers.[2] But the orientation of much of the urban economy toward a privileged group of consumers very much shaped the working class. Work remained oriented toward the production of consumer goods, commerce, and services. Spurred by the introduction of electricity in the 1890s, French and Spanish immigrant merchants installed large modern textile factories in Mexico City and the surrounding Federal District, and helped give rise to a small but significant factory proletariat: in 1910, more than 10,000 workers labored in the twenty-two textile and cigarette factories around the city, one-third of them women. For example, Esther Torres arrived in Mexico City at the age of thirteen from her native city of Guanajuato in 1910 to join her younger sister and recently widowed mother. Why move to Mexico? According to her mother, the only men to marry in Guanajuato were miners and mule drivers; and now that her husband was dead and she needed to support her family, the only work in Gua-

najuato for her or her daughters was that of domestic servants, earning one and a half pesos a month. Right off the train, Esther's mother approached a woman in a tortilla shop to ask where she could find work. The next day, the *tortillera*'s niece brought her to meet *la maestra* of La Cigarrera Mexicana, who immediately hired her. After Esther joined her mother months later, she and her sister were hired as well, their first of many similar jobs in the city.[3]

In 1910, almost half of the population of Mexico City had been born outside the Federal District that contained it. Rural migrants moved to the city and many campesinos lived in the Federal District that surrounded it, even as a significant portion of migrants came to the capital from the more urbanized states of central Mexico.

Distinct but equally as numerous as factory workers were a variety of skilled workers tied to traditional and new crafts. The growth of the urban economy degraded many artisanal crafts, like cobbling and weaving, while others held their own or grew, like those of printers, plumbers, and mechanics. And the introduction of modern urban infrastructure such as electricity and electric streetcars also led to the creation of new skilled and semiskilled occupations. Railroads, electrical plants, and tramways all demanded mechanics, drivers, and electricians, people able to operate and maintain expensive machinery. By gathering together large numbers of skilled, craft-like workers, these new industries facilitated a high degree of consciousness among workers. Furthermore, the control of these industries by foreign capital and managers injected workers with a fierce nationalism.[4] Workers in these industries often organized at the level of factories as well as by skill, and they acquired great strategic importance after 1911, when new organizations and strikes often brought the city to a standstill.

Some of these skilled workers played prominent roles in working-class organizations from 1910 on. For example, Jacinto Huitrón was born in a tenement house near the center of Mexico City in 1885 of parents who had migrated from towns in the central states of Hidalgo and Mexico. His father, a cobbler, died when Jacinto was seven, and his mother opened a tiny variety shop in the north of the city to get by. After finishing primary school, Jacinto was apprenticed to a blacksmith at a peso a week and continued to take classes for four years at the trade school on San Lorenzo Street. After 1900, he got work constructing carriages and as a mechanic, blacksmith, and electrician. In 1910, he was laid off from the railroad shops, and after a brief stint of work in Puebla he returned to the capital to work as a mechanic and plumber in several of the city's big shops. In Puebla, Huitrón

met Rosendo Salazar, a local typesetter, who soon after began working in various print shops in Mexico City and writing poetry for the working-class press.[5] Whereas Huitrón and Salazar were born into the urban artisanal class, Luis Morones epitomized the geographical and social mobility of many working-class leaders. His parents migrated from rural Jalisco to work in a textile mill in Tlalpan on the outskirts of Mexico City, where Morones was born in 1890. In his youth, he worked as a printer before his employment as an electrician in the Mexico City Light and Power Company. Morones helped found the Mexican Electricians Union in 1914, then went on to become the preeminent labor leader in Mexico in the 1920s.[6]

Despite significant populations of factory workers and skilled craftsmen, by far the majority of the city's population worked in unskilled manufacturing and service occupations. The type of economic growth that occurred in Mexico City perpetuated and even expanded the need for unskilled and casual labor. Construction workers constituted 8 percent of the reported labor force in 1910, with skill levels varying from basic bricklayers to well-paid plumbers. Accounts of the period describe thousands of day-laborers or peons who were periodically employed in construction.[7] Domestic service workers grew by 52 percent in the fifteen years before 1910 and in that year remained the largest single occupational category in the city (28 percent of the work force). Women comprised more than one-third of the paid labor force, but more than 40 percent worked as domestic servants. With the exception of a few growing middle-class occupations in teaching and in private and government offices, most alternatives to domestic service for women were to work as shopkeepers and attendants, or in the garment industry and factories. For men, women, and children, work as servants, or in commerce, sweatshops, hotels, restaurants, street sweeping, or the generic categories of day-laborer, constituted the great bulk of the urban labor market. Organization among these workers was made more difficult by the extreme instability and informality of much of their employment.

This dichotomy went beyond the workplace to include social as well as cultural aspects. Unskilled workers were more likely to have rural origins and darker skin, while skilled workers were more commonly from urban backgrounds and were often lighter-skinned, like Salazar and Morones. Skilled workers were far more likely to be literate, often versed in liberal and even radical European thought.[8] For example, Jacinto Huitrón finished primary school and entered the Escuela Obrera, where he read classics of Mexican history and cul-

ture. Inspired by liberal and anarchist thought, he even named his children Anarcos, Acracia, Autónomo, Libertad, and Emancipación.[9] By contrast, Esther Torres had barely finished the third grade in her native city of Guanajuato before entering the labor market, and even this minimal education differentiated her from many other unskilled workers.[10] Unskilled workers—men in particular—were more prone to drink and honor "Saint Monday." And despite the much more secular environment of the city, religious belief and veneration for the Virgin of Guadalupe remained important, especially for women.[11]

Skilled workers (more so than unskilled workers) had maintained deep-rooted traditions of social organization (mainly mutual aid societies) and of political participation dating back to the nineteenth century.[12] In Huitrón's case, in 1909 he joined the Union de Mecánicos Mexicanos (Union of Mexican Mechanics) while working for the railroad. Salazar helped found the mutualist Unión Tipográfica Mexicana (Mexican Typographers Union) in Puebla that same year. Both engaged in the vibrant anti-reelection politics inspired by presidential candidate Francisco Madero in Puebla and then Mexico City in the first years of the Revolution before helping to found the anarchist Casa del Obrero Mundial (House of the World Worker). In the case of Esther Torres, as with many unskilled workers, unionization and political participation came later with the Revolution—and with help from skilled and educated workers like Huitrón.[13]

Given the changing nature of Mexico City and its working class, the restlessness of young artists at the Academy of San Carlos, and the nationalist urgings of teachers like Gerardo Murillo, it is not surprising that Herrán and a few other artists turned to the working class as a worthy subject for art. Throughout much of the nineteenth century, artists and then photographers had largely confined their representation of plebian classes in general and work in particular to mid-century *costumbrista* inventories of exportable curiosities; nostalgic national "types" (el pulquero, selling the fermented cactus nectar pulque; el aguador, selling water; and other street vendors); or symbols of decline and degeneracy among particular groups (the indigenous or urban delinquent) in need of regeneration and social control.[14] Work as identity or activity is secondary in such portrayals. Similarly, academic art favored historical and allegorical paintings with classical figurations, or rural and urban landscapes that narrowly marked national identity. In the urban case it focused on Mexico City's monumental colonial spaces and national symbols, with modern infrastructure largely hidden.[15]

By the late Porfiriato, the worker was slowly incorporated into the ideological discourse of the state as a source of national prosperity and also came knocking on the doors of the Academy of San Carlos. The Catalán Fabrés, who pushed his drawing students to capture street scenes, even chose a humble bricklayer as a studio model for his natural drawing class. A variety of drawings by Herrán, Rivera, and Roberto Montenegro featured in a 1910 Centennial exhibition attest to a reconfiguration by teachers and students of the classical figure, with bricklayers and porters in more informal poses and in everyday clothing.[16]

Such official and pedagogical nudging bore fruit in 1908 in Herrán's first public painting. Given the pervasiveness and public presence of construction workers in Mexico City, it is little wonder the painting featured them. Two are shirtless, throwing their full bodies into moving a huge cut stone, while another sits eating his lunch with one hand and with the other touches the head of his child nursing at the bare breast of his wife. Entitled *Labor*, it won a school prize and was purchased by the Secretary of Public Instruction and Fine Arts. The following year, Herrán painted *The Glass Mill*, based on his visits to the famous blown-glass factory in nearby Texcoco (fig. 1.1). Shorn of the allegory of family or any individuality at all, this grim painting centers on the bestial labor of the single figure, a rural peon with his face hidden as he struggles to roll the huge stone wheel of a mill. The clothes and technology are timeless—this could easily be a rural, colonial scene, lacking modern technology—as is the exhaustive labor and suggestion of exploitation of the faceless, unskilled worker. A reviewer in the opposition journal *El Ahuizote* praised *Labor* for not vulgarly glorifying labor: "The painter, who has seen how poorly distributed is the wealth from productive effort, doesn't celebrate an unfortunate worker who exhausts himself pushing a stone to construct a founding father's lavish palace." Yet the reviewer questions Herrán's critical restraint: "He doesn't want to comment, and limits himself to showing."[17]

Herrán's most ambitious treatment of work began in 1910 as a commission for the government's School of Arts and Crafts, with a first version displayed at the Exposition of Mexican Painters at the Centennial. He painted a large, two-part wall hanging (plates 1 & 2) entitled *Allegory of Construction* and *Allegory of Work*. The form breaks with the traditional use of the diptych for historical painting and anticipates the scale and didactic and narrative functions of murals. The meticulous human form and luminous colors suggest the Europeanizing influence of his two teachers—Fabrés for drawing and Germán Ge-

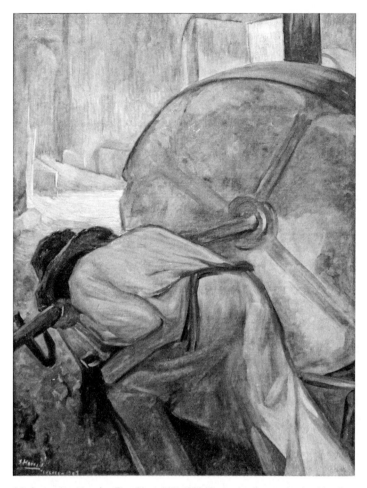

1.1. Saturnino Herrán, *The Glass Mill*, 1908. Reproduction authorized by the Instituto Nacional de Bellas Artes y Literatura, 2015. Collection: Instituto Cultural de Aguascalientes—INBA. Photograph by Ricardo Vega Muñoz.

dovius for painting, as well as the urban themes of Englishman Frank Brangwyn's large panels.[18]

On the central plane are the muscular bodies of workingmen engaged in the heavy labor of construction—carrying stones, cement, and beams and wielding their tools—though the intensity of physical effort and fatigue is less obvious than in *Labor* and *The Glass Mill*. In spite of their degrees of undress and the manual labor of many, their urban clothing and European features suggest an idealized modern, urban worker rather than the lumpen day-laborer with indigenous roots that moved much of the city's construction. For historian

Victor Manuel Macías-González, Herrán creates in this painting a new model of masculinity, one characterized by mestizo factions and Westernized dress, specifically overalls, which identify them as members of the international proletariat: "Danger—says the allegory—, a new Mexico in the works" writes Macías-González, one in which manliness "no longer resides in hacendados, bull-fighters, charros, in creole and European identity." Masculinity is closely linked to citizenship, a trope reinforced by the classic poses and references such as the column and vase.[19]

The dual title insists on the importance of workers to constructing the nation, as the new Mexico is the city that rises on the horizon. The upper left plane is dominated by the scaffolding of the tall building, one that is certainly urban and probably public. The column that anchors the center of the left half suggests the most prominent public construction of the time, the ornate, neoclassical Teatro Nacional, which was interrupted by the Revolution and finished as the Palacio de Bellas Artes in the 1930s. The upper-right plane opens up on an urban scene of workshops and factories that fades in the hazy yellowness. There is nothing in this cityscape to suggest Herrán's later fascination with the churches and colonial architecture—indeed, there is little in the central plane of laboring men or the urban background to mark this scene as particularly Mexican—beyond the arguably mestizo features of the workers themselves.

The limited reference to national identity is to some extent remedied by the foreground corners. On the right the allegory of work extends to family. A man takes a lunch break with his wife and two children, though his fully dressed body is largely hidden and his engagement with the family he labors to provide for is limited. His wife is completely absorbed with the infant at her breast and the male toddler hanging at her arm, whose naked body reproduces the male torsos at the center of the picture, suggesting a cycle by which the labor, masculinity, and fledgling citizenship of the father is reproduced by the mother through the son. Together they construct the public building and the nation.

The woman's rebozo—a marker of Mexican and mestizo roots—exposes her left shoulder and mirrors the corresponding male figure in the left foreground, with his chest bare except for the overall strap hanging from his left shoulder. The male's downward gaze forms a diagonal along his arm, which grasps the earthen pot that he is painting, perhaps like Herrán himself, with the paintbrush in his right hand. With this potter, along with the figure to his right sculpting the col-

umn, Herrán venerates the artisanal skills learned in the School of Arts and Crafts. He also anticipates the later fascination artists develop with the crafts associated with indigenous and mestizo culture.[20]

Herrán's romantic projection of class- and race-based masculinities is shaped in part by his academic studies, revealed in the projection of classical poses, half-naked bodies, and lighter skin on working-class and arguably mestizo men. In the final (1911) version included here, the skin tones are lighter and the features are notably more European, and there is an erotic sensibility in the depiction of well-proportioned and muscular male torsos. The hypermasculinity and eroticism of his workers resembles contemporary portrayals of labor in the United States and Europe.[21] By contrast, the woman on the far right, in spite of her bare shoulder, is confined and de-eroticized by her all-encompassing maternity. Herrán's romanticization of these workers may suggest a middle-class anxiety over their very marginality and exploitation. Gerardo Murillo's criticism of another Herrán painting might apply here: "The real form of beings and things have disappeared before his technical ostentation."[22] Of course the ostentation was as much ideological as technical.

Herrán's paintings were extraordinary at the time for their focus on the physical exertion of labor, the workers' transformation of the world around them, and their traditional role providing sustenance for their families. There is an implicit declaration of class identity that distinguishes them from campesinos and can be seen as a challenge to traditional elite masculinities. At the same time, as hinted by the critic of *El Ahuizote*, and elaborated by Victor Muñoz, Herrán represents "a concept of work close to the act of transformation of the world, but far from its social contradictions."[23] On the eve of the Revolution, the romantic allegorization of labor is not surprising, given it was a government commission, a reminder that the main patron of the fine arts was the government.

While Herrán's paintings make no direct reference to worker organization, they are compatible with the dominant ideology of the mutualist organizations that provided an important form of sociability among workers and remained the key vehicle for their aspirations. Although mutual aid societies sometimes sheltered anarchists and socialists who advocated struggle against employers and the state, the more dominant "mutualist" idiom, encouraged by officials and employers, invoked hard work and moral behavior, celebrated the role of workers in constructing the nation, invoked a patriotism linked to obedience to authorities, and praised unity not only among workers but also between workers and their bosses.

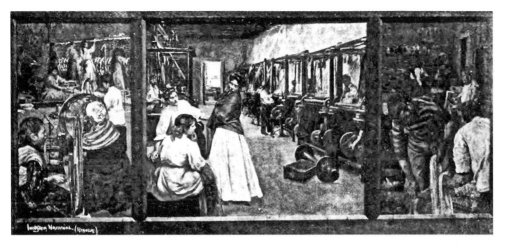

1.2. Francisco Romano Guillemín, *National Industry*, 1910. *El Universal Ilustrado*, March 6, 1910.

Herrán was not alone in his early interest in work and workers or his idealized style and content. A reviewer of the Centennial exhibition described a worker in a painting by Mauricio Garduño as a "sign and symbol of work, man of powerful muscles, healthy, nourished by abundant and generous blood."[24] In the same year, Herrán's classmate Francisco Romano Guillemín exhibited a triptych (fig. 1.2) called *National Industry*. His decision to use the triptych form, traditionally used with religious and historical allegory, also refashions academic painting and anticipates postrevolutionary murals.

Unlike Herrán, Romano Guillemín's choice of a factory setting acknowledges both the significant growth of factory production in the late nineteenth century and the continued importance of women in factory production. Framed within a textile factory, each panel shows a different phase of the production of rebozos. Men manage and interact with the weaving machines, though women visually dominate the painting, suggesting the gendered division of labor typical of textile and clothing factories, as well as the importance of female sociability in such settings. Finally, the woman at the center proudly wears the same rebozo the factory workers are making. That young women were featured in one of the first Mexican paintings of the interior of a factory is remarkable in itself, given discourses at the time of the moral dangers of factory life for women and the tendency in later art to equate labor exclusively with men.[25] At the same time, the painting suggests the blend of modern and traditional at the core of official Porfirian identity—a modern industrial factory, but one that produces a traditional marker of Mexican female identity. The painting cele-

1.3. Francisco Romano Guillemín, *Eternal Martyr*, 1910. from *Acción Mundial*, February 12, 1916. Author's photograph.

brates national industrial progress rather than critiquing the conditions of work, and it resembles promotional lithographs and photographs of modern factories featured in the local press and booster publications.[26]

In a painting done soon after, Romano Guillemín addresses, in a dramatic realist style, the potential for working-class conflict more directly than any Mexican painter before the Revolution. At the Centennial exposition, he featured *Eternal Martyr* (fig. 1.3), which a contemporary critic described as "a social work of protest: before a hostile and violent demonstration, the police fire, various men fall to the earth, the perpetrators escape, and the only ones remaining are a woman with an orphan in her arms and two unhappy prisoners." Though clearly empathetic, the painting suggests the consequences of "hostile and violent" strikes for everyone except perhaps the "perpetrators." The eternal martyr is as much the widowed mother or the fatherless child as the dead or imprisoned worker. Both paintings have

since disappeared, with at least one possibly given to revolutionary leader Francisco Madero, who had campaigned vigorously for president among the textile workers in 1910.[27]

At the same exposition, Arnulfo Domínguez Bello featured his 1906 sculpture done in Paris, *After the Strike*, described by Gómez Robelo as a "throbbing figure of a worker in the deaf desperation of the misery that follows disorder." The message of the counterproductive results of strikes was obvious at the time, but so too was the violence of the authorities. Any contemporary viewer likely drew indirect associations with the massive repression with which the Díaz administration ended the textile and mining strikes of Rio Blanco and Cananea in 1906 and 1907. Also part of the exhibition was sculptor Carlos Zaldívar's plaster model for a monument to the railroad engineer Jesús Garcia, martyred in 1907 when he drove a burning train loaded with dynamite out of the mining town of Nacozari, a fitting symbol of the sacrifice expected of workers on behalf of their community and nation.[28]

POSADA AND THE SATIRIC PENNY PRESS FOR WORKERS

If the artistic representation of workers by middle-class artists around 1910 — trained in the Academy of San Carlos and patronized by government purchases, fellowships, and jobs — was limited to a largely positivist vision of Porfirian progress, the urban working classes were not without their own journals, art, and artists capable of fundamentally critiquing that progress.

Changes in the nature and concentration of production, declining wages, long hours, unemployment, and frequent abuse led many workers to view the industrial system as one of great injustices where their progress did not equal their expectations or their contributions to national development. Many workers began to identify their own class interests as different from those of other industrial classes and subject to the manipulations of political officials.

Many skilled and factory workers began to move beyond the goals and ideology of mutualism to critique the structure of modern industry and even advocate and organize strikes. After 1905, workers groups gave cautious support to the efforts of the exiled and increasingly anarchist-influenced Mexican Liberal Party, incorporating some of its vocabulary, demands, and actions, though not its call for armed rebellion.[29]

Critiques developed in a variety of working-class newspapers, the anarchist-inspired press of the 1870s, as well as periodicals tied to independent mutual aid societies, all earnest and somber in their devotion to liberal doctrines of the redemptive aspects of work, while varied in their attitudes toward employers and political officials. But the richest visual vocabulary, and the most influential portrayal of the working class in the decade before the Revolution, came from the satiric penny press for workers.

This workers' press emerged as a distinct form in Mexico City in the 1890s as part of metropolitan industrialization. These newspapers differed from elite journals, with their focus on European art and their mostly disdainful view of the popular classes. They also differed from the opposition press, most famously *Hijo del Ahuizote*, with its famous caricatures of political elites and occasional references to a generic pueblo (literally the people, or populus), or the Flores Magón brothers' *Regeneración*, which gave unprecedented attention to working-class struggles but had little room for satire or for many images at all.[30]

In the penny press, aimed at a semiliterate audience, images were as important as the text; engravings or line drawings usually filled most of the front page, accompanied by a related poem, dialog, or news story. The most prolific artist of the penny press was José Guadalupe Posada. Relatively little is known about Posada beyond what his abundant published prints and two photographs of him reveal. Like Herrán, he was born in Aguascalientes, in 1852, to a far more modest family. The son of a baker, he managed to study briefly in the Municipal Academy of Drawing before entering an apprenticeship in a print shop and working for a variety of illustrated journals in Aguascalientes and León aimed at literate middle sectors. His first incarnation was as an acerbic and creative political caricaturist in the 1870s, a golden age for caricature and for a relatively free press that reflected rivalries of different political factions.

In the 1880s, as Díaz imposed political order and a degree of press censorship, Posada developed a more realist and *costumbrista* style, functioning as a kind of graphic news reporter with particular attention to urban upper-class pleasure, spectacle, and consumption. From 1888 to 1890 he worked in Mexico City for the upper-class entertainment journal *La Patria Ilustrada* of Ireneo Paz.[31] In both periods, his primary medium was the lithograph common to the illustrated press. His participation in the journal and almanac of Paz suggests a degree of renown and participation in the world of letters that belies his

discovery by middle-class artists in the 1920s. Paz published a note that predicted Posada would become Mexico's finest caricaturist and illustrator. Paz was right, except about the type of publication where Posada left his greatest mark. Fausto Ramírez speculates that Posada and his editor Paz may have parted ways over the "popular touch" of some of Posada's more vulgar lithographs.[32]

By the 1890s, the growth of a sector of literate and semiliterate working people with some disposable income and consumer aspirations created an expanding market for a new penny press, cheap and aimed at the working classes. Posada shifted most of his productive work from elite magazines to the new penny press, setting up his own shop while working closely for, among others, the primary publisher of broadsheets, Antonio Vanegas Arroyo. Posada quickly adapted to the technical and time requirements of the penny press, learning from the artist Manuel Manilla a simpler, deliberately rough-hewn, and more vigorous popular style. He developed an innovative and sophisticated technology that approximated the artisanal appearance of woodblock prints but took much less time.[33]

Antonio Rodríguez notes the phenomenon of a "maestro that, possessing everything necessary to be a 'cultivated, academic' artist accepted by dominant elites, 'lowers himself' to 'inferior' strata to convert himself in an artist of the people." Posada essentially became a part of the city's large artisan class, a small shop owner subject to the intense competition of the large lithographic shops. In a 1900 photograph, Posada stands in the doorway of his print and lithography shop on what is today Moneda Street, in the shadow of the National Palace and a block away from the Academy of San Carlos and from the shop of his main publisher, Vanegas Arroyo. Dark-skinned and portly, he wears the suit of a respectable artisan. Judging by the moves of his shops and residences to ever more marginal addresses, and his burial in 1913 in a pauper's grave, Posada's economic fortunes seem to have been in decline, perhaps assisted by a taste for alcohol,[34] a social decline that ironically coincides with the skillful and deliberate "primitivization" of his visual style to appeal to a different, lower-class audience.

Broadsheets, printed on one or both sides of a single page with a dominant image above a poem, ballad, or news story, were distinct in theme and audience from the satirical penny press for workers. In the hundreds of broadsheets Posada produced for Vanegas Arroyo, he created a broad social portrait of the Mexican people—from drunks, to criminals, to bullfighters, to dandies, to *indios*, to authorities—

unequaled by any other Mexican artist before the 1920s. Many of his broadsheet characters belong to the *pueblo*, literally "the people." But they rarely directly represent the working class in terms of social roles or the place or process of labor. Manifest is Posada's empathy for the concerns of the lower classes, his satire of corrupt politicians and decadent elites, and his denunciation of the latter's abuses and imitative European culture.[35] His broadsheet prints display a general respect for religion and priests, unlike those for the penny press for workers, suggesting that Posada tailored his content to the demands of his publishers and their varied, lower-class audience. In his prints for both, there is a common avoidance of direct criticism of Porfirio Díaz. The conservative bias of the broadsheets, perhaps imposed by market demand, his publisher, or the limits on press freedom, is ironic, given that it is the broadsheets, preserved by the heirs of Vanegas Arroyo, that were most accessible and familiar to the artists who discovered and reinterpreted Posada in the 1920s.

Posada simultaneously produced prints for the satiric penny press for workers, where, true to the orientation of the newspapers, he focused more narrowly on the role and interests of the working class and, distinct from Herrán, their relation to capital. For example, *La Guacamaya*'s masthead in 1902 proclaimed itself as "of the people and for the people," followed by a long list of self-descriptions that began with "gossipy periodical of good humor" and ended with "Scourge of the Bourgeoisie and Defender of the Working Class." María Elena Díaz argues that this medium reflected the development of a working-class consciousness that "narrowed its 'popular' constituency to an urban 'working class' by delineating this identity against other groups, by focusing particularly on issues related to that group, and by expressing them in the language of that group."[36] Satirical weeklies for workers incorporated writers from modest backgrounds who publicly identified with the working class they wrote for. But their primary audience was a specific sector of the working class. As Robert Buffington argues, the "penny press editors and contributors spoke most directly to the specific concerns of Mexico City's long-suffering artisan class," since they were themselves from literate artisan, worker, and petit bourgeois backgrounds, and saw themselves as distinct from the broader proletariat in their self-awareness and capacity for self-improvement.[37]

Still, their audience was considerable. *La Guacamaya* claimed a peak circulation of 29,000, compared to the 40,000 to 100,000 of the largest mainstream newspaper, *El Imparcial*. By one count, Posada contributed to twelve different working-class newspapers between

1.4. José Guadalupe Posada, *Seems Like Chia, but It's Horchata*, in *El Diablito Rojo*, October 24, 1910. Author's photograph.

1897 and 1910. Buffington explains the focus on working-class concerns: its graphic images were accessible to a large, semiliterate public; copies were often shared or read out loud on shop floors and tenement patios; and lacking the government subsidies of the official mass press or the political agenda of the opposition press, it relied on daily sales to finance operations, "a constraint that forced editors to pay special attention to the everyday concerns of their working-class clientele."[38] Thus while fine artists like Herrán depended on the government to buy their art and the government subsidy to *El Imparcial* guaranteed its partiality, the penny press was completely dependent on the market.

For Posada, the pueblo in general, and the worker in particular, were for the most part male, at least by 1900. Like Herrán, he borrowed from the classical repertoire, though his interest was more political than aesthetic. *Seems like chia, but it's horchata* makes reference to the Greek sculpture of Laocoön and his sons, a plaster cast of which was kept in the Academy of San Carlos close to his shop. The father figure of the pueblo is represented (fig. 1.4) by a campesino with rough features and a sombrero, flanked on one side by a smaller artisan, with an apron labeled "Proletariado," and on the other by a woman in ethnic dress, labeled "Indigenous race." All three are entwined by

snakes that represent "political bosses," "Miseria," and "slave-drivers and petty bosses." For readers who might not know of Laocoön's warning to beware the Greeks' gift of a horse, the colloquial title suggests the function of the penny press, to show that all is not as it appears.

The archetypical proletariat, a subset of the pueblo, is the skilled artisan working in the small shop, somewhat similar in background to Posada himself and the editors of the penny press. These respectable figures—identified by their smoother features, their aprons or occasional overalls, and their proximity to tools like the blacksmith's anvil—suggest the skilled craft workers who shared many of the modern values of thrift, sobriety, and education advanced by employers, officials, and middle-class reformers, and who took pride in their role building the nation. They are symbolically both the paternalistic father of the campesino and his offspring, as campesinos migrated to the city and they or their children acculturated into the working class.

Strong, virile artisans are featured in various mastheads of *La Guacamaya* (fig. 1.5) and in prints that portray the skilled worker's family life and healthy leisure activities. In one unusual allegory of the centennial of independence, President Díaz beckons to a proud artisan and his wife to sit in an ornate chair next to a woman representing the Mexican Republic, as Hidalgo observes from above the artisan's role in the progress of the nation. More typically, artisans appear in the background or margins of the print, as disapproving observers—like Posada himself and the penny press—of the various enemies of the working class, be they capitalists, foremen, shopkeepers, or priests. Occasionally, the proud artisan becomes a victim himself, subject to unfair competition and bias by foreign shop owners and workers.[39]

Even more common in Posada's iconography, and reflective of the urban and industrial changes of the capital city, is the figure of the unskilled worker represented with his rougher features, sombrero, sandals, and *calzón*-breeches. He would be indistinguishable from a campesino if not identified by an urban or factory setting, or the words *"clase obrera"* emblazoned across his halo-like sombrero. Race is implicit in their rougher features, and by dressing unskilled workers in campesino garb rather than the apron and boots of his respectable artisans, or the overalls of Herrán's construction workers, Posada emphasizes the social and cultural gaps between different urban groups. But the gap between the unskilled and craft worker was smaller than that between them and the elite who exploited them both.[40]

While the texts and occasional images of the mutualist workers press often celebrated the contributions of labor to the construction of

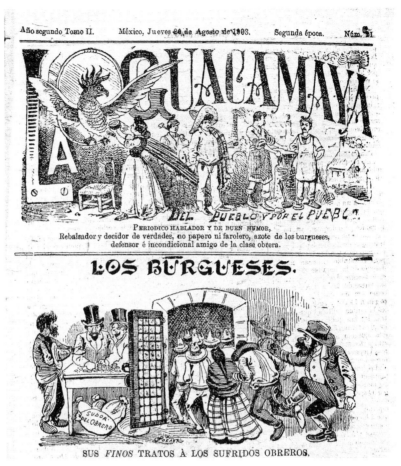

1.5. José Guadalupe Posada, *The Bourgeois*, in *La Guacamaya*, August 20, 1903. Author's photograph.

the nation, Posada's caricatures in the satiric penny press for workers more often denounced the inequalities and abuses of industrialization and the increasing rigidities of the political order. The scene and mechanism of the exploitation is most often a factory, occasionally an artisan workshop. Typical is *The Bourgeois* (fig. 1.5), where a group of humble workers is driven into a jail-like factory, the final woman and man in the line kicked forward by an oversized foreman. Unlike in the paintings of Herrán, workers are exploited by clear class enemies—the Spanish-looking foremen and the dapper "BURGUÉS" or "CAPITAL-IST" identified by his fancy dress, stovepipe hat, and the caption itself. Extraction is direct—we don't see the inside of the factory or the pro-

CALVARIO MODERNO

1.6. José Guadalupe Posada, *Modern Calvary*, in *La Guacamaya*, December 5, 1902. Author's photograph.

cess of labor. Rather, the surplus value of the workers' labor appears as bags of money labeled "THE SWEAT OF WORKERS," from which two "BURGUESES" count out a few coins to pay a worker dressed in rags.

Posada's prints were not simply allegories about the situation of workers. *The Bourgeois* appeared above a letter from female workers from the Compañía Cigarrera Mexicana, complaining of abuses by the female supervisor, and various of his prints were used to denounce specific instances of abuse; one accusatory print is even labeled as an "INSTANTÁNEA [snapshot] taken by our correspondent in the Metepec Factory," suggesting the influence of photography on Posada.[41]

In one print from the series *Modern Calvary* (fig. 1.6), the victimization of the worker and the extraction of profits are even more direct. An unskilled campesino-worker, his sombrero forming a halo with the words "WORKING CLASS," is crucified as a foreman stabs him in the ribs with a lance. The poem below explains that "the Bourgeois, with crazy longing, catches from his wound the holy fruit," a stream of coins that flows into his stovepipe hat. No factory mechanism is necessary here for the transformation of flesh into profit, just as other Posada images show "ambitious capitalists" wringing profit from the pueblo wedged in a press, or extracting a vomit of coins from the mouth of a woman labeled "WORKING CLASS."[42]

In a reversal of Herrán's allegory of the male worker's labor sustaining his family and the reproduction of labor, for Posada, the ultimate victims of the exploitation of workers are wives and children: in the image and text of *Modern Calvary*, the worker "sheds his blood, and in shedding it leaves his family, which suffers and doesn't complain, in the deepest misery." Unlike the artisan, Posada's factory workers are unmanned by foremen, by their poverty, and by political repression, though they are not feminized.

The fundamental role that women play in Posada's prints is that of mother, ideally to be protected by her husband and given the means through his labor to feed her family, though more often, her misery and offspring are part of the process by which the flesh of the worker is turned into coins, or into the bounty of the abundant tables and enlarged bellies of the burgueses. The worker-campesino and his offspring are consumed instead of reproduced.

Even so, in a series of early prints published in *El Fandango* in the 1890s, Posada has female figures formally representing and labeled "the working class," though invariably a victimized class.[43] By the early twentieth century, this metaphor is rare. Posada does occasionally include women among factory workers, as in *The Bourgeois*, but their prominence never approaches those in Romano Guillemín's *National Industry*, much less their actual importance in the national economy.

Posada's prints also denounce foreigners, including the foreign owners who hire foreign management, Spanish owners of pawnshops, bakeries, and groceries, and Uncle Sam as an ally of the Porfirian elite. Political bosses are often denounced and shown to be in cahoots with foreign capitalists. And in the penny press for workers, Posada makes manifest something not obvious in his broadsheets: his liberal Jacobin hatred of the clergy, denounced as one of the "plagues of workers" for extracting fees and tithes, encouraging fanaticism, and abusing the virtue of female charges.[44] These prints may have inspired the later anticlerical images of Orozco.

Rafael Barajas makes clear in his revision of Posada's oppositional positions that postrevolutionary artists elaborated their own myths about Posada to fit their own moment and ideological positions.[45] Posada's prints reflect a clear class consciousness of workers' exploitation within the capitalist system of the late Porfiriato, when workers were pushing against the boundaries of employer and political paternalism and the traditional goals of their own mutualist organizations. But the threat in the *Guacamaya* masthead, to serve as "Scourge of the Bourgeoisie and Defender of the Working Class," was largely rhetori-

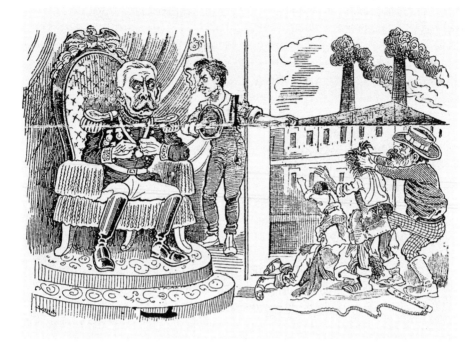

1.7. *You, Great Friend of the Workers, San Lunes,* December 20, 1909. Author's photograph.

cal. Their primary purpose was to call the attention of bosses, political elites, and society at large to these abuses, rather than to guide workers to new forms of organization and confrontation. In a 1909 print (fig. 1.7), a worker in overalls stands before President Díaz and points to a man beating workers in front of a factory. "You, great friend of the workers," he tells the outraged president, "look at the fury of the slave drivers and the abuses of the foreman!" In others, the president is indirectly blamed for the abuse of workers due to his ignorance, his indifference, or through being misled by the sycophants that surround him.[46] Another in his series Modern Calvary follows the "three falls" of a worker: the first two are the worker's encounters with a labor contractor and with alcohol; but the third fall is that of a "maldito burgués," toppled from his throne of tyranny by an anonymous hand of "Justicia," one that, whether divine, paternal, or the rule of law, is clearly not the result of direct working-class action.[47] Though elements of the satirical penny press for workers grew more radical after 1905, they rarely advocated strikes or urged the formation of formal unions, suggesting the limits of affiliated worker organizations and Posada's own radicalism.

One Posada print does move beyond the denunciation of the exploitation of passive workers to suggest action (fig. 1.8). In the first half of *What happens and what will happen*, a foreman in enormous boots squashes the workers beneath his soles; in the second, six individual feet—including a bare foot, a sandal, and a woman's high-heeled shoe—are seen booting the huge rear of an owner. But this unusual print represents more of a warning to owners than a call to action for workers.

Other Posada prints explicitly warn workers away from the dangers of strikes. Indeed, Posada frequently lumped strikes and electoral intrigues together as unacceptable challenges to the hard-earned Porfirian peace, including the efforts of dissident elite Francisco Madero in 1909 to mobilize broad electoral support for his presidential campaign.[48] For example, in the 1909 print below (fig. 1.9) from the conservative *San Lunes*, a campesino-worker returns to his house after "LA BOLA" (the riot or motín written on his machete), which might be a revolt, a strike, or a political meeting.[49] His clothes are in tatters and he carries on his back false hopes, including the promise of democracy. In the caption, the husband explains he is defending their money. The wife responds, "WHO ROBS US? THE 'MITOTEROS' [BRAWL LEADERS], WHO WHEEDLE IT OUT OF THE WORKERS SO THAT THERE

1.8. José Guadalupe Posada, *What Happens and What Will Happen*, *El Chile Piquín*, May 18, 1905. Author's photograph.

(DFSPUES DE LA "BOLA."– Traducción libre, no vendida.)

—Ya ves, Nicasio: todos en cueros. | —Quién te los roba? Los mitoteros
Por qué no dejas esa costumbre? | los que sonsacan á los obreros
—¿Y si nos roban nuestros dineros? | Pa que en su casa no haiga ni lumbre.

1.9. José Guadalupe Posada, *After the Ball*, *San Lunes*, October 4, 1909. Author's photograph.

ISN'T EVEN ENOUGH LEFT TO LIGHT A FIRE AT HOME." As hinted in Romano Guillemín's *Eternal Martyr*, the real victims of confrontation are again the worker's family, deprived of all resources during strikes and subsequent unemployment.

Barajas acknowledges the proletarian militancy of Posada's journalism in the penny press for workers, as well as its limits. On the eve of the Revolution, he concludes, "Posada forms a part of the intellectual vanguard of a backward sector of the proletariat that knows itself to be exploited by voracious bosses but is immersed in a culture of bossism, subordinated to the forms imposed by the government and doesn't understand how the capitalist state functions."[50] Of course, Posada's limits may have been more than ideology. There were many different Posadas, from his broadsheets to the satirical penny press for workers. He responded in part to editors and audiences while asserting a de-

gree of autonomy in where to sell his prints and what content to include.[51] For example, Posada regularly produced prints for *La Guacamaya*, which most directly denounced the abuses of the Porfirian regime until its publication was interrupted, probably shut down by the government, in 1907. After that date he produced for the more conservative *San Lunes*, aimed primarily at moralizing workers. And just as some of his most politically provocative images in *La Guacamaya* went unsigned, when *San Lunes* began its rabid anti-Madero campaign in 1909, the Posada-like prints appear anonymously or with a different signature ("ABCH"). Anonymity may have given him some protection or distance from the views of his patrons or from government repression.[52]

It took the opportunities, press freedoms, and ideologies of the 1910 revolution to push a critical mass of workers to move beyond the denunciation of their exploitation, and the satirical penny press for workers seems not to have survived much beyond 1911, a casualty of the greater freedom of the press under Madero and a new wave of organization and more serious-minded publications in the hands of a mobilized working class. After 1910, Posada collaborated with anti-Maderista newspapers and primarily produced broadsheets for Vanegas Arroyo. His collaborations and prints from these years, including multiple broadsheets attacking the revolutionary leaders Madero and Zapata, suggest that he remained hostile or ambivalent about a revolution that he felt threatened the peace that was the dictator's greatest legacy.[53] Of course, in the same period, José Clemente Orozco produced his own vicious caricatures of the soon-to-be martyred president, Francisco Madero, in the opposition newspaper *El Ahuizote*, and years later he justified them with a logic that Posada might have understood: "I might equally have gone to work for a government paper instead of the opposition and in that case the scapegoats would have been on the other side."[54]

We can only speculate about how Posada's views about the working class might have developed if he had lived to witness the massive mobilizations and strikes in 1914–1916 of the Casa del Obrero Mundial in Mexico City, an organization led by highly skilled workers whose journals included little satire or images.

A Posada broadsheet (fig. 1.10) does endorse one of the first "sensational" tests of workers' rights in Mexico City after the fall of Porfirio Díaz: the streetcar worker's strike of July 1911. In spite of the considerable inconvenience caused by the strike, the general public response was sympathetic, as newspapers and a middle class suspicious of for-

1.10. José Guadalupe Posada, Broadside, 1911, *Streetcar Strike.* Courtesy of the DeGolyer Library, Southern Methodist University.

eign owners proved sympathetic to new demands unleashed by the Revolution. Posada portrays an orderly group of uniformed, middle-class employees who could as easily be directing traffic as conducting a strike. The text praises the streetcar strikers for their "PERFECT ORDER AND LACK OF SCANDAL, THE OPPOSITE OF THOSE [STRIKES] ABROAD," without a mention of the streetcars that had been commandeered and burned by unruly crowds.[55]

In his broadsheets, Posada contrasted the strength and masculinity of the skilled worker with an effete bourgeoisie. The contrast was usually portrayed far from the workplace or the context of working-class exploitation, in a way that extended class conflict to the realm of culture and served as a model for postrevolutionary artists. In his study of working-class masculinities, Buffington compares bourgeois homophobia, with its policing mechanism for heterosexual and family values, with "working class homophobia, [which] by contrast, sought

to subvert bourgeois hegemony by calling into question their claims to class superiority."[56] Posada frequently employed this strategy with the *catrines* (dandies) of his broadsheets, but he uses it most notoriously in his portrayal of what became known as "the famous 41." In November 1901, Mexico City police arrested forty-one men for dressing as women at an elite private dance. The men were publicly humiliated and harshly punished as the event scandalized the metropolitan and penny presses and gained lasting national attention.

The memory of "the famous 41" owes much to a series of four broadsheet prints that Posada produced. The first is titled *The 41 Faggots (Maricones)*, followed by a ballad that describes in playful terms the events of the ball and arrest. The print (fig. 1.11) is a mix of dancing bodies, all young men with mustaches, half of them dressed in tuxedos as they embraced the other half, dressed in extravagant Victorian dresses that featured their curves and with feminized postures and ecstatic expressions. The hard-edged capitalists of the satirical penny press for workers are replaced by their useless, effeminate sons, incapable of work, and feminized by their inherited wealth and leisure. The satiric portrayal is affectionate but ultimately condemns the Porfirian elite as a whole for their decadence and unearned leisure.

On the reverse side of the broadsheet, their expressions of ecstasy turn to anger as the same cross-dressed men are publicly humiliated in a reversal of their class and gender identities. The feminized elite men are forced to sweep the streets, observed by a crowd of male workers in sombreros whose job might normally be cleaning, their masculinity intact, restored, and confirmed by the amusement they share with the viewer of the broadsheet.

A third print, *41 Faggots for Yucatán*, features the upper-class families of the arrestees at a train station as their sons are ordered shipped off to work in the infamous labor camps of the Yucatán, a fate previously reserved for criminals and the working-class *enganchados*, "hooked" into forced labor through drink and debt. The most visible figures are crying women, presumably the mothers, sisters, and perhaps wives of the forty-one. Once again, Posada's mothers are victims, though of a different class. Their tears echo the feminized laments in the accompanying ballad of the exiled sons in the train, traumatized by rough treatment by soldiers. The backs and top hats of male elites, shamed by their sons, are barely visible. In the far right corner, the same working-class crowd arrayed behind the police observes this reversal of roles, as feminized sons of the elite are shipped off to labor camps.

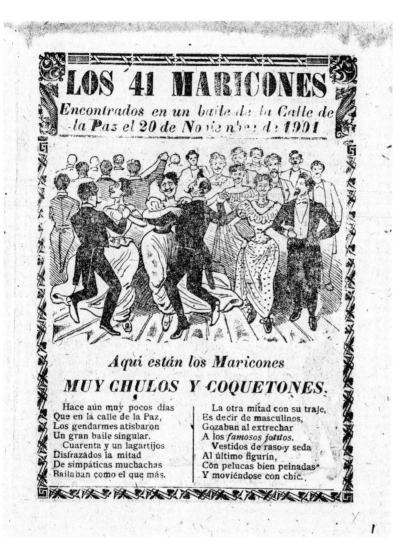

1.11. José Guadalupe Posada, *The 41 Faggots*. Courtesy of the Ransom Center, University of Texas.

A fourth print published six years later suggested how the mere number "41" came to invoke any challenge to traditional gender roles. In *Feminism imposes itself*, men in dresses are confined to the domestic sphere and tasks by the lines of the very number "41" itself, explicitly feminized by the women who "go to the workshop and office."[57] Elements of class disappear, as all men are feminized by modern, masculine women.

The incident of the famous forty-one and Posada's satirical prints initiated a public discussion of homosexuality in the twentieth century, what Carlos Monsiváis calls "the invention of homosexuality in Mexico," that reflects both curiosity and homophobia.[58] It was deliberately picked up by artists in the twenties who embraced Posada's medium, the print, and elaborated on his vision of class.

Posada left a rich graphic legacy in his portrayal of the Mexican working class for his self-proclaimed heirs, a generation trained, like Herrán, at the Academy of San Carlos, but also in the military trenches of the Revolution. Posada's world of penny-press prints was far from Herrán's world of the fine arts, yet they occasionally overlapped, starting in their native Aguascalientes. Posada received preliminary training in the municipal academy of Aguascalientes, worked for two decades as an illustrator for the middle-class "illustrated" press, and showed the occasional influence in his work of classical tropes and Spanish and French graphic traditions, including Goya and Daumier.[59] And in the last years of the Porfiriato, Mexico's restless art establishment was vaguely aware of the existence of Posada. For example, in November 1911 an anonymous art critic in the *Revista Moderna* described drawings by Roberto Montenegro as "dolls whose construction and conceptualization would shame the cartoonist Posada." But the academy's youthful rebels were not yet ready to see his caricatures as art or inspiration.

The death of Posada in 1913 seems to have passed unobserved in the press. But by the time his main publisher died in 1917, elite attitudes toward popular culture had begun to change. An article that year in *Revista de Revistas* celebrated the life of Vanegas Arroyo as "the writer and editor of the Mexican people," describing many of his most memorable broadsheets, and briefly but generously acknowledging the earlier death of his primary artist: "Guadalupe Posadas [sic] . . . unique printer in his genre, nobody had a better perception of the caricaturesque of the lower classes of the capital."[60]

In the years after 1910, Herrán occasionally returned to the theme of labor, as in his 1913 painting of foundry workers. But the vast majority of his paintings between 1910 and his death in 1918, as he and many other artists of his generation observed the unfolding of a rural revolution, addressed the spectrum of indigenous to *criolla* cultures that artists felt more urgently and directly allowed for a representation of a national mestizo identity. And when Mexico City provided the background for his paintings, it was in terms of its colonial churches rather than its factories or newer monumental constructions. Similarly, his

classmate Romano Guillemín, inspired by the Open Air Painting School initiated in 1914, embraced an Impressionist style and rural subject matter.[61]

Herrán's innovation in the representation of the working class was to portray the physical exertion of labor and workers' transformation of the urban world, even as he avoided addressing the exploitation of labor. By contrast, Posada's engravings for the satiric penny press for workers articulated a working class consciousness and denounced the abuses of bosses and foreigners, even as he rejected strikes and condemned revolutionary opposition to the dictator Porfirio Díaz. These sophisticated artistic representations of the working class followed and alluded to the strikes of 1906 and 1907 but predated the intense working-class mobilization that coincided with the outbreak of the Revolution. Both artists sat out the military revolution, Posada confined to Mexico City by his age (fifty-eight in 1910) and Herrán by his poor health, though they may have been uncomfortable with its violence and new ideological currents. In spite of intimate contact with working-class organizations in Mexico City and on the battlefront, the generation of artists who came of age during the decade of fighting would not equal or move much beyond the representations of workers by Herrán and Posada during the 1910s. The artistic neglect of the worker as subject owed much to the interruptions of war and the greater fascination of artists with a newly discovered peasantry that had more fully made the armed revolution its own. Even so, the styles and visions of both the popular caricaturist and the salon painter resonated after 1920 as artists and unions brought the working class more fully into the national imagination.

WORKERS AND ARTISTS IN THE 1910 REVOLUTION

TWO

When Diego Rivera returned to Mexico in 1921, he was a far different artist than the student who had left for Europe in 1907 on a government fellowship. Born in the provincial capital of Guanajuato in 1886 to relatively wealthy parents, Rivera's artistic abilities were obvious at a young age, and soon after his family moved to Mexico City in 1896 he began his studies at the Academy of San Carlos. Rivera quickly attracted the attention of his teachers, newspapers, and officials of the government, who followed his European development closely. On a brief return trip to Mexico in 1910, Rivera sold thirteen paintings included in the Centennial art exhibit to the Mexican government.[1] Over his fourteen years in Spain and France, his painting covered the spectrum of avant-garde art, shifting from romantic, to Cubist, to post-Impressionist styles, all challenges to academic painting that filled the art columns of newspapers back home.

In many narratives, the return of the prodigal Rivera in 1921 and the patronage of Secretary of Public Education José Vasconcelos is the beginning of postrevolutionary art, in which campesino and worker found their pride of place. But if Europe changed Rivera, so too had the Revolution changed the Mexico he discovered on his return. Rivera's European adventures and paintings had marked him as one of Mexico's most famous artists, but they didn't prepare him for the changes wrought in his long absence. Of course, he had absorbed the European avant-garde's fascination with the primitive and the Russian Revolution, and references to Mexico's popular classes and national identity dominated one of his European canvases, a fragmented, Cubist-style painting done in 1915 that features a northern serape, a campesino sombrero, and a rifle, mythologized years later with a new title, *Zapatista Landscape*. But the man who became the most famous and prolific artist of the Revolution did not otherwise feature a single campesino, indigenous person, or worker in his European paintings.

Upon his initial return, the national press complained of the unusual silence of the famously verbose painter, as he slowly absorbed

aspects of a country transformed by revolution. Urged by Vasconcelos to "de-Europeanize" himself, Rivera accompanied him on a pilgrimage of discovery to indigenous Yucatán. A few days before, Rivera confided to a journalist friend his halting realization that "the painter who has no sense of the longings of the pueblo—even if he doesn't exactly walk among the pueblo—will not do solid work."[2] But Rivera's revelation was nothing new for artists who had lived the decade of revolution in Mexico and had made far more abundant national and popular references in their art.

This chapter explores the discontents of artists and workers and their attempts at reinvention during a decade of bloody social conflict, including their creation of new organizations, alliances with revolutionary leaders, and the developments that made possible new ways of representing the working class. It is short on images of workers in part because the military revolution interrupted artists' lives and state patronage, and in part because artists' creative imaginations were more taken with the campesinos who were fighting the Revolution than the working-class subjects at the heart of this book.

While Rivera's huge personality and talent make him difficult to ignore, his absence from the events and trends of the decade of fighting helps accentuate the artists who experienced that change firsthand. A central personality of this chapter is the painter Gerardo Murillo, best known after 1912 as Dr. Atl. More than any other artist, Dr. Atl represents the vibrancy of art in the years just before and during the decade of the Revolution and its intersection with the social transformations of the Revolution. Known today mostly for his expressionist volcanic landscapes, Atl was immensely influential in artistic and intellectual circles in the first two decades of the century, providing a model for the younger Rivera, Orozco, Siqueiros, and many others with his many passions, his outsized personality, his invented personas, his immersion in art and politics, and his life of contradictions, travelling from the utopian anarchism of his youth to the anticommunist and anti-Semitic fascism he embraced in the 1930s and 1940s.

Atl was born in Guadalajara in 1875 and moved to Mexico City to study at the Academy of San Carlos. He received a government fellowship to Europe in 1897, a full decade before Rivera. There he was influenced by Impressionist and post-Impressionist painting and the monumental art of Italian frescos. Atl taught and organized a whole generation of art students at the Academy of San Carlos on the eve of the Revolution. A student at the time, Orozco later wrote of the return of "the rebel" in the last years of the Porfiriato: "Dr. Atl had

the rainbow of the Impressionists in his hands and practiced all the audacities of the Parisian School." He regaled students with stories of Michelangelo, drew "muscular giants in the violent attitudes of the Sistine," predicted "the end of bourgeois civilization," and, with his vigorous hikes and outdoor landscape painting, challenged the dominant academicism of drawing from models and copying the paintings of European masters, a challenge distinct in style and content from more Eurocentric symbolists such as the Mexican Julio Ruelas, who died in Paris in 1907.[3]

When the Díaz government announced the Exhibition of Contemporary Spanish Painting as the central artistic event of the Centennial celebration in September 1910, it was Atl who led a group of sixty art students in one of their first attempts at independent organization, the Society of Mexican Painters and Sculptors. Why celebrate independence from Spain with an exhibition of Spanish painting? They demanded and organized the alternative Exhibition of Mexican Painting that included works by Rivera, Herrán, and Romano Guillemín, among others. Soon after, Atl and the same group received permission to paint the walls of the Amphitheater of the National Preparatory School, an embryonic mural project interrupted by the outbreak of the Revolution in November 1910 and eventually inherited by Rivera.[4]

During the Revolution Atl served as a key intermediary between artists and the most visible organization of workers, the Casa del Obrero Mundial, and between both groups and the Constitutionalist faction of the Revolution that eventually triumphed. While social mobilization and politics took precedence over art in the decade of fighting, Atl's ideas, organizations, and occasional images, along with those he helped inspire, helped set the table for the decades of frenzied activity that followed.

LA BOLA

The Revolution began in 1910 as a crisis among elites, when the wealthy liberal reformer Francisco Madero challenged the ritual re-election of the aging dictator Porfirio Díaz, dividing elites and incorporating a sector of the urban middle and working class in his election campaign. When voting again proved fixed, Madero's reformist challenge exploded into armed revolt, one that brought Mexico's rural majority into a conflict that became a revolution. The Revolution unfolded in distinct phases and around a dizzying array of leaders. A first

phase began with the first major military skirmishes against Díaz in spring 1911 that soon brought Madero to the presidency, only to be challenged by campesinos led by Emiliano Zapata and others as well as by Porfirian elites, culminating in General Victoriano Huerta's assassination of Madero in 1913. A second phase involved multiple fronts that eventually brought down Huerta's reactionary government. A third was the civil war of 1914 and 1915 that pitted the Convention armies of Zapata and Francisco Villa against the eventually triumphant Constitutionalist armies of Venustiano Carranza and Alvaro Obregón. In spite of the eventual defeat of the Zapatistas, the quintessential agrarian rebels from the south, and of the Villistas from the north, the typical *"serrano"* rebels challenging centralized authority, the mobilization of campesinos by all factions was the key dynamic of the Revolution and its aftermath.[5]

The urban working class played a lesser military role in the national drama, yet their multiple organizations and mobilizations helped shape the decade, leading some to assume arms and take sides in the military conflict, and preparing organized workers to become significant actors in the postrevolutionary period.[6] The eventual consolidation of a stable regime led by upper- and middle-class generals was ultimately predicated on a series of promises in the Constitution of 1917, of agrarian reform in Article 27 and of workers' rights and protections in Article 123, and the willingness of governments after 1920 to fulfill them.

It is difficult by any measure to see artists as fundamental to the military phase of the Revolution. Even so, they repeatedly expressed their aspirations and agency extending well beyond art. Some carried arms, though most assumed roles akin to those played by middle-class intellectuals as a whole: as bureaucratic clerks and officials, as propagandists, and as intermediaries between revolutionary generals and particular social groups. Most important, the decade of fighting consolidated the way artists organized collectively and saw the world they represented in their art.

Artists and workers suffered the dislocations of war, seized opportunities to organize and reinvent their role in the nation, and occasionally joined specific revolutionary factions, frequently crossing paths in Mexico City and on the battlefield. These experiences prepared them to play an even greater role in organizing and imagining postrevolutionary society.

The decade of revolution stimulated artists' thirst for change while material conditions of scarcity, diminished state patronage, and po-

litical turmoil limited the formal possibilities for their art. Rivera returned to Mexico for the 1910 Centennial just as Madero's revolution began, yet saw no reason to postpone his return to Paris in spring 1911 and would not return again until 1921, when political and social order had largely been reestablished. Murillo, disappointed by the limited opportunities under the government of Madero, sat out the first part of the Revolution in Paris, painting, meeting leftist intellectuals and politicians, and trying to set up a utopian community for artists. It was there that he assumed the name Dr. Atl, from the indigenous Nahuatl word for "water," a hint at his continued obsession with Mexico, and part of his performance, similar to Rivera's, as exotic "other" for his Parisian peers. During this same trip, Atl joined a group of artists, Action d'Art, that was inspired by anarchist doctrine and dedicated to joining avant-garde aesthetics with politics.[7]

Artists in Mexico complained not only of limited opportunities to paint but also of shortages and the quality of paint. Most of the great illustrated magazines of the Porfiriato shut down, depriving artists of a key source of employment and expression, and similar publications would be revived only after the relative stability of 1917.[8]

But the Revolution also provided inspirations and opportunities. In July 1911, within months of the fall of Díaz, the students of the Academy of San Carlos, including Orozco, Carlos Neve, Romano Guillemín, José Guadalupe Escobedo, Ramón Alva de la Canal, and Siqueiros, initiated a strike after the secretary of education ignored their earlier demands: the separation of the divisions of Painting and Sculpture from that of Architecture; a modification of teaching methods; and a competitive contracting of professors. Striking students insisted on the removal of architect Antonio Rivas Mercado as school director. In April 1913, the strike finally ended with Rivas Mercado's resignation, an important step in an ongoing debate about the nature of artistic education. Siqueiros later recalled, "Thus began our political militancy, and also, without knowing it, our march toward revolutionary political art."[9]

In the midst of war, political and military leaders saw the utility of sponsoring art exhibitions and mobilizing artists, whether to graphically attack rivals (as with Posada's and Orozco's acid caricatures of Madero), to forge a national identity, or to counter the image abroad of a barbarous Mexico torn by revolution.[10] In the years after 1910, art moved out of the academy and into the streets and countryside, as subjects earlier explored and preached by instructors like Dr. Atl suddenly became central to the national canvas. An example of both

is the Open Air Painting School on the outskirts of Mexico City in Santa Anita, opened in January 1914 by the Huerta government's new director of the Academy of San Carlos, Alfredo Ramos Martínez. On the model of the French Barbizon school, art students mounted their easels in rural villages and pursued an "impressionist synthesis" of nature and the peasantry aimed at representing new national values. Expositions continued in Mexico City throughout the decade, with the exception of 1915, the most intense year of fighting, when many key artists found themselves taking sides in the conflict and outside of Mexico City.[11]

The "discovery" of the pueblo by intellectuals in general and artists in particular was a fundamental shift brought about by the Revolution, although one pioneered by Herrán and others before 1910. Fausto Ramírez identifies three themes in art fortified during the decade of the Revolution, all linked to an intensified search for national identity. One is painters' attention to the countryside itself as emblematic of the nation. Another is a renewed pride in colonial art and architecture. And finally, the "indigenous theme," with deep roots in Porfirian art, was made more urgent by the events of the Revolution. Typical are the early Impressionist-style landscapes and portraits painted by the director of the Open Air School, Alfredo Martínez Ramos, and his students, including Siqueiros, Fernando Leal, and Alva de la Canal, which emphasized the Mexican aspects of local landscapes.[12]

Of even greater resonance at the time and since are the carefully drawn symbolist paintings of Saturnino Herrán, employed as an instructor in the Academy of San Carlos. Herrán largely abandoned his earlier attention to the city and its workers and instead focused on the daily life of rural campesinos and indigenous people, with an intimacy distinct from earlier *costumbrista* paintings of the "folk," or from the classical renderings of a distant Aztec past of emperors, deities, and legends that had characterized late nineteenth-century Mexican painting. Examples include *The Harvest* (1909), depicting a campesino family laboring to bring in the harvest and akin to his concurrent paintings of urban labor, or the extended indigenous family of *The Offering* (1913), in a dugout loaded with marigolds bound for the cemetery on the Day of the Dead.[13] On a different scale and medium, the covers and even the advertisements of metropolitan weeklies such as *Revista de Revistas* featured Aztec warriors, *criolla* ladies, campesinos planting or harvesting, and camp scenes of revolutionary soldiers drawn in Art Nouveau styles by Herrán, Carlos Neve, Jorge Enciso, Roberto Montenegro, and Siqueiros, among others.[14]

Given the role of the armed peasantry in the Revolution, it is not

surprising that amid the upheaval the artists' gaze was drawn to the countryside, the rural worker, and the indigenous population more than to the city or the urban working class. For middle-class intellectuals, the rural majority—indigenous and mestizo—had long been the central challenge to the task of *forjando patria*, forging a fatherland that embraced the majority, and the massive armed participation of the peasantry in the Revolution drew artists' attention to rural manifestations of the pueblo.

Even so, the mobilization of the working class and the ongoing contact between urban artists and workers during the Revolution created lasting affinities. While the new prominence of the working class after 1910 didn't immediately create a body of art equivalent to that focused on the peasantry, artists' encounters with organized labor facilitated the emergence of a related visual culture after 1920.

For all the daily encounters and affinity of many artists with organized urban workers, workers' numbers and the scale of their mobilization during the Revolution paled in contrast to that of the now-armed peasantry. And in contrast to the peasantry, with its ready association with indigenous culture, the wide-brimmed sombrero, and the Mexican landscape, any portrayal of the worker implied a fundamental challenge that Herrán and Romano Guillemín had already faced: how to make of the largely modern and universal worker a symbol of Mexico amid a struggle that, beyond the battlefield, artists, intellectuals, and politicians increasingly linked to the construction of a cohesive national identity.

The emergence of new forms of working-class organization paralleled that of artists and ultimately brought them together. The working class was in many ways remade by the Revolution itself: by its ideological currents; by its greater political freedoms, due partly to weakened and constantly changing local and national authorities; and finally by the material changes in the urban environment brought on by the military and economic turmoil. During the presidential elections of 1910, a significant portion of workers backed the candidacy of Francisco Madero, who promised "a real vote, and no boss rule." But when Madero's presidential campaign was repressed and he turned to armed rebellion, his support came from the countryside. The possibilities of political participation for workers were limited and frustrated during Madero's brief presidency and during the ensuing conservative dictatorship of Victoriano Huerta, pushing urban workers to strengthen their own organizations in the workplace and their own communities.[15]

Since the demise of the colonial guilds, mutual aid societies, con-

cerned with issues of security and cultural and moral improvement, had been the only form of worker organization sanctioned by employers and the government. By 1913, many of the new workers' organizations had formed as unions. In the process, they moved to more direct confrontation with large employers and demands for government regulation.[16]

The leadership and cultural orientation for much of worker organization and the definitive move away from mutualism was led by the Casa del Obrero Mundial (House of the World Worker). The Casa was formed in 1912 by various organizations of craft workers, individual workers like Jacinto Huitrón, and intellectuals such as Antonio Díaz Soto y Gama. The Casa functioned first as a cultural organization, holding night classes and poetry readings and instructing workers in both self-improvement and the writings of radical European thinkers.

Despite the urgency with which the Casa and many of its component organizations undertook the task of *ilustración* of the working classes, their initial newspapers (*Evolución, Lucha, El Sindicalista, La Tribuna, Emancipación Obrera*) made sparse use of illustrations before 1915 beyond their modest mastheads (fig. 2.1). Perhaps they lacked the resources and artists needed to imitate the illustrated metropolitan press, or saw the caricatures of the traditional satiric penny press for workers as beneath them. They may simply have revered the written text above all. When the rare image found its way into their early publications, the template was the form and content of the anarchist press of Spain and Italy.

Within a year of its founding, the Casa became a catalyst for the formation of unions and the implementation of direct action, generally through strikes. Working-class militancy ultimately led Huerta to repress union activity and close down the Casa in the last months of his rule. But after the military defeat of Huerta in July 1914 by the northern-based Constitutionalist armies, the Casa and the union movement in Mexico City reemerged, mobilizing and incorporating many of the principal workers groups in the city, including textile workers and new and powerful industrial unions, such as those of the streetcar workers and the electrical workers, of whom Luis Morones was a key leader. Perhaps most unusual of all, given the gap between skilled and unskilled workers, is that many of the more marginal and unskilled workers in Mexico City began to organize during this period. Often with the sympathy of occupying revolutionary generals, many bricklayers, seamstresses, female cigarette workers like Esther Torres, and even marginalized workers in the corn tortilla mills formed Casa-

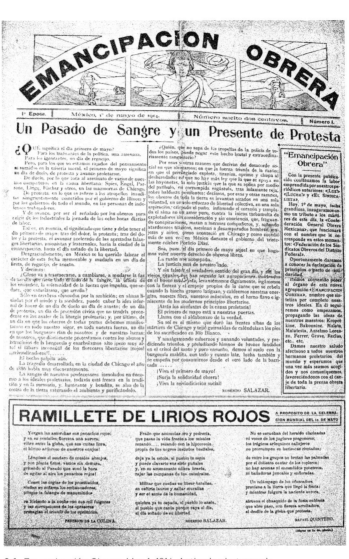

2.1. *Emancipación Obrera*, May 1, 1914. Author's photograph.

affiliated unions and pressed for legal recognition and better working conditions and pursued issues of food, rent, and the provision of basic services.[17] When at the end of 1914 the triumphant rebel forces that defeated Huerta split along regional and social lines between the Convention forces led by Emiliano Zapata and Francisco Villa and the Constitutionalist forces led by Carranza and Obregón, the Casa claimed a membership of 52,000.[18]

Throughout the Revolution, campesinos often spontaneously and

collectively took up arms and seized land they felt belonged to their communities. By contrast, even the most radical workers and the organizations they led never advocated the immediate seizure of the means of production, except on a few occasions when it involved a foreign company, and even then only when the instrument of intervention was the state or revolutionary generals. More often, their increasing militancy was aimed at ameliorating the worst abuses of the capitalist system, asserting greater control over aspects of the work process, and claiming citizenship rights to which they felt entitled by their role in national development. Similarly, distinct traditions of anarchism and liberalism shaped the working class and the Casa in particular. For example, although many of the eventual founders of the Casa supported Madero in his initial campaign for the presidency, the Casa itself maintained a position of cautious neutrality toward all factions of the Revolution through early 1915.[19]

Intellectuals inevitably noticed the emergence of the working class during the Revolution. The greater agency of the working class in the context of the Revolution forced middle-class intellectuals, professionals, and military leaders to move beyond their traditional concerns with the moral reform of the urban lower classes to embrace their concerns and even join and attempt to lead their organizations. For example, a handful of middle-class radicals and intellectuals, including the tailor and journalist Rafael Pérez Taylor, former Mexican Liberal Party member Antonio Díaz Soto y Gama, and the Maderista congressional deputy Heriberto Jara, were central to public activities and cultural events of the Casa. In many cases they played important roles in organizing specific groups of workers.[20]

No person better represents or managed the affinities and ongoing contact between artists and the working class in this period than Dr. Atl. A few days before the fall of Huerta to the Constitutionalist forces in July 1914, Atl returned from Europe, spouting the language of revolution and assuming a key role as intermediary among artists, revolutionary leaders, and organized labor. With remarkable facility he got close to the group of progressive generals under Obregón's leadership who pushed Carranza to declare support for social reforms. During Carranza's first occupation of Mexico City in 1914, Atl was named director of the Academy of San Carlos and also briefly served as a "neutral" intermediary with the forces of Zapata, although after a frustrating meeting with Zapata he gave up on the campesino leader and confirmed his loyalty to Carranza.[21]

During his brief time as director, Atl publicly speculated (as "the

foe of academic institutions") on how to bring about the fundamental reform of the Academy he had long denounced. "I find myself in this dilemma: whether to propose that the school be scrapped, or else converted into a workshop geared for production."[22] Atl didn't scrap the Academy, but he publicly rejected the values of the recently closed Open Air School and instead articulated a growing self-identification of the artist as worker, distinct from his earlier ambitions to create an elite community of artists set apart from the rest of society.[23] The notion of the artist's studio as a workshop was partly rooted in the recent appreciation by artists for the popular crafts produced by rural artisans, an extension of the rediscovery of the countryside and indigenous culture as emblematic of the nation. This fascination is manifest in the success of the Exposition of Manual Labor and Fine Arts held in 1914, which displayed the paintings of San Carlos students along with ceramic pots, *lacas* from Michoacán, and carved wood objects, among other crafts. Artists like Herrán frequently incorporated craft objects, such as finely woven rebozos or painted ceramic pots, in their rural scenes and portraits of indigenous families. These democratizing gestures inevitably challenged traditional notions about the division between the fine arts and crafts, as well as the role of artists themselves. "Art, after all," concluded the art critic José Juan Tablada in a review of the crafts exhibition, "is nothing more than a manual labor."[24]

Atl connected renaissance artistic guilds to artisan crafts; he threatened to change the name of the School of Fine Arts "to that of 'workshop,' where all the workers may do three things: take a bath, work, and make money."[25] For the next decades, the ideal of an artist-worker trained in workshops shaped debate around the pedagogy and practice of art.

An essential lesson that Atl drew from the Italian Futurists he had met and his involvement with the anarchist-influenced Action d'Art in Paris—one he offered to a new generation of young artists swept up by the Revolution—was that artists should see themselves as initiators of revolutionary social change. At a crucial moment of definition in the Revolution, he urged artists to get involved politically. At one level, "the criteria that inform this [artistic] training need to be a logical consequence of the necessities of the Republic." At another level, at the current moment, artists needed to "take part in the conflict" by establishing "a program of action, brief, clear, practical, completely in accord with the necessities of this country, where we are going to live." In the context of his own travels and the aspirations of previous generations of artists who had looked to Europe, his declaration

that Mexico was the country "where we are going to live" must have resonated. In late September 1914, Atl organized the fleeting Union of Revolutionary Artists around three goals that, with different ideological inflections, continued over the next three decades: "to intensify revolutionary ideals"; "to morally and materially aid in the development of lay instruction"; and "to guarantee the material interests of artists." All three goals required artists to take sides among the competing military factions that claimed the revolutionary mantle.[26]

When Atl was not organizing artists as workers and revolutionaries, he was proselytizing to the recently organized working class to enter the revolutionary fray. Intense, austere, and charismatic, he impressed the leaders of the Casa as a prophet of social change and someone who had the complete trust of Carranza and his key general, Obregón. Casa member Rosendo Salazar, awed by Atl's Internationalist experiences in Europe, later described him as "not just any revolutionary, but rather of those that believe that the world belongs to the poor."[27] The presence of Atl among the Constitutionalists seemed to Casa leaders the passionate guarantee of social change, the counterpart to the virile Obregón, who repeatedly took Mexico City by storm in the fall of 1914 and the spring of 1915.

Atl worked closely with the unions of the Casa around a number of labor conflicts during Obregón's occupation of the city, most notably as intermediary between the recently formed Mexican Electricians Union and Obregón during the Telephone and Telegraph Company strike. Obregón dramatically resolved the conflict by turning the administration of the foreign company over to the electricians union (rather than the mostly female telephone workers), which named Morones to run the intervened company. For many, this was worker ownership of the means of production, and indeed the electricians held de facto control as long as the government of the city constantly changed hands through mid-1915. In a city devastated by shortages and multiple currencies, Atl facilitated Obregón's populist and short-term solution, funneling freshly printed currency to the city's poor, much of it through the Casa's unions as well as through the art students.[28]

Atl's interventions facilitated the incorporation of key groups of artists and workers into the Constitutionalist cause. When Obregón's Constitutionalist forces temporarily ceded Mexico City to the Convention forces of Zapata in November 1914, urging *capitalinos* to enlist and follow their retreat to the more defensible Veracruz, many art professors and students followed Atl to Veracruz.[29]

The Casa, in spite of the urgings of Atl and its collaboration with

Constitutionalists over material aid and key strikes, was hesitant to choose sides in the national conflict, priding itself in its anarchist neutrality in what was still perceived largely as a political struggle.[30] But three months later, in a musical chairs of alternating occupations of the capital by Convention and Constitutionalist forces, a portion of the Casa leadership abandoned its neutrality.

The tensions within the Casa inevitably exploded at a general meeting called on February 7, 1915. After initial approval of a manifesto condemning militarism and demanding that the Convention and Constitutionalist factions alike put down their arms, Atl made a passionate speech denouncing the manifesto and claiming that the Constitutionalist movement was the incarnation of workers' aspirations for social reforms, sabotaging the manifesto of neutrality. At a subsequent meeting, the Casa agreed to support the Constitutionalist forces of Carranza. Rosendo Salazar later attributed the shift to a "collective psychological phenomenon," namely, the mesmerizing influence of Dr. Atl.[31] But various factors explain the reversal: the dire shortages and unemployment in the city that made the guaranteed pay and supposedly corporate structure of battalions of worker-soldiers attractive; the failure of the Convention forces of Zapata to appeal to or court urban workers or resolve urban shortages and the contrasting record of Constitutionalist interventions on behalf of workers; and internal divisions between skilled and unskilled workers and rivalries over leadership within the Casa.

Those who opposed the alliance argued in universal and class terms that coincided with anarchist internationalism. For others, the alliance with the Constitutionalists was seen as a type of social charter that acknowledged the historical role of workers as citizens of the nation. One speaker bluntly warned that if the Casa remained neutral "later the proletariat will not be able to justify its militancy in the armed struggle of the revolution." In many ways, these divisions over political alliances reappeared over the next decades within the working class and among artists. The leadership of the Casa pushed through a formal "pact" on a divided membership and negotiated with a reluctant Carranza the creation of 5,000–7,000 worker-soldiers, organized into five "Red Battalions." In March they followed Obregón to Veracruz, leaving behind a divided but vibrant labor movement led by, among others, Morones and the electricians.[32]

Atl did not control the Academy of San Carlos long enough in the fall of 1914 to implement his reforms, but in many ways, his flight to Orizaba in Veracruz allowed him and the artists who followed him

a chance to create the "practical workshop" he had imagined, what Orozco later called "San Carlos in exile," pragmatically dedicated to supporting the Constitutionalist cause while forging closer ties to the organized working class. Among the dozens of artists who accompanied him were Orozco, Siqueiros, Romano Guillemín, Carlos Zaldívar, José Guadalupe Escobedo, and Ramón Alva de la Canal. Others, like the sickly Herrán, remained in Mexico City, painting without patrons or exhibitions and contributing to what remained of the illustrated press.

The primary activity of most of Atl's group was the creation of the newspaper *La Vanguardia*, which, along with its successor *Acción Mundial*, constitute important graphic innovations.[33] They also did handbills and posters, but few have survived, and there is limited evidence of their systematic political use during the Revolution. Broadsheets and *corridos* continued in the early years of revolution, describing events for a popular audience and endorsing and denouncing caudillos.[34] Siqueiros, Alva de la Canal, and others soon abandoned art and journalism to take up arms under General Manuel Diéguez, participating in key battles against the Villistas, and Zaldívar and Escobedo died fighting in 1915.[35]

Their newspaper *La Vanguardia* ultimately served as the official propaganda organ of Constitutionalism's more progressive wing: it provided news of the military fronts, discussions of culture, praise for Constitutionalist leaders, and denunciations of their enemies, primarily the "counter-revolutionaries Zapata and Villa." It advocated a vague socialism influenced by Atl's time in France. Drawings by affiliated artists featured prominently in the paper and suggest an attempt to reach out to a broad and semiliterate audience. Most notable were the caricatures by Orozco of coquettish schoolgirls, prostitutes, and a joyful woman, flagged by dagger and hatchet and declaring "I am the Revolution, the Destroyer." Other Orozco caricatures viciously attacked a lecherous and corrupt clergy and religious fanaticism, reminiscent of Posada's earlier anticlerical caricatures and suggestive of Orozco's future work for *El Machete*. It echoed a Constitutionalist anticlericalism that, in the words of Ben Fallaw, tended to "equate masculinity with reason, nation and progress while painting femininity as vulnerable, fanatical and potentially treasonous," thus defining "gender roles that aided in consolidating post-revolutionary patriarchal positions."[36]

A few articles celebrated the role of the Red Battalions, but the space and graphic images dedicated to the working class were lim-

ited to a separate section that covered labor conflicts and celebrated local Constitutionalist decrees of different generals that limited work hours and occasionally protected wages.[37] During its short life from April to June 1915, *La Vanguardia* fulfilled many of the goals Atl had pronounced in the capital months before: to support revolutionary idcals, to provide accessible, secular instruction, and to guarantee the material interests of artists. *La Vanguardia* was an important precedent for later artists' publications with similar goals. But its ties to the most progressive branch of Constitutionalism, its support of the Casa's unionization campaigns, and its constant denunciations of capital, the clergy, and militarism created problems. The politically moderate Carranza, determined to assert his political control, closed down the newspaper in June 1915, soon after Obregón had won crucial military battles against Villa. He also formally removed Atl as director of the Academy of San Carlos.[38]

The intimacy and influence of these artists with workers is obvious in the new periodical of the Casa del Obrero in arms, *Revolución Social*, also published out of Orizaba, with a title that invoked the journal of the Gran Círculo Obrero a decade before in the lead-up to the 1906 Rio Blanco textile strike.[39] Their new journal took on many of the same themes of *La Vanguardia*: a defense of Constitutionalism, a denunciation of the Zapatistas as reactionary, and attacks on the church that differed from its previous attempts to avoid religious conflicts. The influence of *La Vanguardia* artists seems to have led the Casa for the first time to include caricatures in *their publication*, most often attacking the clergy, and in a style so similar to Orozco's work in *La Vanguardia* that the credit ("E. Moneda") might well have been a pseudonym for Orozco, or perhaps the Orozco-inspired efforts of printer and Casa founder Eduardo Moneda.

For the Casa workers who joined the Constitutionalists, the alliance with Carranza lasted about as long as that of the artists. Carranza kept the Red Battalions divided into smaller units, located on different fronts, with their successful military officers, like Celestino Gasca, always subordinate to generals not affiliated with the Casa. Casa leaders quickly ran into problems with First Chief Carranza over their attempts to organize workers and to call for strikes in the regions they occupied, the product of a provision in the Pact that allowed the Casa to organize workers throughout Constitutionalist territory. By April 1915, they had organized twenty-two propaganda commissions with more than 139 militants. Carranza labeled the organizational work of the Casa as "subversive." After the defeat of Villa at Celaya,

and with Mexico City definitively taken by the Constitutionalists, Carranza began the demobilization of the Red Battalions in August 1915, barely a year after their formation.[40]

ACCIÓN MUNDIAL AND THE GENERAL STRIKE OF 1916

Demobilization of the Red Battalions allowed for the fairly quick reconciliation of returning union leaders with those who had stayed in Mexico City, initiating a renewed cycle of autonomous mobilization at an unprecedented level.

Meanwhile, Atl returned to Mexico City and announced a new journal with the object of defending the working class, which, he explained, "constitutes the future of the country, and one must help them for their progress and well-being." Atl's declaration parallels Manuel Gamio's almost simultaneous call in *forjando patria* for intellectuals to explore the nation's indigenous past.[41] His new journal, *Acción Mundial*, was published from February 1916 through the end of July 1916. Though not an official organ of any particular group of organized workers, and likely funded by sympathetic generals tied to Obregón, it was viewed by many as a labor journal. This was because of its sympathetic coverage of labor and because Atl used its pages to promote his own efforts at labor diplomacy, namely, his attempt, along with rising labor leader Luis Morones, to use labor federations in the United States and Mexico to ease tensions after Villa's raid on Columbus, New Mexico, and the subsequent US expedition into Mexico led by General John J. Pershing. Salazar and other members of the Casa collaborated, either by writing articles specifically for *Acción Mundial* or by lending articles already published in the Casa's latest newspaper, *Ariete*.[42]

Acción Mundial's illustrations were even more prominent than in *La Vanguardia*, especially in the Saturday edition with its full-page color cover. Caricatures signed by Orozco portrayed schoolgirls, while others, signed by "A. Zaldívar" and "Salgado," skewered the clergy, Huerta, and Uncle Sam with a strident sharpness equal to that of Orozco. Romano Guillemín and Atl produced cover images, and art reviews surveyed and included the works of young "modern" Mexican painters. In its second weekly edition, *Acción Mundial* featured a photographic essay celebrating the military and organizational efforts of the Casa del Obrero Mundial and included a reproduction of Romano Guillemín's 1910 *Eternal Martyr*, now given a distinct reading with the title *Porfirian Justice (Scene of the Dictatorship)*.[43]

Dr. Atl and *Acción Mundial* wavered between support and caution while covering the escalating conflict between union leaders and the new provisional government of Carranza. Only ten days after the Constitutionalists took definitive control of Mexico City in August 1915, the SME launched a strike against the Mexican Light and Power Company that darkened the city. With the labor movement reunited and energized, the next year was punctuated by constant strikes. But the Constitutionalist attitude toward workers was no longer one of consistent support as it had been in the fall of 1914, with its conflict with the Convention forces pending. The provisional government's attitude was clear from a message sent by the head of Carranza's Labor Department to striking workers in the spring of 1916: "Strikes were more or less justified in the time of Generals Díaz and Huerta . . . but now are absolutely inappropriate and inconvenient given that the Constitutionalist authorities support the working class." In the face of the electricians' support for strikes in the state of Mexico, Pablo González, the general in charge of the Federal District, denounced the "professional agitators" and declared that "if the Revolution had combated capitalist tyranny, it could not sanction proletarian tyranny, and that is the tyranny to which workers aspire."[44]

Organizational bonds among workers, on the one hand, and conflicts with employers and officials, on the other, were both furthered by the difficult situation in Mexico City. Agricultural production plummeted during the years of worst fighting. In such a situation of scarcity, merchants and millers profited enormously by cornering limited supplies of foods. Speculation was facilitated by the tremendous concentration of ownership and distribution networks in the city, a tendency that seems to have increased during the years of the Revolution.[45] Constitutionalist officers condemned merchants publicly and imposed ineffective price controls. But officers also controlled the train stations of the capital and further upped the price of food through deals and extortion. The situation for urban workers was worsened by the paper currencies that every revolutionary faction printed to finance war and government, unbacked by any guarantee.

As conditions worsened throughout the spring of 1916, the Casa responded by organizing a series of successful strikes to force employers to recognize unions and grant wage and other demands, but these gains proved short-lived, as long as the Constitutionalists failed to guarantee regular shipments of food and to create a stable currency. On May 22, 1916, the Casa briefly declared a general strike. But since there had been ample public warning of these plans, General

Benjamín Hill moved quickly to impose an agreement with factory owners and merchants. The results proved minimal and fleeting. By mid-July, the Casa began quietly planning a general strike.[46]

Articles and editorials in *Acción Mundial* repeatedly criticized merchants and industrialists for starving the population. In one caricature (signed "A. Zaldivar") a naked merchant with winged helmet and feet and a scepter entwined with snakes (dubbed "the thief Mercury") smiles as he strangles a skinny *calzón*-clad pueblo. More pointedly, Orozco published two caricatures in mid-April: the first, a hand wielding a bloody sword to disperse three donkeys, with the caption "BANKERS AND MERCHANTS. WARNING: THE HAND THAT GRASPS THE WEAPON IS GOING TO MOVE"; the second, a group of merchants drinking a fine liquor while "DISCUSSING THE FORM OF INCREASING HUNGER." Even as the newspaper cautioned workers and threatened merchants with retribution, it increasingly criticized the provisional government's monetary policy.[47]

In this context, *Acción Mundial* published its June 3 cover image (plate 3), perhaps the most striking representation of the working class during the decade after the fall of Díaz. In an image enclosed in a circle, three powerful-looking workers, shirtless and in overalls, walk to the left away from a modern factory, bounded by geometric shapes that suggest mountains. A hammer laying in the right foreground suggests the workers are leaving their place of work, but the placement of the hammer and the posture of the two most central workers indicates the defiance of a strike: one extends his right fist, while the other clenches his left hand at his side, as if to throw a punch or swing a hammer. The black and white contrasts are mediated by the pinkish exposed torsos of three workers, the reddish factory door, and the highlights of the chimney, set against modern industrial architecture. From the chimney emerges a blossom of smoke that extends artfully outside of the encircled image. The unsigned image suggests the influence and perhaps the hand of Atl himself: the style and composition resemble *pochoir*, the color stencil printing technique that Atl explored and exhibited in Paris from 1911 to 1914 and returned to in the early 1920s. Of those earlier Atl prints, John Ittmann identifies features of Japanese color woodblock prints popular in France at the time: "stark outlines, flat expanses of color, and the playful visual conceit of allowing an element of a composition to intrude into the otherwise empty enframing margin."[48] What is unique is the subject of working-class militancy, distinct from Atl's emblematic mountain landscapes, though there is a suggestion of his undulating volcanoes on the horizon. The

hand extended in defiance moves the representation of workers beyond the limits explored by both Herrán and Posada, anticipating the ideological militancy of *El Machete* and the Art Nouveau influences of *Revista CROM* in the 1920s.

The image reflects the general tensions between capital, labor, and military authorities in Mexico City that led to the May 22 "practice" general strike days before and weeks later to the real thing. On July 21, just days before the outbreak of the general strike, the "Workers' Movement" section of the paper cryptically announced a meeting that day for the unions affiliated with the Casa "for an affair that everyone already knows, and that we believe is useless to repeat."[49]

In late July, the Casa had made a series of demands to employers, the most important an insistence that wages be paid according to the same standard of hard currency that shops demanded for payment of goods. The real audience was clearly the military government, since such a standard could be imposed only by authorities. Casa tactics led inevitably toward confrontation with the provisional government of Carranza. When they received no answer, the labor movement, as united as it would ever be until the 1930s, decided to act. By resorting to the general strike without the explicit warnings given on previous occasions, the Casa made clear their break with the Constitutionalists. At 4 a.m. on July 31, 1916, the electricians of the SME cut off power, effectively closing down all production, transport, and commerce. By midmorning, thousands of working people had gathered near the city center to celebrate their unity and ability to bring the city to a stop. The strike committee itself was in many ways a microcosm of the organized working class of Mexico City. Its ten members included two women, including Esther Torres, and represented the unions of seamstresses, hatmakers, carpenters, waiters, printers, commercial employees, and, of course, the electrical workers. The link between work and consumption issues was clear in the strike and served to unite working people across skill and gender lines.

Through the auspices of Dr. Atl, Carranza responded by inviting the strike committee to negotiate and immediately court-martialed them for treason. When Atl protested, Carranza jailed him too. Martial law further denied workers the streets and meeting halls. In his public decree of martial law, Carranza made the unlikely claim that the strikers had "responded to the instigations of North American labor unions and foreign capital." Thus he invoked the nationalism and anti-imperialism that would repeatedly be used by postrevolutionary governments to demand unity from all Mexicans, especially

workers. The Casa conceded defeat three days after the general strike began, as the army restored electricity and streetcar service, as other working-class leaders were rounded up by police, and as the popular support that had fueled the strike collapsed in the face of repression.[50]

AFTERMATH

The repression of the general strike in Mexico City in August 1916 ended an intense period of collaboration among artists, workers, and the Constitutionalist victors of the Revolution. Ironically, the most vibrant representations of workers came before rather than during the Revolution. Posada, with his complex caricatures denouncing the exploitation of labor by capital, died largely unknown to the academy and at precisely the moment when the new, aggressive syndicalism of the working class moved beyond his denunciatory mutualism. By 1913, Herrán had shifted his artistic focus from the urban working class to pre-Colombian themes and contemporary rural customs. It was for these paintings that he was hailed on his death in 1918 and invoked in the 1920s as the visual progenitor of an essential figure of postrevolutionary nationalism, the mestizo campesino.[51] In spite of artists' limited elaboration of images representing workers in the years of military struggle, the separate and occasionally overlapping experiences of artists and workers in that decade formed a self- and mutual-awareness that would flourish in the 1920s and 1930s.

The constitutional order of President Venustiano Carranza from 1917 to 1920 hardly ended activities of artists and workers. The 1917 Constitution's labor provisions, grouped under Article 123, were among the most progressive in the world at the time. They went far to recognize the right of workers to organize and even to strike, while fortifying government intervention "to achieve equilibrium between diverse factors of production, harmonizing the rights of labor with those of capital."[52] National leaders learned by 1920 that they had to offer formal concessions to campesinos and workers and a degree of political incorporation, at least to those groups that had organized or taken up arms. After the dissolution of the Casa del Obrero Mundial in 1916, the working people of Mexico began again to rebuild the union movement and assert themselves in local and national politics. With the legal right to organize, unions multiplied, and membership soon greatly exceeded the levels of 1916.[53] Still, workers were chastened by the continued reluctance of business to recognize unions and the non-recognition or repression of strikes by Carranza from 1916 to 1920.

Artists experienced a degree of normalcy in the years immediately after 1916. With relative peace in the capital, classes resumed at the Academy of San Carlos, though under the conservative direction of sculptor Arnulfo Domínguez Bello and with few teachers of note beyond Herrán. Artists such as Carlos Neve, Siqueiros, Ernesto García Cabral, and Roberto Montenegro produced sumptuous decorative covers for the revived and new metropolitan journals such as *Revista de Revistas*, with covers that exalted prehispanic motifs and the costumes of the popular classes, while often incorporating elements of decadentism, symbolism, and Art Nouveau—confirming the indisputable influence of Herrán and Montenegro on their counterparts in the years before 1920.[54] But the full artistic flowering imagined during the Revolution would have to wait—for peace, for a stable government willing to patronize the arts, and for the return of key artists exiled abroad by their ambitions, by fighting, or by postrevolutionary military intrigues.

For example, on his release from jail after the 1916 general strike, Dr. Atl continued to run into trouble over his support for workers and a possible plot to overthrow Carranza. He finally fled to Los Angeles.[55] Atl had been a pioneer in rethinking the role of artists in Mexican society and bringing artists and workers face-to-face. By his return in 1919, his alliance with the working class was largely over, and his leadership among young artists passed on to his followers.[56]

Among them, Orozco had also left for several years in the United States, soon after the disappointing reception of his first individual exhibition in Mexico City in 1916, which featured drawings of prostitutes. At the US border, customs agents confiscated many of his drawings for "lack of morals." Siqueiros negotiated his time on the battlefield into a stint as a diplomatic attaché in Europe, where he consorted with Rivera and published, in 1921, a single-issue journal, *Vida Americana*, that included an influential manifesto outlining his ideas for a politically engaged and revolutionary art. Only the 1920 rebellion and formation of a nationalist government by Obregón, and the ambitious project of his secretary of public education, José Vasconcelos, would be sufficient to bring all of these artists back to Mexico.

For Rivera, the Mexico he discovered on his return in 1921 was a revelation. But for the artists who had lived through it, the social transformations of the Revolution were familiar, and the artistic revolution to which they aspired was long overdue. By 1922, as Orozco notes in his autobiography, "the table was set" for Mexico's artists.[57] The same could be said for organized labor.

THREE

EL MACHETE AND CULTURAL AND POLITICAL VANGUARDS

I n March 1924, *El Machete* began its first incarnation, as the newspaper of a group of artists organized in the Syndicate of Technical Workers, Painters, and Sculptors of Mexico, which included Diego Rivera, Davíd Alfaro Siqueiros, José Clemente Orozco, and Xavier Guerrero, among other politically engaged artists. The black-and-red masthead (plate 4), a woodcut of a hand gripping a machete, invoked the prerevolutionary penny press for workers, confirmed the paper's tone and orientation, and announced the primacy of its visual language. Below the masthead a poem written by Graciela Amador declared, "The Machete serves to cut cane, open trails in shady woods, behead serpents, lop off bad weeds, and humiliate the arrogance of the impious rich." The announced audience of this newspaper made by self-described artist-workers was the working class.

This chapter explores the representation of the worker in the early 1920s and offers a close reading of *El Machete* in its first year. Many artists involved in state projects of public muralism and Open Air Schools drew close to the officially sanctioned labor movement, the CROM, before embracing the Communist Party's critique of it. Artists began to portray workers in their art, drawing from related but distinct worlds of artistic representation, including murals, the Open Air Schools, and the early avant-garde Estridentista movement.

Chapter 4 will examine the reformist *Revista CROM* from 1926, offering an explicit comparison to *El Machete,* as well as other developments in working-class representation in the late 1920s. These two self-described working-class periodicals offer arguably the most complete and revealing graphic portrayals of the working class in that decade. They merit attention at a variety of levels: as the products of a particular historical moment; as pioneers in developing a graphic representation of the worker; as collective artistic and ideological projects with direct relations to better-known works by individual artists; and as two distinct visions of workers and their relations to the state in the 1920s.

Latent artistic tendencies burst forth as Mexico emerged from a decade of fighting. Alvaro Obregón assumed the presidency in 1921 through a military rebellion with broad social support from organized campesinos and workers against the intransigent Carranza. Artists soon received the generous support of a government that sought to project an image of national unity, social justice, and an ethos of creative reconstruction at home and abroad. Secretary of Public Education José Vasconcelos's commissions for murals on the walls of public buildings epitomized official support for a renovation of the arts. Artists who benefited helped shape the state's nationalist discourse and, on occasion, challenged it, both in murals and in more independent art forms.

Representations of the working class in the 1920s emerged slowly, as a part of a search by artists for a visual vocabulary and as a result of their engagement with postrevolutionary politics. Government murals served as a public canvas where artists conducted early attempts at creating a new art, but it is worth noting the absence of references to workers or even campesinos in the first mural attempts, in the National Preparatory School (now the Antiguo Colegio de San Ildefonso), as a point of departure for the visions of the working class that followed. Rivera's first mural is the ahistorical, neo-Christian *Creation*, painted in 1922 in a Byzantine style with Cubist elements and tentative references to Secretary Vasconcelos's concept of a Cosmic Race that combined the best elements of European and Indigenous cultures. The only remaining mural from Orozco's first efforts in 1923 is a Botticelli-like painting of a blonde Madonna and child commonly known as *Maternity*, perhaps inspired by the short-lived, Michelangelo-like murals painted nearby by Dr. Atl the year before.[1] Neither mural directly engages the Revolution or what were to become its main symbolic social actors. David Craven writes of Rivera's *Creation*: "the mural ultimately showcases a nonpolemical, bloodlessly abstract 'universalism' that was situated along the lines of Vasconcelos's static philosophical abstractions and disconnected from the lively historical predicament of post-revolutionary Mexico in the 1920s."[2] These artists moved beyond these initial murals to include by 1924 an extensive representation of the working class.

Certainly one of the most important factors influencing artists was a continued awareness of and renewed collaboration with the working class, dating back to the mobilizations of the Revolution and fortified by the dramatic growth of the labor movement after 1920. Workers

had been chastened by Carranza's repression of the general strike of 1916 in Mexico City and by the reluctance of business and Carranza's government to recognize unions from 1917 to 1920. Even so, workers and unions emerged from the Revolution emboldened by their experience of revolution and the labor guarantees of Article 123 of the 1917 Constitution.

The tension between President Carranza and his most powerful general, Obregón, leading up to elections furthered the influence of unions that embraced political strategies. Many of Mexico City's unskilled workers made the transition to the ranks of the Regional Confederation of Mexican Workers, formed in 1918 under the leadership of former electrician Luis Morones, with support from federal and state political leaders. Carranza and CROM leaders remained wary of each other, but Morones was quick to join the upstart presidential campaign of Obregón, even creating a Labor Party for that purpose. When Obregón assumed the presidency after a successful military coup, the CROM leadership was in a privileged position to incorporate the majority of unions and assert itself into workplaces and local and national politics, emerging as the dominant confederation of organized workers through the 1920s.[3]

Also fundamental was the recovery of industry and the growth of Mexico City. Manufacturing grew by 70 percent between 1921 and 1927; and while industries whose production value exceeded 100,000 pesos a year were only 2.5 percent of industrial establishments, they employed close to 50 percent of the industrial workforce and a majority of the workers most easily organized.[4] Mexico City's population more than doubled from 1910 to over a million by 1930, as refugees fled the turmoil of the Revolution and migration continued afterward.[5] Along with a continued stream of campesinos destined to become unskilled labor, the number of teachers and government office workers in Mexico City expanded dramatically. From 1921 to 1930, the number of public employees tripled to 4 percent of the workforce (compared to 10 percent for industrial workers).[6] Together with the populist culture brought by the Revolution, the elitist capital seemed more and more a city of working people.

The reformist CROM federation advocated a partnership between capital and labor and "multiple" (i.e., political) action that allied it closely with the state, a relationship reinforced by the affiliated Labor Party. CROM leaders like Morones and Celestino Gasca had learned a degree of pragmatism from the events of the Revolution. Given the size of the working class and its vulnerability to government repres-

sion, they felt that close cooperation with the new rulers could yield both considerable personal rewards and assure organized labor a real presence in the workplace and in public affairs. Under the tight control of the secretive *Grupo Acción*, Morones and a few loyalists dominated the confederation and its political party. Through the end of the presidential term of Obregón's successor, Plutarco Elías Calles, in 1928, they facilitated the new government's protective regulation of the greatest abuses of capital, represented many of the workers' demands, and incorporated CROM workers into the rituals of political participation.[7]

Despite authoritarian leadership, the CROM alliance with the state offered many workers clear benefits in the workplace—in many cases the closed shop, control over hiring, and leverage against rival labor unions and confederations—while ensuring their loyalty to the new regime. Strikes reached a crescendo in 1921 and 1922, with the majority decided in favor of workers. The declared membership of the CROM, 50,000 in 1920, grew dramatically in each of the first three years of the Obregón administration, reaching 1.2 million in 1924. Though these numbers were bulked up and included members of campesino organizations, the strongest working-class base of the CROM was among the textile workers of Puebla and Veracruz and the multiple service, manufacturing, and government unions consolidated in the Federation of Unions of the Federal District. Many were low-skilled workers with leaders inclined to seek out political alliances. For these workers, whose insertion into the labor market had been relatively weak, stability and regulation of the terms of employment was a fundamental concern and one of the clearest rewards of joining the CROM.[8] The CROM's financial resources were guaranteed when Obregón's government allowed for union dues of government workers to be paid directly to the CROM.[9]

Conspicuously absent among the CROM's ranks were workers in key national industries and infrastructure such as electricity, oil, railroads, and mining. Organized workers in these sectors, whose strategic position meant they could bring the national economy to a standstill, maintained strong traditions of independent strikes, democratic governance, and political independence through the decade. Others, including streetcar workers, bakers, and textile workers in the Federal District, joined the anarchist-inspired General Confederation of Workers (Confederación General de Trabajadores—CGT). Labor radicals within and independent of the CROM were often forcefully opposed by employers and the government, as well as by the CROM.[10]

On the political front, the CROM's Labor Party gained a foothold in the legislature, with 11 of 58 senators and 40 of 272 deputies in 1926, and continuously dominated either the government of Mexico City or that of the Federal District that contained it throughout the administrations of Obregón and Calles. Since the governor of the Federal District was responsible for administering the local arbitration boards made up of worker and employer representatives, the CROM wielded tremendous power in the settlement of labor conflicts. In the 1924 CROM national convention, the confederation announced the imminent inauguration of what it claimed to be the labor government of Calles and called for the establishment of CROM unions in key industrial sectors where they were weakest, particularly among railroad and oil workers, thereby laying the groundwork for conflicts with powerful independent unions over the coming year.[11]

The dramatic growth of the labor movement attracted the attention and involvement of artists and intellectuals, many of them exposed to labor through the mediation of Dr. Atl during the previous decade. A key interlocutor from the 1920s on was the brilliant and ambitious lawyer Vicente Lombardo Toledano, who rose to prominence as the CROM's secretary of education during the 1920s. During his troubled tenure as director of the National Preparatory School in 1922 and 1923, where many artists labored on their first murals, Lombardo Toledano involved students and artists alike in his attempt to move the school beyond Vasconcelos's civilizing, spiritual curriculum toward one that more directly addressed the political and social problems facing the nation.[12]

In 1922 Lombardo Toledano recruited the muralists already painting in the school, including Rivera, Siqueiros, and Orozco, to join prominent intellectuals in forming the Grupo Solidario del Movimiento Obrero. For artists like Siquieros and Orozco, involvement with the Grupo Solidario echoed their involvement with Atl and the Red Battalions during the Revolution; for Rivera and other artists, it provided the first direct experience of collective organization and exposure to the concerns and organizations of the working class. Rivera participated in the Grupo Solidario's project to offer night classes for workers in the elite National Preparatory School, and Orozco undertook trips to Morelia and his native Guadalajara to recruit intellectuals. Of course, the solidarity of the group was more with the CROM than with the labor movement as a whole: Rivera himself attended the fourth national convention of the CROM in September 1922 as a delegate from the Grupo Solidario, and their short-lived journal, *Vida*

Mexicana, condemned the strike of streetcar workers in Mexico City affiliated with the rival CGT in 1923.[13] As in 1914, a collaboration with progressive factions associated with Obregón made sense to artists and workers and inevitably brought them together.

Participation in the Grupo Solidario also led to artistic collaboration. Rivera illustrated a pamphlet written by Lombardo Toledano and published by the Grupo in 1922; the cover featured a simple line-drawing of Christ appearing before a campesino plowing a field in order to bless his desire for land and counter the claims of conservative clergy and hacienda owners. One of Rivera's earliest explicitly political drawings, it linked the concerns of workers and campesinos, directly incorporated Christian iconography, and incorporated the pamphlet form from the penny press as an outreach strategy.[14]

But many artists in the Grupo Solidario soon became disenchanted with the CROM and its increasingly corrupt, centralized, and conservative leadership. In 1923 and 1924, as Morones and his closest allies consolidated control of the confederation and tightened its alliance with the presidential candidate Calles, the CROM distinguished itself in a variety of notorious public actions. In 1922, they undermined the Mexico City Renters' Strike supported by the recently organized Communist Party. In 1924, CROM leaders orchestrated the assassination of a senator for his sympathy with the rebel leader Adolfo de la Huerta. And throughout 1924, the CROM intervened in a variety of strikes, most importantly (and unsuccessfully) among oil workers in Tampico, to assert control over independent and CGT unions and to facilitate the government's efforts to impose a degree of stability on a vitally important economic sector.

An important step in the political education of artists was the organization of what became known as the Syndicate of Technical Workers, Painters, and Sculptors in December 1922, incorporating almost all the artists involved in the overlapping endeavors of the government-sponsored Open Air Schools, the Estridentista movement, and the incipient murals in the National Preparatory School. Rivera, Siqueiros, Xavier Guerrero, and Fernando Leal were the SOTPE's principal officers.

In spite of their largely middle-class backgrounds, these artists often saw and presented themselves as workers or artisans, and the name of the Syndicate was even modified later to replace the term *"grabadores"* (printmakers) with "technical workers." As noted, artists under the influence of Atl had begun as early as 1910 to organize in groups and in 1914 to self-identify as workers in their initial at-

tempts to redefine the curriculum at the Academy of San Carlos and in their growing appreciation for national crafts and artisans. The self-identification of some artists as workers grew with their preference for murals and prints over easel painting in the early 1920s, as they experimented with gouges and woodblocks in their graphic work and painted murals in teams of masons and assistants, charging by the square meter. This artist-worker refashioning was often expressed in their donning of overalls as a work uniform and as a sign of political identity and militancy, elaborated in self-depictions in working-class clothing in their art. Poet Germán List Arzubide remembered the young Leopoldo Méndez in the 1920s as "the ultimate dandy in overalls." Clothes indeed seemed to make the man. List Azurbide wrote of Méndez's "muscular, scaffold-like hands" and "legs, as firmly planted as a laborer's."[15]

The turn to working-class forms of organization in the midst of a revitalized labor movement was obvious. The artists' Syndicate tentatively formed the Cooperativa Tresguerras, along the lines of efforts by nineteenth century mutual aid societies, to create work for its members, and they proposed that their work be communal and anonymous. Above all, since they largely relied on a single employer for their commissions and access to walls, they proposed collective action to defend their pay and common interests vis-à-vis the government.[16]

The creation of the Syndicate was in part a response to uncertainties about the official status of mural painting. By late 1923, few artists other than Rivera had received new mural commissions, though many held on to jobs as teachers or bureaucrats in the Secretariat of Public Education (Secretaria de Educación Publica—SEP). Their principal patron, Vasconcelos, was weakened politically by ongoing conflicts with the CROM. As a union, the Syndicate was largely a failure, given their employer's monopoly on mural commissions. Vasconcelos rejected their initial efforts to negotiate collectively, leading Orozco to remind members that "I already told you that the Syndicate was bullshit." Personal conflicts and ambitions further undermined their attempts to paint collectively. According to Siqueiros, Orozco wouldn't come to initial meetings because of his personal enmity for Rivera. And when Orozco and Siqueiros were dismissed from the Preparatory in July 1924 after their murals were attacked by students, Rivera distanced himself from the other painters and resigned from the Syndicate, thus assuring its swift demise and his own continued mural commissions.[17]

Nonetheless, the Syndicate proved instrumental to the political and artistic development of artists and became an important point of entry into national politics. Even Orozco acknowledged that it exposed artists to socialist ideas. And as Siqueiros remembered, it allowed artists to abandon the symbolic, cosmic vision of Vasconcelos "to debut works of revolutionary social intent." In their famous manifesto, they elaborated their rejection of academic styles and easel painting and identified directly with the popular classes, their forms of expression, and their social struggles.[18]

With little leverage in the workplace, the Syndicate found its voice in periodically issuing statements and manifestos, eventually in *El Machete*, defending the artistic production of members from critics and denouncing acts of vandalism against public murals. Crucial to their public position, as well as to their understanding of Mexican politics, was the December 1923 rebellion led by general Adolfo de la Huerta, with the support of an array of progressive and conservative forces, against Obregón and his chosen successor, Calles. In response, the Syndicate publicly endorsed both Obregón and Calles and began arming themselves to join government forces. The comic image of overweight and poorly armed artists preparing for battle is repeated in a variety of memoirs. But for the artists, the armed mobilization of organized campesinos and workers in defense of the government, and the death of Yucatán's socialist governor, Felipe Carrillo Puerto, at the hands of conservative insurgent forces, all brought back the theme of armed revolution.[19]

Perhaps more than any other factor, the growing influence of the Communist Party of Mexico on key artists during the course of 1923 would make the worker a central theme in their visual vocabulary. Formed in 1919, the PCM briefly collaborated with the anarchist CGT and coexisted with the CROM before breaking with both, leading to a deep crisis in membership. Following Communist International policy from 1921 to 1928, the PCM rejected the formation of its own labor federation, instead trying to organize party membership in industries without unions or in cells within existing unions. After 1925, they made a deliberate outreach to campesino leagues. Their influence in the early 1920s was limited mostly to urban rent strikes, campesino leagues in Veracruz, what would become an important group of railroad office workers affiliated with the Alliance of Mexican Railroad Workers, and a few small groups of miners and oil workers.[20]

The PCM's greatest influence in the early 1920s would be among intellectuals and artists. By late 1923, the artists Rivera, Siqueiros, and

Guerrero filled three of four positions on the party's executive committee. According to the fourth committee member, Bertram Wolfe, "from a party of revolutionary politicians, it changed to a party of revolutionary painters." This dual militancy further exposed these artists to the radical ideologies circulating within the early PCM—particularly the centrality of the proletariat to revolutionary transformation. It also disposed them to share the party's bitter rivalry with the CROM. The CROM in turn remained close to the reformist American Federation of Labor and viewed the Communist Party as a dangerous and "foreign" rival.[21]

ESTRIDENTISMO, MURALISM, AND PRINTMAKING

The development of a visual representation of workers in the early 1920s depended on three influences that would ultimately shape and be shaped by *El Machete*: the rediscovery of printmaking and Posada through the Open Air Schools; the avant-garde innovations of the Estridentista movement; and a second round of murals developed by Rivera in the new SEP building and by Orozco in the National Preparatory School.

The rediscovery of printmaking as a legitimate art form in the early 1920s provided a crucial grounding for graphic innovations and reinventions. The Academy of San Carlos had largely ignored printmaking, taught primarily in relation to the commercial production of stamps and diplomas. Even so, Julio Ruelas had experimented with haunting Symbolist etchings and aquatints in Paris in the late Porfiriato, and Dr. Atl exhibited stencil prints in Paris in 1911 and incorporated an apparently similar technique for several covers of *Acción Mundial* in 1916.

The revival of printmaking began as part of the Open Air School of Coyoacán, a more sustained implementation by director Alfredo Ramos Martínez of his 1914 attempt to challenge the insular curriculum of the Academy of San Carlos with open-air easel painting in rural settings. A privileged state project in the early 1920s, it would prove to be a nursery of training and experimentation for a generation of young artists that included Ramón Alva de la Canal, Fernando Leal, Gabriel Fernández Ledesma, Fermín Revueltas, Francisco Díaz de León, and Leopoldo Méndez.[22]

A key figure was the French-born Jean Charlot. Inspired by Gauguin's dreamlike prints of the South Pacific, those of the German ex-

pressionists, and the Mexican tales and antiquities of his "exotic" maternal ancestors, the young artist arrived in Mexico in 1921 with his own woodcut prints in hand, a religious series of *The Way of the Cross* that fascinated his fellow painters in Coyoacán.[23]

Charlot initiated a variety of artists into the techniques and possibilities of woodcut printmaking. Besides the legitimacy this traditional art form gained by its links to the European avant-garde, with its fascination for "primitive" forms and cultures, the woodcut appealed to a new generation of young artists seeking a more democratic art form, one that didn't require expensive materials, allowed for wider distribution, and that was associated with urban popular culture. For these artists, woodcuts offered a bold, expressionist medium, with black form and shadow to white line, in contrast to the dominant Impressionist focus on light and colors.[24] The form and lines of the woodcut may also have seemed a perfect medium for a group struggling to find ways to represent the mestizo as central to national character. Early prints at the rural schools largely reflected the pastoral landscapes and popular character studies of their easel paintings, though Charlot often portrayed laboring campesinos, including porters bent under heavy loads, that were also a part of the urban landscape.

Charlot also began to gather and circulate the works of the largely ignored and forgotten engraver Posada. In 1921, Dr. Atl had included images by Posada in the influential Centennial Exposition of Mexican Popular Arts. In the catalog, Atl's focus was the penny-press publisher Vanegas Arroyo, and only one mention is made of Posada by name. In early 1924, Rivera praised Posada in press interviews, and in 1925 Charlot published the first of several articles on Posada. In the same year, Francis Toor's *Mexican Folkways* featured several Posada prints, consistently misspelling his name.[25] Just as Posada used rougher features to distinguish the indigenous roots of his campesino-workers from his artisans, the crude lines of the first Open Air prints may also have appealed as a way to capture the racial "otherness" and authenticity of their campesino and indigenous subjects.

Many of the younger artists involved in the Open Air Schools also provided Estridentismo, the avant-garde literary movement, with a creative visual counterpart. The movement was founded by poet Manuel Maples Arce in 1921 when he plastered the walls of Mexico City with a self-published manifesto with a photograph of himself and an iconoclastic text that attacked just about every aspect of Mexican culture while praising a variety of European avant-garde movements.[26] In its first phase in Mexico City (1921–1925), Estridentismo

was notable for its relative independence from any direct government sponsorship.[27]

Soon after its founding, Charlot, Revueltas, Leal, and Alva de la Canal began to create paintings and woodblock prints to expand on the Estridentista ideas and illustrate its flyers, books, and journals. Their visual innovations, inspired in part by Italian Futurism, were influential in the emerging aesthetics of both murals and prints. Their art broke with the sensual and romanticized styles of Symbolism and Art Nouveau that had inspired an earlier generation like Ruelas and Herrán. It featured a mix of the figurative and abstract, extending art to the streets with posters and periodicals, and featuring flattened, fragmented elements of modern technology and urban landscapes that moved these artists beyond the rural thematic and Impressionist styles of the Open Air Schools. Echoing the literary themes of the movement were portrayals of urban modernity: skyscrapers, radios, electrical wires, and the occasional factory, an urban utopia with limited connection to the mix of traditional and modern, wealthy and poor that constituted most Mexican cities. This "Estridentropolis" was largely devoid of the presence of workers or people of any kind.

For example, Revueltas's painting *Indianilla* (1921) depicts an electrical center for the Mexico City tramways, with chimneys, telephone lines, and multiple power cables radiating out. Despite the lack of human figures, the canvas suggests the energy, noise, and labor of the specific urban environment of the capital. Leal's 1922 woodcut *Fábrica* is a simple silhouette of factory chimneys that borders on abstraction. An exception is Méndez's 1923 ink drawing *The Seamstress*, which centers on a seamstress in an interior space, abstracted by Cubist angles.[28]

Revueltas's 1923 watercolor *Exterior Scaffolding* includes two workers in overalls largely hidden in an urban landscape of telephone poles and wires, rooftop water tanks, and the external scaffolding on a building in construction or repair. As Tatiana Flores notes, unlike his earlier *Indianilla*, the painting inserts labor while also suggesting the "workmen as surrogates for mural painters."[29] This was a time when Revueltas and others were painting their first murals, becoming aware of the burgeoning labor movement, and organizing the Syndicate.

By 1924, Estridentista art began to reflect the complicated political culture of the decade and the influence of related artistic developments of muralism and *El Machete*. Flores notes the tension and eventual "cross-pollination" between the Estridentistas and artists determined to address social change that would mark the move-

3.1. Ramón Alva de la Canal, *Color Mill*, circa 1924. Reprinted in
Nuestra Ciudad, April 1930, page 42. Courtesy of Jorge Alva de la Canal.
Author's photograph.

ment's development over the decade. Ramón Alva de la Canal's wood-
cut *Color Mill* (fig. 3.1) is dominated by two human figures straining
against the wheel of a mill, a vivid paraphrase of his former teacher
Saturnino Herrán's 1909 oil painting *Glass Mill* (fig. 1.1). There is a
suggestion of exploitation, though the title references the mills used
to grind painters' colors, extending the collaborative and work-like
aspect of artistic creation.

Revueltas's first woodprint, dated the same year, features a stark
portrayal of a man squatting before two dead workers in what could

be a factory or a prison cell, with a hammer and sickle lying uncrossed at their side. The image fits more than any other Estridentista work within the concurrent subject, style, and tone of *El Machete*.[30]

Other artists like Manuel Rodríguez Lozano and Agustín Lazo experimented with form and content in this same period in their scenes of everyday urban life and inevitably included the working class. In Lazo's 1924 painting *Workers*, angular workers dance around abstracted factory machinery, in a scene suggestive of Rivera's graceful, curved sugar workers in the SEP and the dynamic elements of early Estridentismo. Typical of the artists of this "group without a group," which would later coalesce around the *arte puro* journal *Contemporaneos*, Lazo avoids any narrative of exploitation or conflict.[31]

The most important literary work of the Estridentista movement, Maples Arce's 1924 poem "Urbe: super-poema bolchevique en 5 cantos," imagines the modern city of the title as the key character, dominated by skyscrapers, train stations, and cinemas, traversed by fast-moving cars, buses, and trolleys and connected by webs of electrical and telephone cables, radio waves, newspapers, and posters, almost all of them elements of modernity present in Mexico City. But Maples Arce moves beyond the modern technology of the city to reveal its inhabitants. According to Flores, the poem "marks a turning point . . . describing the urban environment as a contested space, rife with social problems."[32] The poem is dedicated to Mexican workers, and multiple excerpts capture the presence and agency of workers as key inhabitants. A typical passage ("Oh the poor union city scaffolded in cheers and shouts") acknowledges the role of organized workers in constructing the city. In others, the workers are divided, but they are ultimately destined to some form of radical or reformist solidarity: "The workers are red and yellow," but "Strikers throw stones and insults, and life is a raucous conversion to the Left."[33]

By contrast, Charlot's stark woodcuts for the poem present, in Flores's view, "a bleak view of modern life" and suggest "how technology dwarfs the individual."[34] In these images, unlike the poem itself, workers and human life are virtually absent; in the lone exception, undistinguished masses almost disappear in the face of towering *Skyscrapers* (fig. 3.2), diluting the class-based tensions explicit in Maples's poem.[35]

When the poem was translated into English by John Dos Passos in 1929 as *Metropolis*, Charlot's prints were replaced by a single new image by Fernando Leal (fig. 3.3). Leal revisited the dynamic aesthetic of the earlier years of Estridentismo with a busy cityscape of modern

3.2. Jean Charlot, *Skyscrapers*, 1924. From Manuel Maples Arce, *Urbe*. © The Jean Charlot Estate LLC. Used with permission. The Jean Charlot Collection, University of Hawaii at Manoa Library.

buildings, a factory chimney, cables and antennae, and a tramway car. What is new, and indicative of the distance travelled by Estridentismo in its second phase, is the tiny pocket in the lower-left corner of a crowd of workers marching behind a banner and confronting a variety of individuals. The protesting workers rectified Charlot's earlier images of a largely empty metropolis, incorporating the undercurrent of social mobilization that was a key part of the poem and was, increasingly, a theme of the avant-garde artists during the later 1920s.[36]

In short, the experiments in printmaking in the Open Air Schools and by Estridentista artists up to 1924 were crucial experiences for the artists of *El Machete*—but they had not yet created a complex iconography of labor.

The first extensive and direct representation of workers in the 1920s occurred as part of a second phase of muralism that moved

3.3. Fernando Leal, untitled, illustration for *Metropolis*, by Manuel Maples Arce, T. S. Book Company, 1929. Courtesy of the Ransom Center, University of Texas. © Artists Rights Society (ARS), New York/SOMAAP, Mexico City.

beyond the earlier search for styles and themes and coincided with the organization of the artists' Syndicate, the involvement of many with the Communist Party, and the formation of *El Machete*. Charlot, Leal, Revueltas, Alva de la Canal, and Siqueiros simultaneously participated in 1922–1923 in the experimental hot house that was the National Preparatory School. These young artists rejected the initial ahistorical, Cubist, and neorenaissance murals of Rivera and Orozco, instead using many of the avant-garde aesthetics of Estridentismo to explore epic moments of Mexico's past, and the continued tension between competing aspects of its European and indigenous heritage, in ways that would find full flower in the later epic murals of Rivera and Orozco. But their innovative murals did not directly address the figure of the worker.[37]

Siqueiros, torn throughout the decade between his artistic and political activities, may have come closest in his late contribution to the "first round" of mural painting in the National Preparatory School. His small but incomplete mural came to be known as *Burial of a Worker*, though the event commemorated was the assassination of left-leaning Yucatán governor Felipe Carillo Puerto in 1923.

Rivera and Orozco would most directly address the working class in a "second round" of murals. In 1923, Rivera began painting the interior courtyards of the new, neocolonial SEP building. He abandoned the ahistorical, byzantine style of his first mural for a simpler, more readable style and deliberate social engagement, most obvious in what became known as the Patio of Work. Painted in 1923 and 1924, this series depicts the agricultural, artisanal, and industrial labor of mostly male workers. Even though lines and forms hint at the modern technology and aesthetic of Estridentismo, most panels center on rural workers and their traditional technology: potters turn, paint, and fire their wares; weavers are entrapped in their artisanal looms; and sugar workers dance gracefully around a press and boilers. (The exception is a group of foundry workers; see fig. 4.9.) The workers lose any individuality as they share the collective endeavor of labor, and there is an implicit identification between the work of the muralist and the work of the artisan-workers.[38]

More pointedly, the two murals *Entering the Mine* and *Leaving the Mine* directly depict the exploitation of Christlike workers (fig. 3.4). Unprotected and barely dressed, they carry minimal tools and cross-like beams into the mine and are patted down for hidden ore as they exit. These images suggest work as a noble and collective but exploited endeavor, but none move toward organization or action. Rivera did in-

3.4. Diego Rivera, *Entering the Mine*, 1923–1924, mural, Secretariat of Public Education, Mexico City. Author's photograph.

clude in *Leaving the Mine* an excerpt from poet-in-overalls Carlos Gutiérrcz Cruz urging the "Comrade Miner" to make knives for themselves instead of money for the rich from the ore they dig, "and thus you will see how all metals will be yours." But he was forced by Vasconcelos to remove the offending verse, revealing the limits on artistic expression enforced in public murals. According to Rivera, Vasconcelos allowed a compromise on a nearby panel—the embrace of a worker and campesino who seem to be consoling each other rather than uniting forces, as later versions of this trope suggest.[39]

Unlike the endeavor of multiple artists who each painted their own

3.5. José Clemente Orozco, *The Ambush*, 1924, mural, Antiguo Colegio de San Ildefonso, Mexico City. Author's photograph.

murals at the National Preparatory School, the SEP murals became virtually a one-man show at a time when few new mural commissions had been offered. Amado de la Cueva, Guerrero, and Charlot were marginalized, and Rivera actually painted over one of Charlot's three SEP murals. Guerrero continued on as an assistant there through much of the first year of *El Machete*.[40]

Unhappy with his initial efforts in the National Preparatory School, Orozco destroyed all of his first murals there except *Maternity*. In the early months of 1924 he developed another style that combined his long experience as a newspaper caricaturist with a narrative of class conflict parallel in theme if not tone to those of Rivera. For example, in *The Banquet of the Rich*, two wealthy men carouse with a prostitute, amused while three workers below fight among themselves, holding apart a hammer, a sickle, and an artisan's trowel that should be united and used to fight against the rich. Another mural (fig. 3.5), later known as *The Ambush*, centers on a brutish-looking manual laborer, shovel in one hand and the red-and-black flag of the labor movement in the other. In front of him and pointing him forward is an enormously fat and well-dressed labor leader, a barely disguised Morones. Behind the laborer is a masked character in a priest's

vestment, dagger raised to strike the distracted worker in the back. The suggestion is a moral equivalence and informal collaboration between official unions and the Catholic Church to confound and exploit the worker. Other murals from this cycle similarly attack the despotism, hypocrisy, and exploitation of bankers, bishops, and high-society ladies, using grotesque figures distorted in form and emotion.[41]

Orozco's murals aimed at the failures of the postrevolutionary order and responded to the Syndicate's manifesto that art be "for education and for combat" and not necessarily as "a finality of beauty for all." These murals, with their class content, distortions, dark ironies, and barely concealed personalities, were denounced by critics as offensive and soon after defaced by students, ultimately leading to Orozco's temporary dismissal from the National Preparatory School. At that moment, he had begun a mural titled *Troops Defending a Bank Against Strikers*, for which there is no photographic record.[42] It is the caricaturesque style and working-class subjects that he took with him to the pages of *El Machete*.

THE REVOLUTION IN RED, BLACK, AND WHITE: *EL MACHETE*

The cultural politics of labor and the artistic innovations of the early 1920s came together most directly in the newspaper inaugurated by the artists of the Syndicate in March 1924. Their decision to produce a newspaper is not surprising: through much of the Porfiriato and during the Revolution, short-lived newspapers had proliferated to express the views of political, social, and cultural groups. In the cultural effervescence of the early 1920s, political and cultural journals that incorporated the writings and drawings of artists proliferated as independent or government projects. Siqueiros published a single issue of *Vida Americana* as a manifesto to artists in 1921, and in the same year Manuel Maples Arce initiated Estridentismo with *Actual*, using a manifesto-poster format. In 1923, the Grupo Solidario published two issues of *Vida Mexicana*, and the Estridentista movement published three issues of a new journal, *Irradiador*. All were ready examples of periodicals produced entirely by writers and artists, and *Irradiador* in particular offered a model of a vivid graphic style, including images by Syndicate artists Charlot, Revueltas, and Rivera.[43] For the artists of the Syndicate, the creation of *El Machete* must have seemed natural and urgent. Finally, the absence of an official newspaper for the Com-

munist Party of Mexico at its moment of greatest weakness since its founding in 1919 provided a further incentive and a way for Syndicate artists Siqueiros, Guerrero, and Rivera to tighten their ties with the struggling party.[44]

Guerrero, Siqueiros, and Rivera were the main artists involved in *El Machete* and formed an executive committee that mirrored that of the PCM. Although the newspaper claimed a staff of some thirty writers and illustrators, the day-to-day operations and much of the content depended on Guerrero, listed as the *responsable*, Siqueiros, and Siqueiros's first wife, the actress Graciela Amador.[45] Estridentista members of the Syndicate are conspicuously absent from its pages, while others, such as Amado de la Cueva, contributed sporadically or, in Orozco's case, joined late.[46] Since Rivera continued to paint in the SEP, his primary contributions in its early months were articles and money rather than images. Even so, the influence of his SEP murals on the newspaper's graphics was palpable. A variety of foreign Communists, most notably the American Bertram Wolfe, advised the artists on the organization of the newspaper and contributed articles on Marxism and the Russian Revolution.

The penny press provided an important model. Drawing from the broadsheet as well as the Estridentistas' *Actual*, it was a "*periódico-mural*," designed to open up as a poster to hang on walls with the front and back pages featured. Guerrero recalled how "Siqueiros and I would sally forth, loaded with papers, brushes and a pail of glue. In the dark we hurriedly pasted the *Machete* on strategic walls, and retreated before dawn." Charlot recounts how, at a state dinner for artists visiting from fascist Italy, "members of the Syndicate appeared outside the high windows and let a red, black, and white snow of *Machetes* flutter down." The newspaper, Siqueiros remembered, served as the Syndicate's "calling card" to the masses, though as Charlot's anecdote suggests, their public was often cultural and political elites.[47]

Initially a biweekly of four pages, it sold for ten centavos an issue, more than most unskilled workers or peons could afford. By August 21, 1924, it became a five-centavo weekly. Early on they declared a circulation of 3,000, most of which probably went to workers in the limited sectors where the Communist Party had influence—among carpenters and oil, metal, and railway workers.[48] Readers came primarily from Mexico City, though the newspaper claimed a significant circulation in Tampico, presumably among oil workers, and a regular readership in Havana. Lists of subscription prices and frequent warnings to keep subscriptions paid suggest that some received it through

formal organizations, perhaps unions, or else were well off enough to afford to pay for several months. Certainly much of the circulation came to readers indirectly. Financing *El Machete* was a continuous problem. Ads were rare and eventually rejected altogether as the alignment with and subsidy from the Communist Party became more direct. Ongoing operations depended on members' donations of time and money.[49]

Despite the Communist membership of key editors, and perhaps due to their fledgling militancy, the newspaper in its first year reflected a spectrum of liberal, populist, and radical traditions before veering toward a clear communist line by the end of 1925. *El Machete* drew from the discourses of the satiric penny press for workers, enhancing them with the struggles of the Revolution. "This journal is of the People and for the People" began a short statement of "propositions" penned by Guerrero for the inaugural issue. Like earlier working-class papers that challenged elite explanations for working-class vice, Guerrero condemned exploitation that led el pueblo to drink pulque to forget their miseries. Invoking the agrarian, populist nature of the Revolution, the statement promised that "we will struggle for the Pueblo that continues humiliated, that still doesn't have all the land that belongs to it. . . . We will struggle for the native consumed in the workshop or the Factory." A single sentence in capital letters acknowledges their role as artists in the task of working class enlightenment: "WE WILL MAKE OF ART A SOCIAL FUNCTION; WE WILL WORK FOR RATIONAL EDUCATION . . . so that moral and aesthetic values flourish." Only the closing phrase invokes their newly discovered communism: "workers and campesinos of the world, unite."[50]

More deliberately than Dr. Atl's newspapers and in contrast to early Estridentista publications, the artists of *El Machete* reached out to the working class in general and unions in particular. For Siqueiros, their audience was "a new spectator . . . the great masses of workers, campesinos, and Indians . . . rather than the university professors and students that formed the only daily spectator of our mural works."[51] In an appeal Siqueiros penned in *El Machete* "to the proletariat," he modeled working-class readership:

By subscribing [to *El Machete*] and making sure your comrades do too; by sending small donations that do not involve too great a financial sacrifice; by advertising the proletarian press in whatever way you can; by sticking our newspaper on walls; by sending information about the situation of the proletariat in different regions; by taking collections and holding fund-raising events, etc.[52]

El Machete repeatedly invited readers to send articles, but with the exception of an occasional letter, most content came from members of the Syndicate or the Communist Party. The winner of a "Proletarian Drawing Contest" was the "young worker" Máximo Pacheco, who was already contributing drawings regularly.[53] Unlike the intended audience of the Porfirian penny press for workers, the working-class reader was to be converted to active militancy, preferably on behalf of the Communist Party.

The rhetoric, political content, and perspective of *El Machete* came over time to mirror that of the Communist Party, as well as the changing perspectives and situations of the artists themselves. Very few articles would qualify as news; many were deliberately didactic and tied loosely to the ideology, figures, and events of international communism. As with the anarchist press of the Casa del Obrero Mundial, readers were introduced to the traditions of the European left, with new attention to Marx and Lenin and the struggles and accomplishments of the Soviet Union.

A frequent focus was the CROM's problematic leadership and underhanded intervention in labor conflicts. Articles covered a variety of worker conflicts, the vast majority among workers in sectors independent of the CROM, such as electricians, miners, and railroad workers. The most extensive coverage in its first year followed the Tampico oil workers' strikes against the Anglo-Dutch company El Águila in the spring of 1924, even though the Communist Party had limited influence among the leadership of competing unions there. Typically, articles denounced "the pseudo-anarchic leaders of the General Confederation" (the CGT) and the "bad shepherds" of the CROM for their "villainous role of Judas" in undermining independent workers. *El Machete* condemned the CROM for its declared dual allegiance to working-class militancy and official nationalism, exemplified when the CROM featured the "impossible amalgam of the national flag with the red and black [flag]" in its congresses and the 1924 May Day celebrations. Congruent with communist positions until 1925, campesinos generally played a supporting role as a rural proletariat.[54]

El Machete made direct pronouncements on Mexican politics. Siqueiros remembered the paper's "ultraradical tendency and direct opposition to the government," but the reality was more a complex balance and strategic shifts between populist and radical, official, and opposition politics.[55] A manifesto penned by Siqueiros denounced supporters of opposition presidential candidate Angel Flores, linking

them to the de la Huerta revolt. While warning that "the effective salvation of the workers can never be found within a bourgeois state, which must be destroyed at any cost," the newspaper supported Calles as Obregón's chosen successor in the July 1924 presidential elections, given that "his definitively revolutionary personality guarantees more than any other in the government of the Republic the betterment of the productive classes."[56] Their endorsement of the government made some practical sense. Only Rivera and Orozco continued to paint murals under government contract in the first half of 1924, but most artists in the Syndicate still held paid positions in the SEP bureaucracy. Critical support of Obregón and Calles in the aftermath of the de la Huerta rebellion also echoed the position of the Mexican Communist Party. Even so, such dependence didn't stop them from denouncing specific policies of Obregón, or eventually those of Calles. In the months before elections, *El Machete* denounced the subordination of the Mexican government to the United States in the Bucareli Accords on debt and damage to US property and condemned the government policy of taking arms away from the workers and campesinos mobilized against the de la Huerta revolt.[57]

The first issue minimized the newspaper as a product of artists. Even so, an overriding concern from the first issue was the politics of culture, suggesting their intended audience was as much other artists and intellectuals as workers. Multiple articles and images denounced or parodied "bourgeois" intellectuals and artists, roughly divided into "reactionary" and "pseudo-revolutionary" factions, as well as the bourgeois press. Targets included cultural bureaucrats like Ezequiel Chávez, rector of the National University, writers like Salvador Novo and Jaime Torres Bodet, critics of early murals, and artists like Atl who practiced "bourgeois" art forms or participated in official cultural exchanges with the fascist government of Italy.[58]

Only in the seventh issue, in late June, would they fully elaborate their views on the relation of art and politics in a manifesto: "The creators of beauty must strive to make their labor present . . . ideological propaganda for the good of the people, making of art, currently a manifestation of individualist masturbation, a finality of beauty for all, of education, and of combat."[59]

Even as the artists developed their rhetorical skills as political writers, they made graphic images central to *El Machete* content, combining the graphic traditions of the popular penny press with the ideological universe and subject matter of postrevolutionary radicalism. They drew directly from three traditions that had long been used

to capture popular sentiments, appeal to a semiliterate public, and challenge social injustice and dominant cultural assumptions: one was the use of prominent graphic images that might stand alone or work hand in hand with texts; another was the use of short plays, poems, and *corridos* (ballads); and the third was satire.[60]

The design of the paper as a foldout poster gave prominence to graphic images, creating affordable art for the masses. Readers were urged to embellish the walls of their homes with the newspaper, and many of its images were reproduced and offered for sale or as raffle prizes ("Comrade Worker: If you want to have the original print in your own house, union or cooperative . . .").[61] *Machete* images sought to address a primary problem of the initial cycle of murals painted on the walls of the National Preparatory as well as many Estridentista paintings. Their obtuse symbols and fragmented, almost abstract visual language were deemed inaccessible to a broad public and inadequate to the more direct political messages they sought in the context of the events of 1924.[62] Moreover, if some of the articles assumed a fairly sophisticated readership, or at least a reader looking to be enlightened, prints condensed the messages into their graphic essence. The intent, Siqueiros remembered, was that "the articles would illustrate the drawings."[63]

The artists of the Syndicate researched the development of Mexico's visual history, searching for artisanal and popular traditions that could provide a model for capturing a narrative of the armed revolution and their aspirations for worker and campesino militancy. They found a vivid and immediate model in the *corridos* and rustic plays of broadsheets and the prints of Posada.

The rediscovery of Posada was paradoxical. The prints featured in the 1921 Exhibition of Popular Arts and made available to Charlot in 1922 were the relatively conservative broadsheets done for Vanegas Arroyo and made available by that publisher's family, rather than those of the satirical penny press for workers. And as noted, Posada had probably been hostile to new forms of worker organization and action as well as the turmoil of revolution. Artists presented Posada as unknown during his life, yet both Rivera and Orozco elaborated specific youthful encounters with Posada in his workshop. Orozco's caricatures in the decade of the Revolution probably come closest to suggesting a direct legacy. Finally, the artists of the Syndicate romanticized Posada and woodcut prints as "primitive," in spite of the fairly modern etching innovations Posada developed in his later career.[64]

The tie between Posada and *El Machete* is most direct in an August

1924 issue, which reproduced one of Posada's last broadsheet prints without crediting him. In the print, a band of mounted campesinos overwhelms the federal army. The caption warns that "TODAY'S ARMY NOT FORGET ITS REVOLUTIONARY ORIGINS," or it risks the same fate as Díaz's once "INVINCIBLE FEDERAL ARMY." Posada would have been comfortable with the recycling of his print, though maybe not its new message.[65]

The use of woodcut prints created possibilities and limitations: the flat, black-and-white images were well suited to the budget, experience, and political messages of El Machete's artists and fit well with their search for a popular and "authentic" art form. The influence of Posada, the penny press, and the use of the woodcut print helped keep radical artists in the 1920s and 1930s from a close imitation of emerging Soviet models of socialist realism.[66] At the same time, these early woodcut prints carried a limited information load and were far less versatile and dynamic than the etchings of Posada, the Machete line-drawings later done by Orozco, or the linoleum and woodcut prints developed by Méndez and others in the late 1920s and 1930s.

The artists of the Syndicate had access primarily to the broadsheets Posada published for Vanegas Arroyo, which were reproduced widely beginning in the 1920s, but may have drawn directly from the satiric penny press for workers. As we saw, Posada had developed a visual language there that drew heavily on a Manichean portrayal of class differences. The Marxist-inspired artists of El Machete took the traditional iconography, with its "clase obrera" (and its more specific components, "the artisan," "the worker," and, to a lesser extent, the "campesino" or "indigenous") and its traditional enemies (employers, hacendados, foreigners, caudillos, and clergy) and fortified them with an imperative for working-class solidarity, organization, and militancy.

The visual universe of El Machete revolved around two archetypes: the worker and the campesino. Since the outbreak of the 1910 revolution, campesinos had captured the imagination of a new generation of artists, and they were referenced in the very title of El Machete, a Mexican variation of the communist sickle. Guerrero produced a powerful portrait of Zapata in charro dress, with bandoliers across his chest and his rifle held in the air, bounded by hammers, sickles, and machetes. Another Guerrero print depicts a ceremony of land distribution that echoed and radicalized related mural panels painted simultaneously by Rivera in the SEP.[67] But the most important graphic subject was the worker, a factor of the urban backgrounds and per-

spectives of the artists, their self-images as workers, their recent in-volvement with the labor movement, and the related bias of commu-nist ideology. Even so, as the membership of the Communist Party began to recover in the second half of the 1920s, its influence grew pri-marily among state campesino leagues, making the peasantry impos-sible to ignore and blurring the idealized representation of the ideal worker as uniquely urban.[68]

Guerrero was the artist in the Syndicate with the clearest working-class origins; short and dark-skinned, this son of a sign painter grew up mostly in Jalisco, decorating the interior walls of the houses of the Guadalajara elite. He called himself a "Toltec" and signed his 1925 drawings for the Communist Party's anti-imperialist journal *El Liber-tador* as "Indio."[69] Guerrero worked as an assistant in the early murals of Roberto Montenegro and Rivera. It was with *El Machete* that he first came into his own as an organizer and artist. A variety of his prints parallel content that Diego Rivera was simultaneously develop-ing in the SEP, though with fewer political constraints.

As with Rivera, in Guerrero's prints labor is reduced to its most basic elements: unskilled workers and their tools. Like the mining murals, the focus is on exploitation. There is limited reference to the factory settings that were often the background for class relations in Posada's prints, or the modern technology and cityscapes, largely de-void of workers, of early Estridentista images. Industrial landscapes are rare, reflecting as much the artists' emphasis on unskilled workers as the actual state of the Mexican economy.

In an early *El Machete* print (plate 4) by Siqueiros, a kneeling figure, naked from the waist up and devoid of the context or tools of work, reveals his multiple gashes. With a cry of "My owners, my masters," he declares himself a slave and victim. The caption generalizes the worker as both rural and urban: "THIS WAY, DISARMED AND ON THEIR KNEES, WHIPPED AND BEGGING FOR CHARITY, IS HOW THE HACENDADOS, INDUSTRIALISTS, OIL TYCOONS AND ALL THE RICH OF MEXICO IN GENERAL WANT TO SEE THE WORKERS FOREVER."[70]

Related (fig. 3.6) is a Guerrero woodcut of three workers wielding shovels and pick-axes for the El Águila oil company that accompanies an article on their strike. The caption emphasizes the exploitative conditions of the workers: "HOW ONE WORKS IN THE 'EL AGUILA' REFINERY, WITH RAGS ON THE HANDS INSTEAD OF GLOVES." These are not the highly skilled and strategic workers who led the Águila strike, in an industry with high capital and technology inputs. The simplicity and emphasis on the primitive is closer to the early Open

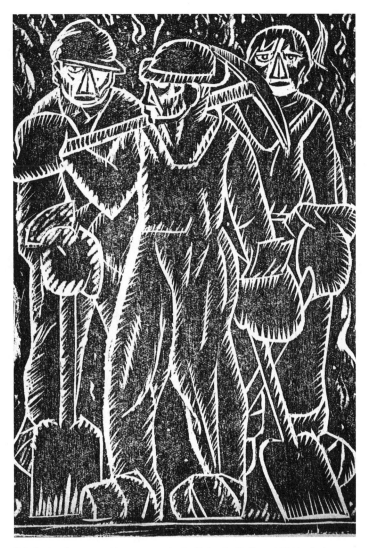

3.6. Xavier Guerrero, *How one works in El Aguila Refinery*, *El Machete*, June 1924. Author's photograph.

Air prints of Charlot and Leal than to the complex, fragmented geometries and symbols contained in Estridentista prints from the same period. Much of the power comes from the crude woodcut lines and the break with rules of perspective and scale.

These workers also are Posada's unskilled majority, though Guerrero and the radical artists of the mid-1920s proletarianize them, shedding the campesino *calzón* and sombrero Posada used to mark un-

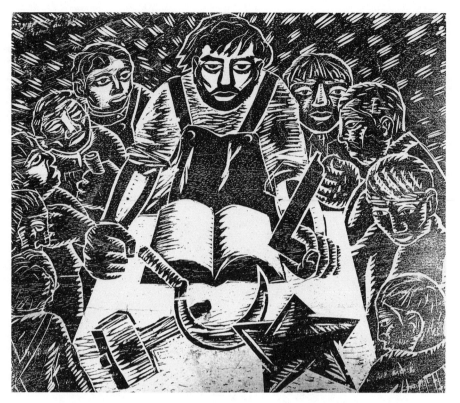

3.7. Xavier Guerrero, *Judgment of the Intellectual Enemies of the People*, *El Machete*, June 15, 1924, page 2. Author's photograph.

skilled laborers. Mestizo identity is suggested by the dark tones and rough lines of the print, which Posada often used to distinguish his worker-campesinos from his artisans. Overalls become the fundamental marker of class identity and pride in these early *El Machete* depictions, often obscuring the variety of work clothing used from site to site and within many worksites, ranging, in relation to race, skill, and status, from campesino breeches to jacket and tie. Of course, the vast majority of Mexican workers were rural, and the paltry membership of the Communist Party would grow primarily in the countryside in the next years.

In a more finely turned image (fig. 3.7), Guerrero indirectly distinguishes between elements of the proletariat. In *Judgment of the Intellectual Enemies of the People*, the dominant worker, perhaps the counterpart of Posada's skilled artisan, stands before a table—in overalls, but with a T-square in one hand and an open book, presid-

ing over the enlightenment of his fellow workers as well as the judgment of reactionary intellectuals. Just as Posada and the editors of the satiric penny press for workers probably identified with the artisans they celebrated, *El Machete* artists saw themselves, as intellectual workers, in a similar leadership position. Unlike Posada's prints, the hammer and sickle suggest an imperative of action by workers, led by their communist-inspired leaders.

More numerous and didactic were a series of prints that showed workers in direct relation to enemies and allies. The first issue included a separate broadsheet, *Corridos del Machete*, with a large print (fig. 3.8) by Siqueiros entitled *The Trinity of the Shameless*. The first is a European capitalist with a wad of bills in his hand declaring "I plunder the world." At the center is a politician silently receiving money from the foreigner and passing some to a worker who is a traitor to his class ("I am the Iscariot").

All three figures are similarly drawn as powerful and masculine, with their type described through their dress. Their depravity is shown through their grasp of money and their speech unfolding in a banner-like bubble. The symbols of bills and moneybags stems directly from the penny press. What is new, and directly related to the postrevolutionary organization of labor, is the repeated portrayal of a divided working class. If Siqueiros were to give another name to the Judas (Iscariot), as the accompanying articles frequently do, it would be the CROM or its leader Morones.

Of course, the worker as victim or traitor is only half of the new equation; the counterpart was the imperative for workers to unite. Siqueiros makes it more explicit two issues later with a second woodblock (fig. 3.9) entitled *We Three Are Victims, We Three Are Brothers*. It features three similarly powerful figures dressed as a campesino, a revolutionary soldier, and a worker in overalls, locked arm in arm and leading a mass of comrades. Both prints are stamped with simple, vigorous lines, and all have the characteristic strong Siqueiros nose. The second is particularly striking for its use of standing, virile figures, assembled masses, and the repeating geometries of the halo-like hats of the campesinos, workers, and soldiers. Though the "three brothers" dominate the picture, the multiple figures behind them anticipate images of the unified masses in the 1930s.

Immediately below and directly complementing these two Siqueiros prints is a farcical play in two parts titled *The Fall of the Rich and the Construction of the New Social Order*. Written by Amador in a simple and popular style reminiscent of broadsheets, it contrasts with

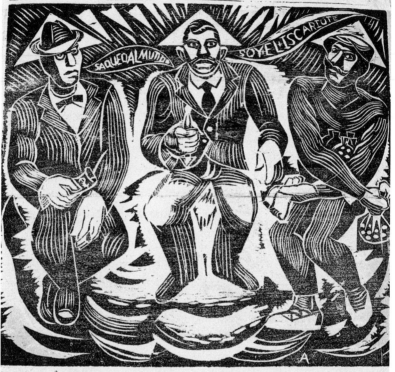

3.8. Davíd Alfaro Siqueiros, *Trinity of the Shameless*, *El Machete*, Corrido, March 15, 1924. © Artists Rights Society (ARS), New York/SOMAAP, Mexico City. Author's photograph.

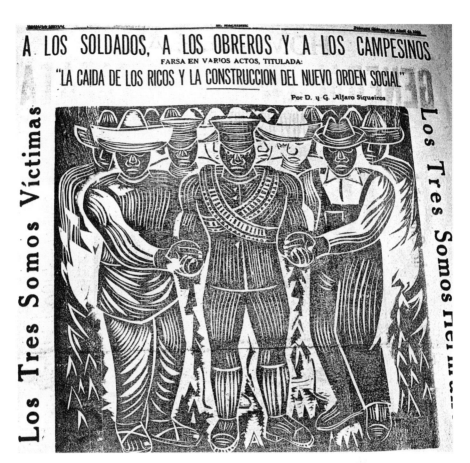

3.9. Davíd Alfaro Siqueiros, *We Three Are Victims; We Three Are Brothers*, *El Machete*, April 15, 1924. © Artists Rights Society (ARS), New York/SOMAAP, Mexico City. Courtesy of CEMOS, Mexico City. Author's photograph.

the dense prose of most of the paper's articles and introduces an element of satire completely absent from the woodcuts of Siqueiros and Guerrero. As the "shameless ones" are warned that the masses are organized and won't put up with them for long, the repentant politician explains how, together with foreigners, he had exploited the people for four hundred years. The contrite "Judas" worker confesses how he used to struggle against the exploiter, humiliating the "scab," but then "one day ambition spoke to me from America . . . and thus from a good worker I turned into a usurer, a villain and a monopolist." In the utopian second half, the former victims come into their own as brothers after judging and punishing their former exploiters.[71]

Just as the earlier satiric penny press for workers rarely showed

workers divided, neither did they show workers and campesinos united other than in their parallel roles as victims of abuse. Charlot notes the close relationship between the mural movement and the *El Machete* illustrations—in Siqueiros's case, the heroic types he had earlier painted in his first, modest mural in the National Preparatory. In addition, this trinity of soldier-worker-campesino, while obvious from communist ideology and frequently mentioned in the paper's editorials and articles, draws visually from the worker-campesino *abrazo* painted by Rivera in 1923 in the Patio of Work at the SEP.[72]

Crucified victims, haloed workers and campesinos, Judases, and organized trinities were familiar and accessible religious symbols for any Mexican audience in 1924, and devotional literature had constituted an important market for a sector of the penny press. But unlike the apparition of Christ on behalf of the poor in the 1922 pamphlet collaboration by Rivera and Lombardo Toledano mentioned above, the religious symbolism in these images has been secularized and applied directly to class struggle. The crucified worker—dating back to Posada—and the heroic or diabolical trinity became common rhetorical devices in prints and murals from 1923 onward.

The heroic trinity also raises questions about the artists' vision of who would lead the unification of campesinos and workers. The visual center of the trinity is a soldier, who might be seen—certainly in a mural in a public building—as part of a centralized leadership emanating from Mexico City, or even the government, led at this time largely by middle-class generals like Obregón and Calles. Yet *El Machete* often invoked the "soldiers of the people" and "armed campesinos and workers," and it repeatedly criticized the government for disarming the campesinos and workers mobilized corporately against the recent de la Huerta rebellion. The three figures represent a vanguard leading the masses against capitalism and against corrupt or reformist political and union leaders. An editorial note at the end of the play offers readers belonging to worker organizations a "communist actor" to help them study and perform it, a reminder of artists' perceived vanguard role in artistic and political performance.

A print by Guerrero, published soon after the July attacks on the National Preparatory School murals, represents a revealing variation of this trinity (fig. 3.10): at the center is an artist painting a mural of a huge Soviet star enclosing a hammer and sickle. With a bat representing "*Reaccionarismo*" hovering above, the painter is flanked and protected on one side by an armed campesino with his sickle, and on the other by an armed worker. While denouncing reactionaries for at-

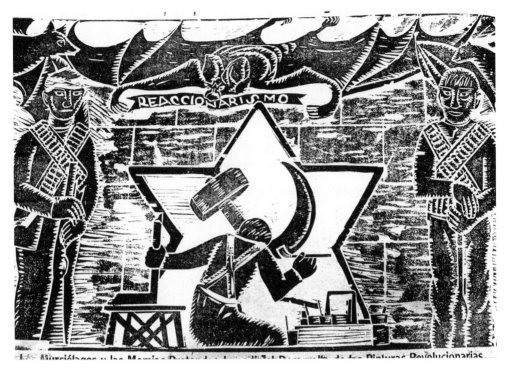

3.10. Xavier Guerrero, *Bats and Mummies*, *El Machete*, July 31, 1924. Author's photograph.

tacking the SEP murals, the print embodies how the artists saw themselves, their art, and their newspaper at the center of the proletariat vanguard.[73] The woodcut is the first of two illustrating the play *Judgment of the Intellectual Enemies of the People* (fig. 3.7). Together they draw an explicit connection between the painters and skilled workers who together lead the working class. Of course in the 1920s, artists' leadership of the working class was largely imagined, and workers and peasants had hardly rallied to defend the National Preparatory School murals.

The mutual influence between the graphic images of the first months of *El Machete* and the concurrent cycle of murals painted by Rivera at the SEP are fairly obvious, with influence moving in both directions and Guerrero playing a central role as both intermediary and as an artist in his own right. The Syndicate and their newspaper consistently sought to defend muralism as art and employment.

The ties between muralism and graphic art are equally strong in the eventual collaboration of Orozco with *El Machete*, begun at the same time that Rivera left the journal and the Syndicate. The precipi-

tating event was the June 1924 attack on the uncompleted murals of Orozco and Siqueiros at the National Preparatory School by a group of students tied to artistic and political conservatives from the National University, though perhaps with some involvement by the CROM. The attack helped push president Obregón to accept the resignation of the weakened Secretary Vasconcelos and led to a suspension of all mural production except that directed by Rivera in the SEP. In late July, Orozco was also fired from his position as drawing instructor at the Preparatory School of Bellas Artes on direct orders from Obregón.[74] The Syndicate responded to the attacks and firings with another manifesto, printed as a free broadsheet. In a cautious political appeal, they accused the bourgeois press and reactionary officials of manipulating students and threatened to intensify their use of satire as a social weapon: "We will change the walls of public buildings for the columns of this revolutionary periodical." Although Rivera signed the manifesto, his individual statements to the press were tempered by his desire to continue his murals in the SEP. A month later, *El Machete* announced that Rivera had resigned from the artists' Syndicate, and his name disappeared from the paper's executive committee.[75]

Orozco, with no walls to paint, took up the proposition of *El Machete* and literally moved the style and subject of his murals on public walls to its pages. His frequent contributions were remarkable as much for their continuity with his previous murals at the National Preparatory School as for their quality. In the process, he introduced an element of sharp satire sorely missing from previous graphic images, one that fully drew from Posada's legacy.

Beginning August 1924, Orozco began a productive collaboration with *El Machete* that would continue into the first months of 1925 and include at least twenty graphic images, many of them reprinted in subsequent editions. Siqueiros recalls Orozco's punctual and regular graphic contributions, but his participation differed from the total commitment of Guerrero and Siqueiros in the same period, as befitted his character, work style, and ultimate suspicion of organized ideologies and politics. Unlike most of his previous political drawings and many of the other artists in *El Machete*, Orozco did not sign his contributions.[76]

In many ways, the method of Orozco's graphic art in *El Machete* differs little from that of his long line of caricatures going back to 1906. Dismissive of the search for the folkloric and primitive among his fellow artists, he stuck with pen-and-ink drawings, which allowed him a much greater density of detail, action, and ideas than the first

crude woodblock prints created by Siqueiros and Guerrero. Only one of Orozco's images depends on a play, or *corrido*. The rest are largely self-contained and sometimes contradict the upbeat visions of worker militancy in the accompanying articles. Unlike the Siqueiros prints, which together with their accompanying *corridos* filled a full page, all but one of Orozco's drawings are produced on a small scale. Despite forgoing engravings, the style and subjects of Orozco's earlier caricatures for political journals like *El Ahuizote* in 1911, and *Vanguardia* and *Acción Mundial* in 1914 and 1915, suggest a far more direct influence from the satiric penny press for workers and Posada himself than any other artist of the Syndicate could claim.

Like most of his earlier caricatures, his subjects are highly political and very contemporary. But the particular historical moment and the goals and ideologies of the Syndicate gave his caricatures a new subject matter and visual language, similar to those of his recent murals and resonant with the concerns of the newspaper. While his earlier newspaper caricatures make symbolic and occasionally specific references to the wealthy, the clergy, political elites, and el pueblo, in the pages of *El Machete* his class divisions are sharpened. Of Orozco's more than twenty drawings, fourteen feature workers, for the most part identified by their overalls and miscellaneous tools rather than any industrial setting or activity. In eleven of those fourteen, the essential role workers play is that of victim of their economic, political, and religious exploiters. While the bourgeoisie is almost always present, dressed in tuxedos and top hats and spilling money extracted from the working class, his accomplices vary. Occasionally he is Uncle Sam (Tío Sam), the church, or national politicians; in at least six drawings, he is the worker-traitor of official CROM unions, Catholic unions, or the "free workers" allied directly with their employers.

Typical is the drawing *Fratricide!* (fig. 3.11), which illustrates an article on sectarian divisions among textile workers in Atlixco. Reminiscent of his mural *Banquet of the Rich*, a capitalist smiles ecstatically as he presides over the division between organized workers, his hands full of money and his head haloed by peso signs. The "FREE" workers in the company union "STAB (WITH THE DAGGER OF THE RICH) THEIR CLASS BROTHERS AND THEREFORE THEIR OWN LIBERATORS" according to the caption.[77]

Orozco at least three times gives his "traitor" a specific identity: the CROM leader Luis Morones. In one (fig. 3.12), an enormous, tuxedoed Morones, his fingers aglow with his famous diamonds, embraces and kisses a worker. Across his belly is written "Judas Morones." Behind

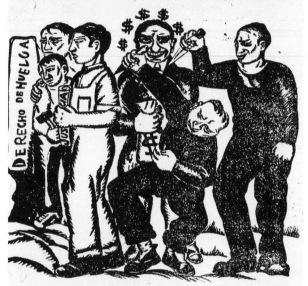

3.11. José Clemente Orozco, *Fratricide*, *El Machete*, September 4, 1924. © Artists Rights Society (ARS), New York/SOMAAP, Mexico City. Author's photograph.

is a row of capitalists in top hats, daggers in hand. The image of Judas Morones resonated with the readership of *El Machete*, or at least its editors, as it was reprinted several times in later editions and offered as a raffle prize.

In another, Calles's choice to head the Ministry of Industry, Commerce, and Labor is labeled as the "Minister Agent of Wall Street." The huge figure of Morones is draped in a royal (or clerical) gown, his chest exposed and his finger pointing to a gunshot wound from a heated exchange in Congress. A bishop's miter crowns his top hat, and he

carries a scroll mocking his recent appointment to the Calles cabinet: "Industry, Commerce and Strike Breaking." In a third, Morones and a syphilitic priest both wield whips above their heads, one holding a chain and the other a rosary attached to a groveling worker.[78]

Three drawings attributed to Orozco seem to adhere more closely to the party line in terms of ideology and the elaboration of an iconography of heroic workers capable of taking on their exploiters. For example, in one, two virile, heroic figures wage a titanic battle with clubs labeled "The Dictatorship of the Bourgeoisie" and "The Dic-

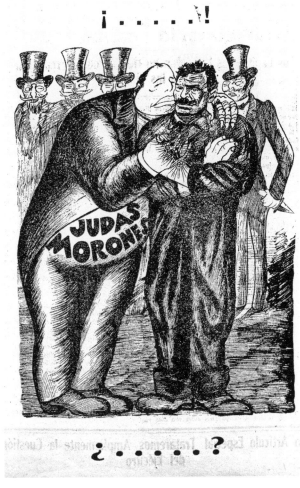

3.12. José Clemente Orozco, *Judas Morones*, September 25, 1924, page 2. © Artists Rights Society (ARS), New York/SOMAAP, Mexico City. Courtesy of CEMOS, Mexico City. Author's photograph.

tatorship of the Proletariat." These possible Orozco drawings conform to the party line more than one would expect of Orozco, who was known for his suspicion of all dogmas.[79] Orozco never joined the Communist Party. It is difficult to apply to any of these drawings what Orozco wrote in his autobiography to explain his anti-Maderista caricatures, that is, that they were about money rather than politics: "No artist has, or ever has had, political convictions of any sort." A dubious assertion for 1911, it is more so for a newspaper like *El Machete*, kept afloat by artists' contributions of their work and money.[80] In 1925, Orozco seems to have been as close as he ever would be to flirting with the symbols and worldview of a fledgling and still flexible Communist Party. An FBI report on Orozco's visit to the United States in the late 1920s may have been correct to label him a "fellow traveler" (i.e., a Communist) from 1924 to 1927.[81] Even so, these party-line images, if indeed they are by Orozco, are his least interesting and least typical contributions to *El Machete*.

In at least five other drawings, workers are tricked or exploited by priests. Orozco's visceral anticlericalism diverges from the typical concerns of *El Machete*, but it has deep roots in nineteenth-century liberalism, parallels that of Posada in the satiric penny press, and was further honed in the anticlericalism of Atl's *Vanguardia* during the Revolution. Catholic Unions were much weaker in 1924 than they had been in 1910 (except in Jalisco), and of course the Obregón and Calles governments and the CROM were bitter rivals with the Catholic Church for the allegiances of poor Mexicans, a conflict that would soon express itself in the Cristero Rebellion of armed Catholic campesinos from 1926 to 1929. By making symbolic allies of these rivals, Orozco shows his disgust with the hypocrisy of all, as they protected class and institutional interests in the name of helping the poor. The caption below the drawing of Morones and a priest wielding whips against a worker condemns the reformism of the first and the fanaticism of the second, making both "FALSE APOSTLES" and "PARTISANS OF THE EQUILIBRIUM OF INTERESTS," a dig at state, church, and CROM endorsements of class harmony.[82]

Orozco eschews the easy appeal of secularized Christian symbols incorporated in the concurrent images of Rivera, Siquieros, and Guerrero, or he gives them a satirical turn. Rather than saintly workers, his capitalists wear halos of dollars. In another drawing, *Christ According to the Rich and Clergy*, a pistol-toting Christ blesses not the land reform of Rivera's pamphlet but rather the rich man's exploitation of a "cursed Bolshevik" and starving campesino. In two drawings the victim-worker is presented as analogous to the crucified Christ,

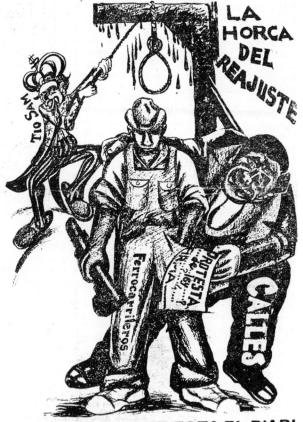

3.13. José Clemente Orozco, *Justicia Proletaria*, *El Machete*, May 18, 1925. © Artists Rights Society (ARS), New York/SOMAAP, Mexico City. Author's photograph.

a trope also used by Posada (fig. 1.6). In the first, the worker is spread-eagled with his hands nailed to the ground, straddled by the "bourgeoisie" and blessed by a "clerical leader" and a "scab leader." On the ground lies the hammer, as if used to drive the stakes crucifying the worker; separated on the other side is the sickle, unable to join the hammer or cut the ropes by which the worker has been enslaved.

The other (fig. 3.13) invokes austerity measures required by Mexico's

1924 Bucareli Accords with the United States, among them a February 1925 Calles decree that put all employees of the national railroad system under the jurisdiction of the Secretariat of Communications and Public Works. This federalization of railroad employees limited their right to strike and facilitated a reduction of employment that targeted workers affiliated with an independent labor confederation over the minority affiliated with the CROM. Orozco portrays Calles leading a railroad worker to be hung at the gallows, with Tío Sam pulling the noose from behind. "BEHIND THE CROSS IS THE DEVIL" reads the caption.[83]

For Orozco, the venality of the oppressors of the working class is also expressed in their monstrous and distorted physicality. But even exploited workers are often drawn grotesquely, like the ambushed worker in the National Preparatory School, in contrast to the ultimately virile and heroic workers in the prints of Siqueiros and Guerrero. With the exception of the party-line drawings mentioned above, Orozco's workers are portrayed as at best naïve and innocent, at worst brutish and dehumanized, and occasionally feminized by their oppression. They are literally seduced and prostituted by the cash offered by capitalists or by the lies and sensual embrace of Morones and the fanaticism of the church. Orozco's graphic images of workers differ from others in *El Machete* by suggesting little faith that workers might bring about their own redemption. Often it is left to the articles illustrating the Orozco drawings to salvage hope.

Orozco's drawings are also the most direct visual attacks on Presidents Obregón and Calles in *El Machete's* first year, and it was apparently such visual images that most provoked government officials. Guerrero recalls: "I was ousted from my employment at the Ministry of Agriculture for an Orozco drawing of President Obregón, with moon face and upturned snout, consorting with Uncle Sam and an archbishop." Another image, on the occasion of Calles's visit to Germany, shows an equally grotesque president-elect embracing "capitalism" and "yellow unionism."[84]

Orozco's graphic images in *El Machete* drew on his previous experience and method as a caricaturist, but the new content and experience helped transform his tone and style.[85] While Orozco provided considerable ammunition for the radical left, his limited sympathy for a working class he saw as perpetually complicit in its own exploitation may ultimately explain why his *El Machete* images of workers have rarely been reproduced after 1940 and are largely forgotten.[86]

More than the early murals, the graphic images of the artists of

the early *El Machete* helped to challenge the incipient official iconography of campesinos and workers in the Revolution. But they largely re-created dominant representations of gender. With the exception of Orozco, the artists of *El Machete* portrayed workers as powerful in their labor and eventually in their collective force. But the masculinity they associated with workers, and by extension with radical politics, largely excluded women and feminized advocates of alternative artistic projects.

Although the Syndicate included at least two women artists, and Graciela Amador played a major role in the newspaper as administrator and writer, women rarely appear in the images of the newspaper during its first year.[87] There are no female counterparts to the triumvirate of revolutionary campesinos, workers, soldiers, or artists of the Siqueiros and Guerrero prints. Unlike the earlier prints of Posada or the paintings of Saturnino Herrán, or even the publications of the CROM, there is a limited link between family and work or celebration of women as mother and homemaker. Instead, the women represented in the early *El Machete*, primarily by Orozco, are either prostitutes—symbols of the corruption and hypocrisy of the exploiters, or the ultimate victims, accompanying their exploited campesino or worker spouses.

Despite females' continued strong presence in the urban labor force after 1920, there is not a single image of women as workers in the early *El Machete*, a bias that coincides with the restrictive protections on women's work and the family-wage policies pushed by the government and the CROM.

If the artists of the Syndicate portrayed themselves in *El Machete* as akin to the heroic, virile workers, their bourgeois enemies were represented either as political and economic *chingones*, thugs with their daggers ready to betray, or as *maricones*, effeminate men of arts and letters. The collaborators of *El Machete* questioned the masculinity of intellectuals critical of muralism or of artists more concerned with aesthetic form than politics; the openly gay Salvador Novo is a "momia fresca" and the hostile intellectuals of the National University are "fifís" and "clerical pederasts."

On this front, Orozco was in complete harmony with his colleagues. His first contribution to *El Machete* (fig. 3.14), unusually large and prominent on the front page, is the drawing *The Fascist Babes*, which depicts a group of artists associated with Jaime Torres Bodet and Salvador Novo, soon to form the Contemporaneos group, on their return from welcoming a cultural delegation sent from fascist Italy.

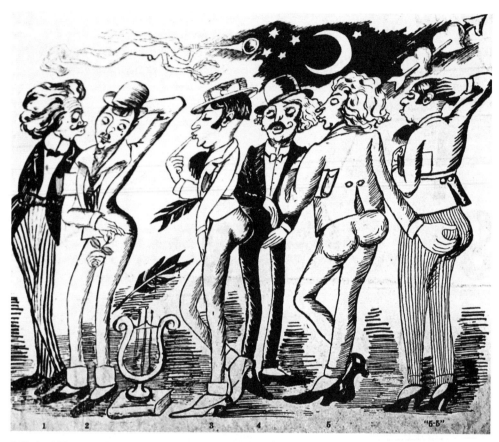

3.14. José Clemente Orozco, *The Fascist Babes*, *El Machete*, September 28, 1924. © Artists Rights Society (ARS), New York/SOMAAP, Mexico City. Author's photograph.

Orozco's drawing and the accompanying poem, in which the "erudite lads" swoon and fondly reminisce about their visit with the "fascist" Italian artists, derive directly from Posada's 1901 depictions of *The 41 Faggots*. Orozco's six "fascist babes" are not wearing dresses, but they are shown with high heels, flowing locks, ridiculous mustaches, and flowers or quill pens in hand. Just short of dancing, they prance as couples, with angled hands and elbows. And in case their poses don't reveal their homosexuality, one dandy caresses the voluptuous buttocks of another. *El Machete* helped sanctify the problematic association of hypermasculinity with revolution and femininity and homosexuality with "nonrevolutionary" or "counterrevolutionary" art and politics.[88]

By early 1925, editorials warned of the financial straits of the news-

paper ("Will *El Machete* die?" asks a February 19 headline), and in mid-March, after a fairly continuous run of one year, publication was interrupted for six weeks. The financial problems of the newspaper were eventually solved, or at least attenuated, by the Communist Party and a direct subsidy from the newly arrived Soviet ambassador in Mexico.[89] When it reappeared on May 1, 1925, it declared itself the official organ of the Communist Party. By 1927, Rivera, Orozco, Siqueiros, and Guerrero had all left *El Machete* for other places or projects: Rivera for multiple public mural commissions; Siqueiros to Jalisco to organize miners; Orozco to New York; and Guerrero to the Soviet Union. Despite the participation of a younger generation of printmakers, including Máximo Pacheco and Leopoldo Méndez, the size and originality of the graphics were diminished, ceding pride of place to photographs, including Tina Modotti's iconic images of workers and campesinos (discussed in chapter 4). Its pattern of denunciation of the official union movement and the failures of the government continued and intensified.

Within a period of one year the artists of the Syndicate, in dialog with muralism and Estridentismo, had created symbols and a narrative of the worker—male and mestizo—victimized by capital and corrupt politicians and labor leaders yet powerful in his labor and solidarity with other workers. Open to the leadership and enlightenment of communist "intellectual workers," this worker was pictured as ready to play his role in transforming the Mexican Revolution into a proletarian one. Artists borrowed from the penny press and the European avant-garde to become worthy heirs of Posada. And if their representations of masculinity are devoid of the allegory of national identity and the sensuality with which Saturnino Herrán imbued workers' bodies, *Revista CROM* would soon provide an alternative vision.

2. Saturnino Herrán, *Allegory of Work*, 1911. Reproduction authorized by the Instituto Nacional de Bellas Artes y Literatura. Courtesy of the Fundación Cultural Saturnino Herrán A.C. Photograph by Rafael Doniz.

1. Saturnino Herrán, *Allegory of Construction*, 1911. Reproduction authorized by the Instituto Nacional de Bellas Artes y Literatura. Courtesy of the Fundación Cultural Saturnino Herrán A.C. Photograph by Rafael Doniz.

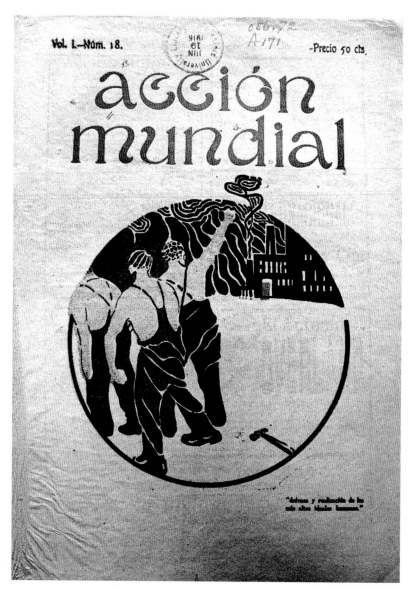

3. Uncredited cover, possibly by Gerardo Murillo (Dr. Atl), *Acción Mundial*, June 3, 1916. Author's photograph.

P E R I O D I C O Q U I N C E N A L

Núm. 3 | Responsable: XAVIER GUERRERO | México, D. F., Primera Quincena de Abril, 1924 | Registrado como artículo de 2a. clase el 13 de marzo de 1924. | Redacción: Uruguay 160 APARTADO 2703

El Machete sirve para cortar la caña, para abrir las veredas en los bosques umbríos, decapitar culebras, tronchar toda cizaña y humillar la soberbia de los ricos impíos.

SUMARIO.---La inercia del Gobierno da pie a un nuevo golpe reaccionario, por Diego Rivera.--Editoriales.-Con el robo se forman los Latifundios, por Antonio Hidalgo.--Los grandes diarios de los ricos, "Excelsior" y "El Universal", por Domingo A. Sierra.--Los crímenes de los vendidos en Veracruz.--Homenaje al Gral. Emiliano Zapata, Grabado en madera, por Xavier Guerrero, "Corrido" por D. y G. A. S. y X. G.--Continuación de la forma "La caída de los ricos" y la construcción del nuevo orden social, por D. y G. Alvaro Siqueiros.--El Agrarismo en peligro, por Bertram D. Wolfe.--El Fascismo Italiano, por Spinelli Aldo.--El terror blanco en Guatemala, protesta del Partido Comunista.--Machetazos, por G. L.--Varias notas importantes.

La Inercia del Gobierno da pie a un Nuevo Golpe Reaccionario

CUESTION DE VIDA O MUERTE

Por Diego Rivera

ASI, DESARMADO, DE RODILLAS, AZOTADO E IMPLORANDO CARIDAD, ES COMO LOS HACENDADOS, LOS INDUSTRIALES, LOS PETROLEROS Y TODOS LOS RICOS DE MEXICO EN GENERAL, QUISIERAN VER PARA SIEMPRE A LOS TRABAJADORES Y PARA LO CUAL INTRIGAN DE DIA Y DE NOCHE AYUDADOS POR LOS MALOS MILITARES Y FUNCIONARIOS PUBLICOS, QUE, TRAICIONANDO SU PROCEDENCIA REVOLUCIONARIA, QUIEREN DESARMAR A LOS CAMPESINOS QUE DIERON EL TRIUNFO AL GOBIERNO Y APOYANDO A LOS ESQUIROLES, DESTRUIR LAS ORGANIZACIONES OBRERAS. EL PUEBLO DEBE ESTAR ALERTA, Y URGE QUE LOS BUENOS FUNCIONARIOS PUBLICOS ESTEN ENTERADOS.

En el próximo número trataremos de una manera amplia el Conflicto de los Obreros del Petróleo en Tampico - -

El Ayuntamiento Emplea el Dinero de los Pobres en Embellecer las Colonias de los Ricos

EL AYUNTAMIENTO NO DEBE EN ESTOS MOMENTOS EMPLEAR NI LA MAS MINIMA CANTIDAD DE DINERO DEL PUEBLO EN EMBELLECIMIENTOS SUPERFLUOS DE LAS COLONIAS DE LOS RICOS, QUE LO ESTAN LO SUFICIENTEMENTE CONFORTABLES E HIGIENIZADAS Y BORDEADAS DE ARBOLES, CON BUENOS DRENAJES Y MAGNIFICO ALUMBRADO. EL DEBER DEL AYUNTAMIENTO ES MEJORAR EL ESTADO DESASTROSO DE LAS COLONIAS DE LOS POBRES, QUE A DIEZ CALLES DE LA PLAZA DE ARMAS ESTAN SIN PAVIMENTACION Y EN LAS MAS PELIGROSAS CONDICIONES HIGIENICAS CON ESA ETERNA MANIA DE NUESTROS HOMBRES PUBLICOS DE "EL QUE DIRAN LOS EXTRANJEROS", ESTE AYUNTAMIENTO, COMO TODOS LOS ANTERIORES, ESTA BLANQUEANDO LA FACHADA DE UNA CASA QUE POR DENTRO ES UN MULADAR.

4. *El Machete*, April 15, 1924. Courtesy of the Jean Charlot Collection, University of Hawaii at Manoa Library.

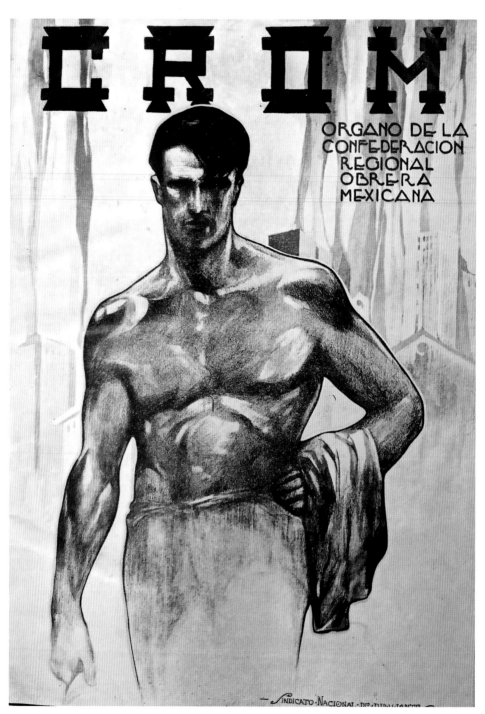

5. Sindicato Nacional de Dibujantes, cover, *Revista CROM*, September 1, 1925. Centro de Estudios Lombardo Toledano, Mexico City.

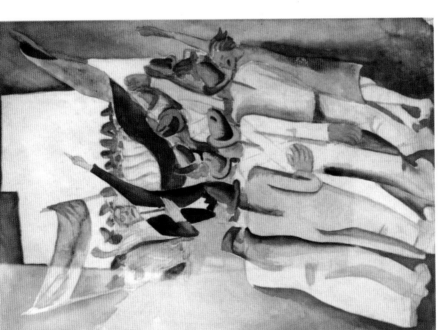

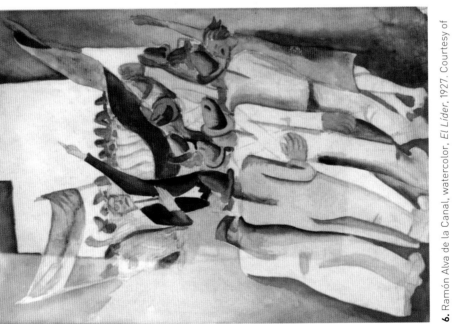

7. Ramón Alva de la Canal, *Capitalism, the Clergy, and the Union Leader Against the Worker,* 1927. Courtesy of Jorge Ramón Alva de la Canal. Author's photograph.

6. Ramón Alva de la Canal, watercolor, *El Líder,* 1927. Courtesy of Jorge Ramón Alva de la Canal. Author's photograph.

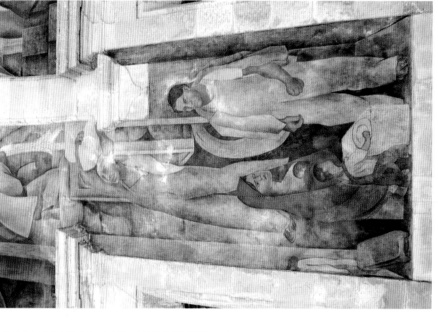

9. Pablo O'Higgins, fragment, *The Workers's Struggle Against Monopolies*, 1934, Mercado Abelardo Rodríguez. Courtesy of Fundación Cultural María y Pablo O'Higgins. Author's photograph.

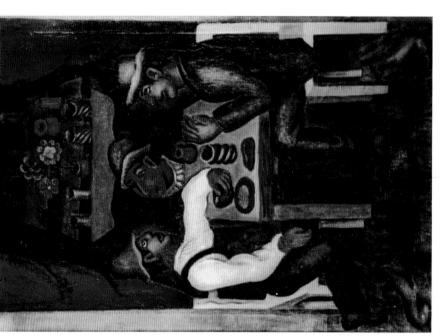

8. Pablo O'Higgins, oil on canvas, *In the Cantina*, 1927. Courtesy of Fundación Cultural María y Pablo O'Higgins.

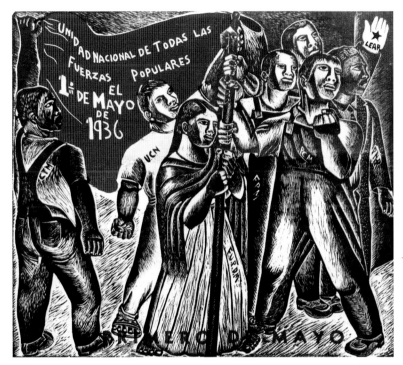

10. LEAR, *Unidad Nacional*, in *El Machete*, May 1, 1936. Author's photograph.

11. Davíd Alfaro Siqueiros, Josep Renau, and others, *Portrait of the Bourgeoisie*, 1939–1940. Courtesy of the Sindicato Mexicano de Electricistas. Photograph by Bob Schalkwijk.

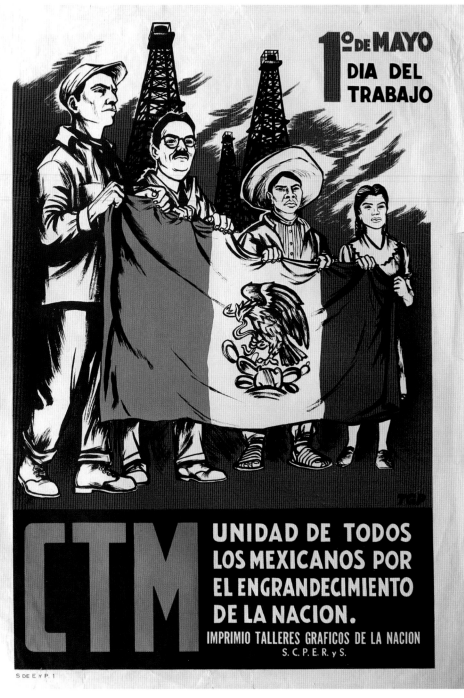

12. Alberto Beltrán and Arturo García Bustos, *Unity of All Mexicans for the Aggrandizement of the Nation*, 1947. Courtesy of Michael T. Ricker.

CONSUMING LABOR

REVISTA CROM, ART EDUCATION, AND LA LECTURA PREFERIDA

The Regional Confederation of Mexican Workers, the official and dominant labor federation of the 1920s, published its first issue of *Revista CROM* (an "Illustrated and Literary Journal for Workers") in February 1925. Featured on the multicolor cover is an Indian princess (fig. 4.1), sitting pensively with a paintbrush in hand on an Art Deco–style throne, her head haloed by an Aztec calendar. The lead page announced the magazine's purpose: to "raise the intellectual culture of the masses, procuring to unite the useful with the entertaining, [to create] harmony between the two important factors of human progress, which are called CAPITAL AND LABOR."[1]

One can imagine *Revista CROM* as a response to *El Machete*, begun eleven months earlier, just as the SOTPE artists' break with the CROM had been a step in the formation of their own organization and newspaper. But *Revista CROM* was probably not a deliberate rejoinder. After all, the CROM was at the peak of its power and influence, while the Communist Party had direct connections to only a very small group of organized workers. And the murals and prints of Syndicate artists, touted by many as Mexico's most important artistic movement, were undoubtedly less familiar to the man and woman on the street than the billboards and illustrated ads of the metropolitan press, done by commercial artists immersed in the values of nationalism and middle-class consumerism.

Any dialog between these two journals is mostly indirect or academic. A central task of this chapter is to highlight the dramatically different ideologies and aesthetics by which workers were represented in each. In addition, it looks beyond these contrasting poles to four projects after 1925 that expanded the representation of the worker, part of a paradoxical proletarianization of political culture under the increasingly conservative presidency of Plutarco Elías Calles (1924–1928). Three of these projects were attempts by artists and the state to bridge the gap between art *of* the people and art *by* the people: the Centros Populares de Pintura, where middle-class artists taught

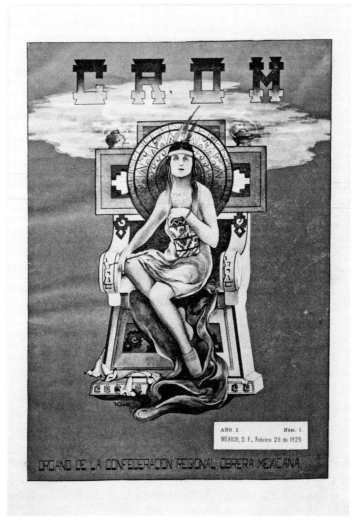

4.1. W. Soto, cover, *Revista CROM*, June 15, 1924. Centro de Estudios Lombardo Toledano, Mexico City.

workers and their children; the Academy of San Carlos, where director Diego Rivera briefly sought to turn middle-class students of art into "qualified workers"; and the Veracruz journal *Horizonte,* sponsored by the radical governor Heriberto Jara and illustrated by Estridentista artists Ramón Alva de la Canal and Leopoldo Méndez, among others. Finally, I consider Italian-born Tina Modotti's efforts to elevate photographs first to art and then to an artful medium of political activism, most notably in the pages of *El Machete.*

With the inauguration of President Calles in late 1924, the CROM celebrated its participation in what it declared to be a "laborist state." Calles appointed Morones to his cabinet as head of the Secretariat of Industry, Commerce, and Labor, and through much of the next four years Morones could plausibly aspire to replace Calles as the next president. "Mexican politics," announced Calles, "should be understood as the realization of the social reforms that the workers of Mexico long for."[2] The support of the CROM and its affiliated Labor Party provided Calles a counterbalance to his predecessor Obregón's reliance on organized peasants and generals. The prominence of Morones in the Calles cabinet increased state leverage in provincial labor disputes beyond the federal government's formal jurisdiction in the Federal District. Finally, the CROM fully endorsed Calles's initiatives to attract foreign investment while protecting national industry. CROM-affiliated workers would "patriotically cooperate" with capitalists who, through their investments, would create new jobs. In return and in collaboration with the CROM, the state would assure many CROM members a degree of leverage with employers and improvements in salaries and work conditions.

The appeal of such policies and goals to workers was real. The share of the economically active population engaged in manufacturing, extractive industries, construction, and electrical power grew steadily in the 1920s from 11.5 percent in 1921 to 14.4 percent in 1930, increasing jobs in the sectors most likely to be organized; meanwhile, the official numbers of workers affiliated with the CROM—inflated by hyperbole and campesino organizations—grew from 1.5 million in 1925 to a peak of 2 million in 1928. In the confederation's most important sector, textile workers' wages rose 34 percent from 1925 to 1929.[3]

Of course, patriotic cooperation, according to CROM leadership, meant forgoing strikes. In February 1925, CROM's leadership furthered its centralized control by announcing that affiliated unions could strike only with the permission of the CROM's central committee; workers' problems were to be resolved through intervention of the CROM and the government-mandated arbitration boards. As their journal explained, the program of the Mexican-organized working class included "two grand goals: class struggle and economic nationalism." But the CROM "has resolved, without neglecting the first, to deliver itself fully to the intense labor in favor of the second, whose urgency is vital for all Mexicans."[4] National strikes dropped dramatically from 1925 until 1928;

within CROM-affiliated unions, they almost disappeared by 1928. The exceptions were the tumultuous strikes of independent oil, tramway, and railway workers who asserted themselves in those years as much against CROM encroachments as against their bosses.[5]

Mexico's most powerful and wealthiest labor organization chose an auspicious moment to launch its periodical; not surprisingly, no labor publication had ever been as ambitious in terms of its scale and production values. As noted, the tradition of labor periodicals dates back to mid-nineteenth-century mutual aid societies. But these publications were usually short-lived due to financial straits, political turmoil, and government censorship. And with the important exception of the satirical penny press for workers, the written word took precedence over the image, whether conceived as art, illustration, or satire. Even in the relatively stable environment of the 1920s, few unions or federations could sustain a periodical, and even fewer could illustrate it. By contrast, the *Revista CROM* was well funded and had the extensive organization and government patronage of the CROM behind it. As a result, the biweekly was unveiled full-blown, with multicolor covers and eighty pages of articles, art, and ads.

In contrast to the artisanal and semioppositional organization of *El Machete, Revista CROM* benefited from support at the highest levels. On its editorial board were key CROM intellectuals, including Vicente Lombardo Toledano. Fundamental was the participation of Eduardo Moneda, one of the founding members of the Confederation of Printers and the Casa del Obrero Mundial during the Revolution. Moneda rose up in the CROM ranks and in 1925 served as both CROM secretary general and director of the government's Talleres Gráficos de la Nación, founded in 1919. Moneda took over as editor in 1926, with the support of the government printing offices and the powerful CROM-affiliated Federation of Graphic Arts, which on numerous occasions in the 1920s censored and shut down the metropolitan press over criticism of the CROM or its leaders.[6]

Revista CROM was touted as a journal "edited by genuine workers enthusiastically devoted to the graphic arts."[7] It far exceeded *El Machete* in size, and it cost considerably more, from fifty to twenty centavos. As much as 50 percent of the copy of *Revista CROM* was taken up by paid ads, which generated revenue beyond the resources of the CROM and the government print shop. No reference is made in the magazine to circulation numbers, but in addition to the forty outlets that sold the magazine around Mexico City, it was probably distributed widely among affiliated unions.[8]

The ideology and purpose of *Revista CROM* are clear in the opening page of its inaugural issue. If other entities in society have their publications, the editorial proudly explains, so, too, "worker organizations" need a publication to be the "public voice of their ideals and defender of their rights." This would be a publication "that shortens the material and moral distances that separate working class elements in various corners of the republic, that unites the wage earners of all the world." Notable is the attenuation of the radical language of class that had even been evident in many sectors of Porfirian mutualism as well as the original statutes of the CROM: instead of a united working class, the constituency is "working-class elements," and Marx's slogan has become "wage earners" of the world unite.[9]

The editorial invokes a fundamental goal of mutualism and anarchism that remained a part of postrevolutionary unionism, the enlightenment of its membership through articles that deal with useful knowledge. Regular sections such as "Small Industry" and "Mechanics and Electricity" offered workers practical advice and opportunities for self-improvement. In addition, entertainment sections on sports, literature, bullfighting, theater, and attractive "Stars and Starlets" promoted patterns of leisure that borrowed from middle-class illustrated journals.

The relatively few articles dedicated to union affairs concentrate on speeches by CROM leaders, conventions, and new public rituals such as May Day that had become largely orchestrated by the CROM. Coverage of strikes is limited; a rare editorial that addresses the streetcar workers' strike of 1925 begins by reluctantly noting, "We would not have wished to treat in this section any point relative to conflicts between Capital and Labor," given our goals "to establish a kingdom of harmony between those two forces, based on absolute equality." Instead, tripartite arbitration boards, often controlled by the CROM, were celebrated as the primary channel for workers' grievances.

When strikes became inevitable, the blame was as often placed on rival federations or amoral workers as on "stubborn" bosses. The anarchist CGT was denounced for its "absurd radicalism, absent the force in numbers to sustain its ideals," while communist workers were the product of "bolshevism as an imperialist tendency."[10] The language of betrayal echoes *El Machete*: for example, two electricians who initiated a wildcat strike were ultimately expelled from a factory and the CROM as "unworthy and amoral beings who sought to satisfy their bastard passion and were capable of committing the vilest betrayals, converting themselves in Judases." When violence broke out between

Calles and the Catholic Church, the clergy became "the eternal traitors of the fatherland."[11]

Revista CROM served as a vehicle for labor caudillos, or as critics called it, *liderismo*. Among frequent images of the "worker president" was a photograph of Calles in overalls, as well as a painted portrait of Calles dressed in the elegant jacket of a magnate-president, standing in front of a vast industrial complex. No image or article criticized Calles during his term, though former president Obregón, increasingly at odds with Morones and the CROM on his march toward re-election, was occasionally criticized. Similarly, speeches and public appearances by CROM leaders were featured. A periodic column called "The Triumph of a Worker" presented short bios of the Grupo Acción leadership. In one, Morones was celebrated for his rise from modest working-class origins—the son of factory workers—to middle-class modalities and dress, modeling the message of social mobility pervasive throughout the magazine. His infamous diamond rings were explained as bought with an inheritance from his parents, half given to the "movement" and half spent on jewelry. More instrumentally, the journal celebrated his rise from a simple electrical worker to become "the father of the national labor movement" and a statesman with presidential ambitions.[12]

The form, ideology, and strategies of the magazine's "illustrations" are revealing. Its model was the thick and glossy *revistas ilustradas* of the early post-Revolution, such as *El Universal Ilustrado* (1917–1941). This new genre was made possible by the proliferation of new printing technology, but it was also a product of the larger consumer markets made possible by metropolitan development and the cosmopolitan aspirations of elites and the middle class.[13] *Revista CROM* urged readers to subscribe to "our artistic magazine in which you will find carefully chosen material and color supplements with the best artists," and it proudly reported the praise of the dominant daily for its drawings and graphic layout. In fact, *Revista CROM* shared artists, styles, ads, and ideology with the mainstream press, adding a layer of *obrerismo* that distinguished its audience and reclaimed the importance of workers in building the nation.[14]

Notable is the rejection of almost any reference to or images by the artists associated with the muralist movement, and certainly not any by Rivera or Orozco, once members of the CROM's Grupo de Solidaridad.[15] The one written exception is a reprint of a London article by Eileen Dwyer on "The Modernist Movement in Mexico," shorn of images, that may have been chosen for its mixed praise of Rivera

("neither the greatest nor the most important of the Mexican modernists") and Orozco, both guilty of a "disconsolate realism" and "obstinate radicalism." By contrast, Mexico's greatest painter was Roberto Montenegro, who was "more perceptive [as] his figures are less crude than those of his contemporaries in Mexico."[16] Like Dwyer, *Revista CROM* apparently rejected the artists' styles as much as their politics.

The artists and images reproduced in the magazine fell largely within the realm of modernist Art Nouveau and Art Deco styles and Orientalist themes. Art Nouveau, with its undulating organic motifs, and Art Deco, with its geometric shapes, emerged in Paris in the early twentieth century from commercial design and advertising. Both idealized the beauty of the human body and female beauty in particular, unlike Cubism and other avant-garde European movements of the 1910s and 1920s.[17]

Images of formal art were most prominent on the color cover, though the magazine included regular color art supplements. Featured artists included Andres Audiffred and Carlos Neve, both prolific contributors to the metropolitan press. Many were organized in the National Union of Commercial Artists (*dibujantes*), affiliated with the CROM and more directly with the powerful Federation of Graphic Arts. The prestigious commercial artist Ernesto García Cabral was its secretary general in 1925. Unlike the artists Syndicate, this union used its leverage with the CROM to negotiate compensation with the metropolitan press. Several covers of *Revista CROM* are attributed collectively to the union. Most of these commercial artists were not inclined to radical politics, and the magazine lacks self-referential images of artists, much less those of worker-artists.[18]

The artist most favored and reproduced was Roberto Montenegro, once Rivera's peer and rival, whose politics remained moderate and whose art, after his return from fifteen years in Europe in 1920, combined folkloric nationalism with a cosmopolitan European style inherited in part from prerevolutionary modernists Julio Ruelas and Herrán. Critics at the time praised how Montenegro showed young painters "how to dress the indigenous spirit in European clothing."[19] His sinuous and seductive indigenous and oriental women were repeatedly featured in the magazine's art supplements and influenced the journal's other images.[20]

Typical of his influence was W. Soto's already mentioned cover for the first issue (fig. 4.1) depicting a light-skinned Indian princess on a throne. The image had a long lineage—Europeanized Aztec royalty had been a common trope in late-nineteenth-century painting, re-

vived and made more realistic as symbols of national identity after 1910 in painting and magazine covers by such renowned artists as Herrán and García Cabral. In Soto's drawing, the intricate geometric shapes of the throne, the calendar, and the letters reveal the pervasive influence of Art Deco on commercial art in the 1920s and enhance the Orientalism inherent in this genre.

Multiple covers featured drawings or photographs related to Mexico's indigenous past or present. The intention was not necessarily to appeal to a readership of campesinos in CROM-affiliated organizations. Rather it was to embrace the now dominant themes of postrevolutionary national identity and display the sophisticated artistic tastes of the CROM leadership.

Although many *Revista CROM* covers could easily have been featured on any of the capital's mainstream illustrated journals, others featured workers and contributed to the visual representation of the worker. The cover of the third issue (fig. 4.2) featured a muscular, shirtless worker holding a flagpole with the red-and-black flag of labor militancy, capped by a ribbon with the colors of the Mexican flag. This was the "amalgam of the national flag with the red and black [flag]," of class consciousness and patriotism, that Morones had debuted in the May Day celebration the year before and that *El Machete* had so stridently condemned.[21]

A few weeks later, the May Day issue featured a drawing by Carlos Neve, one of the most successful commercial artists of the decade with a real talent for translating the ideas of working-class movements into images. In 1924, Neve was the principal graphic artist working on Plutarco Calles's presidential campaign.[22] He had beautifully illustrated what became a classic history of working-class mobilization through the Revolution, *Las Pugnas de la Gleba* (1923), by Rosendo Salazar and the journalist José Escobedo. *Las Pugnas* in many ways represents a culmination of the crossed paths of workers and artists in the previous decade, portraying the Casa del Obrero Mundial as the nation's fundamental working-class organization, emphasizing its anarchist roots, and presenting the 1916 general strike as the narrative climax of working-class militancy during the Revolution, all in a graphic style influenced by the European anarchist press.

In *Las Pugnas* Neve depicted the exploitation of the working class. In a drawing captioned "AND THERE WE HAVE THE PEOPLE" (fig. 4.3), a worker in overalls is crucified against a background of factories and phantoms, reminiscent of Posada's crucified *obrero*, though the style is inspired more by the tormented symbolism of Julio Ruelas and the

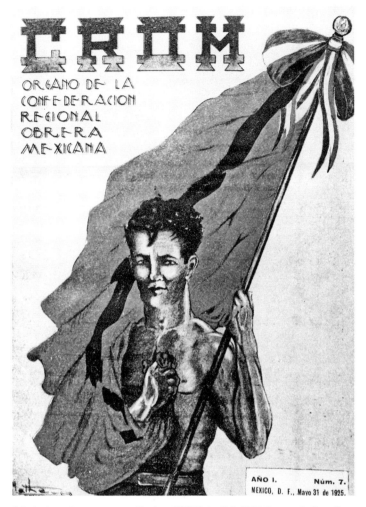

4.2. Artist unknown, cover, *Revista CROM*, April 8, 1925. Centro de Estudios Lombardo Toledano, Mexico City.

precise Art Nouveau work of Robert Montenegro. In another (fig. 4.4), Neve captures the general strike of 1916 with a dramatic image of an electrical worker cutting power to the city, using flexible, undulating lines similar to Dr. Atl's 1916 images in *Acción Mundial* (plate 3). When viewed retrospectively through the lens of *El Machete* and generations of artists inspired by Posada, Neve's drawings and the phenotype of his workers seem remarkably European. Shorn of their militancy, they provided an important model for illustrations in *Revista CROM*.

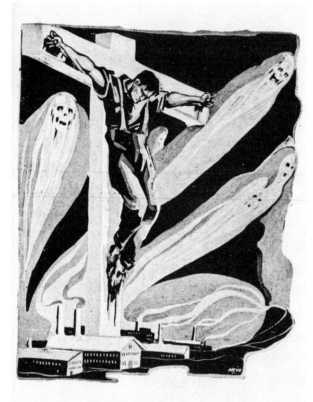

¡He ahí al Pueblo!

4.3. Carlos Neve, *And There We Have the People!*, from Rosendo Salazar and José G. Escobedo, *Las Pugnas de la Gleba*, 1923. Author's photograph.

4.4. Carlos Neve, *The Pulse of the Proletariat*, from Rosendo Salazar and José G. Escobedo, *Las Pugnas de la Gleba*, 1923. Author's photograph.

El pulso proletario no tiembla al suspender las actividades industriales de las urbes

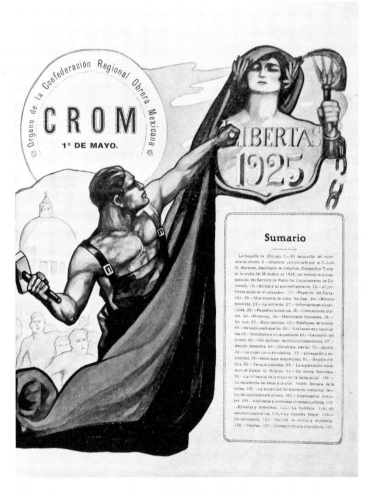

4.5. Carlos Neve, cover, *Revista CROM*, May 1925. Centro de Estudios Lombardo Toledano, Mexico City.

In his May Day cover for *Revista CROM* (fig. 4.5), Neve used a more rigorous and realist style to portray a muscular, dark-skinned worker in overalls, his right arm extended back, about to swing a hammer against the chisel in his left hand to strike the word "Libertas" on the bust of a woman. In the background, men rally behind his actions, while the dome, cupola, and mountain, flanked by the sunlike globe of the CROM, mark the scene as Mexican. In both this and the previous cover, workers are celebrated as essential and heroic actors in the construction of the nation, though their specific actions and their enemies remain unclear. Even so, with the black-and-red flag of

working-class militancy draped on the woman's head, and the indirect association between the man's hammer and the woman's sickle, Neve flirts with the symbols of labor radicalism.

A third cover suggests the range of meaning with which these images of workers are imbued. Like several similar covers, this otherwise anonymous drawing (plate 5) was identified as the product of the National Union of Commercial Artists. A light-skinned, well-built man walks away from a factory. Bare-chested and with his shirt draped over his arm, we assume that his workday is over; this is not a strike, unlike the workers leaving the factory in the 1916 cover of *Acción Mundial* (plate 3), and the casually draped shirt and lack of tools or machines suggests leisure rather than a work routine. The depiction of an industrial cityscape as the background is unusual in the art of the 1920s.[23] Also unusual for the visual universe of *Revista CROM* is the suggestion of actual work, though here the pending leisure is more palpable than the previous exertion. Without the industrial smokestacks in the background, one might imagine one of J. C. Leyendecker's *Saturday Evening Post* covers from the same period, or a Boston Brahmin walking away from a tennis match. In most *Revista CROM* art, tools and clothing serve to identify workers more than industrial settings, skin color, or features.

All three *Revista CROM* covers are reminiscent of Saturnino Herrán's 1911 diptych *The Allegory of Construction* and *The Allegory of Work* (plates 1 & 2). The visual language harkens back to the romantic and allegorical elements of nineteenth-century art in Europe and the United States that extolled preindustrial, artisanal notions of work. Such a profile uneasily fit the small unions of skilled and unskilled labor that constituted the bulk of the CROM's small affiliated unions, if not the proletarianized textile workers that made up its largest and most powerful constituency.[24] The covers extend Herrán's model of working-class masculinity, expressed with light-skinned mestizo features, Westernized dress, and a muscled, shirtless eroticism. The first two deliberately celebrate workers as part of the political transformation of the Mexican nation, though it is the individual worker featured, rather than a collectivity. The second two are similarly contained within a busy cityscape. As with Herrán, there is a complete absence of class conflict, but in none do we see Herrán's vision of work as a process of transformation of the physical world. All these workers, individualized but tamed by their beauty and symbolic functions, are in sharp contrast with the anonymous workers in *El Machete*, with their forceful but not sensual figures, their primitive

distortions, their sharp satire, and their unrelenting focus on exploitation by and collective confrontation with capital.

Revista CROM also featured simple cartoons as entertainment and politics, done by in-house artists or reprinted from the mainstream press. All are somewhat flat in style and humor, with limited recourse to satire. Most prolific are the simple line-drawings of W. Soto, the artist of the first cover. In one, a *peladito* (vagabond) in rags with a bottle in his hand asks a bystander whether Labor Day was coming soon. Why? "Because I am really excited to work, but can hang on until then." In another, one *peladito* asks another to identify an approaching fat man with cane and top hat. The answer: "a vagabond with money."[25] These cartoons are somewhat reminiscent of the "street talk" columns of the Porfirian penny press for workers[26] and offered a vague sense of class difference typical of Ernesto García Cabral's cartoons in mainstream newspapers. But in *Revista CROM*, the implication is slightly different: there are the idle *pelados* and the idle rich, and then there are the productive "working-class elements" organized in the CROM.

Other cartoons were more instrumental. A pair of Soto cartoons embodies the official self-image of the CROM as a partner with Calles in growing and leading the nation. In the first (fig. 4.6), a worker wields a watering can marked "CROM" to irrigate a "tree of the nation." Dangling from the limbs above his head is ripe fruit labeled "Work," "Respect," "Peace," "Order," and "Progress," reminiscent of nineteenth-century positivist slogans.

In the second (fig. 4.7), Calles, dressed in the same overalls as the worker, leans on the axe of "GENERAL ADJUSTMENT" to reflect on his work trimming the tree of the nation, pruned limbs at his feet. Each pruned limb refers to the austerity measures of the February 1925 decree that put all employees of the national railroad system under the jurisdiction of the Secretariat of Communications and Public Works, limiting their right to strike and laying off members of the independent unions.[27] The reform led to a series of strikes over the next two years, culminating in repression and the absorption of the independent unions into the CROM.[28] In Orozco's related *El Machete* caricature published a month later (fig. 3.13), the metaphor for the fiscal reform is a gallows on which the worker is hanged; here the metaphor is the trimming of "unjustified jobs."

One of the most striking visual aspects of *Revista CROM* is the abundance and nature of its advertisements. In the first issue, forty of eighty pages are devoted entirely to ads. Many are by the same art-

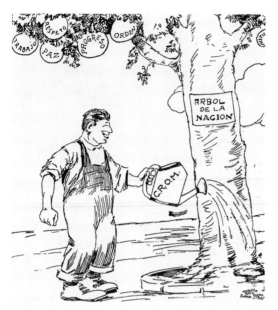

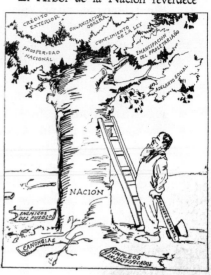

4.6. W. Soto, cartoon, *Revista CROM*, April 8, 1925. Centro de Estudios Lombardo Toledano, Mexico City.

4.7. W. Soto, cartoon, *Revista CROM*, April 8, 1925. Centro de Estudios Lombardo Toledano, Mexico City.

ists producing the covers of *Revista CROM,* as Art Nouveau and Art Deco styles extend from the covers to the ads. As Joanne Hershfield notes, Art Deco was "affixed to modern consumerism through the design and marketing of fashion, interior design, housewares and the flood of technological household appliances," and thus to the modern woman.[29] Most ads are published elsewhere in the middle-class press, though many are tweaked to appeal directly to male workers. The majority marketed light consumer goods and retail establishments. From the mainstream press there are ads designed by Antonio Gedovius for the French cosmetic company Bourjois for perfume and whitening face cream, featuring a couple elegantly dressed for a ball and including text in French. By contrast, Neve's ad for the Tardan hat company, which featured Stetson and other upscale hat styles, insisted that "all the comrades of the CROM use Sombreros TARDAN."[30] Ironically, there are no ads for workplace clothing. In the CROM imaginary, the overalls and the exposed muscular male torsos of the covers marked men in terms of their class and productive role in the nation, but their aspirations to consumption and citizenship required ads for the uniforms of the middle class.

It is too easy to assume a disconnect between a struggling working-

class readership and advertisements for imported French perfume and Stetsons pushed by advertisers and publishers. But *Revista CROM* ads and many articles initiated the readership into patterns of consumption and leisure. While most CROM affiliates were poor campesinos and unskilled workers, many of its core constituencies—in the textile factories of Puebla and Orizaba, the graphic arts workers of the metropolitan press, and government workers, the most likely readers of *Revista CROM*—earned salaries that allowed for at least aspirations of leisure, consumption, and middle-class respectability. Formal dress in public places remained a way for some workers to assert equality with their employers as *gente decente*.[31]

The leadership of the CROM modeled a high standard of middle-class fashion. Rosendo Salazar looked back disdainfully on the May Day celebrations of the 1920s as a carnival and a farce, with "the leaders of the CROM uniformed in splendid suits, perfumed, with flowers in their lapel, each one with a walking stick and a straw hat brilliant in the sun, cheeky and pedantic."[32] But any perusal of official pictures of working-class leaders in the early twentieth century reveals that the public uniform of union leaders and many "respectable" workers was the business suit. For many workers, the appeal of consumption goods and social mobility was as powerful as any dream of working-class solidarity or a leveling socialism.[33]

Over time a type of CROM consumer consciousness developed in the pages of the magazine, inflected more by nationalism than by class. At first the editors simply made a crude appeal for readers to buy from companies that advertised in the magazine. By 1927, in a variation of Fordism that reflected the push by Morones, as minister of industry, for protective tariffs, *Revista CROM* insisted that "to consume articles of national industry is to build the fatherland [*hacer patria*]." A related article includes as national industry the many commercial and manufacturing establishments owned and run by immigrants, who contributed capital and energy to national development ("while always subject to government control of their morals"). Only in 1928 does *Revista CROM* insist that members use their purchasing power to reinforce the power of their unions vis-à-vis industry, with a circular calling on members to pressure employers to label products "Made in Mexico by members of the CROM" and to consume products only with such labels.[34]

Abundant advertising reinforced the aesthetic styles of the art covers and an ideal of social mobility and middle-class patterns of consumption. But a handful of advertisements elaborate a distinct, indus-

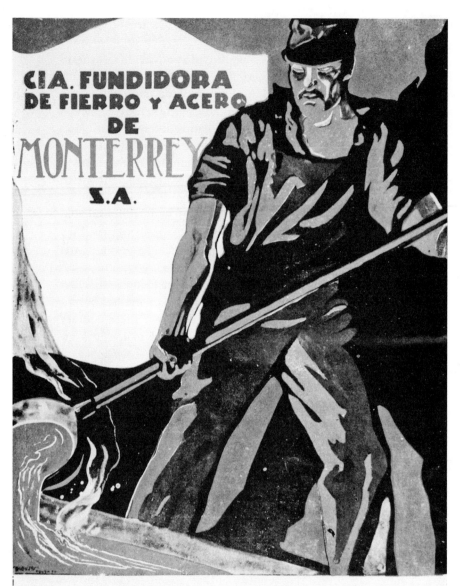

4.8. Mariano Martínez, advertisement, Fundidora de Monterrey, August 8, 1925, *Revista CROM*, back page. Centro de Estudios Lombardo Toledano, Mexico City.

trial aesthetic and unique image of workers' sociability. Most striking are the five different color advertisements by Mariano Martínez (known as "Sixto") for the Fundidora de Monterrey, which alternate on the back cover of every issue for the first year of publication.[35] This northern factory was Mexico's greatest example of heavy industry. One drawing shows a worker in overalls leaning against a hammer in front of a dense landscape of factory buildings with chimneys belching smoke. Others portray workers channeling streams of molten steel with hand paddles and cauldrons (fig. 4.8) or workers using cranes and trucks to move the final product, steel construction beams. Together they feature workers not only engaged in strenuous labor—an activity completely absent in the art images of the magazine—but also immersed in an industrial landscape and interacting with machines, a depiction, as noted, absent from *El Machete* and largely absent from formal art in Mexico in the 1920s.

More than Estridentismo, these ads suggest the machine aesthetics and productive themes of Soviet Constructivism and echo Rivera's atypical 1924 depiction of workers in a steel foundry in the Patio of Work (fig. 4.9) at the SEP. An important difference is that Rivera's foundry workers labor collectively and are anonymous, with their backs turned to the viewer, while the ad features a frontal view of an

individual worker. These same ads also appeared in the mainstream press, but they fit particularly well with CROM's ethos of industrial nationalism.[36]

Perhaps exclusive to *Revista CROM* are two advertisements for Moctezuma beer, a company based in the CROM and textile town of Orizaba. One shows a group of four workers emerging from a factory (fig. 4.10). As they shed their work clothes and don their Stetsons, they enthusiastically look at a glass and bottle of Moctezuma beer in the fore-

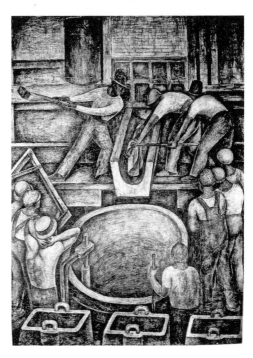

4.9. Diego Rivera, mural, *The Foundry*, 1924, Secretariat of Public Education, Mexico City. Author's photograph.

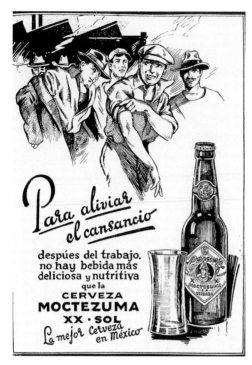

4.10. Montezuma beer advertisement, *Revista CROM*, May 1925. Centro de Estudios Lombardo Toledano, Mexico City.

4.11. Montezuma beer advertisement, *Revista CROM*, January 1926. Centro de Estudios Lombardo Toledano, Mexico City.

ground ("To alleviate your tiredness after work"). In another a large crowd—mostly workers in overalls with a few in suits—gathers around a huge bottle of beer outside a factory (fig. 4.11). Both ads reinforce a pattern of consumption aspirations similar to the ads and articles appearing in the rest of the magazine, but the industrial landscape and scenes of working-class sociability are unthinkable in the pages of *El Machete* and rare in the world of art.

As with the early *El Machete*, there is scarcely an image of women as workers in *Revista CROM*. On one hand, their lack of visual representation obscures the reality of women workers' significance in a variety of sectors, including many where CROM unions were strong, such as teachers, government office workers, and textile workers. For example, in 1921, 48 percent of the workforce in thread and textile production nationally were still women. On the other hand, their visual underrepresentation naturalized the process by which male union leaders used new labor laws designed to protect women to re-

duce their numbers in formal industrial labor and safeguard skilled jobs for men. Women's skilled labor and union leadership were ultimately seen by CROM leaders as threats. In Mexico City, women's participation in the industrial workforce dropped from one-third in 1920 to less than one-quarter by 1930. Even where women were a majority, their dominance rarely transferred into leadership positions within CROM unions, and the CROM's executive committee and department heads in the 1920s were positions invariably filled by men. By contrast, women defended their positions, protested their exclusion, and achieved greater leadership roles in the anarchist CGT for much of the 1920s.[37] Yet in contrast to the mainstream press, where the situation of women workers was constantly debated and photographs of workingwomen were common, the female worker was virtually invisible in the idealized world of *Revista CROM*.[38]

At the same time, the CROM forcefully promoted female domesticity and the celebration of motherhood as a counter to the threat women posed to male jobs in the workplace.[39] In a CROM article titled "The Influence of Women in the Social Struggle," Ofelia Meza laments that women's presence in unions "is almost nothing" but insists that any transformation of women's role should begin in the home, in their roles as mother and educator.[40] The counterpart of the CROM ideal of a wage for male workers sufficient to support a family was the celebration of women as homemakers and consumers. Unlike *El Machete*, where women are the ultimate victims or prostitutes of exploitative capitalists, there is a positive association in *Revista CROM* between male workers and family, as in many Posada prints and the paintings of Herrán. Virtually every issue includes articles written by women on their essential roles as mothers and homemakers and on fashion and beauty. In this sense, the articles mirror the advertisements, with both modeling a pattern of middle-class consumption in which women are the fundamental consumers.

The fact that women were an important audience for the magazine is suggested by one anonymous cover drawing, an elegant woman sitting on cushions and reading a copy of *Revista CROM* (fig. 4.25). In contrast to the many idealized images of Aztec princesses or traditional Tehuanas, this woman, as with those illustrating multiple covers and articles, has her hair closely bobbed. As recent scholarship has shown, bobbed hair in the 1920s was not simply a fashion but a politically loaded and divisive choice. Not only did traditional conservatives denounce the "*chica moderna*" with her bobbed hair, short skirts, and the athletic, androgynous ideal as morally loose, but many

progressive nationalists denounced these styles as foreign and countered with the consecration of the India Bonita as a national feminine ideal. We can see the negative connotations of flappers as foreign, as ridiculous, and even as prostitutes in the early caricatures of Orozco and the Patio of Fiestas murals of Rivera at the SEP.[41]

By contrast, *Revista CROM* fully embraces the flapper as part of the eroticization of women in entertainment features on Hollywood or those on the scantily clad stars associated with Morones's infamous parties. But just as often, the magazine featured women with modern styles who assume public roles beyond the home. One article instructed women on hairstyles, with nine of twelve photos featuring women with bobbed hair. And as if to put the debate over *"las pelonas"* to rest, an interview with Calles's daughter Ernestina describes her as a self-identified flapper and "the best symbol of the New progressive spirit" of Mexico. Of course, the flapper in these pages was almost invariably light-skinned and had European features. In this sense, the magazine shared many of the contradictions of official revolutionary discourse. It diminished women's role in the workplace while reinscribing their central role in the home; it embraced a modern, American-influenced flapper style that expanded women's public role in the postrevolutionary project and challenged the conservative, patriarchal social order, even as it idealized, with the help of artists, the India Bonita as the bedrock of tradition and female abnegation.[42]

WORKERS INTO ARTISTS AND ARTISTS INTO WORKERS

Could workers move from being the subjects of middle-class artists in murals, prints, and magazine drawings to wielding their own brushes and gouges? A variety of collaborations between artists and the government moved in this direction in the 1920s. By 1925 the Open Air Painting Schools, originally set up under the direction of the Academy of San Carlos to offer middle-class art students greater spontaneity and improvisation, were expanded (to seven total) with a new mission of turning campesino and indigenous children into artists. "The purer the indigenous bloodline, the more potent the art," Ramos Martínez declared.[43] Former middle-class students of these schools became the new art teachers, possibly in an attempt by the government to both distract these artists from the radical art that had developed out of earlier government-sponsored projects, and to compensate for the curtailment of mural commissions. Siqueiros denounced the SEP for

turning artists into bureaucrats in the schools instead of purchasing their work and offering them commissions for public art.[44]

In 1927, in the midst of the Calles administration's pragmatic push for industrial development and a curtailment of strikes, three urban counterparts to the Open Air Painting Schools were set up. Sculptor Guillermo Ruiz directed the Escuela de Escultura y Talla Directa in the former Convento de la Merced. And Gabriel Fernández Ledesma and Fernando Leal became directors of two separate Centros Populares de Pintura, the first in the central factory district of San Antonio Abad, and the second, named after Saturnino Herrán, in the industrial zone of Nonoalco, the site of railroad workshops on the outskirts of the city.

Because of its artisanal orientation, the pedagogy of the Escuela de Escultura—which taught metalwork, printing, and wood and stone sculpture—was more complex than its rural counterparts. But the two Centros Populares de Pintura were organized around a similar antiacademic pedagogy, had no prerequisites, and charged no fees. Most important, the students were primarily urban workers or their children rather than campesinos.[45] Painting, drawing, and printmaking were taught with a method that sought to stimulate the artistic sensibility of the children, helping them to discover the visual qualities of the urban environment itself.[46]

The Centros Populares provided a transition from the preindustrial vernacular of the Open Air Painting Schools to a more cosmopolitan, industrial aesthetic. The students created some of the earliest modern paintings and prints of the urban milieu—trains, smokestacks, and machines. Many images (fig. 4.12) are evocative of those of their teachers, former Estridentistas with urban and futurist perspectives, but cruder, replacing the sharp lines, contrasts, and abstracted images of Estridentista cities with rounded figures, grays, and pastels rooted in the immediate surroundings.

Fernando Leal, director of the school at Nanoalco, declared that "the works of my students are always distinguished by the unsuspected refinements of color and form that arise from the very life of the barrio. They have become the painters of the city, those in charge of discovering the urban beauty, just like the others have discovered the countryside."[47]

A counterpart is the industrial landscapes developed by a variety of professional artists in the same period: photographs, drawings, and paintings promoted by state and business, best exemplified by the advertisements and the contests of the cement company La Tol-

4.12. Alfredo Lugo, *Wall and Cauldrons*, circa 1928. Archives Cenidiap. Author's photograph.

teca. James Oles identifies this aesthetic as a "chilly precisionism" that served to promote industrialization and symbolically "nationalize" foreign-owned monopolies, similar to the Fundidora ads, though these images mostly rendered labor invisible.[48]

By contrast, many of the paintings and prints from the Centros Populares represent workers, typically wearing overalls, carrying heavy objects, or working with artisan tools. For a writer in the SEP journal *Forma*, these signs of modernity distinguished them from the "curiosities" of the Open Air Schools and gave them a certain proletarian universality:

> The working class child reflects the environment in which he is surrounded, no longer local, but part of a "standard" civilization, practical, sober, young and shorn of the charm of the things and customs on the verge of disappearing: the clothes— overalls, caps and Sunday dress, the landscape, factories, machines, the attitudes of work and rest, can be identified by the dress, the machines and the attitudes of all the workers of the world.[49]

A report around 1932 by Leopoldo Méndez, then chief of the Drawing Section of Bellas Artes, hoped that the Centros would lend themselves to a more political art than that of the Open Air Schools, one

that avoided "that microbe called 'arte puro'" and that would "facilitate resources for the struggle of their class."[50] But for the most part these children, as children, lacked a critical vision of their environment and their art is mostly devoid of conflict.[51]

In one print, three workers, in overalls and wearing hats typical of railroad workers, embrace while a dog looks on. Was this working-class solidarity, or simply a group hug? More explicit but atypical is a painting by the prolific "Rigo G." that does present a stark vision of class difference (fig. 4.13): a worker in overalls, back to the viewer, reaches up to move the huge wheel of a machine. To his left, a huge man in a suit and top hat smiles directly at the viewer with all the satisfaction of the multiple bags of money that the worker and machine have produced for him.

"Rigo G." may have seen the prints of *El Machete* at home or even

4.13. "Rigo G.," untitled, circa 1928, Archives Cenidiap. Author's photograph.

at the Centro, or he may have been an older student. Class conflict does not seem to have been a part of the teaching methodology, which minimized technique and focused on intuitive and spontaneous impressions of students' surroundings. Nor was it the priority of those directing the schools, with some exceptions such as Méndez, by then a member of the clandestine and radicalized Communist Party of Mexico.

The sponsors of the schools may have undermined any cultural agency of these artists by essentializing their art in national and racial terms. For the *Forma* journalist visiting San Pablo, these children were universal and Mexican:

The modern child paints employing a language of universal reach, but without eliminating his ethnic characteristics. In certain paintings of this school, the iron structure, the webs of telegraphic wires, the concrete tanks, are themes that serve as a trampoline to enable the meditation and assimilation of the indigenous. The colors detected by childlike observation in the metal of tanks or the cement walls are essentially from here, they have the taste of jungle, of mountain, of tropics.[52]

The assumption of cosmic, un–self-conscious creation almost by definition excluded the possibility of artistic development. Critics acknowledged that the schools could awaken the artistic sensibility of children yet doubted whether they were capable of forming professional artists.

Even so, several students trained at the Centros Populares pursued careers as artists, among them Jesús Escobedo, Isabel Villaseñor, Enrique Aguilar, and Roberto Castellanos. The most emblematic artist to come from the urban schools was Fernando Castillo. Of rural origins, he had worked as shepherd, porter, newspaper vendor, miner, soldier, and bootblack, epitomizing the typical casual laborer in Mexico City. Director Fernández Ledesma recounts how this lame shoe-shiner, already an adult, arrived at the school and begged to be allowed to paint. The director accepted him on the condition that he give up drinking, and in a short time he became an accomplished painter and graphic artist, with more than a hundred works sold and one honored with a prize at an exhibition in Seville. Castillo was atypical in that he arrived as an adult and painted images rooted in his rural origins. Despite his success—one of his paintings hangs in the permanent exhibition at the National Museum—he died of tuberculosis and in poverty at the age of forty. Many more students entered and left the schools in relative anonymity. Fernández Ledesma knew many

simply by their nicknames—Gato, Pelón, Naco, Pulgar, la Güera—and some of the works of art shown in contemporary exhibitions were presented with titles but no names, or with the occasional initial verging on the anonymous ("Rigo G.," "Raymundo X.," etc.), as if to reinforce their essential collectivity as workers-mestizos-artists.[53]

The Centros Populares got less and less attention from their teachers and fewer resources from administrators, particularly after 1929, when the Centros were separated from the Academy of San Carlos and became dependent directly on the SEP. They folded in 1933 and 1934, to be partially replaced by the Escuelas Nocturnas de Arte para Obreros under Cárdenas.[54] Despite their short life and the essentializing rhetoric of their sponsors, the Centros Populares de Pintura constitute an important attempt to bridge the gap between workers and artists and were an advance in the representation of the city and its workers.

Whereas the Centros aspired to make workers into artists, Diego Rivera's brief tenure as director of the Academy of San Carlos from August 1929 to May 1930 aimed—and failed—to turn artists into workers. In 1927 Rivera had commented in an interview, "The only salvation for the Academy is a fire."[55] His threat and eventual project to transform the Academy of San Carlos were in many ways reminiscent of Dr. Atl's 1914 dream of turning the elitist San Carlos Academy into a medieval artisanal workshop. Rivera's election to the post by the National University council came at a moment of change: his own recent return from the Soviet Union and subsequent expulsion from the Communist Party in its new, ultra-left phase; the anti-Academy challenge of a group of avant-garde artists, the Grupo 30-30, over the selection of a new director and continued support for the Open Air Painting Schools; and the granting of autonomy to the National University, of which the Academy of San Carlos was a part, two months before.[56]

Rivera immediately pushed through the student-faculty council a resolution that faculty help students "find an aesthetic orientation in agreement with the epoch . . . so that thereby the function of artists can be socially positive action."[57] Months later, he introduced a new curriculum intended to completely remake the school, starting with a new name: the Escuela Central de Artes Plásticas. Previously, entrance required completion of primary studies. Rivera sought to open the school to workers, to teach "real technical workers, skilled in the crafts directly connected to the fine arts."[58] Entrance into a preliminary three-year cycle was to be based on ability, with no previous studies required and with classes offered at night, so that working-

class students could attend after work. As Rivera explained, the work-study model would allow the student to become a "qualified worker."[59]

By contrast, entrance into a five-year superior cycle of day classes would now require completion of secondary school—a substantial increase in the requirements for traditional students—although provisions were made for workers without that degree to attend selected upper-level classes.[60] The cycle of superior studies would end with an apprenticeship, and the school and government would work together to provide an initial government commission.

Just as fundamental was the complete overhaul of the school's curriculum. The new curriculum broke dramatically with the spontaneous methodology of the Open Air and Centro Popular schools (now under SEP jurisdiction). Students were to take a rigorous series of classes that included theory and studio, as well as practical elements such as building furniture, architecture, and clothing design. For example, the plan called for each student in the first year of the superior cycle to take seven different classes for a total of forty-two hours per week in the classroom or studio.[61] Rivera sought to close the gap between artist and artisan, equalizing the minor and the fine arts, the monumental and the nonmonumental, with an emphasis on rigorous method and practice rather than untutored inspiration based on youth or race. The new school, he explained, would constitute "a great workshop that will tend toward the establishment of collective artistic work, as it has always been in art's greatest days."[62] Rivera's reforms served the government's industrialization project, with its emphasis on ties to industry, worker housing, public buildings, and, of course, the monumental art that Rivera favored and monopolized.[63]

Just as Rivera's appointment was the product of the democratization of the National University, so his dismissal was part of new and complicated university politics. The students and faculty of the School of Architecture, which had historically shared the former convent in the San Carlos building with the art school, saw the new curriculum and its multiple links to the building arts as an infringement on their purview. When they proved unable to stop approval of the reform at the University Council, they undertook a series of mobilizations that were countered by Rivera and his supporters. The conflicts attracted the press and involved the police, leading ultimately to Rivera's suspension by the same council that had elected him and passed his curriculum reforms.

According to Rivera's first biographer, Bertram Wolfe, the conflicts between students fell along class lines. The "architects were more numerous, wealthier, more respectable, more conservative than the

painters."[64] Rivera denounced the clashes and his eventual removal in similar terms, denouncing the council for taking a "position of class against class, of interest groups against interest groups, creating a front against the proletariat"—in other words, against the art students and their director, referring to himself as someone "who has been and is but a delegate of the working class."[65]

A series of letters exchanged between Rivera and the rector suggest a more complicated pattern. Many art students, while generally less well off than architecture students, were hardly working-class and may not have been thrilled with the new model of artist as "qualified worker." Many complained that the new curriculum required too many hours. Rivera admitted to having had little success attracting students to join the new school under its "workshop" model, be they workers or the traditional middle-class constituency of the school, but he insisted that the low enrollments were due to university employees' attempts to sabotage the project. Devastating for Rivera was that the organization of art students ultimately voted to disown him and his project, supported by the Mexican Federation of Students, which ultimately gave the university more leverage to withdraw its support of the director. Rivera rejected the vote of the art students, accusing the architecture students of enrolling en masse in the art school in order vote against him.[66] This may have been the case, though they most certainly were joined by genuine art students. And Rivera employed similar tactics, organizing a short-lived Sindicato de Pintores y Escultores that paid thirty-three men, apparently dressed in overalls, one and a half pesos each to appear on his behalf at the University Council meeting.[67] Such efforts may have brought workers into the Academy, but not on the terms that Rivera had originally proposed. Regardless, Rivera's authority was curtailed by the University Council, and he had little choice but to resign. Though his ally, labor lawyer Vicente Lombardo Toledano, replaced him as temporary director, little of Rivera's reform program was implemented. The expansion of art education to the working class would have to wait until the 1930s and 1940s and would occur outside the walls of the Academy.[68]

HORIZONTE AND BEYOND

As Calles, in alliance with the CROM, supported and harnessed the official labor movement within the rhetoric of the Laborist State, the image of the worker became more generalized in the world of art, veering between the militant and patriotic elements developed mid-

decade in *El Machete* and *Revista CROM* while increasingly following the style developed by avant-garde artists. Rivera's ongoing murals in the adjacent Patio of Fiestas at the SEP (1924–1928) developed an essential part of his mature mural style: crowded tableaus that feature worker militancy, as in *Assembly of the First of May* and *The Arsenal*, with workers making and carrying arms as they lead a Marxist, Soviet-style revolution. The more militant rhetoric of the later panels reflected Rivera's recent return in early 1928 from a visit to the Soviet Union, but also the greater tolerance of the Calles government for a rhetorical militancy in state-supported art that critiqued yet burnished the credentials of his Laborist State. Of course, during the second half of the 1920s Rivera had a near monopoly on new public murals in federal buildings, with overlapping commissions for the SEP, the Chapingo agricultural school, and the National Palace.

An exception was Orozco, who was invited back to the National Preparatory School in 1926 and there developed the Monumental style of some of his most famous murals, most depicting the fighting of the Revolution. While Orozco's *El Machete* drawings suggest little of the epic vision of the Revolution that characterized these extraordinary murals, they anticipate his view on those walls of a process doomed to senseless violence and inevitable betrayal. A thematic exception in the same Monumental style is his moving and deadly serious mural *The Strike* (fig. 4.14), in which three men declare a strike by hanging a red banner in front of the door of a workplace. The building, in the sparse, quiet style of the other murals in the series, suggests a rural setting, perhaps the office of a mine or hacienda, as do the white *calzón* pants worn by the two men, naked from the waist up, who hold the banner. Their bodies are neither idealized nor distorted, the face of one short on detail and the other looking away. Half-hidden on the right is a third figure. The rebozo-like cloth wrapped around the upper body suggests a woman, while the short hair and exposed ear suggest a man. The powerful image is rendered ambiguous or perhaps universal by the lack of detail specific to any industry, the almost surreal landscape, and the classical column standing to the left. The meaning may be transformed by the haloed head of Christ above the door frame, a remnant of the mural he painted over, *Christ Destroying his Cross*. For Renato González Mello, the new reference in the context of the striking workers is to Christ's resurrection from the burial tomb.[69] Regardless, the image of workers hanging a banner to declare a strike would be frequently repeated by later artists.[70]

In January 1926, Estridentismo took a turn toward the provinces,

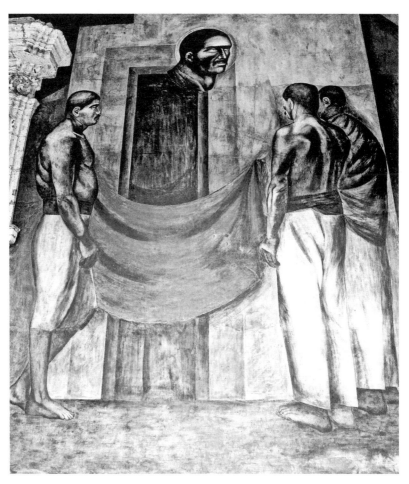

4.14. José Clemente Orozco, mural, *The Strike*, 1926. Antiguo Colegio de San Ildefonso, Mexico City. Author's photograph.

revolutionary politics, and a greater visualization of the working class when founder Maples Arce accepted a position as the second-in-command to the radical governor of Veracruz, Heriberto Jara. He soon secured jobs for a variety of his followers, bringing artists into a new environment, the modest provincial capital Jalapa, close to the highly industrialized and unionized textile town of Orizaba and to the radical campesino and urban movements linked to the port of Veracruz. Most important, they came under the ideological and financial patronage of Governor Jara.

Jara had a long association with organized labor: his youth as a bookkeeper in the Rio Blanco textile factory; close relations with the

Casa del Obrero Mundial during the Revolution; and a hand in formulating the Article 123 labor provisions in the 1917 Constitution. In Veracruz, his closest supporters were labor organizations. But that meant an uneasy alliance with the CROM, which dominated the textile industry in Orizaba, pushed Jara for jobs in his administration, and strongly contested his support of independent unions. As Tatiana Flores notes of this new phase of Estridentismo and their magazine *Horizonte*, the Estridentistas, previously independent of government patronage, faced the "challenge of finding a place for the avant-garde within a venue of political propaganda."[71]

A primary collective project for the Jalapa Estridentistas, while continuing to produce individual paintings, fiction, and poetry, was the ten issues of the journal *Horizonte*, edited by the poet Germán List Arzubide and published from April 1926 to April 1927.[72] Announced as an "exponent of all the ideas of the vanguard and of the struggles of the moment," it made no mention of its relation to the government of Veracruz, but it frequently included Jara's image and praised his works as governor.

Horizonte reproduced the work of artists residing outside Jalapa, contemporary murals by Rivera and Orozco, photographs by Edward Weston and Tina Modotti, and paintings of urban scenes and factories by Gabriel Fernández Ledesma and Rufino Tamayo.[73] But all the covers and most of the inside art were produced by art editors Ramón Alva de la Canal and Leopoldo Méndez, both veterans of the Open Air Painting Schools and early Estridentismo.

A variety of texts and images address the working class, most prominently in the issue honoring May Day 1926 with "an homage to the laboring classes." On the cover, by Méndez, workers in overalls raise red-and-black flags in front of factory smokestacks in a tame evocation of Labor Day, which by 1926 was an important political ritual of revolutionary politics. More interesting is a drawing inside titled *The March* (fig. 4.15), which Méndez frames as a river of parading men in sombreros and banners between the zigzag of tiled roofs characteristic of Jalapa, adapting some of the visual effects of Estridentismo to social protest and to the provincial capital.[74] The sea of sombreros, besides their striking visual effect, may reflect both the relatively rural setting of Jalapa and Governor Jara's need to convey stronger support among local campesino movements than he actually had.[75]

Alva de la Canal, even more prolific than Méndez in the journal, illustrated many articles with small ink drawings using sharp contrasts that resembled woodcut prints. Estridentista symbols of urban

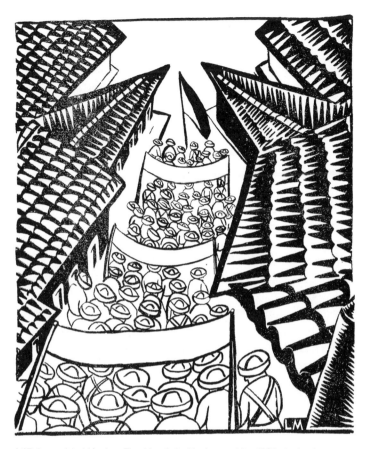

4.15. Leopoldo Méndez, *The March*, in *Horizonte*, May 1926. Author's photograph. Permission of Pablo Méndez.

modernity were balanced with references to social struggles in the city and countryside.[76] For example, he illustrates a story by Ricardo Flores Magón with a vignette of a group of miners overwhelmed by the collapsing crisscrossed beams of a mine shaft.[77]

As Flores notes, the political function of the magazine limited its content, as "labor disputes, social tensions, and government opposition . . . were absent from its pages," and it otherwise "conveyed the impression that the state of Veracruz was a veritable utopia." Editor List Arzubide's positive image of Veracruz and Mexico dramatically differed from the tone of *El Machete*, even as a variety of local and national conflicts involving labor steadily undermined Jara's government.[78]

Two fascinating watercolors by Alva de la Canal, painted in this

same period but not published at the time, suggest the real challenge of reconciling social art and political obligations in *Horizonte*. In *El Líder* (plate 6), two rows of workers in overalls march, their bodies and banners lurching in opposite directions as they mirror the militant gestures of a suited leader sandwiched between both rows with his hand extended. A short-haired woman in a knee-length skirt stands out as a woman and for her dress and pose. Her face and the líder's are the only ones we see. The painting is ambiguous. Is this dynamic scene one of modernity and social progress, with the líder an Estridentista artist, an intellectual worker, or intermediary between the revolutionary government and the masses? Or is he a CROM demagogue manipulating the masses, a slender and local counterpart of Morones, with the "flapper" winking knowingly along with the artist at the viewers?

The latter interpretation is suggested by a less ambiguous watercolor the artist did about the same time (plate 7).[79] In *Capitalism, the Clergy, and the Union Leader Against the Worker*, a faceless worker in overalls leans as if crucified between the hands of a rat-faced man firing a gun and holding a bag bulging with coins. As the title confirms, the assassin is dressed in the clothes of the worker's enemies, with a priest's cassock and collar and a capitalist's top hat fitted over a worker's cap. The painting is an ingenious reworking of Orozco's early murals at the National Preparatory School (fig. 3.5) and several of his *Machete* drawings from 1924 to 1925 (figs. 3.11 and 3.12). By association, it incriminates the *líder* of the related watercolor.

Both paintings were likely too provocative for the pages of *Horizonte*, particularly at a time when Governor Jara faced constant pressure from Morones and the CROM over his support for independent workers organizing against the El Águila oil company and from President Calles regarding aggressive local taxes on the Huasteca oil company, at a time when the president was trying to reach an accommodation with foreign capital over federal taxes. In this context, Alva de la Canal's unpublished watercolors of labor leaders tell a much more revealing story than the images of *Horizonte*. In September 1927 these and related conflicts led Calles and CROM to support an abrupt ouster of Jara and his followers, effectively ending Estridentismo's second phase.[80]

Artists involved with Estridentismo continued to move their avant-garde aesthetic toward socially engaged art in Mexico in the next years, including their participation in the 30-30 movement of 1928–1929 as well as the Block of Intellectual Workers. Méndez, Maples Arce, List Arzubide, and Fermín Revueltas were all involved in the Block's journal *Crisol* (1929–1934). Similar to *Horizonte*, it in-

cluded abundant and beautiful prints of revolutionary workers while receiving funding from (and staunchly defending) the newly formed Party of the National Revolution (Partido Nacional Revolucionario— PNR), which would institutionalize politics under five years of indirect Calles rule.[81]

But these same artists pursued a variety of paths. After the collapse of *Horizonte* in 1927, Méndez moved closer to the PCM, formally joining and producing prints for *El Machete* in 1929, just before the PCM and its newspaper were both outlawed. In spite of his growing political militancy, many of his prints explored other aspects of working-class culture. Notable is his 1929 woodcut (fig. 4.16) *The Madman*, in a style and with a theme of domestic violence close to some of Posada's penny-press broadsheets. He portrays a working-class man

4.16. Leopoldo Méndez, *The Madman*, 1929. Courtesy of Peter Schneider and Susan DeJarnatt. Permission of Pablo Méndez.

"possessed" by alcohol and threatening to strike his wife and children with a chair, a rare image among the typically noble representations of workers in the 1920s.

In the late 1920s and early 1930s, Méndez worked in a variety of positions in the Bellas Artes division of the Secretariat of Public Education, illustrated the SEP journal *Maestro Rural* and various books and government publications, and traveled briefly to the United States for two exhibitions of his work.[82] Typical of his commissioned work are the 1930 prints he did for *Ciudad Nuestra*, a journal published by the Mexico City government to promote civic pride. Méndez portrayed workers in overalls and men and women in campesino clothing crossing busy city streets beside men in suits, entering official buildings or engaged in sports or leisure. Particularly evocative is *The Workers Park Swimming Pool* (fig. 4.17), with its upper benches of workingmen relaxing, watching, and conversing; a middle plane of sensual female sunbathers; and the pool in the foreground with a playful diver and graceful, dancing swimmers.

The style is distinct from earlier prints and drawings, the curved parallel hatchings generating softer lines and tones than the sharp black-and-white contrasts and angular figures that conveyed class conflict and solidarity in *El Machete* and *Horizonte*. Instead, these woodcuts suggest a sense of easy class coexistence, of working-class sociability, and a modern interaction between the sexes. The theme and composition are perhaps inspired by an earlier Posada print (fig. 4.18), though the meaning is distinct. Posada shows rich men frolicking in a pool presumably off-limits to the poor, "while the poor lacks the water he needs for his daily necessities." The images of *Nuestra Ciudad* show a city where workers share and have their own public spaces.

Similarly, Pablo O'Higgins's quiet drawings and small easel paintings of men at work and leisure suggest related aspects of a working-class culture distinct from the ones represented in *El Machete*, *Revista CROM*, or *Horizonte*. The blond and blue-eyed American, born Paul Higgins, abandoned his art studies in San Diego in 1924 to work as Rivera's assistant. By 1927 he had renamed and reinvented himself as a Mexican artist and a Communist. In one of his first individual works (plate 8), the 1927 oil painting *In the Cantina*, three men in overalls sit around a table in a bar after work, sharing conversation and a drink. With a primitive style akin to that of the students of the Centros Populares de Pintura, he paints without any obvious political agenda beyond offering a glimpse of everyday working-class cul-

4.17. Leopoldo Méndez, *The Swimming Tank of the Workers' Park*, *Nuestra Ciudad*, April 30, 1930, page 23. Permission of Pablo Méndez. Author's photograph.

ture, with vernacular traditions of pulque, pottery, and flowers distinct from the middle-class consumption patterns featured in *Revista CROM*.[83]

Méndez and Tina Modotti moved from the late Estridentismo of *Horizonte* in 1927 toward the worldview of the Communist Party, increasingly at odds with official revolutionary nationalism.[84] The transformation of Modotti's photographs is particularly notable. As John Mraz notes, on their arrival in Mexico in 1923, Edward Weston

LA ESCASES DE AGUA.

Mi2 ntr as el pobre carece sin la cual más se empobrece; la gasta continuamente
del agua tan necesaria El rico que aumenta y crece dejando mugre indecente
para su faena diaria hasa en caudales estraños en una casa de baño.
 siempre usando finos paños

4.18. José Guadalupe Posada, *Water Scarcity*, in *La Guacamaya*, January 28, 1904. Author's photograph.

and the Italian Modotti had helped elevate photography to modernist art, in contrast to the picturesque postcards of Hugo Brehme or the official journalism of photographers like Agustín Casasola.[85] Modotti's photographs circulated in different cultural journals, including the SEP's *Forma*, the independent journals *Norte* and *Mexican Folkways*, and eventually *El Machete*, now Communist-affiliated, and its US counterpart, *The New Masses*. Two Modotti photographs that appeared in issues of *Horizonte* suggest her broader transformation as an artist and activist. *Telephone Wires* is composed entirely of the parallel lines of poles and wires and shares the devotion to modern technology of early Estridentismo and Weston's fascination with form, natural and manufactured.

By contrast, *Workers' March* (fig. 4.19) uses form as political argument and suggests the dialog between prints, painting, and photojournalism to witness and represent the experiences of the working classes. In the photograph, a mass of working-class men march forward in the 1926 May Day demonstration in Mexico City.[86] As Leonard

Folgarait notes, Modotti manipulates the scene in a variety of ways to make it represent her political ideal: shooting from above, unfocusing the lens, and cropping the photo to create a surging sea of identical sombreros. The abstracted hats work to emphasize collectivity, blurring distinctions between urban and rural masses and asserting the active potential of the working class to be an agent of revolutionary transformation.[87] The image owes much to the anonymous and collective masses in Rivera's murals at the SEP and Chapingo that Modotti photographed over the previous six months and may paraphrase the flowing river of sombreros in Méndez's *The March* (fig. 4.15).

The political shift in her photography reflects and anticipates her

4.19. Tina Modotti, *Workers' Parade, 1926.* © Museum of Modern Art/Licensed by SCALA/Art Resource, New York.

changing personal relations in 1926 and 1927: her affair with Rivera, her committed relation to Xavier Guerrero after Weston's return to the United States, and her relation with Cuban Communist Julio Antonio Mella after Guerrero left for the Soviet Union, all coinciding with her move toward and membership in the Communist Party and her work for *El Machete*.[88]

Soon after *El Machete* became the official organ of the Communist Party in 1925, photographs displaced the primacy of prints and drawings in the newspaper, as the initial artists moved on to other projects or allowed their political tasks to crowd out their artistic endeavors. The use of photographs was also an attempt to incorporate a modern medium that might appeal to a more sophisticated urban working class, as the Communist Party wavered between its rural and urban constituencies. Modotti's photos brought art to photojournalism in a way that served the current moment of the Communist Party.

Many of her photographs emphasized the nobility of work. In a final print published in *Horizonte*, construction workers emerge almost organically from vertical and horizontal scaffolding that resembles the crosses carried by Rivera's miners in the SEP.[89] Several 1927 close-ups published elsewhere focus on hands: a male *Worker's Hands* at rest on a shovel; and presumably female *Hands Washing* clothes against a rock. These photographs suggest some of the reframing of hands she did in her photographs of Rivera's murals.[90]

Particularly resonant with early print and mural images of workers is *Workers, Mexico City* (fig. 4.20), done in 1926. Two manual laborers in overalls and sombreros fill the frame as they walk up a diagonal plank, the first bending under a huge concrete slab, the second stabilizing the burden with his outreached hands. The image harkens back to Herrán's construction workers (plates 1 & 2), but the bodies and effort of such unskilled labor are hardly romanticized. Their faces, and therefore any individual identity beyond their class and everyday solidarity, fade into anonymity. Like Charlot's porters and Guerrero's manual laborers, they lack any tools beyond the single back brace, though unlike those earlier images, there is a deliberate contrast between the manual laborers and the massive concrete building they are presumably constructing.[91]

The very existence of a woman photographer of Modotti's stature was unusual, and the relative freedom with which she lived her life and photographed was enabled by her position as a foreign woman. While not involved directly in feminist organizations, her photos incorporate women as laborers more fully than the art of most of the

4.20. Tina Modotti, *Workers, Mexico City,* 1926. Courtesy of Amon Carter Museum of American Art.

politically engaged male artists who were her peers.[92] While she accepts the naturalization of the paid proletariat as male, within this world she photographs women in their domestic labors, caring for children, carrying burdens on their heads, washing laundry. In 1929, months before her expulsion from the country as a dangerous, foreign Communist, Modotti constructed an image of female militancy that is unique for the period: in *Woman with Flag* (fig. 4.21), a single, indigenous-looking woman dominates the frame, striding defiantly forward with the red flag of labor militancy falling across her body. Part of the legend of the photograph is its association with Benita Galeana, a Communist whose feminist beliefs got her kicked out of the party in the 1930s, though recent scholars have shown the model to be Luz Jiménez, an indigenous woman from Milpa Alta who frequently modeled for Modotti, Leal, Rivera, and Charlot. Regardless, the photo was not meant as an individual portrait but rather as a powerful representation of the agency of working-class women.[93]

Fully immersed in the party and *El Machete* by 1927, Modotti produced around twenty-five photographs for its pages in which she com-

4.21. Tina Modotti, *Woman with Flag*, 1929. Reproduction authorized by INAH.

bined her socialist aesthetic with the demands of the party.[94] Among them were still lifes of symbols of proletarian militancy and Mexican identity and a new type of photojournalism that brought her to Colonia de la Bolsa, one of Mexico City's poorest neighborhoods. Influenced by Soviet photography, Modotti introduced a series of basic photomontages that were the first self-consciously done in Mexico. Each presents a vertical comparison of rich and poor: the elegant Avenida de la Reforma with a street of Colonia de la Bolsa; an imposing government ministry with a shanty; the bedrooms of the rich

with those of the poor; and rich children and their nanny with street kids, all tied to Mexico's present as a series titled *The Contrasts of the Regime*.[95]

The last and best of these (fig. 4.22), due to its subtlety and humor, was published under the title *Those on Top and Those Below*.[96]

In an almost seamless montage, in the bottom half a despondent, poorly dressed man sits on a curb holding his head and hiding his face.

4.22. Tina Modotti, *Elegance and Poverty*, 1928. Reproduction authorized by INAH.

At the top is a billboard for a clothing store for the rich: "From head to toes, we have everything a gentleman requires to dress elegantly." Together they offer two very different visions of leisure and consumption, the fair-skinned man in the ad dressed in fancy clothes by a servant or shopkeeper, the anonymous man below idled by poverty and unemployment, wearing rags and homemade sandals. The photomontage challenges not only the "contrasts of the regime" but also the CROM project of class harmony and the aspiration of middle-class consumption portrayed in *Revista CROM*.

LA LECTURA PREFERIDA

On March 17, 1928, *El Machete* featured a photograph by Tina Modotti of a man intently reading a newspaper folded backward to reveal the unmistakable masthead of *El Machete* (fig. 4.23). The caption below is "LA LECTURA PREFERIDA," that is to say, *El Machete* is the public's preferred reading matter, though it invites other readings. The preferred reader is a worker, as indicated by his coveralls, but he is not just any worker. He is an individual standing alone, and unlike many of her photos of workers we have a direct view of his face. His indigenous features reveal him as a campesino transformed into a worker. Many readers would recognize his hat as peculiar to railroad workers, since during the previous two years *El Machete* had covered the strikes of the National Confederation of Railroad Societies against foreign employers, government austerity, and the minority unions affiliated with the CROM. In an era of ever tighter control of the labor movement, railroad workers were the militant exception.[97] The railroad worker was in many ways the ideal reader of *El Machete* and the ideal proletarian: skilled and situated in the strategic transport sector, and this photograph suggests that his militancy grew from his reading of the party newspaper. Indeed, after the 1927 strike railroad leaders Hernán Laborde and Valentín Campa went from jail cells to Communist Party cells, becoming the PCM's most important leaders over the next decade, with Laborde serving as secretary general from 1929 to 1940.

A year later, Modotti broadened the preferred readership with a photograph shot from above (fig. 4.24) that shows seven men hidden below sombreros, one of them presumably reading *El Machete* out loud to the others.[98] In different printings, the title alternated between *Workers Reading "El Machete"* and *Campesinos Reading "El Machete,"* depending on the reading its various publishers preferred to give it. *El Machete's* headline in the photo, "ALL THE LAND, NOT

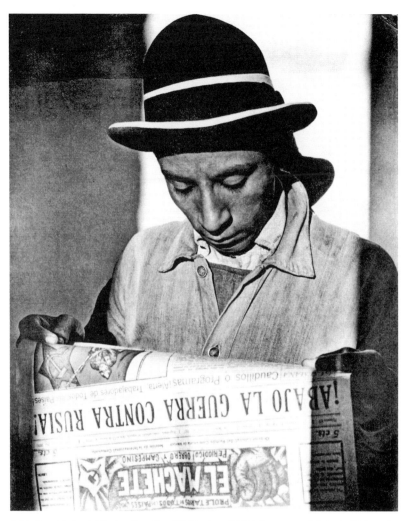

4.23. Tina Modotti, *Worker Reading "El Machete,"* 1928. Courtesy of Galerie Bilderwelt and Reinhard Schultz.

PIECES OF LAND," suggests an appeal to the campesinos of the photo, as does the Méndez print below the headline, of Zapatistas riding below a banner of "TIERRA Y LIBERTAD." But the message for *El Machete* was the same: reading *El Machete*, a paper written and read collectively, would lead to class consciousness, militancy, and the creation of a better world.

In a similar meta-reading, a 1927 *Revista CROM* cover (fig. 4.25) portrayed an elegantly dressed flapper holding the magazine in the privacy of her home, presumably reading about fashion and preparing to buy products "Made in Mexico by members of the CROM."

4.24. Tina Modotti, *Campesinos Reading "El Machete,"* 1929. Reproduction authorized by INAH.

The contrasts are suggestive: a male versus a female reader/protagonist; class conflict versus class harmony; active, collective protest versus passive, individual consumption; radical internationalism versus patriotic nationalism; in-house artist-workers in a failed union versus contracted artists organized in a pragmatic, functioning union; an innovative Mexicanized avant-garde style versus a modernist style largely derived from Europe; a rejection of ads versus a reliance on them for cash, values, and aesthetics; women as the ultimate victim of capitalism and women as modern, empowered consumers.

Together the two journals establish the range of public positions on the role of working people in the 1920s. They reflect unprecedented gains workers made in the workplace and in political life, as well as their continued demands for a greater fulfillment of the promises of the Revolution. Regardless of different styles and worldviews, the artists who participated in both periodicals together created rich visual representations of the working class that—along with early muralism, late Estridentismo, and the Centros Populares de Pintura—were unequaled since the art of Herrán and Posada and heavily indebted to both.

The two publications probably shared an inevitable distance between the publishers and their intended audiences. Modotti's photographic "evidence" aside, it is extremely difficult to know the extent to which workingmen and workingwomen in the 1920s identified with or rejected the aesthetics and political meanings of these distinct images. It is easy to imagine that both journals were browsed, discussed, and displayed in workshops, homes, and hair salons in 1920s

4.25. Anonymous, cover, *Revista CROM*, January 15, 1927. Centro de Estudios Lombardo Toledano, Mexico City.

Mexico City. It is just as easy to imagine them both circulating among middle-class intellectuals and union bureaucrats like the ones that produced them.

In his autobiography, Orozco speculated with characteristic irony on the experience of the Syndicate and proletarian art: "Proletarian art . . . turned out to be an error, since a worker who has spent eight hours in the shop takes no pleasure in coming home to a picture of workers on the job." The reality, Orozco noted wryly, was that "the bourgeois bought proletarian art at fancy prices" while "the proletarians would gladly have bought bourgeois art if they had had the money and, for want of it, found an agreeable substitute in calendar chromos."[99] Orozco recognized proletarian art as the creation of radical intellectuals in the name of workers, and workers' taste in art was dependant on their resources. With no irony at all, Rivera in 1929 blamed limited interest in proletarian art on the Mexican worker, who "has a perfectly bourgeois taste: he sees all the ads in the streets . . . every Sunday he sees the supplements of the newspapers, and he sees the bad canvases that are the shop windows."[100]

The glory days of the CROM ended with the deep crisis of the political system in 1928. When Obregón was assassinated by a religious fanatic soon after his reelection, suspicion fell on Morones and the CROM. The Labor Party refused or was denied entry into Calles's new Party of the National Revolution, and many of the CROM's constituent unions began to defect, limiting its power to a few regions and sectors. *Revista CROM* continued to publish through 1939 with fewer, duller pages, and its political line was considerably out of step after 1934. The rival Communist Party was outlawed in 1929, forcing its newspaper underground, shorn almost completely of images. Only in late 1934, when the Communist Party was again legalized, would the pages of *El Machete* once again be filled with high-quality prints in red, black, and white.[101]

The variety of images produced in the 1920s transformed the early innovations of Herrán and Posada into graphic representations of the worker that would resonate over the next decades. The legacy of *El Machete*'s prints and photographs was central to the development of the more radical graphic traditions that flourished in the Popular Front radicalism of the 1930s. *Revista CROM*, though largely forgotten, reflects the commercial visual culture of the 1920s and anticipates a very appealing message of nationalism, class collaboration, and consumerism that became dominant again after 1940.

CARDENISMO, THE POPULAR FRONT, AND THE LEAGUE OF REVOLUTIONARY ARTISTS AND WRITERS

In 1934, American writer Verna Carleton Millan visited the recently formed League of Revolutionary Writers and Artists that she would soon join. Of the LEAR's decrepit headquarters she wrote, "The faint-hearted never returned, but those who did were prepared for anything." The dilapidated colonial tenement in the marginal neighborhood of San Gerónimo, once the convent of Sor Juana Ines de la Cruz, suggested the recent past of Mexico's politically engaged artists, though not their immediate future. By 1937, the LEAR occupied a respectable, government-subsidized building in the commercial and political center of the city, included a wide variety of prominent artists and intellectuals, and was one of the most important cultural organizations in the nation.[1] It embodied many of the ideals of the antifascist Popular Front of the Communist International: supporting the progressive policies of President Lázaro Cárdenas, forging close ties with working-class organizations, developing public discourses of proletarian struggles, and making antifascism an imperative for working-class organization and unity. The LEAR, particularly its visual artists, shaped and illustrated the social and political struggles of the decade and revealed the possibilities and limits of Mexico's Popular Front.

This chapter and chapter 6 explore the radical transformation that defined the worlds of artists and workers in the early years of the progressive presidency of Cárdenas. The transformation is all the more dramatic when traced from 1929, when Calles, the former president and strongman, installed the most conservative postrevolutionary regime since 1920, and labor unions and radical artists were orphaned by a decline in government support and repression of the Communist Party. From 1934, many artists and much of organized labor mobilized around strikes and in support of President Cárdenas against a conservative opposition, further encouraged by the Popular Front.

A second narrative is the creation of the Communist-influenced LEAR, the most important collective organization of artists and intellectuals of the decade. The chapter considers its artistic influences, or-

ganizational circumstances, and visual strategies in its journal *Frente a Frente*, as well as its alternative murals and ephemeral graphic material produced in the course of mobilizations and outreach to the working class. In its publications and collaborations, the LEAR temporarily resolved the political and aesthetic differences of working-class representation in the 1920s, fashioning a Popular Front version of the radical ideology and aesthetics first formed in *El Machete* and constructing an image of the worker as a fundamental social actor in postrevolutionary Mexico.

TOWARD THE POPULAR FRONT

The conditions for organized labor and the opportunities for artists on the left between 1929 and the early 1930s were dismal. With the assassination of Obregón following his 1928 reelection, power shifted to a group of generals and caudillos led by the former president, Calles, that resolved to settle conflicts within the structure of a unified official party, the Revolutionary National Party. Leaders constructed a patriarchal discourse of the "Revolutionary family" that tried to contain existing political organizations, opposing interests, and centrifugal forces. The pragmatic social reforms of the 1920s were curtailed or sacrificed in the interest of a centralizing political project and in response to the uncertainties of the Great Depression. From the ranks of the official party came three short-term presidents who served at the discretion of Calles, whose informal title, Jefe Máximo (Maximum Leader), has come to mark the period of his indirect rule (1929–1934) as the Maximato.

The CROM lost political favor and its outsized influence in the workplace. It soon divided into smaller pieces that struggled among themselves for the remnants of CROM influence. None of these smaller federations gained significant political traction at the national level, despite Morones's continued close ties to Calles. The CROM-affiliated Labor Party was excluded from the official party umbrella and ceased to exist as a national party, while many former CROM unions grew suspicious of political strategies in the context of a clearly unfriendly government. The Communist-backed Unitary Syndical Confederation of Mexico (Confederación Sindical Unitaria de México—CSUM), founded in 1929, briefly flourished in the vacuum left by the CROM before faltering in the face of brutal government repression.

The CROM's fall from grace ended the unprecedented public profile and leverage against employers that many unions had achieved. The onset of a global economic crisis further dampened labor militancy, at least through 1933, as did the general intolerance of labor demands by the three short-term presidents and their Jefe Máximo. In 1931, the hardest year of the economic crisis, only eleven strikes involving 227 strikers were officially recognized nationally. With labor at its weakest point since 1919, President Ortiz Rubio implemented a federal labor code, a long-pending institutional framework for the nation, but one that many workers found less generous than their state labor codes and existing contracts.[2] In short, organized labor was orphaned, temporarily outside of the so-called Revolutionary family.

As the government veered right, the Communist Party of Mexico turned sharply to the left, motivated by international mandates and domestic repression. From 1928, the formal position of the Communist International was a rejection of any alliance with "reformist" unions and socialist parties in favor of a policy of "class against class," a "bolshevization" that further guaranteed its marginality in Mexico. In the midst of a military rebellion led in March 1929, the PCM pushed its campesino leagues to pursue autonomous armed resistance of their own. In response, President Portes Gil broke ties with the Soviet Union, outlawed the PCM and *El Machete*, and repressed its affiliated labor federation. His government sent many militants to the penal colony at Islas Marías, forced others underground, and expelled foreign Party militants like Tina Modotti. In the process they devastated the PCM's influence among labor unions.[3]

The reorientation of the labor movement after 1934 depended on a variety of factors. The 1933 nomination and 1934 election of Lázaro Cárdenas as president was part of a measured radicalization of a sector of political elites over the meaning of the Revolution and, in the context of the Depression, over the limits of capitalism and the possibilities for the state to play a greater role in national development, exemplified by the PNR convention that approved a six-year plan and nominated Cárdenas as the presidential candidate. Both ruffled the feathers of Jefe Máximo Calles without directly challenging him.

Cárdenas was a compromise candidate, known as much for his loyalty to Calles as for his role as a radical governor who had pushed agrarian reform in his home state of Michoacán. Even as he launched an unprecedented electoral campaign that covered the entire country, urged campesinos and workers to organize, and promised revived agrarian reform and relief for workers, Cárdenas was careful to pay

homage to Calles, whose protégés were well represented in his initial cabinet appointments. Cárdenas promised renewed, progressive leadership with the possibility of a degree of independence from the strongman Calles and a fulfillment of many of the stagnant promises of the Revolution, even as he was denounced by opponents from different sectors as much for an assumed continuity with Calles as for an alleged communism.[4]

Cárdenas realized that he needed a mass social base to undertake a broad agenda of socioeconomic reforms that included massive agrarian reform, working-class organization, and the nationalization of foreign companies. He advocated unified national mass organizations to eliminate infighting and support reforms. Just as important, he needed a well-organized and unified base to counter resistance from the church, national and international capital, and conservatives within his own party and government, many of them generals with armed followings who looked to Calles to enforce the status quo. The ready and organized support of workers gave Cárdenas an important margin for political action, even as labor actions subjected the new president to working-class pressure and the autonomous initiatives of labor leaders. Even in rural areas, the success of government policies among the far larger campesino population often depended on teachers and agricultural workers organized by the Communist Party.[5] Cárdenas imagined a strong state that would balance the interests of capital and an organized working class, but questions remained. What mix of capitalism and socialism would the state negotiate? Where would urban and rural workers fit in that mix, and how autonomous would they be from their renewed state ally?

Another important factor in the radicalization of labor was the PCM's complete reversal from its ultra-left position of uncompromising confrontation with all nonrevolutionary actors from 1928 to 1933. The swing of the Communist International to a Popular Front strategy from mid-1934 coincided with the Soviet reality of "socialism in one country," after years of an ultra-left advocacy of worldwide revolution showed limited results. Above all it was a response to rising European fascist movements, culminating in Adolf Hitler's appointment as German chancellor in 1933. Its antifascism was as much strategic as ideological, a reaction to inevitable Nazi expansion on the Soviet Union's western flank. By the formal confirmation of the Popular Front strategy in July 1935, most national communist parties were already seeking antifascist alliances with a wide spectrum of political parties and unions and other progressive actors across class and ideological spectrums. The results were significant in France, and even

more dramatic in Spain, where the Communist Party formally joined the elected Popular Front government in 1936.

The PCM was at first hesitant. As candidate Cárdenas wooed workers and campesinos throughout 1934, the still illegal PCM ran its secretary general, Hernán Laborde, as an independent candidate for president. In his campaign, Laborde lumped together the official candidate and the Jefe Máximo. When the government allowed the PCM to openly publish *El Machete* in late 1934, it immediately published a caricature that showed president-elect Cárdenas seated on a throne below a swastika with Calles loyalists while suppressing the working class.[6] As tensions between Callista conservatives and Cardenista progressives rose in the first months of Cárdenas's presidency over accelerating labor conflicts, the Communist Party slogan became "with Cárdenas no, with the Cardenista masses yes."[7]

Through much of 1935, the PCM was quick to identify any individual or group they opposed as fascist. But a turning point was the emergence of the openly fascist and rabidly anticommunist group Mexican Revolutionary Action (Acción Revolucionaria Mexicana—ARM), also known as the Gold Shirts (Camisas Doradas), led by former Villista general Nicolás Rodríguez with support from businessmen and prominent Calles loyalists. On March 2, 1935, as the newly legal PCM inaugurated its headquarters, a hundred Gold Shirts rode in on horseback, injuring members and seizing their archives. Many skirmishes later, during the November 20 Revolution Day commemoration in the capital's main plaza, the Zócalo, mounted Gold Shirts again attacked a group of parading union members, killing three workers and hurting many more. But at the same event, unions and the PCM responded in kind and routed the Gold Shirts.[8] The radical right and radical left fought over the meaning of the Revolution on its symbolic day. A widely circulated photograph by Manuel Montes de Oca captures the dramatic moment when a taxi driven by a unionized driver in the parade crashed against a mounted Gold Shirt, knocking down rider and horse. The image immediately became a symbol of the forces of working-class modernity crushing those of fascist tradition (figs. 7.18 and 7.19).

PCM secretary general Laborde angrily denounced Cárdenas's initial reluctance to contain the Gold Shirts.[9] But the reality of Cárdenas's support for labor mobilizations, his increasingly open confrontation with Calles, and the tentative welcome many sectors of organized labor began to give the PCM meant a gradual shift in the PCM position. By the time Laborde returned from the Comintern Congress in Moscow in July 1935 that made the Popular Front official

policy, the embrace of Cárdenas was the de facto policy of Mexico's Communists.[10]

The Popular Front strategy gave dramatic and unprecedented impetus to the Communist Party, which saw its membership grow from barely 1,000 in 1934 to around 5,000 in 1936 (and a claimed membership of as many as 35,000 in 1939).[11] The Popular Front alliance also facilitated a revitalization of PCM ties to labor and artists, even as it shifted its rhetorical focus from the battle against capitalism to the battle against fascism. The PCM of the mid-1920s that Bertram Wolfe half-jokingly called "a party of revolutionary painters" became one in which intellectuals, artists, and teachers, many of them government employees, played a major role alongside workers from key industrial unions.

The fractured and repressed labor movement that characterized the first years of the Maximato changed rapidly. Efforts to create powerful national industrial unions in the early 1930s—first, among railroad workers in 1933, followed by mining and metal workers in 1934 and petroleum workers in 1936, created synergies and made clear the viability of a national labor front to replace the much-diminished CROM. Former CROM leader Lombardo Toledano founded the General Confederation of Workers and Campesinos of Mexico (Confederación General de Obreros y Campesinos de México—CGOCM) in 1933, which incorporated dissident CROM unions, agrarian organizations, and the influential Syndicate Federation of Workers of the Federal District led by Fidel Velázquez, the head of the dairy workers union. In spite of its varied membership, the CGOCM leaned left, promising a unification of the labor movement, internal democracy, independence from political groups, and attention to pragmatic economic demands. But unions with strong communist leadership were excluded, and the national industrial unions saw little reason to join. Lombardo Toledano came back from a visit to Moscow in mid-1935 singing the praises of the Soviet Union and the Popular Front strategy, even as he kept a certain distance from the PCM and struggled to assuage Velázquez and other anticommunist union leaders within the CGOCM.[12]

Within days of the inauguration of Cárdenas in January 1935, a series of high-profile strikes broke out among oil and electrical workers in Tampico, textile workers in multiple states, and streetcar workers in Mexico City. The growth of worker militancy was evident in the expansion of union membership and the frequency and scale of officially recognized labor conflicts, which rose from thirteen strikes with barely 1,000 strikers in 1933 to 674 strikes and 114,000 strikers in 1936.[13]

A key turning point was the strike of Mexico City telephone workers in May 1935. Calles publicly challenged President Cárdenas by denouncing "constant" and "unjustified" union strikes as "not only ungrateful but treason."[14] The day after, the SME (the electricians union) invited most of the major labor organizations of the country to meet to contest the comments of Calles, defend the rights of workers, and rally behind Cárdenas. The National Committee of Proletarian Defense (Comité Nacional de Defensa Proletaria—CNDP) that they formed promised a "defense against the possible implantation of a Fascist regime in Mexico," threatened a general strike, and declared their intention of "maintaining class unity." The CNDP was unprecedented in its inclusion of Mexico's most important labor federations and key national industrial unions, including those affiliated with the PCM. The following day, Cárdenas publicly sided with labor against his former mentor, embracing recent strikes as "the natural consequence of an adjustment between the two factors involved in production." Soon after, he dismissed all cabinet members associated with Calles.[15]

In February 1936, the CNDP brought the same anti-Calles coalition of unions together in the creation of a new national labor federation, the Confederation of Mexican Workers, under the leadership of Lombardo Toledano and with union leaders affiliated with the Communist Party in positions of importance. By 1938, the CTM could plausibly claim 3,594 affiliated organizations and nearly a million individual members.[16] The Popular Front strategy had been launched: organized labor and the Communist Party had come full circle from the dark days of 1929 and had provoked and helped Cárdenas to create a new political order. Cárdenas had taken clear sides in the clash between right and left by legalizing the communist left, sanctioning strikes, and encouraging labor unity. By the end of 1936, he had dissolved the fascist ARM and exiled Calles and Morones.

ART IN THE MAXIMATO

As with the labor movement, radical artists faced a dearth of opportunities in the years of the Maximato. The first governments of the Maximato limited funding for the Open Air Painting Schools and their urban counterparts, and commissions for public art projects that employed artists virtually disappeared. Many artists associated with the PCM were fired from teaching and bureaucratic positions.[17]

At the same time, hardliners in the clandestine PCM made it dif-

ficult to combine political militancy and art. Soon after Rivera's return in 1928 from a trip to Moscow, he was expelled from the PCM, allegedly for his work on government murals and his acceptance of the directorship at the Academy of San Carlos. Only in the 1950s did he return to the party. Rivera spent much of 1930–1934 painting murals commissioned by wealthy businessmen in San Francisco, Detroit, and New York City.

By contrast, Davíd Alfaro Siqueiros largely abandoned art in the second half of the 1920s and organized miners in Jalisco on behalf of the PCM. After he returned from representing Mexican workers at the Congress of Red Trade Unions in Moscow in the spring of 1928, he was continually harassed by the government for his organizing activities. On May Day 1929 he was arrested and imprisoned and was eventually moved to house arrest through 1931 in the colonial town of Taxco. Just before his arrest, Siqueiros was briefly expelled by the PCM for "indiscipline."

Siqueiros's detentions allowed him to dedicate himself to art in a way that he hadn't since he was a student. In prison he produced thirteen mordant woodcuts that included a portrayal of an employer lockout of workers and a proletarian "slave" with his arms bound from behind, a theme he first explored in the early pages of *El Machete* (plate 4).[18] In the 1931 easel painting *Accident in the Mines*, three mine workers labor to remove huge stones that pin down a fallen comrade. In 1932 Siqueiros was granted permission to leave Taxco for exile in the United States. Orozco, drawn by greater opportunities, had already been working almost continuously in the United States from 1927. These three would return to Mexico only after the election of Cárdenas in 1934.[19]

Many younger, lesser-known artists spent shorter periods abroad during the Maximato, particularly in New York City and Moscow, but most remained in Mexico. They relied on jobs as teachers in public schools in the capital, or served a kind of political exile with the SEP's Cultural Missions in the provinces. In addition, they illustrated books and government publications and channeled some of their work toward a US audience.[20]

A radical visual discourse around workers' struggles was most fully pioneered in the early 1930s by Mexican artists working in the United States. During his stay in Los Angeles in 1932, Siqueiros painted *Workers' Meeting* on the outside wall of the Chouinard School of Art. The mural depicted a militant union leader addressing a multiracial crowd of white, brown, and black workers on a street corner not un-

like the ones near his mural. It was notable not only for the theme but also for its execution. Siqueiros experimented in collective painting with local artists and used an industrial spray gun to paint directly on the exterior cement wall. Its impact was limited; as with another of his Los Angeles murals, the alarmed patrons quickly shielded it from public view with a fence and eventually whitewashed it on orders from the police.[21]

Far more complex and influential in theme (if traditional in its fresco technique) were Diego Rivera's 1933 *Detroit Industry* murals for the central courtyard of the Detroit Institute of the Arts, a monumental and utopian representation of the interaction of nature, skilled workers, and advanced machines that produced the Ford Model A in the River Rouge factory, the largest and most advanced in the world at the time. By capturing what seemed to be every step in the process of production, from mined raw materials to the assembly lines, he went far beyond workers and tools or the limited industrial backgrounds of his own or others' art in the 1920s. Rivera's mural, a celebration of technology and the labor of workers of a variety of races, was a brilliant evolution of Romano Guillemín's 1910 *National Industry* (fig. 1.2), though for a different industry and nation. Absent in Rivera's triumphant portrayal of the graceful dance of workers and machines is any hint of alienation or class or racial conflict, an odd oversight—or a concession to patron Henry Ford—given Rivera's avowed Marxism and the recent massive layoffs, violent repression of protests, and deportation of Mexicans in Detroit.[22]

When Rivera was commissioned the next year to paint a mural at the new Rockefeller Center in New York City, he may have tried to prove himself to his critics on the left. He painted his *Man at the Crossroads* around a worker engaging technology and nature at the center of a cosmos divided between a decadent, wartorn capitalism and a hopeful, Soviet communism. When he refused to remove a portrait of Lenin, he was dismissed, and his unfinished mural was chipped from the wall. Soon after his return to Mexico in 1934, he repainted a modified version of the destroyed mural in the soon-to-be inaugurated Palacio de Bellas Artes of Mexico City. The blond worker at the technological and political center of the universe was now flanked not only by Lenin but also by Trotsky and Rivera's non–Communist Party allies on the American left. Dramatic and provocative when painted on the walls of the financial capital of the world and on behalf of one of its titans, it lost much of its impact as a state commission in the smaller, narrow-viewing spaces of the ornate, neoclassical palace in

the capital of a developing nation.[23] Even so, these two murals and his next helped recenter radical art in Mexico toward a more global vision of labor and its relation to capitalism and technology.

In 1935 Rivera completed his monumental narrative of Mexican history begun in 1929 on the walls of the massive stairway of the National Palace. The final south wall diverged from the bright colors and crowded nationalist epic of the main wall completed in 1930. Leonard Folgarait brilliantly reads the main wall as a nationalist simulacrum of the Mexican flag, the embodiment of muralism as part of the postrevolutionary state building project. The main wall featured a dense narrative, with the center dominated, like the Mexican flag, by the foundational Aztec symbol of an eagle clutching a serpent and perched on a cactus. The foreground depicts the Spanish conquest of indigenous peoples as the basis for the nation's mestizo race, and the upper corners reference the French and US interventions that, along with the Revolution, framed national consolidation. The upper half of the main wall unfolds around an ambiguous class division in which anonymous members of the peasantry and working classes, their backs to the viewers, observe a crowded montage of national leaders who in real life had often been at odds with each other (Díaz, Carranza, Zapata, Calles), unified apparently by their opposition to foreign invasions.[24]

But the political and social scene in 1934 when Rivera began the final wall was very different from the political repression and relative social passivity of 1930, when he completed the main wall. The final wall, titled *Mexico Today and Tomorrow*, brought the chillier tones and global Marxist vision of *Man at the Crossroads* to contemporary Mexico, just as workers and campesinos pushed for agrarian and labor reforms advocated by the newly elected president, Cárdenas.

At the top, Marx points workers upward and leftward toward the socialist future, holding a fragment of the *Communist Manifesto* up to a campesino, a worker, and a soldier: "The history of all hitherto existing society is the history of class struggles" it begins, ending with "it is not a matter of reforming society as it exists, but rather of forming a new one." The narrative of the mural winds upward from the exploitation of campesinos and workers to the confrontations of striking workers with fascist police. At the center, former president Calles, portrayed as a founding father in the main wall, is now framed by the machinery and corrupt relations of capitalism, including foreign capitalists and the Mexican military and church. If Marx points to the socialist utopia at the top left, in the top right Mexico City and

its Zócalo, bordered by the National Palace, is literally on fire from the strikes and heightened confrontations of Cárdenas's first year as president. Airplanes flying through the smoke-filled plaza allude to the recent bombing of Ethiopia by fascist Italy and may have also reminded contemporaries of the shower of illustrated flyers unleashed over the city by planes during repeated labor mobilizations (fig. 5.17). Signed and dated November 20, 1935, Revolution Day, Rivera painted as the city burned from strikes and Communist and labor organizations confronted the fascist Gold Shirts and Calles loyalists. Rivera's final wall of the National Palace mural suggests the historical contingency of artists' collaboration and contestation when painting for the government.

Siqueiros and other artists had denounced Rivera as the "house painter" of the government, and he may have felt he had much to prove. His citation of Marx invoking revolution over reform and his representation of recent working-class mobilization as a revolutionary conflagration may also reflect the "Permanent Revolution" advocated by his new political ally, Leon Trotsky, more than the recently formalized Popular Front strategy of communist parties that had expelled both Trotsky and Rivera.[25] At any rate, the Cárdenas government could afford an incendiary mural about Mexico that pleased neither the Callistas nor the Communists.

Despite Rivera's pioneering work on these three murals, all of which made workers central protagonists in national and global histories, he remained reviled by many of his fellow artists resentful of his fame and his relations with the government, US patrons, and Trotsky.[26] As the PCM rose to cultural prominence through its Popular Front strategy, Rivera declared himself part of the "leftist opposition" to Stalin and his emerging socialist-realist orthodoxy on art. Rivera and his art, even with its focus on the working class, was deemed more dangerous by much of the left than the "eccentric" right turn of Dr. Atl, now an enthusiastic advocate of the strong-armed fascist dictators of Germany and Italy.[27] Atl and Rivera were on opposite political extremes of an artistic community increasingly drawn toward Popular Front communism, but Rivera's art and political actions were much harder to ignore.

The unease with Rivera was obvious in the state-sponsored public mural project commissioned by the city government on the walls of the neocolonial Abelardo Rodríguez Market, named after the president under whose term it was constructed. Begun in 1933 in a poor neighborhood, the project incorporated ten young artists, most of

whom would soon join the LEAR, which came to embrace and defend the collective project as its own. Most prominent among these artists was Pablo O'Higgins. In the 1930s, O'Higgins reinvented himself again as his own artist and militant, distinct in style and politics from his former mentor, Rivera. Others included Antonio Pujol, the American sculptor Isumu Noguchi, and the American sisters Marion and Grace Greenwood, who became the first women to paint murals of their own in Mexico. The artists reluctantly accepted the imposition of Rivera as their intermediary with the government but were largely left alone to pursue murals that were inevitably influenced by Rivera's technique and style.

Aware of the conservative motives of government sponsorship, O'Higgins rejected the utopian vision he had once helped Rivera paint at the SEP. "To paint the victory of the proletariat at present," he wrote Marion Gracewood, "merely serves the demagogic ends of the Gov [sic]." Aware of the very different audience in the market, he urged his peers to emphasize local conditions "and the necessity for struggle and means of struggle," insisting that their murals "touch the everyday problems of the people—get immediate demands up on the walls with as little allegory as possible." Broadly organized within the requested themes of food, safety, and hygiene, the best murals paired the monopoly control of food production and mining with, in the words of James Oles, "lurking dangers, including poverty and unemployment, the suppression of strikes, and the triple threat of war, fascism and imperialism."[28]

In O'Higgins's own mural cycle, *The Worker's Struggle Against Monopolies*, a series of vignettes connects corn production with hoarding by commercial middlemen and the struggles of the urban working class against hunger, exploitation, and the forces of fascism. In one panel (plate 9), a stream of corn connects the farm painted above where it was grown to a worker unloading bags of grain in the city. In spite of agricultural abundance, a worker in overalls stands below, his fist clenched in anger as his wife and children go without food at home.

When funding for the market murals expired in 1935, the LEAR pleaded unsuccessfully with Cárdenas to intervene to extend the incomplete project, as well as to create new mural projects for LEAR members.[29] The project's Callista origins may have played a role in its termination, but journalist J. H. Plenn wrote of other factors. In the context of tensions between Calles and Cárdenas, "the Cardenistas sought a more immediate, more widespread form of reaching

the people. The press, the radio, the poster become the favored mediums. Funds were withdrawn from mural work and shunted toward the more direct publicity."[30]

Although Mexico was full of would-be and former muralists, the urgency of the moment and the policy of the Cárdenas government shifted artists' aspirations and media from murals commissioned for monumental government buildings, to murals in local schools, and to graphic works in periodicals, posters, and flyers that were more immediate and more accessible to the public. Even so, the didactic portrayals of Marxist relations of production and worker protest developed in the murals of Rivera and the murals at Abelardo Rodríguez Market would be assimilated into the publications and occasional mural commissions of the LEAR.

A variety of organizations and graphic traditions fed into the formation of the LEAR, starting with the first postrevolutionary organization of radical artists in 1922, the SOTPE and its organ, El Machete. But even the dark years of the Maximato offered other precedents. The Communist Party's El Machete continued to publish clandestinely, largely devoid of illustrations. In 1931, PCM members Siqueiros, Méndez, O'Higgins, and Juan de la Cabada formed the group Intellectual Proletariat Struggle (Lucha Intelectual Proletaria—LIP), which published a single October issue of their "wall periodical" Llamada. The masthead featured a banner with the title stretched across a smoke-filled row of factory smokestacks and whistles calling the working class to labor and organize.

Other short-lived collectives published one-off issues in a similar format and aesthetic in subsequent years, such as Golpe and Choque, associated with the Alliance of Workers of the Plastic Arts and edited and illustrated by overlapping groups that included younger artists like José Chávez Morado, Jesús Guerrero Galván, Máximo Pacheco, and Roberto Reyes Pérez. These artists had close ties to progressive sectors within the PNR and the SEP.[31] More durable and artistically significant was the organization noviembre, spelled with lowercase letters and formed in 1929 in Jalapa by writers and artists with roots in Estridentismo—José Mancisidor, List Arzubide, and Julio de la Fuente. Among their notable endeavors were Mancisidor's novel Ciudad Roja (1932), with a cover by Méndez, and the journal ruta, which published regularly from 1933 to 1938.

These overlapping groups sought to move beyond the nationalist cultural lines of state-sponsored journals like Horizonte and Crisol and endorse a Marxist cultural politics whose art and literature aimed

5.1. Leopoldo Méndez, *Pure Art vs. Workers, Llamada*, 1931. Courtesy of the Museo del Estanquillo. Permission of Pablo Méndez.

more instrumentally at reaching and radicalizing the working class. At the same time, they were caught up in artistic rivalries, directly attacking the "art for art's sake" orientation of the artists that came to be identified by their journal, *Contemporáneos* (1928–1931). The Contemporáneo poets, critics, and visual artists advocated a more universal and nonpolitical art and, during the Maximato, attained considerable influence in the Secretariat of Public Education.

For example, a crude Méndez woodcut on the front page of *Llamada* (fig. 5.1) paired an armed artist, or "proletarian intellectual" identified with "LIP" and a worker fighting against an alliance of a fat capitalist, Calles, and an artist representing *arte puro*.

A March 1934 *Choque* headline confirmed the links that radical artists made between political goals and cultural politics. The article ("Pure Art: Pure Faggots") declared that the Alliance "will struggle for art for the workers, for the masses, and against the so-called pure art." An illustration by Guerrero Galván (fig. 5.2) contrasts two artists: "ONE OF THE OTHERS" is an effeminate and overdressed Contemporáneo artist (Agustín Lazo) painting a Cubist scene on an easel in a studio; "ONE OF US" is a manly artist in overalls painting a mural, in a public space and realist style, of an armed worker in a factory

setting. Next to the "Other" is a book defending homosexuality by French writer Andre Gide; next to the proletarian artist is a tome by Marx.[32] The image has roots in Posada's *41 Faggots* and Orozco's *Fascist Babes* (figs. 1.11 and 3.14). These artists and their organizations eventually joined the LEAR.

The precursor publication that most resembled the journal of the LEAR is noviembre's *ruta*, begun in Jalapa in 1933. As Claudia Garay Molina notes, *ruta* was largely a failure as proletarian literature but was far more successful as graphic art.[33] *ruta* covers featured vibrant, two-tone woodcuts by de la Fuente, influenced by his time in New York City in the early 1930s. For example, the 1933 May Day issue featured a woodcut (fig. 5.3) that contrasted the struggles of workers, bearing a "strike" banner in English, with the lynching of African Americans. Connected by a hammer and sickle in the bottom-left corner,

5.2. Jesús Guerrero Galván, *One of the Others*, *Choque*, March 1934. Archive of Francisco Reyes Palma.

the image reflects the US Communist Party's support for African-American rights as well as its criticism of a US labor movement that often excluded blacks and supported the repatriation of Mexicans during the Depression.[34] The hanging bodies suggest Orozco's lithograph *Hanging Blacks* done in New York in the same period.

More typical are de la Fuente's covers of individual or collective male workers and campesinos with powerful bodies in confrontations with bosses and the forces of fascism and imperialism. The December 1933 cover (fig. 5.4) is typical in its portrayal of a mass of strikers

5.3. Julio de la Fuente, cover, *ruta*, May 1933. Author's photograph.

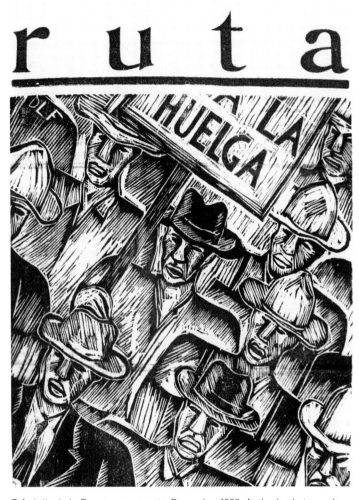

5.4. Julio de la Fuente, cover, *ruta*, December 1933. Author's photograph.

organized around a picket. They are all male, but some are dressed in coats, ties, and Stetsons, with others in overalls and hard hats.

THE LEAR AND ART FOR THE MASSES

Some time between February and April 1934, a small group of visual artists and writers formed the League of Revolutionary Writers and Artists. They invoked the goals and organization of the LIP, with a nod

to the John Reed Clubs in the United States and European counterparts tied to the Soviet-based International Union of Revolutionary Writers. Although Siqueiros may have been the inspiration and dominant personality, he spent most of the life of the LEAR in New York City and Spain. The fundamental organizational and aesthetic tasks of the early LEAR were left to Méndez, its first president, artists Luis Arenal and O'Higgins, and writer Juan de la Cabada, all affiliated with the PCM. By April, the LEAR counted some thirty artists, writers, and musicians as members. Though visual artists would remain its largest group and most active core, over the next four years its presidents would include Arenal, de la Cabada, Mancisidor, and the musician Silvestre Revueltas.[35] The government's greater tolerance toward labor and the PCM during Cárdenas's early presidential campaign facilitated the LEAR's survival, even though it was organized as a challenge to the government and its official candidate.

The aggressive title of its journal *Frente a Frente* (literally "forehead to forehead," i.e., "class against class") borrowed a slogan from the Comintern's 1929 congress and reflected the LEAR's aggressive, ultra-left position and close ties to the PCM.[36] The first issue (November 1934) proclaimed the LEAR to be "at the service of the working class and against the current capitalist regime."[37] *Frente a Frente* aimed to create a proletarian art and literature, reach out and radicalize urban workers, and denounce the Mexican government. Early issues specifically addressed the working class, with denunciations of reformist union leaders, the bourgeoisie, and the "fascist" PNR. The opening editorial established the oppositional poles that shaped the first three issues in visual terms, as if describing the prints that adorned its pages:

HERE: The workers' muscles; the hand that sows and proletarian thought.
THERE: The blood-sucking capitalist, the pocket of the bourgeois, puffed up behind the revolver of the general and the saber of the inspector of police.[38]

The artists of the LEAR extended the print traditions of Posada and *El Machete*, using linoleum and woodcuts to create bold, cheap, accessible, and easily duplicated images that could be posted on walls and incorporated into journals. The first two covers, by coeditors Méndez and Arenal, suggest its initial orientation, its aesthetic influences, and its two main tropes. The first, a relief print by Méndez (fig. 5.5), denounced the inauguration of the ornate Palacio de Bellas Artes, begun during the Porfiriato and finished during the Maximato. How, Arturo

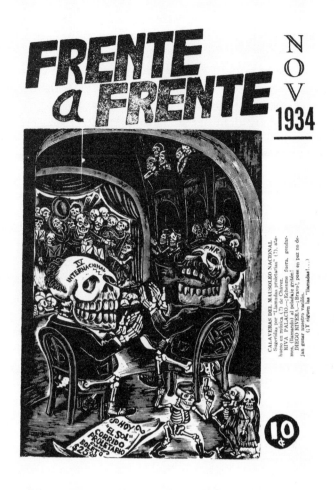

5.5. Leopoldo Méndez, *Calaveras del Mausoleo Nacional*, *Frente a Frente*, November 1934. Permission of Pablo Méndez. Author's photograph.

Zepeda asked in a related article, could tickets for Carlos Chávez's inaugural concert "Proletarian Calls" cost between eight and sixty-five pesos, when the "paltry minimum salary" kept proletarian homes in misery? "There is no basic difference between the Porfirian dictatorship of twenty-five years ago and the one exercised now by the new progressive bourgeoisie," he pronounced.[39] Méndez's cover features two Posada-inspired *calaveras* in seats of honor at the opening performance of the new "national mausoleum." Identified by an adjacent

dialogue, one represents a fat Diego Rivera at the service of capitalism and the Trotskyist "IV International," the other Carlos Riva Palacio, president of the PNR, with a swastika on his seat. On the stage, Chávez receives the enthusiastic applause of well-dressed skeletons, while in the foreground a twenty-five-peso ticket and an armed guard keep a tiny worker in overalls and his wife from the concert whose very name invites them.[40]

The LEAR's critique of the inauguration was most certainly felt by the SEP officials administering the Palacio de Bellas Artes, who hastily organized an "Art for the Worker" series of free concerts and lectures there the following month.[41] And the LEAR's attacks on the "bourgeois fascist" state don't seem to have affected members' continued employment in the education bureaucracy, the most progressive government sector during the last years of the Maximato. Méndez himself had been employed as director of the drawing and plastic arts division of the SEP for much of 1932 and 1933 and spent much of 1934 teaching in Morelia for the public arts school. Their continued employment as they attacked the government in *Frente a Frente* also suggests a growing political permissiveness during Cárdenas's presidential campaign, as well as his awareness of the need for artists and intellectuals to carry out his projects of legitimization and reform. It also suggests artists' constant balancing act between their material needs and their freedom to challenge the government.[42]

The inauguration of Cárdenas a few months later dramatically opened up space for critiques from the left. A January 1935 LEAR poster recounts four demands made of the newly inaugurated president: freedom for imprisoned labor leaders, legality for the PCM, an end to the ban on *El Machete,* and a resumption of relations with the Soviet Union. The poster acknowledges the successful fulfillment of all but the last, which did not occur until Mexico declared war on the Axis powers in 1942.[43]

The first three issues of *Frente a Frente* celebrated the progress of the Soviet Union but paid little attention to European fascism—the "f-word" is used entirely in a Mexican political context, often by way of the divisions on the left. An article in the third issue—published a month before the Calles-Cárdenas showdown, exposed the "false radicalism" of labor leader Lombardo Toledano and his new "aristocratic" labor journal, *Futuro,* full of drawings from the US communist press. A May 1935 woodcut, probably by Arenal, shows Lombardo Toledano allied with Gold Shirts against "revolutionary workers."[44]

The cover of the second issue, published as Cárdenas took office,

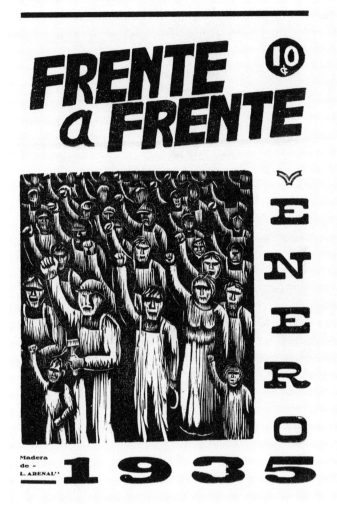

5.6. Luis Arenal, *Frente a Frente*, January 1935. Permission of Graciela Castro Arenal. Author's photograph.

featured a woodcut by Arenal (fig. 5.6) that addressed the imperative for working-class organization at the heart of early issues: a sea of men in overalls extend their fists in solidarity. The sharp contrasts, the uplifted right arms, and the hammers and sickles dangling in some hands all suggest a very public class struggle, one where women, largely excluded from representations of laboring workers, are scarce but prominent in the foreground, ultimately tied by the presence of

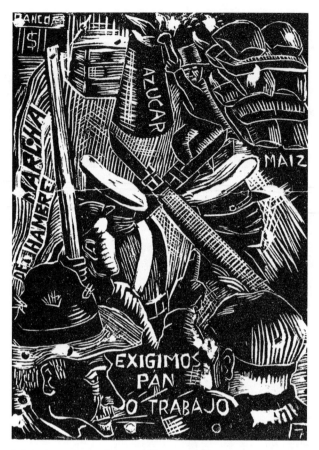

5.7. Anonymous, *We Demand Bread or Work*, *Frente a Frente*, May 1935, page 14. Author's photograph.

their children to their role in reproduction. Like de la Fuente's earlier *ruta* cover and Arenal's previous work for the John Reed Club of Los Angeles, the visual vocabulary of the militant masses is distinct from the allegories of victimized and divided workers or the symbolic trinities of workers, campesinos, and soldiers in the early *Machete* prints and drawings in the 1920s. The motif of the united and mobilized proletarian masses in charge of their own destiny became central to the political art and photography of the decade, along with its dystopian and nationalist variants.

Through the third issue, with printmakers Méndez and Arenal on the editorial committee, prints remained the primary visual medium of the magazine. An interesting example (fig. 5.7) is the anonymous print *We Demand Bread or Work*, which harkens back to the hunger

and unemployment marches on the capital city the PCM organized in 1931–1932.[45] The dense, complex organization of the print synthesizes the direct, systemic relationships featured in the Abelardo Rodríguez Market murals, photos of which were included on the same pages. The Chaplinesque tramp and unemployed worker foregrounded in the print protest against a system in which well-armed capitalists monopolize the corn, sugar, and bars of gold accumulating at the top. Arturo Zepeda's poem six pages later extends the narrative: in "Hunger March," indignant workers tread the asphalt with fists extended, shouting "¡We want bread!, ¡bandidos!," ignoring the warnings and masks of reformist leaders and menacing soldiers. "Don't betray your origins!!!" they urge their fellow workers, ". . . a new world is finally born!!!"

In its first year, the LEAR struggled to reach the mass audience portrayed on their journal's covers. President Luis Arenal sent copies of the first issue to a variety of unions, urging members to subscribe and contribute, enroll in classes, and collaborate with the LEAR's distinct divisions of theater, music, and painting "in your struggles against capitalist exploitation."[46] *Frente a Frente* editorials made similar invitations to "worker-artists." Two early issues included essays by "Mexican workers," celebrated by the editor as "dialectic" in their ability to expose a "world in decomposition" yet organize "the outlines of the proletarian world of tomorrow." But for the most part, its proletarian art was produced by middle-class intellectuals informed by Marxism.[47]

A third focus was the debate among artists themselves about their art and role in society. In the May 1935 issue, Siqueiros, briefly back from New York City, extended his recent attacks on Rivera as the "house painter" for the Mexican government, vendor of "Mexico as curiosity" with "an archaic technique" and a "counter-revolutionary line" (i.e., Trotskyism).[48] The muralism represented by Rivera, he insisted, "simply reproduces official art, that serves official demagoguery, that helps the government lie to the masses of workers . . . making them believe that it is socialist." In late August, Rivera and Siqueiros engaged in a series of high-profile, public debates in front of their peers that ended in "Nine Points of Agreement." The most central was the need for a more critical and collective revolutionary art, one that moved beyond muralism in monumental buildings and the best-known artists (Rivera, Orozco, and Siqueiros) to embrace prints, flyers, moveable murals, and mass media and that served the government and foreigners less and campesinos and workers more.[49] The

agenda was well suited to the priorities and possibilities of the LEAR. It also suited the needs of the Cárdenas government, which looked to new media and new allies to push its reform agenda and mobilize support against political enemies like Calles.

The LEAR and its journal remained a hard sell for workers and intellectuals alike as long as the organization maintained the PCM's hard line. After ten months and two issues, Arenal wrote to the LEAR's French counterpart (known by the acronym AEAR), boasting that membership had grown from thirty to eighty, while denouncing the newly inaugurated bourgeois and pro-Yankee government and the "pseudo-revolutionaries" like Rivera associated with it. But he acknowledged that the activities of the LEAR had been too sectarian and leftist, which had limited its influence among workers.[50]

The hard line became harder to maintain as Cárdenas legalized the Communist Party, permitted strikes, and stood up to Calles and as the National Committee of Proletarian Defense brought together the PCM, Lombardo Toledano, and the labor organizations that *Frente a Frente* had denounced the month before. When Laborde returned from Moscow with the new Comintern line in fall 1935, the LEAR embraced the position of the Popular Front. In October 1935, it made a "call to Unity to the cultural and intellectual organizations of the country" in the face of fascism, imperialism, and war, inviting them to join its ranks. In July, the LEAR had absorbed the noviembre group in Jalapa, and soon after their public call they absorbed three other groups, including two affiliated with PNR.[51] The results were a dramatic expansion in membership—a reported 600 by 1937—that included artists, intellectuals, and professionals.[52]

The LEAR archives maintained by Méndez lack a complete accounting of members, but an undated archival list of its largest division, that of the "Plastic Arts," includes around a hundred members and reads like a who's-who of the capital's politically engaged artists.[53] Even some wary of "committed art" joined, such as writers Efrain Huerta and Jorge Cuesta, both with ties to the Contemporáneos, and painter Rufino Tamayo. In addition, the LEAR opened up branches in several regional capitals, most importantly Puebla, Mérida, and Guadalajara, and incorporated political exiles who received refuge in México, such as the Cuban writer Juan Marinello and the German photographer Enrique Gutmann.

A few women were prominent in the leadership of the organization and the editing and writing of its journal, such as Cuban artist Clara Porset and the writer Maria Luisa Vera, who served on the

LEAR's executive committee, contributed articles to *Frente a Frente*, and formally represented the LEAR at the antifascist writers conference in Valencia, Spain. Other women members, like sculptor Esperanza Muñoz Hoffman, played more prominent roles in organizations closely affiliated with the LEAR.[54] Among the hundred members listed with the Artes Plásticas division were thirteen women, including Isabel Villaseñor, María Izquierdo, and Aurora Reyes. But few women seem to have participated actively in the LEAR's leadership.

Works of art by women featured in *Frente a Frente* include single images by Lola Álvarez Bravo, Grace and Marion Greenwood, Aurora Reyes, and María Izquierdo.[55] The dichotomy suggested in Guerrero Galván's drawing in *Choque*, with the effeminate *arte puro* easel painter on one side and the manly political mural painter on the other, left little room for women, who were largely denied walls of their own to paint. The Greenwood sisters were exceptions, muralists with the relative freedom of foreign women who assumed the visual vocabulary of class struggle of their male peers in their Abelardo Rodríguez Market murals. Under the auspices of the SEP and the LEAR, Reyes became the first Mexican woman to paint a public mural in the public school Revolución, one year after the Greenwood sisters finished their murals in the Abelardo Rodríguez Market.

By contrast, María Izquierdo, who celebrated the maternal role as central to women's "creative force," used her ties with the *Contemporáneos* and the influences of *arte puro* and surrealism to create private and personal easel paintings that eschewed direct reference to politics and destabilized the normative representations of women by the male artists of her day. For example, her 1936 *Allegory of Work*, with its dreamlike landscape, its subversions of the female nude, and fragmented male legs and phallic columns, makes no direct reference to class or work, yet the ambiguities of this and related works evoke the restrictions on women in Mexican society. Aside from the title, it is hard to imagine a painting more distinct from the dominant LEAR tradition.[56]

The Popular Front shift did facilitate a broader embrace by LEAR artists of a variety of artistic influences and media while always privileging the transnational culture of the left as a source of solidarity and aesthetic inspiration. The LEAR repeatedly sought out contact with its French counterpart, but more important, at least until the Spanish Civil War, were relations with artists on the left in the United States. The LEAR appointed a representative in New York to reach out to US artists and intellectuals as well as Mexican immigrants and main-

tained a close correspondence with the John Reed Club and the journal *The New Masses*. In 1935, they sent their proponents of proletarian literature, Mancisidor, de la Cabada, and Miguel Rubio, to the first American Writers Congress in New York, where Moscow's socialist realism mandate was at the heart of inconclusive debates. A year later, the LEAR delegation to the American Artists Conference reflected a far more diverse representation, including Orozco, Siqueiros, Tamayo, Arenal, and Pujol.[57]

Most immediately, growth in membership meant a complicated internal reorganization, new and revitalized activities, and a realignment of relations with the PCM, the government, and unions. The LEAR expanded beyond art, literature, and music to include divisions for theater and cinema, pedagogy, and sciences, as well as a legal and juridical department to advise unions.[58]

Soon after it merged with other groups, LEAR president Juan de la Cabada wrote to a mainstream newspaper clarifying that it was "inexact that the LEAR was a Communist organization."[59] Though many of the new members also joined the PCM, the tight overlap of membership and ideology between the LEAR and the PCM was no longer a given—even as this greater plurality became the new party line. For the most part, both benefited from the relationship, with a core of LEAR members sending a steady stream of articles, prints, and photographs to fill the pages of the resurrected *El Machete*; as late as 1936, the LEAR even sent money to subsidize its publication.[60]

Most dramatic was the realignment between the LEAR and the government. In the same letter, de la Cabada explained that the organization fully supported the government's policies of mass culture, that it was not a part of the official party, and that there was no incompatibility between being revolutionary and working for the SEP.[61] The new LEAR principles and statutes published in 1936 confirmed, on the one hand, the essential role of artists and intellectuals as producers "whose problems don't differ fundamentally from those of other workers" and, on the other, the LEAR's advocacy for the well-being of its members and for working with progressive forces in the government.[62] The SEP offered a sudden largesse, as the PCM and the LEAR became fundamental partners in filling and defending the ranks of teachers, tantamount to an employment agency for its members. This gave a strong incentive to many to join both.[63]

From 1935, the SEP contracted with the LEAR for a variety of its own publications. The LEAR took over the graphically rich *El Martillo* (The Hammer) (fig. 5.8), after merging with the Front of Proletar-

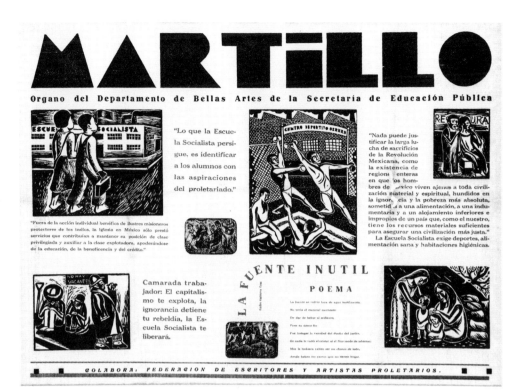

5.8. *El Martillo*, circa 1935. Courtesy of Museo del Estanquillo, Mexico City.

ian Writers and Artists, an organization tied closely to the Secretariat of Public Education. The LEAR version of the *"periódico-mural"* continued as a defense of the government project of socialist education and was widely distributed to rural schools throughout the nation. A variety of flyers and posters promoted the development goals of teachers and denounced the violence they faced from landowners, the church, and hostile campesino communities.

One of the final LEAR projects in 1937 was a series of three literacy textbooks, *Libros de Lectura* (fig. 5.9), to teach literacy to workers in the SEP's Night Schools for Workers, with block-print illustrations by LEAR artists. The unsigned prints and accompanying texts illustrate a variety of working-class experiences, from home life, to work, to exploitation and organization, at times praising government reforms while pushing for more.

In one (fig. 5.10), a worker finishes a wooden wardrobe while the boss puts his feet on the desk, clutches his fat belly, and smokes a cigar. In the accompanying dialogue, two workers speculate how much of the

5.9. LEAR, cover, *Libro de Lectura para uso de las Escuelas Nocturnas de Trabajadores*, 1938. Author's photograph.

sale price of each wardrobe goes to the boss as profit, imagining "the time when all the means of production belong to workers."[64] With more than a million copies printed, the three *Libros de Lectura* were the most far-reaching endeavor of the LEAR's visual artists.[65] Finally, the LEAR made a variety of appeals to the SEP, other government officials, and agencies and to Cárdenas himself for subsidies, the most concrete allowing them to move to a more upscale and central building on Allende Street.[66]

Even as the LEAR's rhetorical focus on working-class culture and

militancy diminished, in the midst of labor unification its ties with unions multiplied beyond those affiliated with the PCM.[67] Instrumental was the organization by the Plastic Arts Division of a Workshop-School of Plastic Arts in October 1935. An outreach letter to unions explained its goal of "making functional revolutionary art . . . for agitation and revolutionary propaganda positively useful to the daily and general struggle of the working people of Mexico." A poster announced (fig. 5.11) classes offered in painting, drawing, stage design, sculpture,

5.10. LEAR, *Diálogo*, in *Libro de Lectura para uso de las Escuelas Nocturnas de Trabajadores*, 1938. Author's photograph.

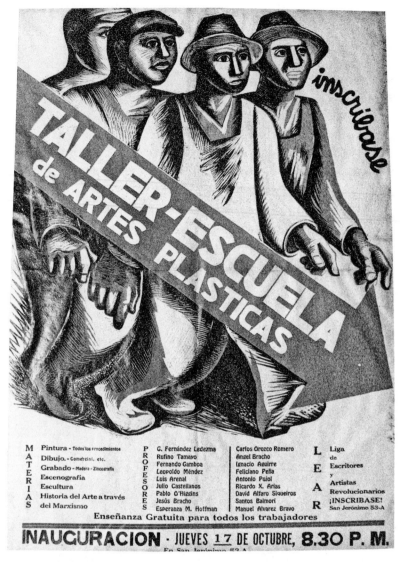

5.11. Leopoldo Méndez, *Inscribase Taller-Escuela*, circa 1935. Permission of Pablo Méndez. Author's photograph.

and a Marxist history of art. The workshop-school model harkened back to Atl's and Rivera's projects for reforming the Academy of San Carlos, reinforced the collective work of artist members, and provided art and education for the newly united working class. Initial members included the painters Tamayo, Julio Castellanos, Carlos Orozco Romero, and Pujol; the photographer Manuel Álvarez Bravo; and

the printmakers Méndez, Arenal, O'Higgins, Angel Bracho, Ignacio Aguirre, and Fernández Ledesma. The Workshop-School became the primary link between the LEAR's visual artists and the working class.[68]

The LEAR also sent delegates to the founding convention of the Confederation of Mexican Workers in February 1936 and soon after began working closely with this newly formed group and its affiliated Universidad Obrera, where members offered art and other classes. LEAR artists reached out more effectively than they had in their first year to unions to distribute their magazine, offer art classes on site and in their Workshop-School, improvise banners for union events and strikes, and contribute to union publications, such as the SME's *Lux* and the CTM's *Futuro*. A flyer in anticipation of the 1936 May Day celebration reminded workers' organizations that the Workshop-School "is equipped to develop any work of design, flyers, posters, periodical illustrations, banners, mural decorations, etc., with a revolutionary orientation and good artistic quality."

Frequently, the LEAR was asked to intervene in conflicts between unions and bosses as well as between different unions. In 1935, a union of stone masons in the capital requested assistance specifically from the artists' division for its meeting before the government Arbitration Board, and they were asked to mediate the attempts of rival teacher federations to merge into a single federation. A year later, the briefly unified National Confederation of Educational Workers (Confederación Nacional de Trabajadores de la Educación—CNTE), which the LEAR had nurtured, charged it with the artistic-cultural work of its weeklong national congress in Mexico City.[69]

Much of the art produced by the LEAR was intentionally ephemeral—simple, unembellished banners with bold lettering, made to be seen from a distance at public protests and parades and preserved only in the occasional photograph, print, or painting; posters on flimsy newsprint designed to hang on street corners, on public walls, and in workers' homes; and flyers distributed by hand or occasionally dropped from above at events. Siqueiros describes a twenty-hour marathon session in which LEAR members worked collectively to complete a banner for a march by the National Committee of Proletarian Defense in 1935. Their efforts met with "a warm applause from the thousands of comrades already gathered for the celebration of the event."[70]

A novel use of art for recruitment printed organizational membership forms on the backsides of prints. For example, on the verso of a Méndez print—of miners producing the ore for bullets that defend

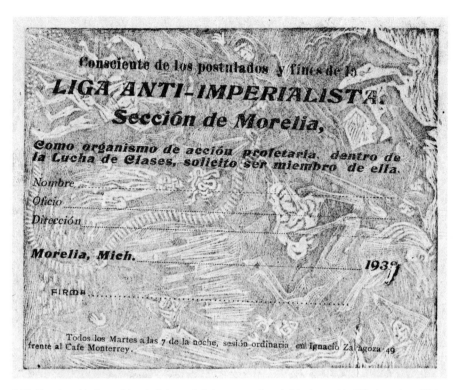

5.12. Membership form, Liga Anti-Imperialista, verso of a print by Leopoldo Méndez, circa 1934. Courtesy of Peter Schneider and Susan DeJarnatt.

international capitalism—there is a membership form (fig. 5.12) to join the Anti-Imperialist League, with the Méndez print lightly bleeding through.[71] The League presumably gained new members, and new members got an original piece of art.

Typical of the flyers is a series, *Hojas Populares*, modeled directly on prerevolutionary broadsheets and the early *corridos* of *El Machete*. The first, by Méndez, featured two men in suits expelling a family and their belongings from their home. The ballad ties the loss of their home to an alliance of the Gold Shirts leader Rodríguez with a gringo capitalist.[72] A separate series titled *Hojas Populares Anticallistas* announced the "Great Anti-Calles March" called by the National Committee of Proletarian Defense for December 22, 1935, to protest the continued provocations of Calles. Two flyers mocked Calles as a drunkard and as a bare-chested pirate, wading through piles of skulls and money. In another, by de la Fuente, a worker throws Calles into a garbage can. More aggressively suggestive of class and ideologi-

cal difference is Manuel Echauri's *Hoja* (figs. 5.13 and 5.14), where a well-dressed but infirm Calles is brought to his knees by a vengeful and violent crowd, armed with rocks and sticks. The caption reads, "HAVE SOME RESPECT, THE HYPOCRITICAL ASSASSIN HAD THE IN-SOLENCE TO SHOUT; BUT THE POPULAR MASSES GIVE HIM WHAT HE DESERVES."

Six months after the demonstration, a LEAR flyer (fig. 5.15) advertised the latest edition of *Frente a Frente* by commemorating the December 22 protest. In Feliciano Peña's print, a plane flies over the Zócalo, dropping "propaganda bombs" over a sea of workers and banners, perhaps the earlier *Hojas Populares Anticallistas*.

In the 1920s, artists from the Open Air Painting Schools and the Estridentistas pioneered the creation of aesthetically sophisticated posters divorced from commercial advertising with their announcements and manifestos.[73] Some of the same artists, now LEAR members, made posters a fundamental medium for political art in the 1930s. Posters appealed to artists as collective projects involving artists, typographers, and printers.[74] Of course, this golden age of the poster also depended on an end to the Maximato policy of arresting activists for hanging posters, and it would be severely curtailed in the 1950s when Federal District regent Ernesto Uruchurtu prohibited the unauthorized hanging of posters on outside walls.[75]

Gabriel Fernández Ledesma and Francisco Díaz de León organized a series of state-sponsored exhibitions in galleries at the Palacio de Bellas Artes, the SEP, and the Biblioteca Nacional (National Library). Influenced by international trends, they created innovative posters to promote each exhibition, with a distinctive style of two-color type, playful geometric text, and typographies inspired by Soviet Constructivism. In the bold text, colors, and style of *Frente a Frente*'s March 1936 cover (fig. 5.16), the text becomes the image, duplicating the style of many posters during this period. Arenal's announcement (fig. 5.17) upon the anniversary of Marx's death combines bold lettering with a multitude of raised fists. Among the state-sponsored exhibitions, three were dedicated to national and international posters themselves.[76] Fernández Ledesma wrote in *Frente a Frente* of the exhibition he curated: "The poster is the theater, the mural decoration and the book that cannot wait to be visited: it goes out into the street, and from the wall shouts its message to the passersby. The voice of a good poster is always heard."[77]

In the SEP's Night Schools for Workers, LEAR artists taught related aesthetics and themes celebrating the worker and socialist education

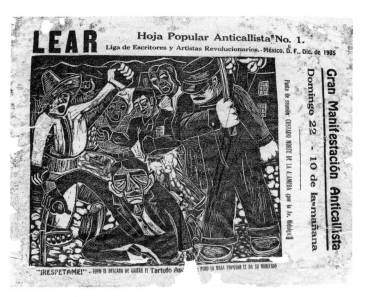

5.13. Manuel Echauri, flyer, *Have Some Respect*, *Hoja Popular Anticallista No. 1, 1935.* Author's photograph.

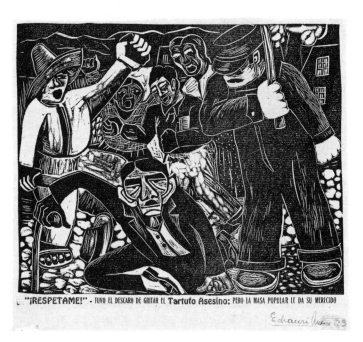

5.14. Manuel Echauri, print version, *Have Some Respect, 1935.* Courtesy of the Philadelphia Museum of Art, 1972.

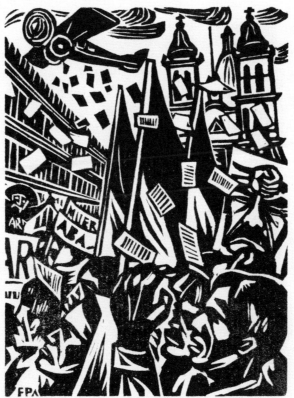

Madera de Feliciano Peña

Compre el Ejemplar de Mayo de

FRENTE A FRENTE

Precio: $ 0.15
Organo central de la LEAR

Número Extraordinario dedicado al Fachismo

¡¡Sensacionales Revelaciones de las Redes
Alemanas del Fachismo en México!!

5.15. Feliciano Peña, *Buy the May Issue*, 1936. Courtesy of Mercurio López Casillas.
Author's photograph.

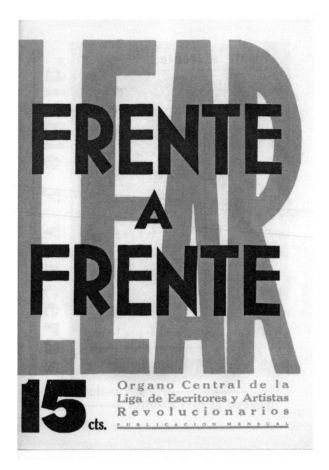

5.16. *Frente a Frente*, cover, March 1936. Author's photograph.

and promoted posters as art and outreach. Many were featured in itinerant exhibitions that travelled the country.[78] LEAR artists, whether as exhibit organizers, artists, or teachers, were immersed in the poster aesthetic and spread it from magazine covers and propaganda posters to the unions and other groups for whom they produced art.

Besides participating in state-sponsored exhibitions, the LEAR sponsored collective exhibitions of its own original art. The first, in May 1936, was criticized for the low quality and narrow political focus of its works. The second was praised for the greater quality and variety of its contributions, as well as the estimated 7,000 visitors, described by journalists as mostly workers.[79]

After the curtailed Abelardo Rodríguez Market murals, the LEAR's frustrated muralists were offered a variety of lower-profile, alterna-

tive mural projects, mostly at schools in rural areas, in Mexico City, and in some provincial cities. Particularly notable is the mural done in 1936 on behalf of the workers of the state print shop, the Talleres Gráficos de la Nación. Painted jointly by Méndez, O'Higgins, Alfredo Zalce, and Fernando Gamboa, and signed simply "LEAR," its terms and content were negotiated between the muralists and members of the union.[80] The printers had been prime movers in the Casa del Obrero Mundial in the 1910s, and the federation of printers, and the Talleres Gráficos in particular had been central to the CROM and the production of *Revista CROM* in the 1920s. By 1936, the union had broken with its CROM past and had dramatically reorganized the government print shop under a regime of worker self-management,

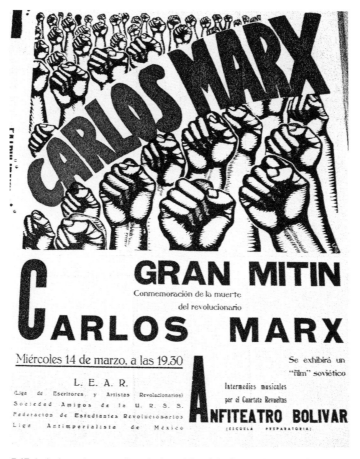

5.17. Luis Arenal, poster. Permission of Graciela Castro Arenal and courtesy of CEMOS, Mexico City. Author's photograph.

5.18. Pablo O'Higgins, Leopoldo Méndez, Alfredo Zalce, and Fernando Gamboa, *Workers Against War and Fascism*, 1936, in the Talleres Gráficos de la Nación. Photograph from Antonio Rodríguez, *El Hombre en Llamas*, 1967.

with close ties to the Communist Party as well as the government.[81] As noted in the Introduction, the director was the journalist Gustavo Ortiz Hernán, an official of the Partido Nacional Revolucionario and a LEAR member. The state agency and the union together subsidized and printed *Frente a Frente*, as well as a variety of other union publications and Ortiz Hernán's proletarian novel *Chimeneas* (*Smokestacks*), thus making it a natural site for a LEAR mural.[82]

The mural was painted on the walls of the main stairwell of the Talleres offices (fig. 5.18) and imaginatively incorporated office doors and their signage. Its title, *Workers Against War and Fascism*, suggests the influence of the LEAR's Popular Front goals. Even so, the mural places the printers themselves at its center, rather than the machines they serve, as in Rivera's 1933 Detroit mural, or the fascism

they struggle against, as in the 1939–1940 mural in the Mexican Electricians Union headquarters (plate 11).

In the central panel, workers gather around a table to discuss a project, with their faces modeled on members of the actual Proletarian Technical Council. It is easy to imagine the pride of the Taller workers in seeing themselves in the mural. At the top corners, two large presses frame the meeting, symbolizing modern technology and the transmission of ideas, and become part of the struggle against the Gold Shirts and forces of fascism who crowd the margins. In one panel a worker prints flyers advocating revolution (fig. 5.19), and in another his coworker distributes them among striking workers.[83] Two narrow upright panels in adjacent vestibules subtly tie the mural to global struggles. In one (fig. 5.18), a worker emphatically embraces a pole, a reference to a Soviet poster reproduced soon after on the cover of *Frente a Frente* (fig. 5.24) that urged the workers of the world to defend Soviet socialism. In the other, a worker struggles with a gas mask, a common visual reference to Italy's use of poison gas in its invasion of Ethiopia.

In the lower-left panel painted by O'Higgins, the fight against union corruption and the forces of reaction is embodied in the rotund body, face, and bejeweled hand of Morones, who leads a variety of blindfolded workers and is partly protected by a sinister Gold Shirt holding a knife. The panel invoked Orozco's 1924 skewering of Morones and union corruption in his San Ildefonso murals and his acerbic drawings in *El Machete*. The much-diminished Morones had remained an important symbol in the 1930s of corrupt unionism due to his staunch political defense of Calles in his conflict with unions and Cárdenas. Cárdenas, sensitive to the need for worker unity in the months after the creation of the CTM, and to potential acts of sabotage from allies of Calles and Morones—still months away from being expelled from the country—ordered the LEAR to paint over Morones's face. O'Higgins eventually obliged after Cárdenas left LEAR protests unanswered (fig. 5.20). But they reproduced the offending image on the back cover of *Frente a Frente* (fig. 5.21), without reference to its forced removal.[84]

Perhaps due to the LEAR's adjustments to the Popular Front imperative, *Frente a Frente* was dormant for ten months after publishing the third issue in May 1935. When it reappeared in March 1936, its larger format and new numbering announced a new epoch. LEAR members had rejected a proposal to change the outdated, militant title, but the new tone was obvious, starting with its embrace of two former political enemies, Cárdenas and Lombardo Toledano.[85] The

5.19. Fragment, *Workers Against War and Fascism*, 1936, in the Talleres Gráficos de la Nación. Courtesy of Fundación Cultural María y Pablo O'Higgins.

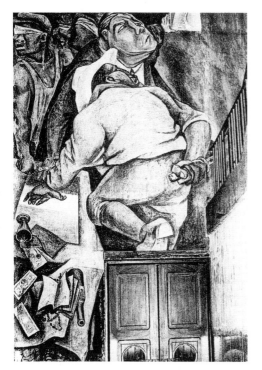

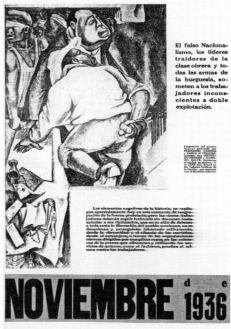

5.20. Repainted version of fragment, *Workers Against War and Fascism*, 1936. Courtesy of Fundación Cultural María y Pablo O'Higgins.

5.21. *Workers Against War and Fascism*, reproduced in *Frente a Frente*, back page, November 1936. Author's photograph.

introductory piece was the inaugural address of Lombardo Toledano for the Universidad Obrera, tied to the newly created CTM, subsidized by the government and staffed by LEAR faculty. Three issues later, the lead article by Luis Chávez Orozco proposed "A Marxist Interpretation of Lázaro Cárdenas" in which the president once denounced as fascist became the embodiment of the social movements that had created him.[86]

As the thematic focus shifted from working-class culture and militancy and domestic politics to global struggles against fascism, the repertoire of art in the magazine moved beyond relief prints to include photos, photomontages, and reproductions of fragments of murals, paintings, and posters—all reflecting the greater variety of LEAR members, activities, concerns, and influences. The absence of any printmaker on the new editorial board from 1936, and the incorporation of German photographer Enrique Gutmann as head of a new photography subdivision and director of finances, meant photographs now outnumbered prints. The March issue included two prints

and a multiplicity of photos, the most ambitious a two-page spread by Manuel Álvarez Bravo and Gutmann. The top five photos feature Calles and economic elites, while the bottom four move from miserable street people to laboring and striking workers in the middle; Álvarez Bravo's already iconic image of an assassinated worker appears bottom-left (see fig. 5.22). The caption below the last photo, a "CAMPESINO ASSASSINATED BY WHITE GUARDS IN THE STRUGGLE FOR LAND," suggests the continued blurring between the representation of workers and campesinos well into the 1930s. The heavily captioned photographs told a story across the page that paralleled the narrative of many LEAR murals and prints produced during the same period. A spread similar in style and subject appeared in the April 1936 issue, credited to "Photography students of the LEAR."

The photo spreads anticipated the fuller use of photomontages. As discussed, Modotti had begun splicing pictures together in the pages of *El Machete* in 1928 to create similar visual arguments. Soviet photomontages were reproduced in early issues of *Frente a Frente* and developed more fully as a Mexican form from 1933 in *Futuro* and *Lux*, most prolifically by Gutmann.[87] It provided an attractive medium,

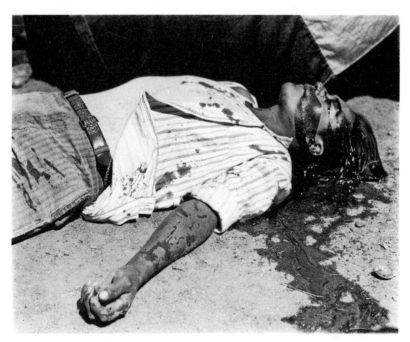

5.22. Manuel Álvarez Bravo, *Striking Worker, Assassinated*, 1934. Colette Urbajtel/ Archivo Manuel Álvarez Bravo, S.C.

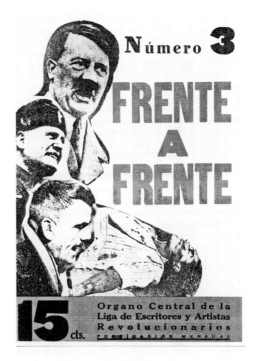

5.23. Photomontage, cover, *Frente a Frente*, May 1936. Author's photograph.

with its modern, realist aesthetic, its ability to make explicit political connections, and its collective aspect, often bringing together photographs by different photographers without acknowledging authorship. The May 1936 cover (fig. 5.23) of *Frente a Frente*, a special issue on fascism, consolidated the magazine's use of photomontage, with a suggestive collage of portraits of Hitler, Mussolini, former president Calles, and Álvarez Bravo's assassinated worker, thus linking international fascism to domestic politics and the repression of the working class. A montage-like centerfold in the same issue linked multiple pictures with arrows that similarly led from Hitler to Calles to the Mexican press to the Gold Shirts.

The next cover (fig. 5.24), published days before Franco's military rebellion in Spain, combined two European photomontages that revealed the international artistic influences and the Popular Front concerns of LEAR artists. One was a celebratory poster by Gustav Kutsis of a triumphant worker straddling the globe with a banner urging the international proletariat to defend Soviet socialism. The poster had been featured on the program for that year's exhibition of Soviet posters and reproduced in *Futuro* with the slogan translated into Spanish.[88] The other featured Spaniard Josep Renau's additions of Nazi images and Spanish text to John Heartfield's photomontage of a swastika constructed in coins. The cover, a collage of distinct collages, thus created something new from three different sources.

REPRESENTING WOMEN

One of the biggest contradictions of working-class unity was the marginal representations and exclusion of women as workers. For the male

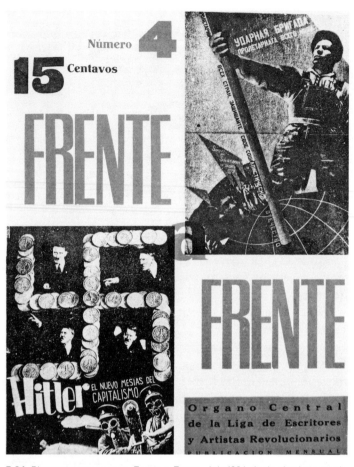

5.24. Photomontage, cover, *Frente a Frente*, July 1936. Author's photograph.

union leaders of the 1930s, and for many artists that identified with workers and the labor movement, workers were naturalized as male, even as women remained a significant portion of the workforce and participated in the transformations of the decade as factory workers, teachers, artists, and organizers of social and feminist organizations.

A photograph of the June 12, 1935, meeting that constituted the National Committee of Proletarian Defense shows a group of men in suits, with no women present.[89] Similarly, the founding of the CTM was largely a male affair. The lone intervention by a *compañera* noted in the minutes of its founding congress was by feminist organizer Concha Michel, who proposed the establishment of a Feminine Secretariat. Michel was a former Communist and one of the more radical founders in 1935 of the Sole Front for Women's Rights (Frente Único pro Derechos de la Mujer—FUPDM), which incorporated a variety of

women's organizations, including those with ties to the PCM, to the PNR, as well as to independents. As FUPDM's membership reached a reported 50,000, they expanded their goals beyond women's suffrage and mobilized rural and urban women throughout the country, in conjunction or in competition with government efforts.

At the founding of the CTM, Lombardo Toledano explained to Michel that it "could not make distinctions regarding workers, between men and women, just as it doesn't in reference to age and nationality."[90] But CTM unions did make those distinctions. In the next months, FUPDM could count on CTM support in their protests over inflation, access to affordable housing, or their attempts to unionize domestic workers; but as Jocelyn Olcott has shown, when women insisted on access to traditional male spaces, like the sixty FUPDM members who demanded access to work in the docks and salt mines in Salina Cruz, they encountered CTM resistance.[91]

In contrast to the prevailing tendencies of the labor movement, the PCM pioneered the public and rhetorical defense of women's rights. From the early 1930s, it began to organize women as workers, emphasizing their fundamental role as "factors of production" rather than reproduction, encouraging their participation in party and union leadership, and celebrating their militant struggles. The PCM was at first reluctant to acknowledge women's gender-specific demands within and outside the workplace and refused to support the separate women's organizations advocated by the PNR and other women's groups to press such demands. When Michel, the companion of PCM Secretary General Laborde, returned from a visit to the Soviet Union in 1933 and began criticizing the party for not acknowledging sexual difference, she was expelled. But by late 1935, following the Popular Front turn and paralleling its labor strategy, the PCM embraced the creation of the FUPDM and its expanded agenda.[92]

A 1937 party memo notes that 8.6 percent of party members were women, though the figure both obscures and reveals, since it simply adds the category "women" to a variety of occupational categories that included women ("36.8% factory workers; 32.4% teachers; 19.5% campesinos; 8.6% women and the rest professional employees and intellectuals"). Even in this self-described vanguard, conservative attitudes about gender roles required a careful balance between conflicting tropes of militancy, self-sacrifice, and moral purity. One public PCM memo urged organizers to recruit "the most selfless [abnegada] and active laboring and campesina women." A male party leader lamented privately that in the party's Women's Commission "there have been until recently sexually relaxed women and lesbians" such that "many

5.25. Raul Anguiano, in *El Machete*, March 11, 1936, page 1.
Author's photograph.

male workers won't bring their women to the [party] for fear that they will be contaminated in that environment of corruption."[93] In 1936, Maria del Refugio Garcia was the only woman among the fourteen members of the party's central committee.[94]

Even so, the party newspaper *El Machete* included Consuelo Arango among its editors and featured a variety of images of workingwomen.[95] In an ink drawing by Raul Anguiano (fig. 5.25), a compact procession of women bear a banner announcing a conference on the rights of women workers. Many wear a type of skirted overall, attesting to their role as workers, while the heads of others are covered in the traditional rebozos. While two women extend one fist in a militant salute of solidarity, other women hold or caress children, as in Arenal's earlier *Frente a Frente* cover (fig. 5.6). In the same

issue, a print by Guerrero Galván announces International Working Women's Day with a rare image (fig. 5.26) of women in a factory setting. While one woman assuredly manages a complicated machine, another cradles her baby as she administers a power lever. As with the Anguiano drawing, the provocative image of female productive labor is stabilized by a reminder of her role in reproductive labor. Or perhaps the image is a cautionary tale, echoing an earlier PCM denunciation of the limited provisions for maternity leave in the 1931 labor code, which meant "the children of working women will be practically born on machinery."[96]

A month earlier, two images in *El Machete* depicted women as central to the labor unification congress in which the CTM was founded. In a full-page print by Méndez (fig. 5.27), a woman marches between a campesino and a miner who sweep away the diminutive figures of Calles, the Gold Shirts, and Wall Street in the path toward worker unification. The image transforms two oft-repeated symbols of alliances dating from the first *Machete* issues and Rivera's SEP murals—the duo of the revolutionary worker and campesino embracing, and the related trinity including the revolutionary soldier, here replaced by the revolutionary woman. Of course, the trio contains its own gendered limits. The men, in worker and campesino clothing, mark the rural and urban proletariat as male, wielding their scythe and pick-ax as the equivalents of the hammer and cycle. The barefoot woman wears the traditional clothing of a campesina, an unchanged and interchangeable female bridge between urban and rural, and wields a child that symbolizes her essential role in reproduction.

By contrast, another Méndez image (fig. 5.28) in the same issue portrays a woman with different markers of social status and employment. Sponsored by the Alliance of State Workers, formed in 1935 at the initiative of Cárdenas, the central figure is a male worker in overalls, presumably representing the working class and perhaps state employees involved in manual labor. But the state bureaucracy employed growing numbers of middle-class office workers, many of them women. Thus the male worker is flanked on one side by a woman with short hair and modern fashionable clothing and, on the other, by a man in a suit. In the mobilized masses that surround the trio, women in similar dress figure prominently. The image fittingly captures the PCM's Popular Front aspirations of a diverse but united working class.

Among the images of working-class life portrayed in the three *Libros de Lectura*, created by LEAR artists, one image of women workers stands out (fig. 5.29). As the adjacent text explains, a "bubbly" group of women with modern dress and short hair leaves the work-

5.26. *Jesús Guerrero Galván*, in *El Machete*, March 11, 1936, page 3. Author's photograph.

5.27. Leopoldo Méndez, *Viva el Congreso de Unificación*, also printed in *El Machete*, February 22, 1936. Courtesy of Museo del Estanquillo, Mexico City. Permission of Pablo Méndez.

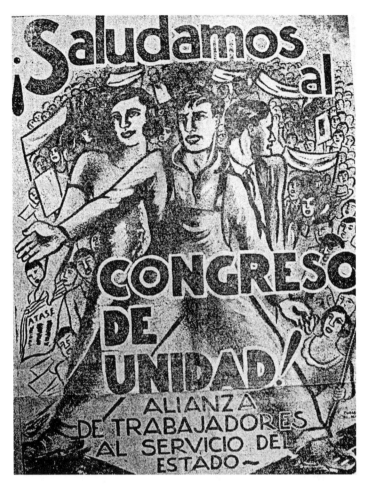

5.28. Leopoldo Méndez, "Saludamos al Congreso de Unidad," in *El Machete*, February 22, 1936. Permission of Pablo Méndez. Author's photograph.

shop, walking arm in arm. "Where are they going?" To the Union of Seamstresses, because "they have understood their position in the realm of social relations; they know . . . that, united, they can defend themselves more efficiently from the exploitation they are subject to." Of course organization and agency of these *mujeres de lucha* were made acceptable by the very segregation by gender and pay within that industry. Nonetheless, the image subverts male labor discourses and most LEAR images by showing the reality of modern working-women with public lives and labor solidarity.

Other images in the same textbook further extend the role of women beyond their traditional spheres. In Ezequiel Negrete's *Casas en las Colonias*, a woman and her children await the husband's re-

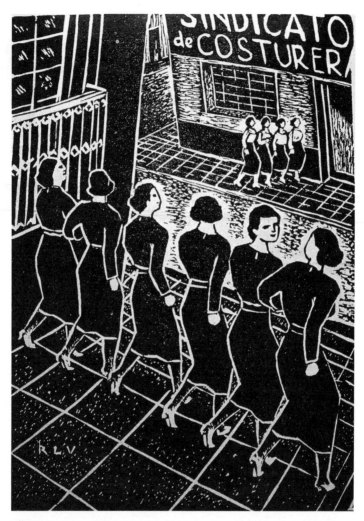

5.29. Rafael López Vázquez, *Libro de Lectura para uso de las Escuelas Nocturnas de Trabajadores (Segundo grado)*, 1938. Author's photograph.

turn from work in front of a comfortable house, but the text reminds us that "happy mothers sing and laugh at the dawn of a new life, tranquil because they know their kids will be well taken care of in the nursery while they are busy in the workshop or factory." In an image by Antonio Silva Díaz, a woman with a rebozo and high heels sits between two men and below a "Strike!" sign. In another by Silva Díaz, women in stylish hats and coats sit among men in a union meeting, while the text explains that in the organization of a union "the gender of the members doesn't matter."[97]

The formation of a unified labor confederation in February 1936 had

marked the end of the labor movement's defensive recuperation from the divisions and repression of the Maximato.[98] From 1934, mobilized workers had supported Cárdenas in his confrontations with Calles and the most intransigent forces of Mexico's elite and had, in turn, been empowered and unified by that transcendent political conflict, by the Popular Front ethos of the Communist Party, and by Cárdenas's encouragement to organize and unify. Starting with unification of the CTM, the labor movement was poised to begin its offensive, including the July 1936 electricians strike and the oil workers strikes of 1938. The LEAR artists, riding a similar wave of unity, aspired to "illustrate workers" along the way.

A relief print (plate 10) published in the Communist Party's *El Machete* in 1936, for the first May Day since the formation of the CTM in February, is exceptional in quality and suggestive of the Popular Front ethos and collaborations at their peak.

The image and the poem below it celebrate May Day by invoking a Popular Front slogan: "NATIONAL UNITY OF ALL POPULAR FORCES," the red flag reads, with multiple hands of distinct groups, classes, and genders holding the flagpole. Each figure bears the acronym of an organization—the Communist Party (PCM), the unified labor confederation (CTM), a union of campesinos (the UCN), the official ruling party (PNR), unified artists and intellectuals (LEAR), and others. With the exception of the suited figure representing the PNR and the mostly hidden LEAR artist, the figures portrayed are poor and working people, dressed in overalls, *calzón*, and rebozo. Significant and unusual is the placement of a barefoot woman in the central position, here representing the FUPDM, and reminiscent of Tina Modotti's 1929 photograph *Woman with Flag* (fig. 4.21). The entire group is ultimately enfolded between the CTM on the left and the PNR on the right, embodying the Communist Party aspiration of a formal Popular Front alliance to culminate the previous seven months of collaboration with Cárdenas and diverse sectors of the labor movement. The image bears no signature—though the style suggests that of Everardo Ramírez or Luis Arenal—and is instead attributed to the LEAR by an extended hand in the upper-right corner. The intellectual worker tied to the hand, or the artist who created the print, might see himself in the vanguard of the Popular Front, or perhaps—with some hindsight—in the shadow of the government party.

For Independence Day the same year, *El Machete* featured a Méndez print (fig. 5.30) that suggested how far the Communist Party and affiliated artists had moved since their ultra-left positions during the Maximato. Hidalgo and Morelos, the priests who led the 1810 struggle

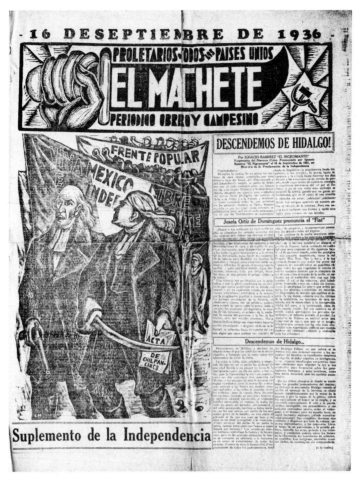

5.30. Leopoldo Méndez, *Viva México libre e independiente*, *El Machete*, September 19, 1936. Courtesy of Museo del Estanquillo, Mexico City. Permission of Pablo Méndez. Author's photograph.

for independence, dominate the print, followed by a group of workers holding a Mexican flag and a banner with the words "Popular Front." The headline declared the Communist Party's patriotic lineage: "We descend from Hidalgo."

Of course, the projects of Cárdenas, artists, and labor were not identical, and divisions within labor and among artists persisted. Even the seeming unanimity of Cárdenas, labor, the Communist Party, and artists on the Spanish Civil War that started in 1936 only postponed a reckoning over the roles of labor and artists in Mexican society.

THE MEXICAN ELECTRICIANS UNION, THE ART OF THE STRIKE, AND THE SPANISH CIVIL WAR

Two portraits bookend a decade of change for the Mexican Electricians Union. The June 1931 cover of *Lux*, the SME's monthly magazine, featured a photograph of a young, fair-skinned girl with bobbed hair snuggling a cat, an image that might easily have adorned the cover of *Revista CROM*. Nine years later, a group of Mexican and Spanish artists, many of them recently returned from the Spanish Civil War, finished a mural (plate 11) for the SME's new modern headquarters, funded by the gains of a successful 1936 strike. Eventually titled *Portrait of the Bourgeoisie*, the mural set an armed revolutionary against the forces of capitalism and imperialism epitomized by a masked dictator leading the masses to war. The first portrait reflects the limited goals, ideology, and aesthetic aspirations of the SME at the beginning of the decade. The second suggests the distance travelled by artists and workers alike during a decade of transformation, as well as the possibilities and limits of their collaborations.

The first half of this chapter considers the self-described "apolitical" and isolated SME and follows its radicalization and artistic collaborations with the LEAR through the journal *Lux* and the SME's 1936 strike. The second half considers the specific reactions of artists, the SME, and organized labor in general to the Spanish Civil War. Their support for the Spanish Republic intensified transatlantic cultural exchanges and graphic innovations, as artists and unions gave distinctly Mexican meanings to the Spanish conflict in their journals, posters, and writings.

PORTRAIT OF A UNION

In the early 1930s, sociologist Marjorie Ruth Clark described Mexico's electricians as a kind of labor aristocracy, a view largely shared by the electricians themselves.[1] The most important union was the SME, constituted by employees of a single company, Mexican Light

and Power Company. The company was formed by Canadian capital in 1906 and quickly dominated the electrical industry in the Federal District and its six surrounding states. By the 1930s its electrical production almost equaled that of the rest of Mexico.[2] Electricians formed the SME in 1914 amid the fighting of the Revolution and the anarchist-inspired mobilizations of the Casa del Obrero Mundial. They had been slower than many of the skilled artisans in the capital to make the transition from mutualism to syndicalism, but their uniqueness within the workforce was obvious to them and to others. Electricians had high literacy rates, like the printers who led the Casa del Obrero Mundial, as well as technical training like the most skilled factory workers. But their consciousness of their role in the city and nation was different. It was impossible to break down each and every function of their work, as in manufacturing (i.e., Taylorism), and they often worked independently throughout the city and beyond. Affiliated workers included those as far away as the Necaxa hydroelectric plant in the state of Puebla. If SME workers went on strike, they shut down production, transportation, and leisure activities in the most heavily populated region of the country. This gave them a strategic importance akin to miners and petroleum workers and an awareness of the social and economic panorama comparable to railroad workers. Of course, with 4,000 electrical workers nationally, they were far fewer in number than, for example, the 20,000 railroad workers.[3]

The SME's strategic importance gave it a unique relation to other unions and to the government itself. Soon after its 1914 founding, the SME joined the Casa del Obrero Mundial and almost immediately challenged the printers who led it, eventually rejecting the Casa's alliance with the Constitutionalists and the formation of the Red Battalions. As discussed, they played a crucial role in shutting down the city in the July 1916 general strike, in turn repressed by Carranza, who singled out SME leader Ernesto Velasco for the harshest punishment.[4] Even in 1922, under the more sympathetic presidency of Obregón, when the SME called for a strike against Mexican Light and Power, the police and army quickly moved in to stop them from shutting off power.[5] These two experiences chastened a generation of old-timers. Leaders avoided strikes for fear of provoking government repression and embraced the term "apolitical" in their statutes and institutional culture to describe their suspicion of any reliance on the state and political parties. This lesson and strategy were distinct from those learned by the former electrician Morones, who led weaker unions into the CROM alliance with the state.

SME leaders were also wary of affiliations with other labor organizations that might minimize the powerful union's voice or pressure members to shut down much of the country with a solidarity strike. The SME was instrumental in forming a national confederation of electricians, which by 1929 included sixteen unions. But in 1934, the SME walked out of this confederation, explaining "we believe in unity among workers, but we are the strongest, yet . . . the Mexican Electricians' Union has only one vote." Also at stake were attempts by the CROM and, later, the CTM to influence the national federation of electricians at the SME's expense. Because the SME preserved its independencc as a single union, it lacked the status of the unified industrial federations that formed in the early 1930s. Though Morones was expelled from the SME soon after he formed the CROM federation, the powerful labor leader maintained relatively benign relations with his old comrades in the 1920s, in marked contrast to his aggressive attacks against other independent unions.[6]

Clark observed that the electricians were "devoted to a policy of conservative action and cooperation with employers" and tried "in every way to avoid action of a political nature."[7] They prided themselves in their relatively high salaries and protections, even as the company often dealt with the union indirectly through worker commissions (and did not formally recognize the union until 1925). The union could proclaim a variety of firsts, such as the first collective contract in 1915 and the first headquarters to be owned by a union in 1927. A cooperative established in 1930 offered basic goods as well as silk stockings for the wives of the mostly male workforce. Members contrasted their democratic decision making, regular rotation of officers, and regular payments of dues with the corrupt unionism pervasive elsewhere.[8]

The SME's concern with workers' enlightenment is clear in the 1933 statutes, with the goal "to develop the moral, intellectual, and physical progress of its members."[9] The goal is evident in the support for a series of periodicals, beginning with the short-lived *Rojo y Negro* (1915–1916) and the photojournal *Electro Unión* (1926). The SME's definitive magazine, *Lux*, founded in 1928, at first differed little from *Electra*, the journal of the administrative personnel of Mexican Light and Power. Aside from a "state of the union" editorial and a brief section of news from the different company divisions, the monthly resembled the middle-class, general-interest magazines of the 1920s, with didactic sections on science, hygiene, national history, classics of world and Mexican literature, and others devoted to sports, comics, and Hollywood stars. Like *Revista CROM*, its covers were often in the

Art Nouveau and Art Deco styles that dominated commercial illustration in the 1920s.[10] The January 1929 cover, for example, featured an indigenous princess, identified as an "Aztec Motif," while others featured colonial churches and towns. Beyond the title *Lux*, a play on the electrical light electricians produced and the intellectual illumination the magazine provided its readers, the cover made no reference to workers or to the union itself.[11]

The magazine rejected all political positions. The lead editorial of the January 1929 issue denounced the attempt of Communists to reconstruct a unified movement of peasants and workers, the CSUM, to fill the vacuum left by the CROM. Two months later an article celebrated a different kind of "revolutionary worker," ones who "let our only weapons be our machines and work tools; let our meeting places be our workshops and offices; let our explosives be steam and electricity, and our projectiles the millions of products our factories launch on the market."[12]

Electricians and their employers effectively defined their work—using metrics of skill, physical demands, and danger—as exclusively male. Photographs of union activities in *Lux* present a sea of faces—dark and fair, young and old, in overalls and Sunday best—but almost invariably male. Women represented less than 4 percent of union membership, primarily as office workers. A *Lux* column in 1932 asked a variety of electrical workers the same "Questions of the Month," and all agreed—including one female office worker—that women workers "cheapened" male labor and that women should not be allowed "to form part of the government."[13]

In early issues, *Lux* regularly included articles on fashion and housework aimed at members' wives, reinforcing a vision of modern female domesticity similar to that of *Revista CROM* and the middle-brow metropolitan press. An advertisement in *Lux* for the Light and Power Company suggests a modern but gendered universe (fig. 6.1). Two housewives fulfill their domestic duties in different houses. One works in smoke-filled drudgery that "dirties the walls and abuses feminine hands," aided only by a servant. The other is liberated by an electric stove and appliances. A small inset shows a hydroelectric dam, where "2000 workers labor constantly to provide you with services day and night." A related company ad reversed the emphasis, with a large image of a male worker at the controls of the dam and a tiny insert of a wife in her modern electrical kitchen.[14] Explicit is a laborite view of a modern world, one where workingmen play a central role, and where foreign capital and women also have their place.

Humo, ceniza, calor "cochambre" tizne que ensucia las paredes y maltrata las manos femeninas.....

Esto y mil molestias más desaparecen con el uso de aparatos eléctricos para el hogar.

Véalos en nuestra "Sala de Electricidad", Gante Núm. 20.

2.000 OBREROS TRABAJAN CONSTANTEMENTE PARA PROPORCIONAR A UDS. SERVICIO ELECTRICO DIA Y NOCHE

Cía. Mex. de Luz y Fuerza Motriz. S.A

6.1. Advertisement, back cover, *Lux*, February/March 1933. Courtesy of the Sindicato Mexicano de Electricistas.

After the election of new officers in 1932, the editors of *Lux* assumed a more aggressive position, adding either the name of the union, that of the national confederation, or "Revista Obrera" to the cover. Cover images by commercial artists celebrated the role of electricians in the generation of power to run a modern nation. In a typical cover (fig. 6.2), a gigantic worker supports the electrical network that powers the busy industrial city below. Articles gave greater attention to working-

class education, while editorials and graphics continued to boast that the union "maintains the best relations with the Mexican Light and Power Company," even as the company tried to use the conservative 1931 Federal Labor Code to scale back benefits.[15]

In a typical cartoon, an in-house artist identified only as "Sánchez" conveyed the continuing conservative tenor of the union: a well-

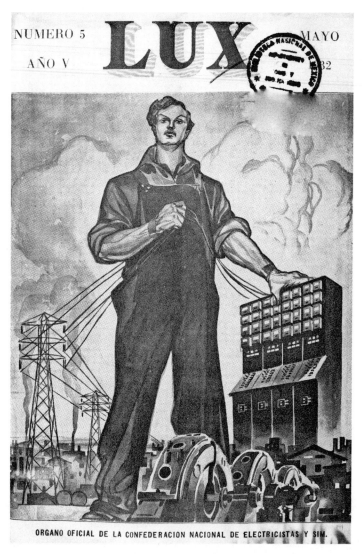

6.2. Cover, *Lux*, May 1932. Courtesy of the Sindicato Mexicano de Electricistas.

6.3. Sánchez, "Participación de Utilidades," *Lux*, April 1932, page 34. Courtesy of the Sindicato Mexicano de Electricistas.

dressed boss shares profits with a worker in overalls (fig. 6.3). In style and message, the drawing resembles the earlier cartoons of W. Soto for *Revista CROM*. However, cooperation between labor and capital is portrayed here without the benevolent oversight of the government. In another Sánchez drawing (fig. 6.4), the proper response to the unemployment brought on by the Depression is the formation of cooperatives, like the union's consumer cooperative formed in 1930, in contrast to the strikes or hunger strikes organized by the clandestine Communist Party.[16] *Lux* editorials continued to reject the introduction of the "foreign" ideas of Communists in union affairs through the CSUM federation, even as some articles explored the ideas of socialism and the "Russian experiment."[17] But a dramatic transformation in the union and its journal was in the works.

6.4. Sánchez, "Crisis Cooperativism," *Lux*, July 1932. Courtesy of the Sindicato Mexicano de Electricistas.

THE ART OF THE STRIKE

The politicization and radicalization of the SME from 1934 was shaped by trends described in chapter 5: a national government sympathetic to labor, a newly expansive and flexible Communist Party, the revitalization of the labor movement, and the cultural outreach of the LEAR. But it was the incorporation of many engineers into the union that was the immediate catalyst for its transformation. Generally considered administrative staff by the company and union alike, a group of engineers was brought into the fold by the SME in order to protect them from layoffs after the completion of a major hydraulic construction project in the state of Michoacán in the early 1930s. The engineers

quickly made their presence felt, rising to positions of union leadership.[18] Engineer Luis Espinosa Casanova was elected to the central committee in 1932 and became secretary general a year later, ending the leadership of a whole generation of old-timers who had struggled for their union's recognition but lacked the broader national and international vision of the engineers.[19] These white-collar workers, with university educations and salaries as high as 300 pesos a month, led a majority of blue-collar workers, some with salaries as low as sixty pesos. Their role was akin to the one artists on the left envisioned for themselves as "intellectual workers."[20]

The new secretary general, who had served on the general staff of the Villista general Felipe Ángeles during the Revolution, immediately got the company to collect dues from paychecks and hand them over to the union and pushed to incorporate less-skilled workers into the union.[21] He also headed off an effort by other engineers, supported by the Light and Power Company, to create a separate administrative union. Wavering between defining themselves as white-collar or proletarian workers, these engineers were forgiven their indiscretion and welcomed into the union. Over the next seven years, engineers Espinosa Casanova, Francisco Breña Alvírez, Manuel Paulín, and David Roldán all served as secretary general and rotated among the other key positions on the central committee, sustaining an "Age of Engineers" that would last formally through 1940. The new leadership brought dramatic transformations in relations with the Light and Power Company, other labor organizations, and the government and accelerated the union's use of art as an expression of its newly radicalized political culture.[22]

The new leadership on the national scene was obvious in the content and tone of *Lux*, the public face of the union, which shed its apolitical and conservative orientation and began to project the leadership's openness to the ideas and cultural offerings of Popular Front communism. Breña Alvírez was elected as the union's secretary of education in November 1933. He made his mark on the union's journal and cultural policies before being elected and reelected secretary general in 1935 and 1936, when he led the union in its external alliances with the labor movement and in its historic strike against Mexican Light and Power. His successor as secretary general, Manuel Paulín, first served as secretary of education, and Breña's final position in the union leadership was again as secretary of education from 1937 to 1938, suggesting how central the education post and control of the journal were to the SME and its leaders in these years. The new leadership

publicly supported proposals for giving women the vote in national elections and pushed for the election of women to the SME's central committee. Two women were elected and served consecutively from 1935 to 1938 as secretary of acts, in charge of the union's documentation. It would be 1983 before a woman would be elected to the central committee again.[23]

Newly reorganized, *Lux* announced in June 1934 its transformation and reorganization into a "new journal . . . TO EDUCATE THE LABORING MASSES." The information section, in addition to news on the company and union, now looked to inform on world affairs and have a separate section on the Soviet Union, "the fatherland of the workers." The educational section was dedicated to "awakening in the workers THE CONSCIOUSNESS OF THEIR CLASS." The editors capitalized letters, they explained, because the low cultural level of workers otherwise meant risking that "the truth, the profundity and the beauty of many concepts pass unperceived."[24] *Lux* articles on socialism, Lenin, and the accomplishments of the once reviled Soviet Union, as well as on the rise of Hitler and fascism in Germany, seem to have provoked only minor resistance among members.[25]

Indeed, feminism was apparently more problematic for some readers than was Marxism. In a November 1933 general assembly, two members protested the "form which the journal has taken of late . . . so shameless and immoral" that they couldn't allow it to "fall in the hands of their families." The offense was an essay by a Spanish anarchist favoring the sexual liberation of women and an end to the double moral standard for men and women. In response to criticism, Espinosa Casanova countered that "our journal has come to occupy an important place, giving prestige to our organization, as it is public and notorious that our periodical is read with interest by all workers." Even so, *Lux* offered a rare public apology for the offending article.[26]

Of the typical run of 3,000 copies in 1934, 2,000 went to members and the rest to other unions and individual subscribers. A year later, Espinosa proudly noted the demand for the journal far beyond its audience of workers—among foreign ambassadors, members of Congress, the Department of Agrarian Education, and, above all, the Secretariat of Public Education, suggesting the union's more deliberate political positioning.[27]

In the early 1930s, Clark wrote that "no other group of workers has been so impervious to communist propaganda as the electricians."[28] Yet from 1934 to the end of the decade, the union officers and *Lux* remained for the most part sympathetic to the Soviet Union and the

PCM and embraced its Popular Front strategy. From 1934 through 1936, various officers, including Espinosa Casanova, Breña, and Roldán, visited the Soviet Union. In December 1935, a single slate of candidates ran uncontested in the union's elections, including three engineers for the top three positions, with the group as a whole self-identified as the "red slate." In spite of accusations to the contrary, only a small number of union members were formal members of the Communist Party; PCM records show ninety electricians registered nationally in 1938. Communists in the 1930s had a reputation for militancy and honesty and held leadership positions in the industrial unions of railroad, mining, and oil workers. But party members were never elected directly to the central committee of the SME in the 1930s, though officers acknowledged their sympathies and alliances with the party, as well as the influence of Mario Pavón Flores, legal counsel to the union for much of the decade and member of both the LEAR and the PCM. Breña wrote for *El Machete* and attended many PCM events but repeatedly refused invitations to join the party.[29]

On his reelection as SME secretary general in December 1935, Breña gave a speech to the union assembly later published as a pamphlet. The current moment was tense. As noted, the fascist Gold Shirts, mounted on horses, had clashed with left-wing unions marching in the Zócalo three weeks earlier. The day before, former president Calles and CROM leader Morones had returned from self-imposed exile in the United States to a large cheering crowd and accused Cárdenas of veering toward communism.[30] The National Committee prepared a massive anti-Calles demonstration in the Zócalo for December 22. Over the next months, as Cárdenas moved to arrest Calles and Morones for sabotage in April 1936 and put them on a plane out of the country, the public debate over communism was particularly acute.

In this context, Breña explained that in spite of what its detractors claimed, communism was neither exotic—no more than Catholicism or the Spanish language—nor a plot to bring Mexico under the control of Stalin. Rather, its goals were justice, the satisfaction of material needs, and to eventually resolve the contradictions of capitalism through collective ownership, an aspiration that seemed clear in the ruling party's six-year plan for a greater state role in the economy. Under capitalism, he explained, class conflict was inevitable and should be the basis of union tactics. And while the SME should reject both dependence on the government and the intolerance and fanaticism of certain communist militants, it should assume the political

risks of supporting Cárdenas and of unifying with other workers, or else "we will never be capable of overthrowing the capitalist regime." Finally, he insisted, the work of unification and socialism would mean that "we have to bring together in our midst and count on the frank collaboration of the technicians and professionals," that is, intellectual workers like himself and the other engineers. The speech embodied the new goals and strategies of the union's leadership.[31]

As the political culture of the SME veered left, art became more central to its educational and political strategies and to the pages of its journal. Part of the impetus came from Secretary General Espinosa Casanova himself, a fine draftsman and amateur artist who designed the SME's emblem: lightning emanating from the knuckles of a clenched fist above the union's initials.[32] In the "red" years from 1935 to 1938, the emblem was often featured on a banner above a hammer and sickle laid across a book (fig. 6.12). From June 1934 until October 1935, the covers of fifteen issues, each on a different colored background, featured the same drawing by Espinosa Casanova (fig. 6.5). The simple line-drawing combines an engineer's sense of the national landscape with a strong Marxist inflection. At the center is the journal's title, flanked by a hammer and sickle and anchored to the bottom-left by a worker reading an open book with library stacks behind. At the bottom-right, a peasant plows a field with oxen, and an urban landscape at the top—marked by electrical lines, tall modern buildings, and factories—frames a variety of urban workers engaged with tools, machines, and construction materials. The physical labor of urban and rural workers is shown as essential to the functioning of the nation, their purview as wide as that of the typical electrical worker himself. Meanwhile, the "intellectual worker" in the act of reading suggests the importance of engineers to such endeavors, as well as the ideal of radicalized enlightenment embodied in *Lux* and the union's educational goals. Despite its simplicity, Espinosa Casanova's drawing constructs a complex map of the leadership's worldview at the time in the only significant example of art by a SME member in *Lux* until the 1940s.[33]

Most of the issues of this period (as with Lombardo Toledano's *Futuro*) were filled with drawings from the Communist-associated New York magazine *The New Masses* by such artists as Hugo Gellert, John Groth, and Kerr Eby (fig. 6.6). Soon after the return of a delegation of union officers from a tour of the Soviet Union in late 1935, *Lux* began incorporating Soviet photomontages. The range of international themes, ideology, and styles in *Lux* suggests the strong influ-

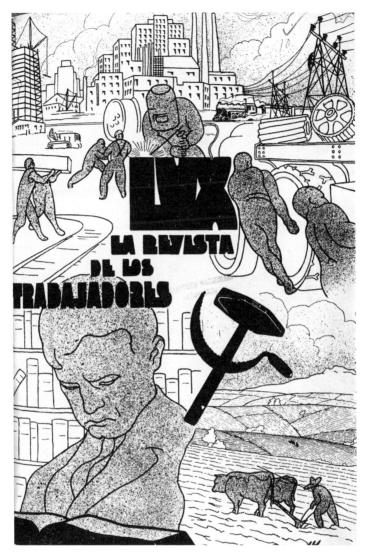

6.5. Espinosa Casanova, cover, *Lux*, October 1934. Courtesy of the Sindicato Mexicano de Electricistas.

ence of international art of the left, related in turn to influences of the Communist Party and the LEAR.[34]

Beginning in November 1935, the artistic production of *Lux* shifted from Espinosa Casanova's homegrown covers and borrowed images from the international left to works by artists affiliated with the LEAR. Multiple covers by Santos Balmori are typical of the union's collaboration with the LEAR, combining the Popular Front imperative with the

6.6. *The Fist of the Proletariat*, reproduced from *The New Masses* in *Lux*, October 1934. Courtesy of the Sindicato Mexicano de Electricistas.

EL PUÑO DEL PROLETARIADO
Lin (New Masses).

union's perspective on national and international events. Balmori was born in Mexico of a Mexican mother and Spanish father but spent much of his youth in Spain and Chile before studying and working as an artist during the 1920s and 1930s in Madrid and Paris. He was influenced more by the European avant-garde and Soviet Constructivism than the styles of postrevolutionary Mexico, and he was closely connected to antifascist movements and publications in Paris. Years later, he would remember his return to Mexico in late 1935: "The political ambience was frenetic. . . . The unions were agile, combative, and a revolutionary mystique seemed to agitate everything; it had an irreversible aspect, of a magnificent wave of faith . . . of youthful vitality. I committed myself without reservations, with devotion, with faith in a recovered fatherland." Balmori immediately assumed an active role in the LEAR, organizing its first exhibition in 1936, and began a close working relationship with Lombardo Toledano, contributing to *Futuro* and teaching at the Universidad Obrera. And for much of 1936 and 1937, he was the principal artist associated with *Lux*.[35]

His first cover in November 1935 is dominated by the head of Lenin, using the flattened diagonal composition and heroic proletarian figures characteristic of Soviet Constructivism. His second, "Christmas," (fig. 6.7) organizes a more complex narrative similar to the LEAR's murals and the print discourse of *Frente a Frente*. Cut by two diagonals, the first divides the bourgeoisie from the working class, with a fat capitalist extracting wealth from a factory and spending it on drink, jewels, and prostitutes, while an exploited worker and his wife slouch from the factory to a hospital by way of drink and poverty. The exploitation is countered on the upper right of the second diagonal

by a colossal worker who towers over a factory chimney and raises his powerful arm and fist over the scene. After spending years in Europe, Balmori's style was distinct from those of the Mexican left— he later complained bitterly of his rejection by fellow artists as "non-Mexican"—but he quickly adapted a narrative familiar to his viewers from murals and photomontage.[36] Just as important, he worked to fit

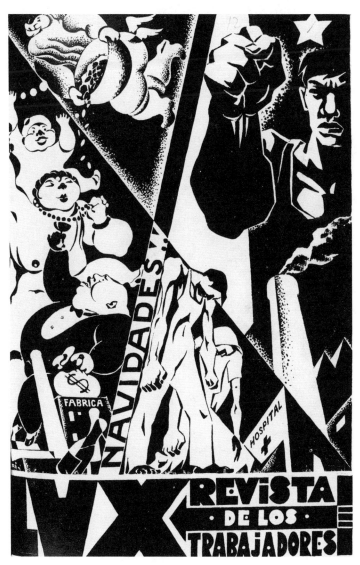

6.7. Santos Balmori, cover, *Lux*, December 1935. Courtesy of the Sindicato Mexicano de Electricistas and the Fundación Santos Balmori.

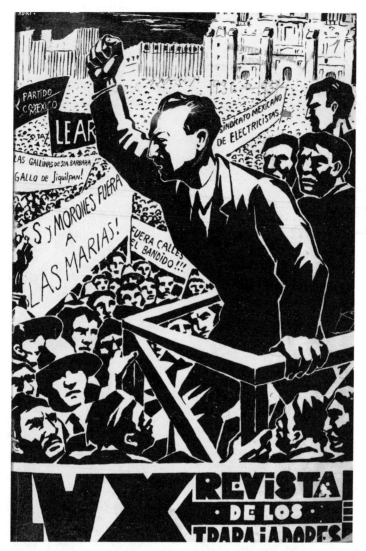

6.8. Santos Balmori, cover, *Lux*, January 1936. Courtesy of the Sindicato Mexicano de Electricistas and the Fundación Santos Balmori.

his *Lux* covers to the distinct perspective of SME leaders on the fast-moving events in the streets.

For example, Balmori's next *Lux* cover (fig. 6.8) re-creates the December 22, 1935, mobilization in Mexico City's Zócalo of some 100,000 workers in support of Cárdenas, just a week after former president Calles's provocative return to the country.[37] The Balmori image summarizes a process of labor unification and support for Cár-

denas that began with his inauguration a year earlier and the wave of strikes that followed, accelerating with Calles's first public accusations against labor in June 1935. On December 22, the PCM leader Laborde and Lombardo Toledano shared the stage with Cárdenas and other labor leaders before the masses of workers, signaling the dramatic shift in relations within the labor movement and among labor, the state, and the PCM.[38] It was a transformative moment in which Cárdenas consolidated his mass politics. He denounced the "exhausted leaders" of the Revolution who made common cause with the Revolution's enemies, and he reminded the nation that the tumultuous character of worker protests "were nothing more than expressions of the pain found in the masses of workers and campesinos." But he cautioned workers that they be "aware of their responsibility and know up to what point we can go . . . that they need to wait until the regime itself, until the Revolution itself . . . can integrally realize the program that permits an improvement in the economic and cultural conditions of the Mexican people." Similarly, when Cárdenas aggressively confronted the Monterrey elite weeks later, famously offering to take over their businesses if they couldn't accommodate labor demands, he insisted that "there is no communism in Mexico" and that his government would fight for "a social equilibrium, with just relations between capital and labor."[39] This realignment by no means assured agreement within the labor movement or between labor and the state, as Cárdenas, like his predecessors, asserted the state as final arbiter between labor and capital.

When Balmori put Breña at the center of the image and, by proxy, at the center of the national stage, he reflected the perspective of his union patrons, though not necessarily a personalistic one. On behalf of his union, Breña had been the first labor leader to respond to Calles's provocative June 1935 attack on labor, convening most national labor organizations as well as the LEAR and the Communist Party to meet in the union's headquarters. The National Committee of Proletarian Defense they created was a rejoinder to Calles and the first step toward forming a new, united national labor confederation. Over the next eight months, Breña and the electricians union played a leadership role second only to that of Lombardo Toledano. The SME's prominent role in the national political crisis was a direct break with its past rejection of politics and its self-imposed isolation from other unions. The pages of the *Lux* issue opened with the speech Breña gave to the December crowd from the same stage as Cárdenas, where he expressed support yet challenged the president's words of caution, urg-

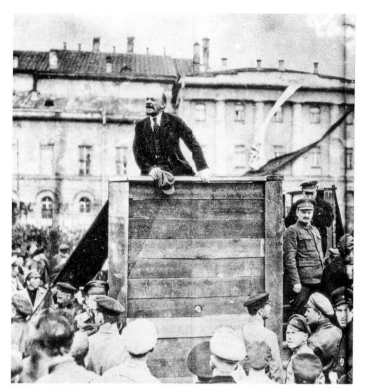

6.9. Photograph of Vladimir Lenin, Red Square, May 5, 1920. Wikimedia.

ing him "to continue his path, every step more to the left," while warning that "the support of conscious workers is never unconditional."[40]

In Balmori's cover, the central figure of Breña exhorts the dense crowd alone. The composition references the famous 1920 photo of Lenin speaking (fig. 6.9) in Moscow's Red Square, a photo reproduced in *El Machete*, though with the figure of Trotsky edited out.[41] The banners embedded within Balmori's image, likely based on those produced by the LEAR for the event, give equal importance to the leadership roles of the SME, the LEAR, and the PCM. Other banners denounce Calles and Morones, demanding their expulsion from the country or confinement to prison, yet no direct visual reference is made to Cárdenas, Lombardo Toledano, or any of the other component unions of the National Committee. Rather, perhaps borrowing from the photograph of the electricians' march to the Zócalo that later appeared in *Lux* (fig. 6.10), the electricians' perspective is projected on the entire event. The design is the product of close collaboration between Balmori and the union leadership, rather than a simple recirculation of dominant LEAR images.

In his March 1936 cover (fig. 6.11), Balmori celebrates the formation of the CTM the month before and reflects the shift of the electricians' attention from national politics to the intertwined goal of working-class unity. It features a colossal worker representing the "*central unica.*" Despite conflicts that emerged in the founding congress, and regardless of the important participation of the SME in the creation of the national confederation, references to either disappear in Balmori's print, metaphorically folded into the giant figure of a unified national labor movement subduing the serpent "*reacción,*" marked by the symbols of capitalism, Nazism, Italian fascism, and death. The issue, devoted entirely to the key speeches and debates of the founding congress, conveys a united vision of the state of labor in the country. The focus is once again on class struggle rather than the political struggles of Cardenismo.

With labor unified, the electricians in spring 1936 could turn more fully to their most immediate challenge, one *Lux* described afterward as "a general struggle between the owner class, represented by the Mexican Light and Power, and the working class, represented

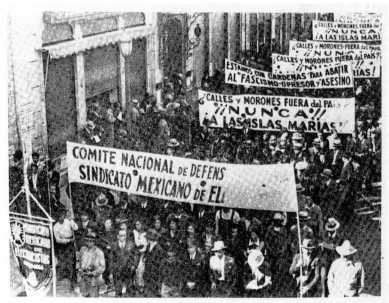

UN ASPECTO DEL CONTINGENTE DEL SINDICATO MEXICANO DE ELECTRICISTAS EN LA GRAN MANIFESTACION POPULAR DE APOYO A LA POLITICA OBRERISTA DEL PRESIDENTE CARDENAS, ORGANIZADA POR EL COMITE NACIONAL DE DEFENSA PROLETARIA EL 22 DE DICIEMBRE DE 1935. (Foto Díaz.)

6.10. Photograph, SME Contingent in Anti-Callist March, December 22, 1935. *Lux*, March 1936, page 23. Courtesy of the Sindicato Mexicano de Electricistas.

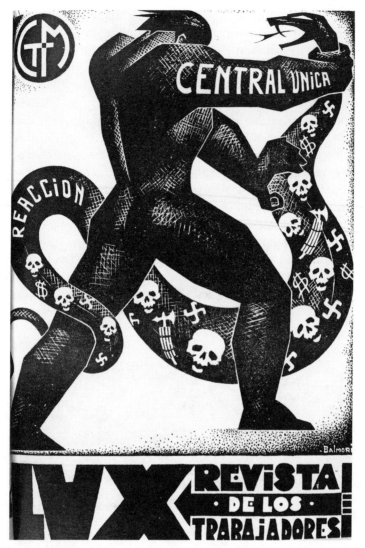

6.11. Santos Balmori, cover, *Lux*, March 1936. Courtesy of the Sindicato Mexicano de Electricistas and the Fundación Santos Balmori.

by the SME."[42] In Balmori's September 1936 *Lux* cover, the first after the strike, a giant electrical worker stands up to a foreign capitalist. The July 1936 strike against the power company was the first since the SME shut down electrical power as part of the general strike of 1916.

Exactly twenty years after the event that had been the high and low point of organized labor's experience of the Revolution, the situations of the SME and the country were dramatically different. In 1934, the

new SME leadership had taken an unprecedented hard line in negotiations with management for a new collective contract. After the SME gave notice of the intent to strike, as required by law, both parties succumbed to government pressure and accepted the compromise proposed by the Arbitration Board before the strike deadline. Victory was partial, but the union came out strengthened.[43] Union leaders went into contract negotiations in spring 1936 with a determination not to compromise that derived, in part, from confidence in their public roles in defending a prolabor president and in creating the CTM.

The SME demanded more than a hundred new contract clauses that went far beyond improvements in wages and benefits to include the regulation of work processes and conditions and control over the hiring of blue- and white-collar workers. The expiration date of the contract was extended four times to allow for complicated negotiations, but the strike committee, led by Breña, refused to compromise on key demands. The union filed a notice with the Arbitration Board that it would go on strike July 16, and talks moved to the Labor Department. The union assembly voted not only to strike but also to refuse to return to work if the Arbitration Board declared the strike illegal, a show of resolve and a challenge to the legal process. Meanwhile, the company remained convinced that the government would intervene before letting the strike begin, as it had done three months before to stop the railroad workers strike.

The electricians strike began at noon on July 16, shutting down power in the Federal District and parts of seven surrounding states. Armed union members guarded key electrical facilities against sabotage and strike-breakers. Most factories shut down completely, while stores and schools opened for limited hours and service. The union made provisions to provide power to government buildings and public services, but strains on *capitalinos* and pressure on political authorities to push for settlement grew, reaching Cárdenas during his month-long political tour in the north.[44]

Bargaining was suspended as the Arbitration Board deliberated on the legality of the strike. While the company, the Labor Department, and Cárdenas's private secretary, Luis Rodríguez, pushed for required state arbitration, the SME's leadership held their ground. A photograph (fig. 6.12) shows a mass of electricians waiting in the building of the Labor Department for the verdict. Some hold the SME banner, emblazoned with its logo and a hammer and sickle. Behind them is a relief sculpture of "Artículo 123," the constitutional provision for labor rights. Other members display a banner that asks, "Does the right to

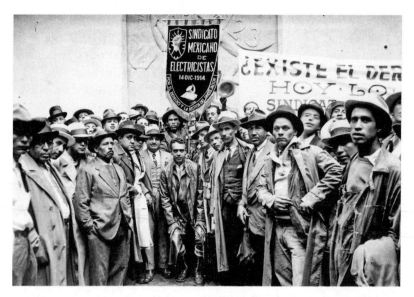

6.12. Electricians at the Junta de Conciliación y Arbitraje, July 1936. Reproduction authorized by the Instituto Nacional de Antropología e Historia.

strike exist? Today we will find out." After two days of deliberation, the Arbitration Board declared the strike to be legal, though this was no guarantee that the government would not force the SME to make concessions.

Among the brilliantly played strategies of the strike committee, made up of the engineers Breña, Paulín, and Roldán and closely advised by the lawyer Pavón Flores, was a series of communications with Cárdenas, including a visit north to talk to him in person in Coahuila. Breña asked the president to allow the strike to be settled directly by the confrontation of capital and labor, as the Constitution allowed for state arbitration only if both parties agreed. Given the clout and recent public profile of the SME, his government's growing wariness of the role of foreign companies in the economy, and his fluctuating beliefs about the intermediary role of the state when labor and capital were equally strong, Cárdenas agreed not to impose arbitration, a decision that helped strengthen the left wing of his ruling party.[45] Cárdenas made clear in a note to the company that the government would not impose a compromise on the union. Without the hope of state intervention, Mexican Light and Power capitulated after a ten-day strike that had shut down much of the country.

In its public statements, the SME praised Cárdenas for eliminating intermediaries and allowing direct agreements with the company.[46]

The president's "intervention" was in reality a nonintervention that the SME had counted on. Such government restraint was effective for a powerful and strategic union like the SME and contrasted with the government's intervention to prevent railroad workers from striking months before.

The SME stressed that the strike was the victory not only of the electricians but also "of the working class in general."[47] The point was important and somewhat defensive. The lack of government intervention could be problematic for organized workers in less strategic sectors who needed greater support by national labor federations or government authorities in negotiations with employers. And, of course, in the public sector, like the railroads, the state was now both employer and intermediary. Regardless, the 1936 collective contract won by the SME would remain the standard for future negotiations for electricians and for other organized workers for decades to come.

On July 26, 1936, when a union official announced a complete victory to the SME assembly, he requested applause for the LEAR and the Communist Party for their valiant support during the strike.[48] Through Pavón Flores, the Communist Party had skillfully advised the strike committee and encouraged the aggressive stance throughout. LEAR artists had provided abundant visual material in support of the strike. For example, LEAR photographer Enrique Gutmann produced a photomontage of the strike that served as a flyer in support of the strike and was reproduced as a centerfold in both *Futuro* and *Lux* (fig. 6.13).[49]

Just left of the center of the image is a fragment showing the SME leader Breña, juxtaposed over a group of electricians marching with their banner at the power company entrance. At the top right is the Necaxa power plant, from which a vast web of electrical generating towers spread transmission lines left and right. These wires are interrupted on the left by two sets of oversized hands with industrial shears that, by cutting the electrical lines, initiate the strike. The fragment echoes Carlos Neve's drawing of an electrician cutting wires in the 1916 strike (fig. 4.4). In the right foreground, masses of laborers from other unions, with Lombardo Toledano in the forefront, appear to support the strike with their bodies and banners. At the center, three candles above a streetcar light the dark sky, symbols of a modern city idled and darkened by the power of the working class. The sizes, times, and spaces of Gutmann's fragments suggest a very different aesthetic from the murals and prints of the period or even the more narrative and figurative function of the earlier photomontages featured

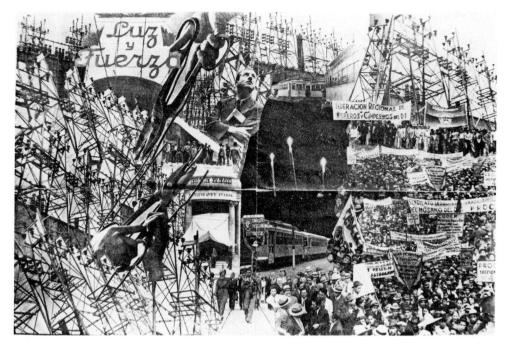

6.13. Enrique Gutmann, photomontage, *Huelga del Sindicato Mexicano de Electricistas, 16–25 de Julio 1936*. Courtesy of the Universidad Obrera, Mexico City. Author's photograph.

in *Frente a Frente*. Here the formal rules of composition are deliberately broken, emphasizing immediacy and contingency. Even so, the chaotic photomontage effectively invokes the SME's public profile, its fundamental role in generating or withholding electricity, and the solidarity of the rest of the Mexican working class on behalf of their electrician comrades.[50]

On closer look, it projects an ideal of labor solidarity that was not the on-the-ground reality. In spite of the SME's prominent roles in the National Committee of Proletarian Defense and the formation of the CTM, working-class solidarity with the SME strike was ambivalent. In the montage, the posters held by the masses identify them as belonging to the Regional Federation of Workers and Campesinos (Federación Regional de Obreros y Campesinos—FROC), the regional federation for the Federal District affiliated with the CTM. Their banners express solidarity with oil workers, not with the electricians.

The recycling of photos is, of course, in the nature of photomontage, but the reality was more complicated. The FROC and the CTM organized supportive demonstrations in the first days of the strike, the national electricians' federation staged a two-hour walk-

out on the first day, and the militant miners union never wavered in its support. But support for the SME quickly waned among many of the smaller unions as the strike shut down factories and businesses, denying workers their wages and raising the cost of consumer items. The FROC expressed concern about the effects of the work stoppage, and some affiliated unions publicly spoke out against the strike. Lombardo Toledano publicly supported the SME and gave considerable credit to the labor movement as a whole for its eventual success, but behind the scenes he had pushed the SME to settle. As negotiations continued, Breña tried to dismiss "rumors" of divisions as the invention of the press. "It would be an exceptional case in the history of the world proletariat," he asserted weakly, "to see a union fighting for precedents for all of the working class . . . fail because of the blows of its own working-class brothers."[51]

The first poststrike issue of *Lux* documents every stage of the successful strike and conveys the union's enormous pride. It celebrated the union's discipline and solidarity and leadership, expressed gratitude for the president's nonintervention, and claimed victory on behalf of the entire working class. In Balmori's cover (fig. 6.14), an enormous electrical worker represents the discipline and agency of the union on behalf of the working class. He towers in front an electrical pylon, as one hand controls the power switch and the fate of the nation, while the other displays the word "Halt!" to a foreign capitalist who clings to a scroll labeled "sophistry" and the empty shackle that once bound the worker. In contrast with his earlier two covers, the struggle between capital and labor is narrowed down to its most basic element, "class against class," the workers of the electricians union against the foreign owners of Mexican Light and Power. The political struggle that brought labor behind Cárdenas in his battle with Calles and the related unification of a fragmented labor movement in a national confederation are not referenced. It is Cárdenas's absence and restraint that is celebrated in the line above: "The right to strike still exists in Mexico." Prominent in spirit are the Communist Party that supported the electricians' challenge to Mexican Light and Power, and the LEAR, which illustrated it along the way.

WORKERS, ARTISTS, AND THE SPANISH CIVIL WAR

When General Francisco Franco led much of the Spanish army against the Popular Front government of the Republic in July 17, 1936, the re-

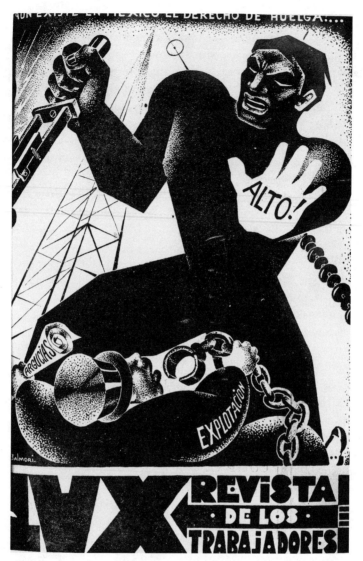

6.14. Santos Balmori, cover, *Lux*, September 1936. Courtesy of the Sindicato Mexicano de Electricistas and the Fundación Santos Balmori.

action in Mexico was at first muted—for the simple reason that the SME strike had shut off power in much of the country, leaving newspapers and radios silent. But as *El Nacional* reported immediately after the strike's successful conclusion, "in the great majority of proletarian centers . . . workers have discussed and energetically condemned" the rebel movement in Spain.[52]

The rough, ungrammatical minutes of a Sunday meeting of a cattle workers union four months later on the outskirts of Mexico City suggest how the Spanish Civil War permeated union affairs in much of Mexico. In attendance were Diego Rivera, members of various Trotskyist unions, and a visiting militiaman from the Spanish Republic. At one point, Rivera gave a brief summary of events in Spain, noting that the government of the Republic hadn't adequately prepared popular militias before the military's rebellion. The lesson, the artist explained, was "that we prepare our own defense, since it is very sure that our enemies will attack us," and he singled out by name local landowners, a priest, and factory owners. Another speaker returned to a theme of the previous meeting, namely "the need to train, [do] gymnastics and learn to use weaponry since very soon we will need it." Such efforts, he added, were better "than time that is lost in taverns where we go to become brutes."

One speaker echoed others when he marveled that "women with arms in hand fight in the Spanish front." Feminist and textile organizer Catalina Frías called on "all the compañeros to prepare their wives, children and siblings . . . to imitate the Spanish women that fight alongside their husbands, that the woman should no longer be a slave of the home or the confessional where she is turned against her own comrades." In closing, she urged the men present to "bring your wives to . . . meetings so that they can take an active part in social life."

Finally, a representative of a union of construction workers made a plea for the *vaqueros* to give a day's salary to the Spanish Republican militias. As important, he went on, was to imitate the Spanish militias, "preparing ourselves for any moment in which the fascist bourgeoisie dares to challenge us. We will know how to answer them like men, and if we do it united we will surely flatten them, since we should know that we are the majority we are those that produce everything and we have the right to all."

At the end of the three-hour meeting, the members resolved to give a half-day's salary to the Spanish militias over the next two Saturdays.[53] Most attendees were affiliated, like Rivera, with Mexico's tiny Trotskyist movement, largely ostracized by the rest of the left. Even so, the meeting suggests a general pattern among many Mexican labor unions during the Spanish Civil War: an obsessive concern with events in Spain and support for the Republic; collaboration of artists with unions around the conflict; their association of the civil war with struggles in Mexico; the prominence they gave to the ex-

ample of female fighters; and the urgency organized workers felt to train militarily.

Helen Graham calls the Spanish Civil War "the neuralgic point of international politics and diplomacy" of the 1930s.[54] As fascist Germany and Italy rushed to support the Spanish military rebels and the rest of Europe insisted on neutrality, only the governments of the Soviet Union and Mexico supported the struggling Spanish Republic. Mexico's official support went beyond diplomatic denunciations to include arms and humanitarian aid, as well as receiving hundreds of orphans in 1937 and thousands of refugees in 1939 and 1940.[55]

In the midst of unprecedented social mobilization, cultural expression, and political reform, Mexicans compared their revolutionary past and present with that of contemporary Spain, seeing different aspects of the civil war mirrored in their own past and present and drawing lessons and formulating strategies accordingly. For the Mexican left it traced high and low points on the arc of the Popular Front experience at home and internationally.

Even before President Cárdenas issued his own denunciation, the recently created CTM denounced the rebellion and expressed solidarity with the Republican government, followed by the premier organization of Mexican artists, the LEAR. Organized labor and artists, already bound together in organizational and artistic collaborations, were the two civil groups in Mexico most vocal about and vested in the Spanish Republic, and they saw its survival as fundamental to the Popular Front project of the left. At the moment of the outbreak of the Spanish Civil War, the PCM, organized labor, and artists on the left were united, and their actions and visions of the war remained largely in sync.

The Spanish ambassador to Mexico identified pro-Republican activists as primarily workers, campesinos, intellectuals of the left, teachers, and public employees.[56] Shared and parallel actions organized by the CTM and the LEAR included public gatherings that often included representatives from the Republican government and Spanish unions. The CTM picketed Spanish businesses that supported Franco and, along with the LEAR and the Universidad Obrera, sponsored a series of educational programs on the Spanish conflict. In Guadalajara, workers called an eight-hour strike in solidarity with the Spanish Republic, and workers in the armaments industry donated free labor to reduce the cost of munitions sent to Spain. Union leaders immediately began asking members to contribute one day's pay a month to the Spanish embassy in Mexico City.[57]

Nine days after the end of its strike, the SME became the first Mexican labor organization to donate money. "In spite of the conflict in which this organism has just seen itself wrapped up," the union declared, "it hasn't stopped observing with growing interest and anxiety the attempt that capitalism—supported by its eternal allies: militarism, the nobility and the organized clergy—is carrying out to smother in blood the liberties of the Spanish working class." Electricians picketed the German and Italian embassies and sent a letter to the French ambassador encouraging the French working class to force its government to support the Spanish Republic. A year later, the electricians union commemorated the first anniversary of its successful strike with a vigil for the struggling Spanish Republic. In 1938 it donated 2,500 pesos to support Spanish orphans in Mexico.[58]

An estimated 300 Mexicans fought in Spain. Communists and the CTM claimed these volunteers were workers, while one scholar asserts that most were middle-class. Anecdotal evidence suggests the working-class roots of many, though no union or workplace seems to have collectively sent a contingent. At least two of the fifty volunteer soldiers who returned from Spain together in 1939 were members of the taxi drivers union. Unions were generous in their financial support for volunteers, particularly the recently unified railroad workers union, as were the CTM, the PCM, and the Spanish embassy. Many recruits were likely members of the Communist Party. Mexican volunteers were far outnumbered by those from several European countries and the United States, but their cultural and political affinities with the Spanish Republicans and the support of the Cárdenas government made them particularly welcome in Spain.[59]

Mexico's most famous brigadier was Siqueiros. The title of his memoir, *Me Llamaban el Coronelazo*, features the nickname he assumed after serving as an officer in Spain and evokes his ideal of the militant artist. Two Mexican artists working with him in New York City joined him in Spain in the fall of 1936. One, Antonio Pujol, had helped to found the LEAR and painted his first mural in the Abelardo Rodríguez Market.[60]

More typical was the response of Mexican artists who wielded their pens, gravers, and brushes in support of the struggle that Octavio Paz termed "the ardent dawn of the world." Just as LEAR members helped legitimize Cárdenas's education and labor policies, its support for the Spanish Republic benefited a key aspect of Mexico's foreign policy. In July 1937, with support from the SEP, the LEAR sent a delegation to the Second International Congress of Anti-Fascist Writers held in Valen-

cia, Spain, including the top LEAR leaders José Mancisidor, Silvestre Revueltas, and José Chavez Morado and nonmembers Octavio Paz, Carlos Pellicer, and Elena Garro.[61]

The Spanish conflict was in many ways a war between fascist and Republican cultures. War accelerated Republican cultural production and catalyzed debates that echoed those in Mexico about the functions, forms, and styles of art. Perhaps nowhere did these debates occur more urgently than in Valencia, not far from the military front where the destiny of the world seemed to be in play. Republican cultural efforts spoke directly to the cultural project of the LEAR—the privileging of art as propaganda, art's collective yet decentralized nature, and art's accessibility to the masses in form and language. The Popular Front and the Spanish Civil War made more urgent the long-standing belief of artists on the left in Europe and the Americas of the essential role of "intellectual workers" in general and artists in particular. In Spain this was manifest in a series of Republican posters that depicted virile figures wielding pencils next to workers bearing hammers, sickles, and rifles.[62] The shared goals of the international left were epitomized in speeches at the writers congress: French critic Julian Benda insisted that "the intellectual is perfectly in his role leaving the ivory tower to defend the rights of justice against the barbarian"; his Spanish counterpart Julio Alvarez declared that "we are combatants of culture"; and most would have agreed with the title of Siqueiros's talk, "Art as an Instrument of Struggle," though not with his insistence that the mural was the greatest medium for that struggle. Instead, mass-produced posters, flyers, newspaper murals, and multiple journals were promoted in Republican Spain as inexpensive and accessible proletarian art forms.[63]

Delegate Fernando Gamboa brought a large selection of LEAR prints to be exhibited as "Mexico in Spain." The exhibition was anchored with Posada prints to emphasize "One Hundred Years of Revolutionary Art." On his return to Mexico in 1938, Gamboa organized an exhibition of posters and photographs from "Anti-Fascist Spain" in the Palacio de Bellas Artes.[64] The transatlantic movement of art and artists and its Expressionist Realism influenced the style and content of Mexican art. Typical are the flattened, mechanical figures of heroic proletarians, partly inspired by Soviet Constructivism, and the diagonal axes and semiabstraction already evident in the covers Santos Balmori did for *Lux* as early as 1935. Similarly, as noted, photomontages by the exiled German John Heartfield and Catalán artist Josep Renau influenced Mexican publications on the left, particularly *Futuro* and *Lux*.[65]

But the greatest influence on Mexican art was the incorporation of

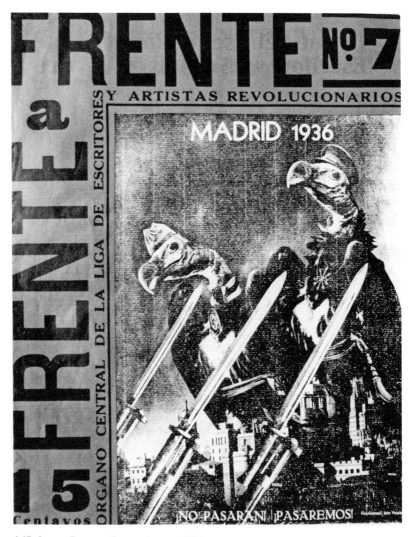

6.15. Cover, *Frente a Frente*, January 1937. Author's photograph.

the Spanish Civil War itself as a transcendent theme. Nowhere was this attention greater than in the LEAR's *Frente a Frente*. As noted, in its second Popular Front phase starting in March 1936, the journal shifted its primary focus from working-class mobilization to antifascism in general and the Spanish Civil War in particular. The magazine ran multiple articles on the Spanish conflict in each of the nine issues published after the outbreak of the war, and it featured the war on six of the nine covers. These include reproductions of Heartfield's iconic *¡No Pasarán! ¡Pasaremos!* photomontage of Nazi vultures crossed by loyalist bayonets defending Madrid (fig. 6.15), as well as a modified

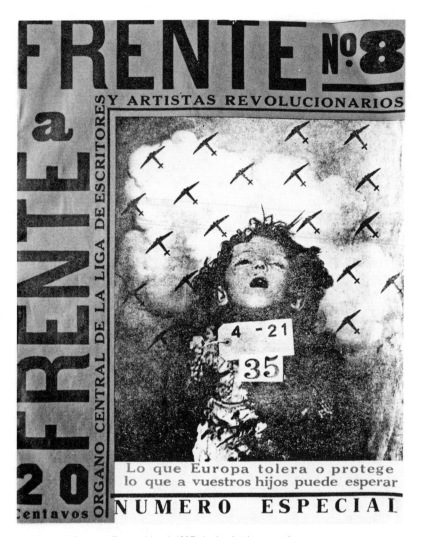

FRENTE N.º 8
Y ARTISTAS REVOLUCIONARIOS
a FRENTE
FRENTE
ORGANO CENTRAL DE LA LIGA DE ESCRITORES
20
:entavos

Lo que Europa tolera o protege
lo que a vuestros hijos puede esperar
NUMERO ESPECIAL

6.16. Cover, *Frente a Frente*, March 1937. Author's photograph.

version of the Republican Ministry of Propaganda's equally famous
image of a child with a dead-body tag, his head framed by Nazi bomb-
ers (fig. 6.16). "IF YOU TOLERATE THIS," the caption read in a variety of
languages aimed at Western democracies, "YOUR CHILDREN WILL BE
NEXT!" The LEAR sponsored a contest of posters in solidarity with the
Spanish Popular Front, and the September 1937 issue was dedicated to
reporting on the activities of LEAR delegates in Valencia. In short, the
Spanish Civil War occupied center stage in the magazine from August
1936 until it ceased publication in 1938.[66]

The SME's *Lux* featured the Spanish Civil War directly on five out of some thirty covers published during the conflict, with frequent content, including editorials, photographs, articles, poems, and poster-like back covers. However, unlike *Frente a Frente*'s single-minded focus, the international conflict mostly embellished or reinforced the journal's principal focus on increasingly complicated union affairs. Representations in text and images in Communist Party, CTM, and SME publications, almost all by LEAR artists, reflected shared assumptions about the Spanish Civil War despite the growing differences among these organizations. They often borrowed directly from Spanish sources, though they filtered them through Mexican circumstances and the agendas of each organization.

The rebels led by Franco were identified as traitors, foreigners, and mercenaries. For example, one of several CTM posters advertising a "week dedicated to Republican Spain" (fig. 6.17) portrays Franco's rebellion as the product of international fascism. At the same time, it racializes the conflict and references Iberia's medieval Reconquest by

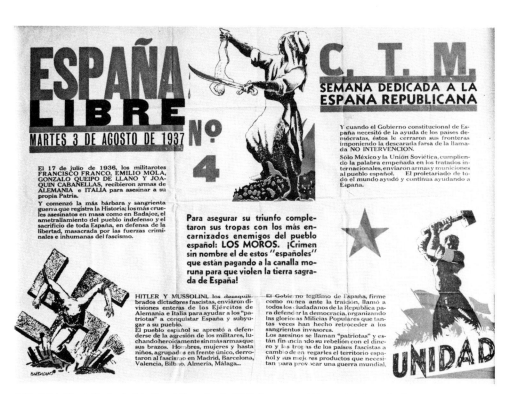

6.17. *CTM: Week Dedicated to Republican Spain*, 1937. Courtesy of Mercurio López Casillas.

emphasizing the rebellion's start in the Spanish protectorate in North Africa and by denouncing mercenary troops made up of "the fiercest enemy of the Spanish people, THE MOORS." An illustration shows a dark-skinned man in Moorish robes dangling an infant upside-down with a bloody sword across its neck. The text explains that Franco and "those 'Spaniards' pay the Moorish rabble so that they violate the sacred land of Spain." In adjacent images, a man is crucified on a swastika, and a worker, backed by red banners and militia, wields the hammer of unity in response to national betrayal and foreign invasions.

Mexican artists and union leaders often referred to the Republican government as the "Popular Front," emphasizing the broad participation of parties of the left and, through them, the working class. The centrality of the Spanish working class to the struggle was made manifest in a variety of violent mobilizations led by organized labor, as well as in the initial dependence of the Spanish government on working-class militias to defend the Republic against military rebels. Not surprisingly, therefore, the CTM viewed the Spanish Civil War as a struggle of armed workers against capitalists and foreign fascists. It was not difficult to extend the conflict internationally and to nationalize it. Cárdenas himself stressed in speeches that the defense of the Republic against imperialism depended on "worldwide worker solidarity."[67] In *Futuro*, the former education secretary Narciso Bassols reminded workers that the Spanish Civil War was "a modern struggle of workers against their natural enemies." Its significance, he explained, was that victory by Spain's Popular Front would mean the "conquest of power for the workers. Anything less than this objective would not be worth the effort." An editorial in the CTM's *El Popular* brought the conflict home: "Mexican workers are seeing a repetition of the Mexican Revolution's experience," with Franco embodying the counterrevolutionary General Huerta of 1913, and with Franco's constituency paralleling the Catholic Church and Cristeros, national and foreign capital, landowners, and the Gold Shirts of Mexico. By extension, *El Popular* warned that the Republic's "defeat is our defeat," and not simply a symbolic defeat. As one visiting Spanish union leader warned a Mexican assembly: "Mexican fascists are preparing a movement designed to deprive the proletariat of the few victories that it has won here."[68]

Within weeks of Franco's rebellion, CTM leader Lombardo Toledano invoked a long-standing labor aspiration that dated back to the 1910 Mexican Revolution. If the victory of Spain's Popular Front was to be accomplished by arming workers, so, too, he insisted, should

the Mexican government arm workers to defend "the conquests of the Revolution." In December 1935, in the face of threats by the CROM and Calles, Cárdenas had invoked the possibility of arming workers and peasants, and in February 1936 he had ordered military chiefs to distribute arms to peasants to defend themselves against the land-owners' White Guards, with as many as 46,000 peasants armed as rural guards by year's end. But the specter of armed workers was more than Cárdenas or the Mexican military could support. Multiple critics within the business community and the army marshaled analogies to the social violence and chaos committed by armed workers in Spain, invoking the threat of a "dictatorship of the proletariat."[69]

Official rejection of their pleas for arms did not stop unions and the PCM from organizing military training among members. Lombardo Toledano ordered all CTM unions to form militias using poles instead of arms, and throughout much of 1938 electrical workers met on week-ends for military training, supervised by leftist elements of the mili-tary. The new SME headquarters begun in 1937 included an arsenal and battlements above its entrance.[70] The purpose of workers militias, an army major explained to a SME assembly, was "so that the workers themselves can make the state work in defense of workers technically and militarily organized." Even the LEAR organized a committee for military training among its members, partly in reaction to an attack by Gold Shirts on its headquarters. When artist Santos Balmori re-ceived a threat from a Spanish merchant in response to one of his anti-Franco posters, the CTM sent him a gift of a pistol to protect himself.[71]

More significant than actual arms or training were attempts by unions and the Communist Party to publicly perform as popular mili-tias. In the wake of Mexico's nationalization of US-Anglo oil compa-nies and fears of military reprisals, the CTM turned the 1938 May Day celebration into a military parade of uniformed workers. It included a group of *milicianas mexicanas* praised in *El Machete* for their class consciousness, discipline, and beauty. *Lux* featured a full-page photo (fig. 6.18) of SME officers Paulín and Roldán dressed as *milicianos elec-tricistas* in the same march. A Communist Party gathering in support of the Spanish Popular Front in Puebla even included a group of chil-dren dressed as "red militia men."[72]

Graphic representations of the Spanish Civil War in Mexico fit into related tropes. The first and earliest celebrated the heroic, organized proletariat in the Popular Front struggle, including armed women. Another emphasizes the threat posed by Franco's troops and the forces of international fascism to the people, particularly women and chil-

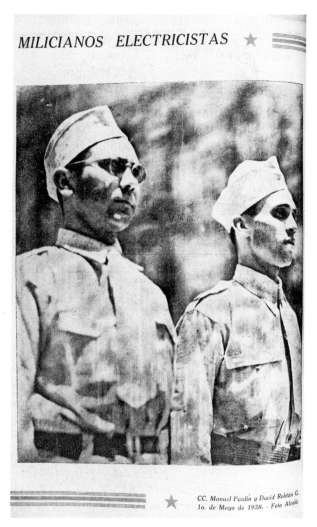

MILICIANOS ELECTRICISTAS ★

CC. Manuel Paulín y David Roldán G.
1o. de Mayo de 1938. · Foto Alcalá.

6.18. Milicianos Electricistas, back cover, *Lux*, May 1938.
Courtesy of the Sindicato Mexicano de Electricistas.

dren. A third trope, predominant as Republican fortunes declined, in-
corporates fascist threats and the desperate Republican defense, with
a more urgent and direct application to ongoing tensions in Mexico.

Visual strategies echoed those of Spanish Republican art, and at
times it is difficult to distinguish Mexican originals from Republican
reproductions, though the former lack the acronyms of competing
groups within the Republic. Prevalent in the first year of the war is
the image of the armed worker on the front. At first depicted in over-

alls, eventually he was drawn in the uniform of the militia, "the people armed," a transformation that reflected the Republican government's need for discipline and unity in the face of decentralized militias.[73]

Of course, the armed soldier and peasant had been a part of the visual vocabulary of committed artists since the murals and prints of the 1920s. However, when *Lux* featured an image of a worker wielding a rifle in 1937 (fig. 6.19), the association with Republican Spain gave greater urgency to a common symbol and to the aspirations of the union's leadership.

More challenging were images of armed women. Women participated fully in the spontaneous armed confrontations during the first

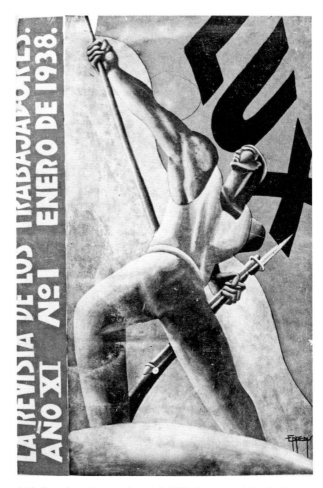

6.19. Francisco Eppens, *Lux*, July 1937. Courtesy of the Sindicato Mexicano de Electricistas.

months of the Spanish Civil War, and they quickly caught the attention of Mexican artists and union leaders in their art and public meetings. Even after most *milicianas* were sent back to the home front in late 1936 by Republican political leaders intent on the "militarization" of *milicias*, the image of the armed female soldier continued to be featured prominently in Spain and Mexico. As Graham points out, her image, aimed at men, was "actively intended as a recruitment device to persuade that male audience to volunteer for military service."[74] Given the limited presence of women in the leadership of CTM unions, in the LEAR, and in the CTM, the prominent references to the *miliciana* in their meetings, marches, and publications seem contradictory. And, of course, there is no Mexican counterpart to the many Spanish posters of women working in factories on the home front, where they made a fundamental contribution to the war effort and challenged gendered ideas about work. The *miliciana* may have been featured in Mexican art to appeal to men to support the cause of Spain, or perhaps to reach out to women for political support, at a time when the PCM sought to incorporate women and women's organizations in unprecedented numbers. Catalina Frías, whose spontaneous speech to the cattle workers union was quoted earlier, used the figure of the Spanish *miliciana* to push for fundamental changes in gender relations in Mexico.

The prominent representation of the *miliciana* paralleled the arrival in October 1936 of one of the first official delegations from Republican Spain to mobilize Mexican support. Caridad Mercader, a high-ranking delegate of the Spanish Communist Party and its Women's Anti-Fascist Committee, led the delegation. She was known as "the Catalan Pasionaria" for her participation in the attack on rebel troops in Barcelona in July 1936 and for her fighting on the Aragon front. She had barely recovered from an injury when she left for Mexico. President Cárdenas and his wife welcomed her and her group on their arrival in Veracruz, and they were featured at a variety of events throughout the country in the fall of 1936. When she spoke at a LEAR-sponsored "Homage to the Spanish People" in Guadalajara, the stage behind her was covered by a huge banner of a male and a female *miliciano* (fig. 6.20).[75]

Mercader addressed the Chamber of Deputies and led the November 20 Revolution Day parade. In a photo of the parade, she walks across the Zócalo alongside CTM leader Vicente Lombardo Toledano, dressed in a *miliciana's mono azul* (blue overall).[76] In Gutmann's photomontage for *Futuro* (fig. 6.21), the parade overflows the Zócalo

6.20. *Homenaje al Pueblo Español*, December 7, 1936, Guadalajara, in *Frente a Frente*, January 1937, page 13. Author's photograph.

with workers and their banners supporting Cárdenas and the Revolution. The image suggests all of the advances of the Mexican working class since the attack by mounted Gold Shirts in the previous year's parade, including the formation of the CTM and the SME strike. But the dominant figures are reminders of the Spanish Civil War, a Spanish *miliciano* on the left flank, and the *miliciana* Mercader on the right. To the right of the *miliciano*, Mercader appears again alongside Lombardo Toledano.

After meeting her in Mexico, the Cuban and LEAR member Juan Marinello wrote, "Never have I come closer to . . . the Spanish tragedy than in the presence of . . . this heroic woman, the good side of the

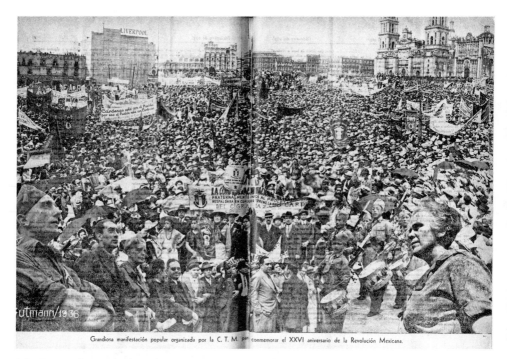

Grandiosa manifestación popular organizada por la C. T. M. para conmemorar el XXVI aniversario de la Revolución Mexicana.

6.21. Enrique Gutmann, photomontage of November 20, 1936 celebration, *Futuro*, December 1936, pages 17–18. Centro de Estudios Lombardo Toledano, Mexico City.

tragedy of her people." Marinello wrote of her a year later from Spain, balancing her role as soldier by imbuing her with the "total abnegation" expected of women, clear in the female soldier's "tranquil decision to march to a sure death . . . without a complaint." Her symbolic warrior status generated rumors; the artist Santos Balmori remembered her as Amazon-like, "missing one breast, blown off by a grenade."[77] For a later generation she would come to symbolize Stalinist excess when it became known that she had returned clandestinely to Mexico in 1939 to support her son Ramón Mercader's successful assassination of Trotsky on orders from Moscow.

Within weeks of the outbreak of the Civil War, the back cover of *Lux* featured a Balmori drawing (fig. 6.22) in "homage to the heroic Spanish women of the Popular Front." A female soldier lies wounded across the foreground, her statuesque body improbably covered by a flowing skirt, while another *miliciana* fires a massive machine gun at the enemy. Behind them, a wall of uniformed women watch, holding pistols and rifles and wearing armbands of the EPR (the Popular Republican Army). *Lux* reprinted the image the following year with

MUJERES

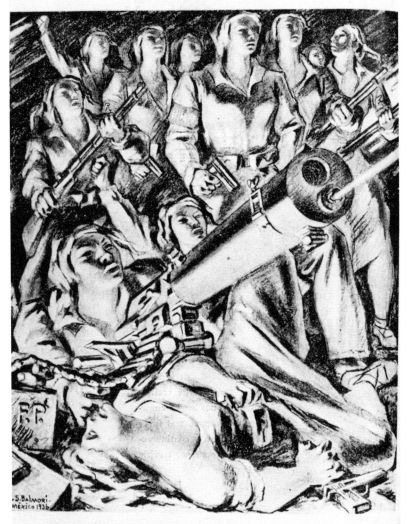

NUESTRO CAMARADA SANTOS BALMORI RINDE CON ESTE VIGOROSO DIBU-
JO UN HOMENAJE A LAS HEROICAS MUJERES ESPAÑOLAS DEL FRENTE POPU-
LAR ESPAÑOL QUE ACTUALMENTE LUCHAN EN CONTRA DE LOS REBELDES FA-
CHISTAS DE SU PAIS, QUIENES PRETENDEN AHOGAR EN SANGRE LAS LIBER-
TADES DEL PROLETARIADO ESPAÑOL.

6.22. Santos Balmori, *Milicianas*, back cover, *Lux*, September 1936. Courtesy of the Sindicato Mexicano de Electricistas and the Fundación Santos Balmori.

6.23. Antonio Arias Bernal, *Miliciana*, *Lux*, August–September 1937.
Courtesy of the Sindicato Mexicano de Electricistas.

the poem "Milicianas," by Mexican poet Manuel González Flores, who linked women's domestic and military tasks: "Before they embroidered with handmade silk threads; today they embroider with the light of bullets the shawls of the trenches."[78]

In a *Lux* cover by Arias Bernal (fig. 6.23), a *miliciana* looks up at approaching enemy aircraft. She cuts a powerful, buxom figure, with broad shoulders, her gun strapped across a uniform that hints at a

worker's overalls, and a bayonet extending behind to challenge the planes, reminiscent of Heartfield's loyalist bayonets defending Madrid from fascist vultures. Particularly striking are her red lips, the artist's reminder of the soldier's ultimate femininity.[79]

In O'Higgins's lithograph *Vultures over Spain* (fig. 6.24), inspired by Goya and Heartfield, a peasant woman at the center urges the village men to attack the vultures of fascism with their scythes and cobblestones.[80] A poem in *Lux*, "Mujer Mexicana," Mexicanizes the *mili-*

6.24. Pablo O'Higgins, *Vultures over Spain*, from *Calendario de la Universidad Obrera de México, 1938*. Courtesy of Mercurio López Casillas.

ciana by linking her to the "Adelita" camp followers in Mexico's 1910 Revolution. In the Spain of 1938, the *soldadera mexicana* embraces the corpse of her Juan in the trenches.[81]

The poem also suggests the more defensive trope that emerged as Republican fortunes declined in the face of infighting and the superior military forces of Franco and his fascist allies. Later images were intended to provoke anxiety and action and featured the need to protect the victimized women and children of Republican Spain, as well as their counterparts in postrevolutionary Mexico. Typical is the Spanish poster reproduced in *Lux* and *Frente a Frente*: A heroic worker-soldier is ordered forward, while the International Red Cross (SRI) promises to defend the daughter pictured below.[82]

At its most direct, this defensive trope shows the technological forces of international fascism laying waste to the most vulnerable. The famous example is the Spanish Ministry of Propaganda's image of a dead, numbered child, reproduced on the front page of *Frente a Frente* (fig. 6.16). Similar is Santos Balmori's carbon drawing of women and children devastated by war (*The Targets of Fascist Aviation in Spain*) that appeared on a *Lux* cover the month after the bombing of Guernica (fig. 6.25). The powerful *milicianas* of his earlier *Lux* cover have disappeared or retreated to their traditional roles as mothers and victims. The explicit message was often, as in the ministry poster, "If you tolerate this (what is happening in Spain), your children will be next!" In one of a series of posters done in 1938 by artist José Chávez Morado for the CTM and the newly unified teachers union (fig. 6.26), the caption is almost a direct paraphrase: if you do not donate, "YOUR TRANQUILITY IS ENDANGERED!" along with that of your children.

Appeals for the mobilization of material and moral support for the Spanish Popular Front were often linked to domestic agendas. As the imminent defeat of the Spanish Republic became clear by mid-1938, the graphic art of the left became increasingly pessimistic. On one hand, artists' representation of the Spanish conflict emphasized the atrocities of fascism rather than the heroic antifascist struggles of the working people of the Republic. For example, one of the first collective projects of the Taller de Gráfica Popular, founded as an outgrowth of the LEAR, was a 1938 series of lithographs titled *The Spain of Franco*. While declaring their adhesion to the "heroic Spanish people," the series featured "a dramatic, ironic version . . . of what happens in the Spain called Francoist." All fifteen lithographs are Orozco-like caricatures that delegitimize and denaturalize Franco and his followers for their brutality, their close ties to the traditional

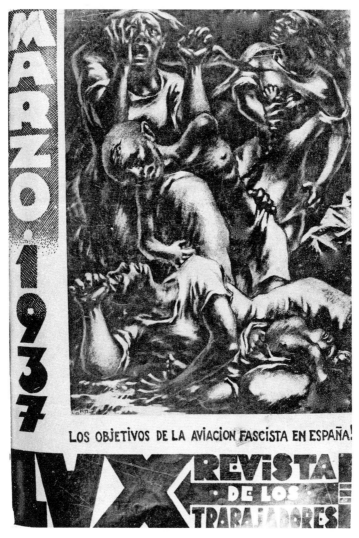

6.25. Santos Balmori, cover, *Lux*, March 1937. Courtesy of the Sindicato Mexicano de Electricistas and the Fundación Santos Balmori.

Spanish church and elites, and their reliance on foreigners, be they the fascist regimes of Germany and Italy or foreign and mercenary troops. At the center of Leopoldo Méndez's *The "Siege" of Madrid of November 1936* (fig. 6.27) is a large, goose-stepping General Franco, carrying two huge flags emblazoned with a German swastika and Italian fasces. His huge Nazi helmet covers his head and shoulders, even more so than the Italian helmet of the priest at his side. The comic

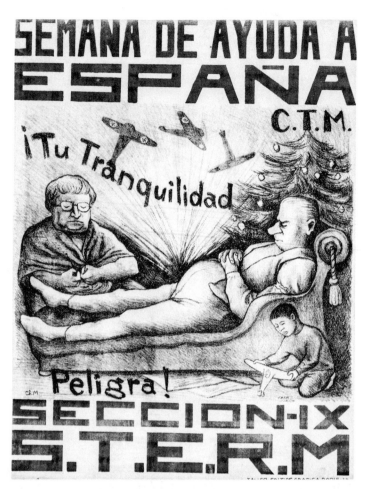

6.26. José Chávez Morado, *Week of Aid to Spain: "Your Tranquility Is Endangered!"* 1938. Courtesy of the Museo del Estanquillo. © Artists Rights Society (ARS), New York/SOMAAP, Mexico City.

leadership is surrounded by dubious North African troops with flowing hooded robes, clownish footwear, and spearlike weapons, suggesting a foreign and ultimately incompetent and unsuccessful conquest. The visual vocabulary of the mindless masses that Méndez references is akin to that used by Orozco and other artists from the mid-1930s (see fig. 7.2), though Méndez's mercenary troops were distinct from Orozco's depictions of crowds, often workers, who followed demagogic leaders of the left or the right.[83] The term "siege," in quotation marks, and the date of November 1936 are ironic reminders that that first siege of Madrid ultimately failed, stopped by a heroic battle joined

by international volunteers and commemorated by Heartfield's iconic work, *¡No Pasarán! ¡Pasaremos!* The greater irony, obvious to many when the print was made, was the inevitability of the fall of Madrid and of Franco's victory. Both were consummated by the end of March 1939, months after internationalists supporting the Republic had been sent home and the flood of refugees to France, the Soviet Union, and Latin America had begun. Well before the formal defeat of Republican Spain, the international topic for Mexican artists had shifted from Spain to the looming threat of German and Italian aggression throughout Europe.

Mexican artists made the Spanish Republic's defeat into a warning for domestic politics. For example, in an article and caricature in *El Machete*, the attacks by two state governors on the local activities of the CTM were *bombardeos* labeled with swastikas against the "indestructible unity of the working class." The rebellion of Cárdenas's former agriculture minister, General Saturnino Cedillo, in the spring of 1938 was proof that "fascist espionage" had chosen him to be Mexico's Franco.[84] And if the left earlier had revived centuries-old

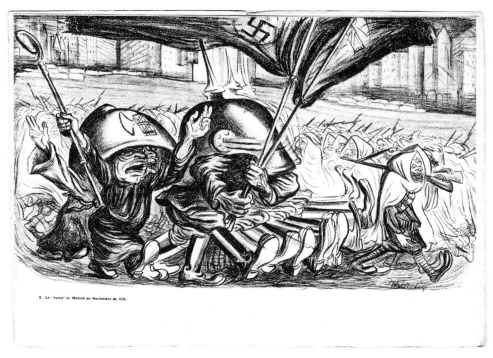

6.27. Leopoldo Méndez, lithograph, *The "Siege" of Madrid in November 1936 (1938)*. Courtesy of Michael J. Ricker. Permission of Pablo Méndez.

6.28. Luis Arenal, *Ultramarino*, from *Calendario de la Universidad Obrera de México, 1938*. Courtesy of Mercurio López Casillas. Permission of Graciela Castro Arenal.

fears of conquering Muslims, they amplified deep-rooted denunciations of *gachupines*, the Spanish immigrants pervasive in commerce and industry, carefully distinguished from Republican refugees. A lithograph by O'Higgins for the 1938 Universidad Obrera calendar denounces exploitative Spanish merchants in Mexico City who monopolize and sell overpriced food staples to a desperate crowd in front of the Casino Español, the bastion of wealthy Spanish immigrants and pro-Franco sentiment. The association of merchants with Spanish fascism is again made through a pair of vultures and, even more unequivocally, through a loudspeaker that projects the words "Bombing of Madrid, women and children dead, long live Franco!!" [85] In Luis Arenal's lithograph for the 1938 Universidad Obrera calendar, *Ultramarino* (fig. 6.28), a crowd of poor men and women mark Independence Day by breaking into a Spaniard's shop and distributing its food.

LEAR member Verna Carleton Millan describes a related scene that conveys the intent if not the exact content of both images:

Only a few days ago, when the agitation against receiving the Spanish refugees was so great here, I saw a large crowd gathered around a poster portraying, with keen satire, a fat Spanish merchant squeezing Mexico dry of wealth. The title said that Mexico would willingly exchange all the Spaniards in the country who were exploiting the Mexican people for the writers, artists and men of science whom Franco had converted into political refugees.[86]

Pro-Franco Spaniards in Mexico organized protests against Mexico's reception of Republican refugees, whom they deemed communist agitators and vagabonds, but they were not alone in their concerns.[87] Solidarity with refugees was increasingly a hard sell by 1939. Labor leaders had been actively pro-Republic, but rank-and-file support had never been uniform. Early on, the Mexican consul-general in Barcelona denounced a small group of Mexican "workers with bourgeois ideas" who were apparently fighting in Spain on behalf of Franco. Probably more significant was a degree of working-class indifference or, for many workers by 1939, exhaustion. Rank-and-file workers in Monterrey began to challenge resolutions proposed by their own leaders to contribute wages toward the Spanish Republican cause. And when Spanish refugees began arriving in Mexico in 1939, SME and CTM leaders had to repeatedly reassure members and unorganized workers alike that the skilled refugees and bereft orphans they welcomed would not compete for scarce jobs and resources.[88]

The Spanish Civil War helped shaped domestic politics and the imaginaries of workers and artists as they constructed shared and sometimes conflicting images of the worker in terms of class, nation, and international struggle. A transnational culture developed from engagement in Popular Front antifascism and the Spanish Civil War and fostered a creative outburst of graphic expression and a call for working-class unity and mobilization. At the same time, the defeat of the Spanish Republic in 1939 mirrored crises among and within Popular Front groups in Mexico. Many of these crises were rooted in latent structural and ideological differences that were reinforced by international and national developments. The call for unity ultimately divided and isolated workers and artists and subordinated much of the newly formed CTM to an increasingly conservative and nationalist government after 1938. After a series of military and diplomatic defeats for Republican Spain, the message Mexican artists and union

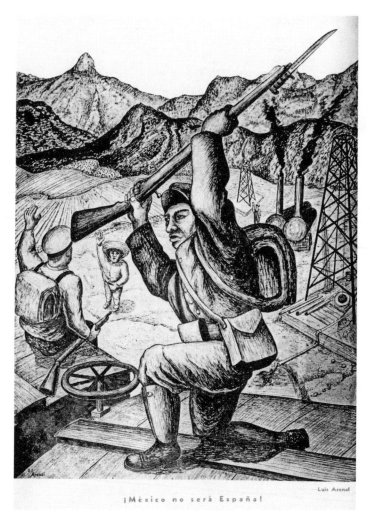

¡México no será España!

6.29. Luis Arenal, *Mexico Will Not Be Spain!*, cover, *Futuro*, July 1938. Permission of Graciela Castro Arenal. Author's photograph.

leaders projected was no longer the victories of the proletariat of both countries, but rather their differences. In Arenal's print and caption in *Futuro* (fig. 6.29), a worker-soldier raises his rifle above a scene of rural technology that suggests the recently nationalized oil industry. The key difference, the caption reads, is that "MEXICO WILL NOT BE SPAIN!" Of course, the lessons of Spain were the subject of intense debate, and the subsequent cry of "Unity at all costs!" would prove both divisive and costly.

"UNITY AT ALL COSTS!" AND THE END OF REVOLUTION

Mexico would not be Franco's Spain, but neither would it be the Popular Front country that many artists and union leaders had imagined. As historians have noted, the period 1937 to 1938, and the oil nationalization in particular, were the culmination of Cárdenas's reform agenda and a pivot around which his government moved toward moderation, national unity, and the political institutionalization of the social forces he had helped to mobilize.[1]

A variety of international factors shaped Mexico's political shift to the center. Cárdenas shared the fears of Western democracies and the Soviet Union of a direct military clash with the fascist forces of Germany and Italy, one that would inevitably envelop Mexico. One scholar suggests that the defeat of the Spanish Republic, presented by some Spanish politicians exiled in Mexico as the result of its excessive radicalization and divisions within the left, was influential in Cárdenas's turn toward moderation from 1938.[2] Dire warnings came from the right and even from Diego Rivera that Spanish refugees, the CTM, and the PCM were all conspiring to "reproduce in Mexico the Spanish war."[3]

But domestic issues mattered more. Mexico's economy mirrored the US downturn of 1937, and reforms were constrained by the costs of nationalization of Anglo-American oil companies and the US boycott of oil exports that followed. In spite of broad public support for nationalizing the oil, a resurgent opposition emerged around various aging caudillos, the clerical right, and more subtly the business elites who insisted on investment guarantees from Cárdenas and his successor, which inevitably shaped the presidential succession of 1940.

Workers played a fundamental role in the strikes leading to the 1938 nationalization and the creation of the institutionalized order that emerged in its aftermath. Organized labor had arguably been the most politically powerful and autonomous of the social forces that Cárdenas depended on for political support during his early presidency, and thus labor played a key role in creating Cárdenas's new political party,

the Party of the Mexican Revolution (Partido de la Revolución Mexicana—PRM), in 1938. But organized labor's incorporation was premised as much on its divisions as on its unity. Two contradictions lay at the heart of the Popular Front ideology it had helped construct. The first was between the public assertion of working-class unity and the reality of its continued fragmentation. Union leaders from distinct sectors of the economy imagined the national labor movement differently. The differences were made manifest in the break of the SME and several other powerful industrial federations with the CTM. The second contradiction was between the aspirations of the PCM and the CTM for central roles in a national political alliance, and the reality of the new dominant PRM, with its corporate subordination of labor and its ultimate exclusion of the Communist Party. These tensions would further divide workers within specific unions, as exemplified here by the crises within the SME.

Both tensions were portrayed in art, while artists themselves were torn by differences over the role of politics in art and their divided loyalties among unions, the PCM, and the government. These in turn played into the "deproletarianization" of the PCM in 1938, and facilitated the demise of the LEAR, soon after both declared their greatest numbers and triumphs.[4] The contradictions are best summarized by the PCM's call for "Unity at all costs!" that papered over divisions and facilitated the taming of the left. The contradictions are contained in the image of the worker, which came once again to signify nationalism and harmony between capital and labor.

Finally, after a dramatic decade of change, a perhaps inevitable "routinization of revolution" settled in among an aging group of revolutionary leaders and, to some extent, among campesinos and workers, curtailing their appetite for radical reform. In the words of Alan Knight, it was the "end of the revolution."[5]

DIVIDING THE CTM

Within the ranks of the newly formed CTM, a fundamental division existed between the powerful national industrial unions and the many company-based unions affiliated with regionally based federations. Railroad, oil, and mine workers wielded strategic leverage in the economy, even more so after the creation of national unions or federations in each sector in the 1930s. They insisted on democracy in their ranks and a large degree of autonomy within any national labor

movement and vis-à-vis the government. The orientation of electricians was similar, though in 1937 their primary organization was the company-based SME rather than the comparable national federation. By contrast, company-based unions and regionally based federations, while more numerous in numbers and membership, had limited economic clout and a much greater reliance on their centralized leadership and government ties dating back to the heyday of the CROM.

A related division within the CTM existed between the unions that had previously affiliated with the Communist-led CSUM federation and those that once belonged to the CGOCM. Within the CGOCM, Lombardo Toledano had distinguished himself as a brilliant intellectual and mediator with the state, but he had limited union backing beyond one of the multiple teachers unions. Instead he depended on the organizations controlled by the more conservative Fidel Velázquez and Fernando Amilpa, with their varied constituencies rooted in the smaller unions of the Federal District and the regional FROC federations. The unprecedented prominence of the PCM within the labor movement and the CTM itself was a lightning rod for discord, mobilizing workers in the early Cárdenas years but dividing them after 1936. The divisions contained within the CTM would plague it from its origins, complicate workplace actions, and limit its participation in society and politics in the final Cárdenas years and beyond.[6]

At the February 1936 unity congress, the SME's Breña Alvírez opened with a report on the National Committee for Proletarian Defense, part of the process of dissolving the organization he had called into being eight months earlier to unify the labor movement. He celebrated the fact that labor had overcome historical divisions among sectors of the working class, supported Cárdenas in his conflict with Calles, and provided solidarity for recent strikes. He did not hesitate, however, to take the transitional organization to task for a long list of "deficiencies." He hoped the proposed CTM statutes, which he had helped write, would resolve these problems. Yet even as he tempered his speech, he warned darkly in *El Machete* the next day that the new organization's "most formidable obstacle and most difficult task consisted in the elimination of professional leaders, that is to say, those who exploited their status as leaders to break the backs of workers."[7]

On the final day of the congress, conflict occurred over the election of officers. Lombardo Toledano was easily elected secretary general; his apparent capacity to mediate between militant and conservative unions, as well as his close ties with Cárdenas, made him the consensus candidate. But divisions emerged over the all-important

position of secretary of organization, in charge of ratifying new member unions. The main nominees were Miguel Velasco, a communist member of the railroad union and the CSUM, and Fidel Velázquez of the CGOCM. Though Velasco had the support of the large and powerful industrial unions, the anticommunist leaders of the former CGOCM threatened to abandon the congress if Velázquez was not chosen. To the disgust of many, communist leaders offered a compromise that made Velasco secretary of education instead and still assured leaders affiliated with the PCM two of six positions on the national committee.[8]

The leadership elections set the stage for immediate and ongoing conflict, as Lombardo Toledano consistently allied with the conservative Velázquez and Amilpa to centralize and control decision making at the expense of the industrial unions and the PCM. As Barry Carr observes, more than a battle for power between left and right, at stake were two different notions of union democracy: One "emphasized the accountability of leadership to rank-and-file opinion, the importance of local and regional union autonomy, and the need to break with the corrupt and antidemocratic tradition of 'leaderism' bequeathed by the largest of the union federations of the 1920s, the Regional Confederation of Mexican Workers (CROM)." The other "emphasized the need for centralization of authority, iron discipline, and unlimited respect for the Cardenista state's project of creating mass organizations tied closely to government economic and political goals."[9]

At the June 1936 meeting of the CTM's national council, the miners union withdrew after Velázquez ignored the jurisdiction of the national union over local organizations of miners, instead incorporating them into regional federations. At a second meeting in October, Velázquez and Lombardo Toledano bypassed unified federations of public employees and teachers led by Communists in favor of alternative organizations that they could control. These divisions made it easier for the government to separate both groups from the CTM soon after. The SME walked out of a January 1937 national council meeting, publicly denouncing the way Velázquez tightly controlled the incorporation of new unions; the fact that 90 percent of unions voted without having paid their dues (making obvious the CTM dependence on government funds); and how, contrary to statutes, small, enterprise-based unions received outsized voting power relative to the big industrial unions.

Tensions finally exploded at the fourth national council meeting in April 1937 when twenty-three state federations and national indus-

trial unions, including the SME and the railroad workers, abandoned the meeting over the manipulations of Lombardo Toledano and Velázquez. CTM leadership blamed dissent on the PCM. But while the PCM vocally supported the protest of the dissident unions, many with communist leaders, they mostly had given voice to the discontents of industrial unions. A SME press statement explained that the problem for the CTM was not ideology but that communist union leaders had "the 'bad habit' of unmasking leaders who deceive and exploit workers."[10]

Santos Balmori's April 1937 *Lux* cover (fig. 7.1) embodies the electricians' critique of the CTM. It inverted the January 1936 cover, which had featured the electricians' secretary general, Breña, speaking before a mass of workers newly unified against a reactionary Calles (fig. 6.8). The muted gray tones of Balmori's new print, perhaps a lithograph, differ from the sharp black-and-white contrasts of the earlier relief print, suggesting not the polar contrasts of united labor and its enemies but rather the ambiguities and divisions of mass mobilization in the age of fascism. The heroic speaker has morphed into a demagogue, shrieking into a microphone at the now undifferentiated and sedate masses. The central banner declares, "LONG LIVE OUR MAXIMUM LEADER," an ironic suggestion that CTM leaders Lombardo Toledano and Velázquez had replaced Jefe Máximo Calles, whom they had recently helped Cárdenas expel from the country. "COMRADE WORKER" reads the editorial caption, "THE FALSE LEADER IS A GREATER DANGER FOR YOU THAN THE AGGRESSIVE REACTION. REMOVE HIS MASK!"

In case there was any doubt about the identity of the false leader, the editorial and interior caricatures of Lombardo Toledano and Velázquez made it clear.[11] In Balmori's print, the false leader to be unmasked is not only Lombardo Toledano but also former labor strongman Morones, whose plump likeness is unmistakable in the top of three masks dangling from the side of the podium. As if summoning Orozco's 1920s images, Balmori makes Morones the ghost of labor movements corrupted by their leaders. The task invoked and enacted by the cover image was the same "bad habit" for which the electricians union had praised the Communists, "unmasking leaders who deceive and exploit workers."

Finally, the false leader of manipulated masses hints at European fascism. Balmori references two of Orozco's 1935 lithographs. In Orozco's *Demonstration*, a working-class leader at the head of a crowd disappears behind a banner, and the crowd is a collective blur that marches in step as the banners become generic and meaningless.

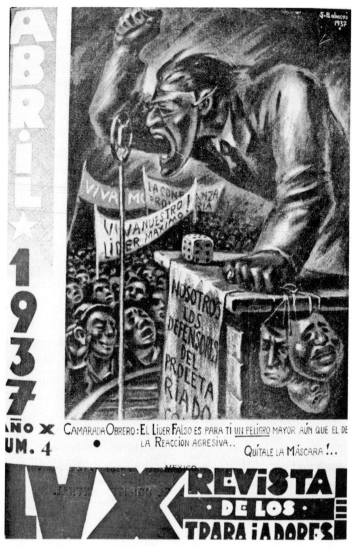

7.1. Santos Balmori, cover, *Lux*, April 1937. Courtesy of the Sindicato Mexicano de Electricistas and the Fundación Santos Balmori.

In *The Masses,* the banners disappear, replaced by a sea of oversized mouths presumably shouting slogans in mindless unison. Reprinted in *Frente a Frente* in August 1936, Orozco's *Demonstration* (fig. 7.2) denounced the de-individualizing potential of mass movements, and it contrasted with the earlier LEAR images of united and powerful masses of workers, just as Balmori's false leader reversed the triumphs portrayed in his earlier *Lux* covers.

The PCM's critical unmasking did not last. Comintern intervention at Lombardo Toledano's request convinced the PCM to abandon dissent. For the Soviet Union, the cohesion of the CTM and its possible alliance with the Cárdenas administration was more important to its global strategies against fascism than union democracy or social gains. The PCM directed its union cadres to come to terms with the CTM's leadership and encourage others to do the same. All but the SME and the miners returned to the fold, even as the CTM leadership punished the Communists by removing their two officers from the National Committee, further centralizing its own power. The PCM's submission was confirmed soon after in its congress, when it agreed to withhold criticism of Cárdenas and introduced its "Unity at all costs!" slogan. By contrast, the SME formally withdrew from the CTM in October 1937 and continued to hold the CTM accountable in

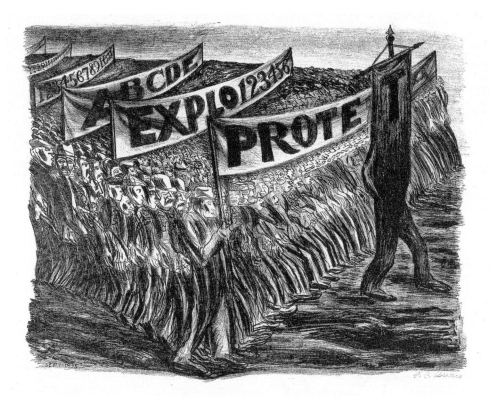

7.2. José Clemente Orozco, lithograph, *Demonstration*, 1935. © Artists Rights Society (ARS), New York/ SOMAAP, Mexico City. Blanton Museum of Art, The University of Texas at Austin, Archer M. Huntington Museum Fund, 1986.

the press and in *Lux* for its multiple abuses, responding vigorously to the CTM's formal charges of "divisionism" and "lack of discipline."[12]

The PCM's reversals came just as it had achieved unprecedented influence among powerful unions of national industries, teachers, and public employees. As Carr observes, "The PCM exited from this controversy not only with its hands tied in the urgent battle to democratize the CTM, but with its prestige tarnished among unions that regarded the Communist party as a firm repository of honest and principled commitment to democratic and revolutionary unionism." Thus began what Gerardo Peláez Ramos calls the "deproletarianization" of the Communist Party, that is to say, the loss of the most significant working-class base since its founding.[13] The consolidation of Lombardo Toledano and his allies in the CTM leadership ultimately ended the ideological plurality that had briefly existed within the labor movement, undermining its potential to assert its autonomy and challenge the government on behalf of working people.[14]

As noted, union leaders had had distinct and changing ideas about the strategy of political alliances between their unions and their government. After 1929, when the CROM alliance with the state collapsed and the government of the Maximato shifted right, the labor movement as a whole grew wary, and newly formed confederations like the CGOCM insisted on political autonomy. Cárdenas's early support for labor mobilizations helped change the attitude of many labor leaders toward involvement in politics, just as the PCM's Popular Front strategy justified the growing intimacy between union leaders, the president, and the institutions of government. But the Popular Front as proposed by European Communists was not simply a strategy of loose alliances among progressive forces. It had a concrete goal: the creation of a government based on an alliance of all progressive parties, including the Communist Party. The obvious model, at least until its defeat, was the Republican government of Spain.

Mexico's version of the Popular Front was to be shaped by the nature of the postrevolutionary political system and its relation to foreign capital. The 1936 congress that founded the CTM endorsed the formation of an "Anti-Imperialist Popular Front," insisting that in a country like Mexico, dependent as it was on foreign capital, "nationalism and socialism for colonial and semi-colonial countries are two aspects of the same struggle." A broad Popular Front, it went on, was the best way to defend the poor and exploited who were not organized in unions, thus assuming an alliance of unions with the state. The declaration insisted that the Popular Front was to transcend ties to any

specific party or even to the CTM itself. But in the Mexican context, the essential players for such a front were the left wing of the official party and the newly formed CTM. In closing the congress, Lombardo Toledano embraced the obvious: "Our duty is to support Cárdenas, against the Callista reaction and against imperialism."[15]

In the midst of massive social mobilizations and ambitious reforms, Cárdenas flirted directly with the concept of the Popular Front. In a January 1937 interview with LEAR photographer Enrique Gutmann, the president noted he had been elected before the possibility of a Popular Front existed, but he insisted that "I can easily imagine a future government of Mexico that could arise from and be sustained by a legitimate and singular Popular Front."[16] Of course, any such initiative would indeed be singular, given the political monopoly of the PNR.

In an August 1937 speech, Cárdenas hinted at the corporate structure of the PRN reorganization: "the transformation that we are realizing is based on four powerful columns"—teachers, campesinos, workers, and the military. In December, he announced plans to restructure a party many still saw as dominated by Callistas. The announcement came on the same day Mexico's Supreme Court decided in favor of oil workers in their ongoing conflict with foreign oil companies.

At the same time, the PCM in effect endorsed the official party as the only electoral representative of mass organizations when it withdrew its independent candidates for the 1937 midterm elections. Instead, they collaborated in a process tightly controlled by the PNR to elect thirty conservative union leaders to the national legislature.[17]

In the subsequent negotiations over the structure of the new party, Lombardo Toledano referred to it publicly as the long-awaited Popular Front. Eventually named the Party of the Mexican Revolution, it was constituted by four corporate sectors: labor, campesinos, the military, and a "popular" sector that would included small businesses, middle-class professionals, teachers, and public employees, among other groups. The incorporation of new groups into the restructured official party was tremendously significant for the country's political system and social movements, but it was hardly the creation of a Popular Front coalition.

Arenal's December 1937 *Futuro* cover (fig. 7.3) embodied the key elements of the newly announced party, with an armed worker and campesino flanked by a soldier and a man in a suit, carrying a book, who represented the popular sector. The labor sector, dominated by

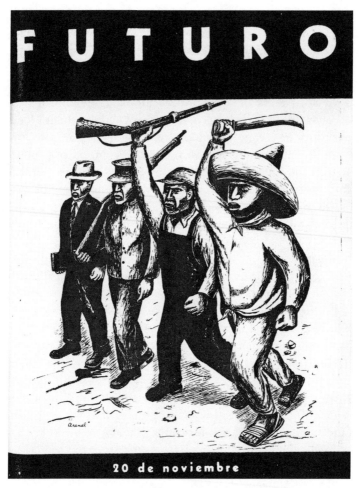

7.3. Luis Arenal, cover, *Futuro*, December 1937. Centro de Estudios Lombardo Toledano, Mexico City. Permission of Graciela Castro Arenal.

the CTM, would begin as the most powerful of the four, with access to a considerable share of political offices that helped it consolidate control over its own ranks. In an *El Machete* caricature, the new national party was even embodied as a worker in overalls.[18]

But the CTM's influence within the PRM proved limited over time. Cárdenas insisted on keeping worker and campesino sectors separate. Similarly, federations of teachers and public employees were eventually maneuvered out of the CTM and into the "popular" sector. Not only was the social organization of these groups separate; within the

PRM they competed with each other for political positions and faced strict limits on coordination among sectors. Members in all four sectors could "not execute any act of a political-electoral nature" except through the PRM, which curtailed union support for independent candidates. As occurred with so many of the groups mobilized in the early years of Cardenismo, the CTM traded its autonomy, its ideological diversity, and many of its specific demands for corporate political representation.[19] Even there, the CTM quickly lost ground. They had won thirty seats in the 1937 midterm elections before their formal incorporation into the official party. In the 1943 midterm elections, the CTM held only 21 of 154 PRM candidacies, far less than the 56 candidacies offered to the rival "popular" sector.[20] By the time the civilian Miguel Alemán assumed the presidency in 1946, the official party had been reorganized and renamed as the Institutional Revolutionary Party (PRI). The language of a "democracy of workers" that had characterized the formation of the PRM disappeared. The "Pact" between workers, campesinos, the army, and popular sectors as the party's base became instead a "political association of citizens," and the management of class conflict became "a function of the State."[21]

The PCM was too weakened by its policy of "Unity at all costs!" to push for a greater role in the PRM. Although it was at the peak of its membership in 1938, had its own radio station, and regularly printed 32,000 copies of *El Machete*, its acceptance of its marginalization in the CTM reduced any leverage it might have had to negotiate the terms of the new party, much less assure its own participation. The old guard of the PNR would not tolerate the inclusion of another political party with its own statutes and ideology.[22] Soon after its formal inauguration, the PCM declared that "the constitution of the Party of the Mexican Revolution and the expropriation of the petroleum industry are the most important [events] in the contemporary history of our country," and it euphemistically asserted that "all Communists will belong to the [PRM] through their membership in different social organizations."[23]

The formal incorporation of much of organized labor into the mechanisms of government was closely tied to the fervent nationalism engendered by the expropriation of Anglo-American oil companies. The PRM was inaugurated on March 30, 1938, twelve days after Cárdenas's nationalization decree, at a time when he urgently needed broad support. The nationalization of the foreign companies that had most humiliated Mexico moved the entire population, including the church, to express support, but the action was particularly meaning-

ful for workers. Conflicts over oil had simmered since 1910, and the resolution began with a May 1937 oil workers strike and the forceful support of Cárdenas and his government. In contrast to the electricians strike, the unified oil workers union, formed in 1936, worked closely with Cárdenas and the CTM from the beginning of the strike, invoking the need for national solidarity against imperialism. Many workers saw the bold nationalization of the oil sector and experiments in worker administration of the railroads as the decolonization necessary for national development. Others saw them as significant steps toward state control of the economy, a more just social system, and eventually socialism. Both views validated the formal incorporation of unions into the ruling party in the name of an anti-imperialist Popular Front strategy.[24]

The new party and the oil nationalization marked a turning point for the government and labor. Mexico faced mounting internal economic problems tied to the US economic downturn, foreign pressure to compensate the foreign oil companies, and the threat of war in Europe. Even as Mexicans unified around the nationalization, opposition to the president's perceived radicalism grew among provincial politicians, the church, conservative sectors of the military, and more subtly the business elites who insisted on investment guarantees from Cárdenas and his successor. The ARM and its Gold Shirts had been forced to disband in 1936, but the extreme right reorganized around new organizations. The more moderate business and Catholic sectors supported the creation of the National Action Party in 1939 and backed General Juan Andreu Almazán in the 1940 elections as an opposition candidate.

As the imminent defeat of the Spanish Republic became obvious, Cárdenas became wary of further reforms that might provoke a Franco-style insurrection at home, and he became suspicious of the PCM's influence among campesinos, teachers, and industrial workers and of Lombardo Toledano's ties to Moscow. He continued to refuse to reestablish formal ties to the Soviet Union and provoked the PCM and CTM in 1937 by granting refuge to the renegade Communist Leon Trotsky. As Cárdenas tacked toward the center, he curbed the radical rhetoric of the first years of his presidency and insisted in public that there was no communist government in Mexico.[25]

Moreover, as he made clear his intention to surrender the presidency and rejected any Jefe Máximo role after 1940, he inevitably became a lame duck within the new party he had created, allowing a struggle for succession that he didn't entirely control. As he shifted

toward the center, the president still demanded and largely obtained sacrifices from organized labor. In the last three years of his term, the number of annual strikes dropped by half.[26] When the PRM demanded support for a moderate presidential candidate, Lombardo Toledano delivered the CTM endorsement for General Manuel Ávila Camacho, in spite of significant internal opposition, setting a pattern for the CTM of ruthless internal discipline and absolute political obedience in future presidential elections.[27] Shortly before Cárdenas's term ended, his nervous defense secretary ordered the CTM's militias to be dissolved.[28]

The context of a popular and progressive president, the oil nationalization, and the incorporation of unions into the PRM's Popular Front strategy facilitated a rhetorical convergence of radicalism and nationalism in worker mobilizations and representations. The oil nationalization was celebrated in multiple graphic images in media of every ideological bent. *El Machete*, *Futuro*, and *Lux* all endorsed the patriotic frenzy. Arenal's cover for *Futuro* (fig. 7.4) emphasizes the act of expropriation in a disembodied hand—that of Cárdenas or the Mexican people?—striking a deathblow to the octopus of foreign oil ownership and freeing the country's national resources as well as the victimized laborer from its tentacles.

A photomontage in *El Machete* (fig. 7.5) for May Day 1938 asserts a direct relationship between the president and workers. A portrait of the president is set against a collage of multiple crowds of workers from provincial cities that together constitute a united nation, "Supporting Cárdenas in the Expropriation of Foreign Companies." At a PCM celebration of Mexico's Independence Day, Hernán Laborde spoke on a balcony draped with portraits of Lenin, Laborde himself, and Cárdenas.[29]

PAINTING A DIVIDED SME

The electricians union rallied to support the nationalization of oil, donating 100,000 pesos to the compensation fund.[30] *Lux* photomontages featured Cárdenas and the masses, but more typical is a cover by Francisco Eppens (fig. 7.6), who had replaced Balmori as the principal *Lux* artist.[31] Like Balmori's depiction of the 1936 SME strike, Eppens features the role of labor, with a single, monumental worker straddling an oil derrick, a symbol of national wealth recovered from foreigners. But Eppens adds two elements: a prominent national flag

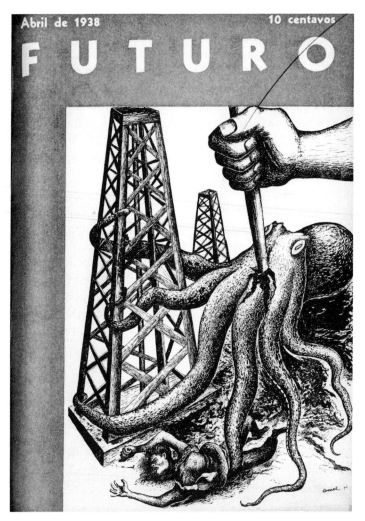

7.4. Luis Arenal, cover, *Futuro*, April 1938. Centro de Estudios Lombardo Toledano, Mexico City. Permission of Graciela Castro Arenal.

whose patriotic colors flow through the entire cover; and an almost orgasmic nationalist release, as the phallic oil derrick extends between the worker's muscular legs and spurts into his hand.

The nationalization of petroleum created a complicated moment for a union that had prided itself on its class-based internationalism. In twelve years of publication, no *Lux* cover had included an image of the president or of the national flag. Two issues after the patriotic cover, the lead article by Alvar Ross, possibly a pseudonym for *Lux*

director Breña, challenged labor leaders who once "condemned patri-
otic sentiment as bourgeois, to be substituted for a wider sentiment
that resulted from our class consciousness," but "today discover them-
selves in front of the national flag and cry to chords of the national
hymn."[32] The article was illustrated by a reprint of Balmori's masked
demagogue (fig. 7.1). The challenge was most likely aimed at CTM
leaders but soon extended to a divided SME.

The four years after the SME's successful 1936 strike were marked
by internal divisions. Relations with the power company were sub-

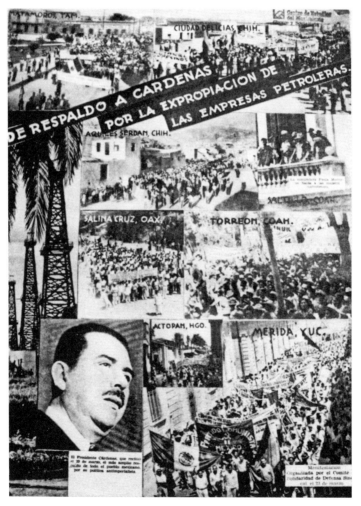

7.5. Photomontage, *El Machete*, May 1, 1938, back page. Author's
photograph.

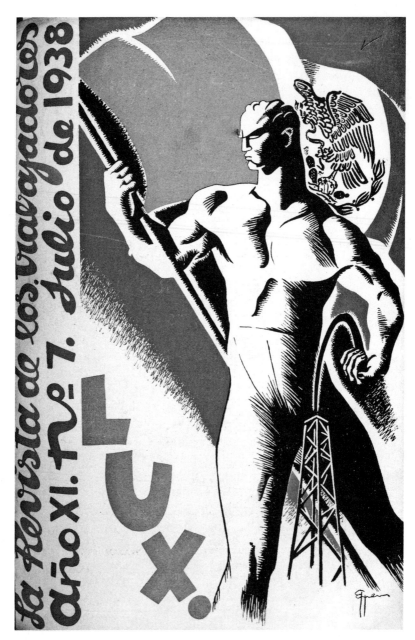

7.6. Francisco Eppens, cover, *Lux*, July 1938. Courtesy of the Sindicato Mexicano de Electricistas.

dued as the union and its members enjoyed the gains won in the strike. Cárdenas had asked for limits on workers' demands, and the SME accepted minor revisions and wage increases in its 1938 contract.[33] Rather, conflicts were internal, as the union divided over its relation to the CTM, the PCM, and the new PRM.

Central to each conflict was the nature and political orientation of the union's leadership. In 1933, the engineers had brought a new generation and style of leadership as they raised the cultural profile of the union, led it in successful confrontations with the foreign owners, and formed alliances with leaders in the labor movement. No figure better represented these accomplishments than Breña, who remained popular among the rank and file and in December 1936 was elected as Secretary of Education, a position he had first held in 1933. He remained a formidable figure in the central committee over the next two years by force of personality and prestige and his control over *Lux*.

Like the other engineers, he brought a moralizing tone to his public interventions that must have grated with some members, constantly urging them to improve themselves intellectually and morally by enrolling in classes, making better use of the library, serving the union for the collective good rather than personal interest, and following to the letter the union statutes he had helped write. Typical is his 1937 annual report as secretary of education, where he concluded that "the rapid growth in the economic potential . . . of the union is of little value if there is not a corresponding elevation in our intellectual and moral level." As *Lux* editor, he didn't hesitate to publish his recommendations in the union elections in that journal, recommendations that included his own reelection as secretary of education. At various moments, individual members accused the central committee in general and Breña in particular of acting as a dictator. In one assembly meeting, a worker who disagreed with Breña confessed to lacking the education to debate the formidable intellectual directly, and so he simply read an article that expressed his dissenting viewpoint. One can hope that Breña took pride in that worker's hesitant erudition.[34]

But the "Age of the Engineers" ultimately ended because they became sharply divided among themselves. The withdrawal of the SME from the CTM remained a point of contention. The new secretary general, Manuel Paulín, reminded members in his annual report for 1937 of the CTM attacks on the union, but he also lamented that the SME had not closed ranks in the face of external aggression. He denounced the "artificial state of agitation" created by members who defended or "spied for" the CTM, which had led the general assembly

to expel a prominent member. The break with the CTM, Paulín acknowledged, had resulted in a degree of isolation that put the union in a tough position and required "a review of the general external policy that our union has been practicing."[35]

The occasion soon came, as the SME divided sharply over its relationship with the new official party. Paulín negotiated directly with the government to allow formal representation for the SME within the workers section of the PRM—subordinate to the CTM but comparable in representation to the positions of the CROM, the anarchist-inspired CGT, and the independent miners union. But bitter debate over the arrangement extended over a series of assemblies. Paulín and a majority of the central committee endorsed inclusion in the PRM: having unions appoint candidates to public office within a powerful state party "would be the beginning of a true democracy." Even if the union didn't change its statutes to allow members to run for political office, they argued, it had to collaborate in resolving national problems. Doing so might allow them to return to the CTM "with dignity and its head held high."[36]

The support of Cárdenas for the labor movement in general, his strategic "nonintervention" in the 1936 strike, the euphemism of a Popular Front, and the flurry of national solidarity around the oil nationalization made incorporation into the PRM irresistible. A line drawing (fig. 7.7) on the back cover of the January 1938 issue of *Lux*, possibly a government ad, evoked the allure of such a partnership. A construction worker strains every muscle as he carries a heavy block marked "contribution" to a rising edifice behind him. "CITIZEN!" shouts the text: "CARRY YOUR STONE TO THE CONSTRUCTION OF THE NEW STATE." The image had a long genealogy, from Herrán's worker constructing the order and progress of the Porfiriato, to the more explicit CROM worker, serving the "amalgam of the national flag and the red and black [flag]" of class consciousness and patriotism. In the new party, it promised, "citizen" would equal "worker." More specifically, the image echoed the most concrete and unifying project of the union at the time: the construction of their new building and headquarters, featured in a photo layout in the same issue (fig. 7.8). At a propitious moment for the nation and for the prosperous but isolated and divided union, the SME had a chance to build both edifices in tandem.

Breña led the minority opposed to joining the PRM, arguing that in spite of obvious advantages, such as ending the union's current isolation, "principles are more important." Just as the SME was denied its rights in the CTM, he explained, the same could happen within the

¡CIUDADANO!

Lleva tu piedra a la construccion del nuevo Estado.

ARTES GRAFICAS DEL ESTADO, S. C. L.

7.7. *Lux*, back cover, January 1938. Courtesy of the Sindicato Mexicano de Electricistas.

PRM, since the PRM statutes allowed it to censure union organs like *Lux* and demand that unions follow the party line on any issue related to national politics. The likely imposition of a party line, he pointedly observed, reminded him of his time in the Soviet Union, where he "never heard a single criticism of Soviet leaders." In spite of his prestige within the union, the assembly voted to join the PRM. Someone in the assembly aptly summarized the conclusion to the extended de-

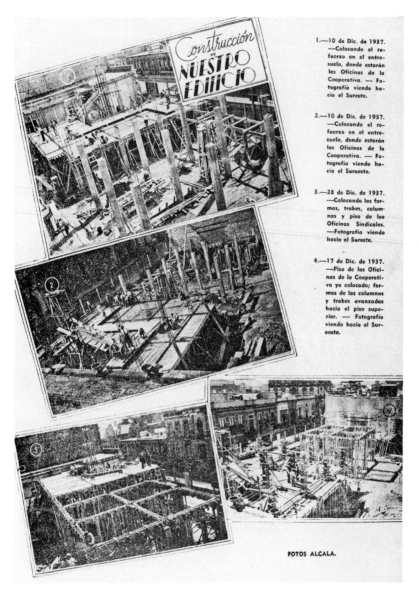

7.8. Photos of "Our Building," *Lux*, January 1938, page 15. Courtesy of the Sindicato Mexicano de Electricistas.

bate: "Breña is a Quixote, but the separation from the party would mean that the union is not behind General Cárdenas."[37]

Breña's public disagreement with Paulín in the assembly meetings was unusual. The union's tradition had been that any minority opinion within the central committee was not to be aired publicly; Breña insisted that the issue was too important not to speak out.

Breña had also revealed related divisions in the leadership over the nature of the Soviet Union and the role of the PCM in union affairs. Immediately after the 1936 strike, Breña had travelled to Belgium to attend the World Peace Conference on behalf of the CTM, and from there he accepted an invitation to visit the Soviet Union. He returned disenchanted but at first did not speak out publicly. But as PCM leader Laborde wrote to Moscow, "in private he doesn't hesitate to express his adverse opinions [about the Soviet Union] under the claim of impartiality, independence and principle."[38]

After the PCM abandoned all dissent in the CTM and announced its policy of "Unity at all costs!," an editorial in *Lux*, still controlled by Breña, gently scolded them:

It is unfortunate for those of us who love communist principles . . . to find that the official faction of the [Communist] Party—whose leaders we know and of whose personal honesty we are convinced—has fallen into the terrain of concession, of opportunism, of demagoguery, blindly sustaining the policy of the Popular Front that is much more in appearance than real.[39]

Breña's analogy between Soviet censorship and PRM rule and his pokes at the PCM opened up a bitter debate in the union assembly meetings and the pages of *Lux* through the summer of 1938. Mario Pavón Flores, the union's legal counsel and the most prominent PCM member in its ranks, denounced Breña for the same disloyal attitude toward the working class and the Soviet Union as the Franquistas, the reactionaries, and the Trotskyists. Juan José Rivera Rojas, who would dominate the union in the 1940s as an anticommunist, declared sarcastically "that he shouldn't be frightened by the Communist Party since it was Breña Alvírez who brought them into the union, and to reject them now is to lack convictions." During assembly discussions regarding the executions of former Soviet leaders, Paulín cautioned, "It is unjust to make those criticisms and ignore the great progress that workers there have achieved." In the June and July issues of *Lux*, Breña stepped up his criticisms by printing excerpts from US journalist Eugene Lyons's exposé of Stalinist terror, *Assignment in Utopia*.[40]

The differences between Breña and Paulín boiled over in July 1938, forcing the central committee to resign en masse during a dramatic assembly of representatives in which a new central committee was immediately elected. The new secretary general, David Roldán, and the secretary of the exterior, Luis Espinosa Casanova, were engineers who adhered closely to the positions of Paulín. Breña viewed the mass resignation as a maneuver of Pavón Flores and denounced the limited

vote as a violation of democratic procedure. For Espinosa Casanova, it was simply "impossible to go forward while the officers fought like cats and dogs."[41]

The new central committee remained committed to a policy of government collaboration tantamount to "Unity at all costs!" while Breña and others continued their dissent.[42] SME relations with the CTM improved considerably through the space carved out for the SME within the workers section of the PRM. Roldán and Espinosa maintained close ties to the PCM, attending its seventh congress as guests, justifying the 1939 Nazi-Soviet pact in *Lux*, and defeating an assembly motion by Breña to send aid to Finland after the Soviet invasion of November 1939.[43]

Eventually, rank-and-file members challenged the central committee over its alliance with the PRM. When Cárdenas and a variety of moderate forces within the PRM rallied around the moderate Ávila Camacho as the PRM presidential candidate, the CTM and the PCM followed suit and imposed the PRM candidate on their members. After the radical Francisco Múgica withdrew as a potential PRM candidate in July 1939, the only point of opposition around which dissatisfied workers could rally was the eclectic coalition backing the presidential candidacy of the conservative general Juan Andreu Almazán.[44] Like Rivera and many railroad workers and miners, members of the SME formed a Comité Pro Almazán and pushed hard against the PRM requirement to support Ávila Camacho. In the summer and fall of 1939, in union assemblies and the pages of *Lux*, the central committee rehashed its defense of SME membership in the PRM and urged members to support the official candidate of *continuismo*. But in a tormented October 1939 assembly, held in the Arena México to accommodate the unusually high attendance, the majority voted to withdraw from the PRM it had joined eighteen months earlier, in order "to allow its members to vote freely in the upcoming presidential elections." The vote was not so much an endorsement of the conservative Almazán as an attempt to return the union to an "apolitical" position in its relation to the state.[45]

The covers of *Lux* in 1939 largely avoided any direct reference to the internal struggles of the union or its divisive alliance with the state. One of two exceptions is a June 1939 cover by Francisco Eppens (fig. 7.9) of a demonic figure, his left side dressed in a tuxedo and carrying a bag of money, the other in overalls and holding up a mask of a tragic face, presumably that of workers deceived by the false promises of Almazán and the bourgeoisie. In October 1939, on the eve of

7.9. Francisco Eppens, cover, *Lux*, June 1939. Courtesy of the Sindicato Mexicano de Electricistas.

the dramatic vote to withdraw from the PRM, Eppens's cover (fig. 7.10) portrayed a worker crucified on a cross of "politics," surrounded by a divided working class. The message, clarified in the accompanying editorial, was that the working class had to remain united to avoid undermining its influence with the government, and that any decision to become "apolitical" would be an act of "passivity" and a con-

7.10. Francisco Eppens, cover, *Lux*, October 1939. Courtesy of the Sindicato Mexicano de Electricistas.

cession to the bourgeoisie. But neither cover made specific political allusions and could just as easily have conveyed the message of the central committee's opponents that the impositions of the CTM and the official party risked masking the interests of capital and crucifying workers on the cross of politics.[46]

The rebellion against union membership in the PRM considerably weakened the union's leadership—particularly the engineers. In partial elections in December 1939, weeks after the Nazi-Soviet pact and

the Soviet invasion of Finland, union members elected an old-timer from the 1920s as secretary of education and director of *Lux*.[47]

In 1939 and 1940 a team of six artists led by Siqueiros painted a mural in the SME's brand-new headquarters. *The Portrait of the Bourgeoisie* was in many ways the ultimate collaboration between workers and artists in the 1930s in terms of its setting, artists, style, and content. The new building was designed by LEAR architect Enrique Yañez in a modern, international style modeled on Soviet workers clubs. But the mural adorning it was initiated in the midst of two crises: the Nazi-Soviet pact was signed days after the mural commission was announced in August 1939, and painting began in October as the SME withdrew from the PRM against the wishes of its leadership. In an assembly report that August, Secretary General Roldán made of the new building a metaphor for the crisis: "But what good is it [the new building]" he asked, "if inside there is no active life, life that signifies work, progress and struggle?"[48] Architect Yañez endorsed the idea of murals to counter the "coldness" of the international style.[49] The mural commission was an attempt by the communist-linked leadership to insert life into the building and the union or, more specifically, to reassert its own political positions within the union. But as Jennifer Jolly has shown, the final mural involved a complicated negotiation among artists and among the painters, union leadership, and the rank and file.[50]

As a work of art, the mural was conceived within the spirit and goals of the now defunct LEAR and its successor, the Taller de Gráfica Popular. Siqueiros was the dominant figure by talent, personality, and contract, but he brought together a collective team of artists, including Arenal and Pujol, the latter a veteran of the Spanish Civil War, and the recently arrived Spanish refugees Antonio Rodríguez Luna, Miguel Prieto, and Josep Renau. The project fit within the goals of an alternative, radical muralism that Siqueiros had advocated throughout the decade. It was done collectively and sponsored by a union in a venue free of any government control. It incorporated modern industrial techniques that included painting on cement with automobile paints and spray guns, a style based on the projection of photographic images and photomontage-like composition, and a dynamic design that assumed a narrative unfolding and consciousness raising as the worker-viewer ascends the stairs.[51]

Both the SME leadership and the communist-affiliated artists embraced the task of art as a political weapon, initially conceiving the mural within the goals of the antifascist Popular Front. The mural had to address the themes of the decade—imperialism, fascism, and war.

But the union insisted that it incorporate the roles of the electrical industry and of the electricians themselves. The artists emphasized the global themes but agreed that one-third of the content would address the electrical industry.[52]

Circumstances and negotiations led to a series of changes in the mural. Essential elements, however, remained (plate 11): the left wall is dominated by a figure of a demagogue or fascist dictator with the head of a parrot that (as an adjacent panel reads) "secretly put into motion by Money, pushes the Masses toward the Grand Slaughter" as a neoclassical building goes up in flames. As Leonard Folgarait notes, the masked figure draws directly from the pages of *Lux*, particularly Balmori's cover of a demagogic union leader, though here applied to the fascist leaders of Europe rather than to the CTM.[53]

At the center of the main wall is a huge machine block or turbine. In the original version (fig. 7.11), the heads of five children with numbered tags borrowed from the Spanish Republican poster (fig. 6.16) form the grist that drives the turbine, converting human flesh into a stream of gold coins. Electrical transmission towers and the SME banner extend over the ceiling, and the right wall invokes elements of war, dominated by a large figure of a revolutionary man, his face twisted furiously as he holds a rifle close to his chest. Though his class may be indeterminate (thus for Folgarait "a perfect soldier of the Popular Front"), he is clearly derived from the multiple images of armed Spanish and Mexican workers featured on the covers of *Lux*, and his indeterminate class may suggest that of the intellectual worker, the engineers, and artists responsible for the mural.[54]

As Jolly demonstrates, the negotiations over the mural were shaped by the reorientations of the Communist Party and the debate within the SME over its political identity. The first set of changes in late 1939 was linked to the Nazi-Soviet pact, which pushed the artists to minimize the antifascism of the Popular Front and instead denounce capitalism as the root of war. The most significant change was the inclusion of gas-masked representatives of the Axis and Allied powers (excluding the temporarily "neutral" Soviet Union) on either side of the turbine, roughly equated in their responsibility for a war born of capitalism.[55]

The second set of changes came in June 1940, after a series of disputes among the artists and after the incomplete mural had been abandoned by Siqueiros, Pujol, and Arenal, who went into hiding after leading an assassination attempt against Trotsky.[56] The union leadership turned to Renau, who revised and finished the mural, addressing both his own concerns and those of the union. Since the initial con-

7.11. Davíd Alfaro Siqueiros in collaboration with Josep Renau, Antonio Pujol, and Luis Arenal. Detail of children's heads sacrificed at Guernica, from the first version of *Portrait of the Bourgeoisie, 1939–1940*. Original photograph by Josep Renau. Siqueiros Archives, Sala de Arte Público Siqueiros, Mexico City. Reproduction authorized by the Instituto Nacional de Bellas Artes y Literatura. Photograph by Leonard Folgarait.

tract, the union leadership had lost considerable influence vis-à-vis its rank and file, evident in members' decision to withdraw from the PRM in October 1939; in the renewed criticisms of the Soviet Union in *Lux* and general assemblies in spring 1940; and in the distaste of members for the artists' attempted assassination and Ramón Mercader's successful assassination of Trotsky in August 1940.

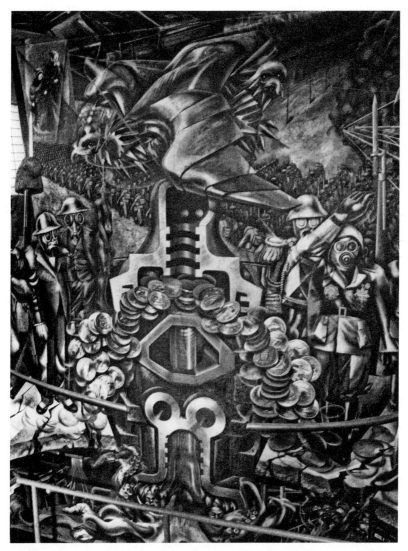

7.12. Final version of detail, *Portrait of the Bourgeoisie, 1940.* Courtesy of the Sindicato Mexicano de Electricistas. Author's photograph.

The most dramatic change Renau painted between June and October 1940 was the elimination of the child victims of the Spanish Civil War at the core of the turbine (fig. 7.12). Jolly argues that the electricians were uncomfortable with the focus on the Spanish Civil War and fascism, given ongoing disagreements in assembly meetings about donations favoring Spanish orphans over the needs of Mexican children. The erasure of one of the most obvious symbols of the Spanish

war, its child victims, must have been painful for Renau as an exile and former director of fine arts in Republican Spain. Finally, Renau strengthened the emphasis on the electrical industry in general and the electricians union in particular. The power that the electricians harness from the lower edges of the mural not only drives capitalism but also drives it to its self-destruction. Electricians, along with the armed revolutionary, provide resistance, ultimately leading to the socialized electrical industry depicted on the ceiling and flying the SME flag.[57]

For Folgarait, the revised narrative of the mural and the process by which it is experienced by the viewer resulted in a manipulated and controlled worker-spectator, ultimately subject to the process of nationalist state incorporation consolidated by 1940. For Jolly, Renau's revisions brought the mural closer to the workers, featuring the role of the electrical industry, emphasizing the revolutionary conflict between capital and labor rather than international political struggles, and demanding an active interpretation by a rational and educated worker. "Its transformation effectively marks a hiatus for the aggressive, propagandistic approach characteristic of the Syndicate's 1930s cultural policy."[58] For all the tensions and revisions, the negotiations around the mural constituted a unique dialogue among the artist Renau, the union leadership, and the rank and file. The *Portrait of the Bourgeoisie* is in many ways the culmination of Popular Front collaborations between artists and workers, but it also marks the limits of such collaborations.

In union elections in December 1940, outgoing officers Roldán and Espinosa Casanova endorsed a list of candidates led by Paulín, who had resigned as secretary general during the 1938 crisis. The engineers list was outvoted two-to-one in favor of a list led by old-timer Francisco Sánchez Garnica as secretary general and newcomer Juan José Rivera Rojas as secretary of labor, bringing an ignominious end to the "Age of the Engineers" initiated in 1933. Since then the engineers had frequently ended their annual reports with an invitation to members to vote them out of office if they ever lost their confidence.[59] This had happened by December 1940. In their outgoing speeches, Roldán and Espinosa railed bitterly against the union's withdrawal from the PRM and blamed the engineers' defeat on the inconsistency of the assembly and a campaign of "politicking, gossip and subterranean intrigue . . . culminating in the false accusation made by C. Breña in an assembly . . . that we were deceiving you." He lamented the union's current political isolation, the passivity of members, and the distance—

presumably in terms of education, effort, and integrity—between the union leadership and its rank and file.[60]

Their defeat was hardly a victory for Breña, much less for union democracy. The new leadership broke ties to the PCM but pushed for a rapprochement with the PRM and the newly elected president, Ávila Camacho.[61] In 1942, Ávila Camacho declared war on the Axis powers and convinced most Mexican unions, including the SME, to sign a Pact of National Unity that limited strikes and returned to a rhetoric of class harmony reminiscent of the 1920s.

In the same year, the new secretary general of the SME, Rivera Rojas, ushered in a decade of corrupt, paternalist rule. He changed and manipulated electoral statutes to allow himself to be reelected through 1952; accommodated the demands of the expanding Mexican Light and Power Company; and led the union back into the PRM, beginning with his own fraudulent election as federal deputy from a town he visited for the first time during his brief campaign. Faced with Breña's charges of corruption, gangsterism, and manipulation of statutes, the new leaders orchestrated an assembly trial that expelled the leader of the 1936 strike "for betrayal, spying and dissident labor."[62] The SME under Rivera Rojas modeled the corrupt, politically incorporated, and anticommunist unionism of the CTM after it passed under the direct control of Fidel Velázquez, from 1942 until his death in 1997.

Lux covers became vehicles for the photogenic Rivera Rojas. Two 1949 cover captions suggest the dramatic ideological shifts of the union and its journal in the midst of the Cold War: "SME: STRONGHOLD AGAINST COMMUNIST FELLOW TRAVELERS [COMUNISTOIDES]" and "THE FLAG OF THE FATHERLAND IS THE FLAG OF THE REVOLUTION AND OF THE WORKERS."[63] In less than a decade, the electricians union had moved from its apolitical stance, to the radical orientation and successes of the "Age of the Engineers," to a series of divisions, to a decade of forced unity around corrupt leadership. In 1952 a new generation finally restored internal democracy within the union, rehabilitating the victims of Rivera Rojas's witch hunt and eventually renaming the SME auditorium the Teatro Breña Alvírez.[64]

FROM THE LEAR TO THE TALLER DE GRÁFICA POPULAR

A high point of the Popular Front period for artists and intellectuals was the LEAR's Congress of Mexican Artists, Writers, and Intellectuals in the Palacio de Bellas Artes in January 1937, with delegates from

Mexico, Latin America, and the United States, including the president of the League of American Writers, Waldo Frank. The announcement for the conference confirmed LEAR goals, particularly the obligation of artists and writers "to join their interests with the aspirations and struggle of the working class" and the need "to give real and permanent aid to the fight against capitalist oppression in all its forms, and in particular its unjust aggressions against weaker countries and its Fascist manifestations." According to participant Millan, "As if by previous accord, every orator related the central point of his speech to the problem of Spain." The Congress endorsed the Cárdenas government and the formation of a Mexican Popular Front and proposed a variety of projects by which intellectuals could address social and political problems. On the fifth and final day, *New Masses* editor Joseph Freeman closed with a speech that compared the role of leftist intellectuals in Mexico with their counterparts in his own country: "In the United States it would have been impossible for a similar congress to have occupied a government building, and to have been inaugurated by the secretary of the President." A report on the Congress in *Frente a Frente* predicted a "third epoch" for the LEAR of "intense work, of great productivity."[65]

The Congress confirmed the cultural dominance of the LEAR, yet by the end of 1937 the group was in crisis. It published its last issue of *Frente a Frente* in January 1938 and dissolved soon after. In its last year, even as its nominal membership numbers remained high, the LEAR faced a variety of challenges and divisions that contributed to its demise, some unique to intellectuals and artists and others paralleling those of the labor movement and PCM.

As with the Popular Front, essential issues of self-definition were never fully resolved within the LEAR's ranks. Was it a vanguard or mass organization? Should it privilege social goals and legibility or experimentation and quality in its art? The debate over the relationship between collective political commitment and individual artistic expression had beset the Mexican artistic community since the 1920s. Journalist J. H. Plenn's 1938 summary of Mexico's literary scene applies equally well to visual artists: "There are the Marxists and the non-Marxists, the revolutionaries in form but not in content, the revolutionaries in content but not in form, the revolutionaries who hold that revolutionary content must have revolutionary form."[66] For cultural historian Carlos Monsiváis, the LEAR was "simultaneously antifascist community and sectarian tribunal, combining talent and intolerance, originality and pamphleteering repetition."[67]

Ironically, a key critique of the LEAR came from *El Machete*, where Guatemalan poet and LEAR member Luis Cardoza y Aragón reviewed its first collective exposition, organized by Balmori and held May 1936 in the Santa Clara convent. "Politically there is no other way than that of revolution, than the left, than to be with the new world," he acknowledged. He endorsed the recent Popular Front opening by the LEAR and recognized the need for "little verses, little stories and such paintings of the urgency of the poster, of daily journalism." But he denounced the LEAR's exhibition for its low artistic standards and its continued reliance on a party line: "All seemed, and still seems to move within a fatal mediocrity, fatal like all mediocrity, clumsily obeying slogans and criteria that shouldn't be obeyed." "Art," he insisted, "either has value on its own, or it isn't art."[68]

Cardoza debated Juan Marinello in a public forum six months later, again rejecting an easy populism, reclaiming classical European culture as Mexican and revolutionary, and insisting that "rather than bringing art to the masses, the masses should be brought to art." Cardoza y Aragón's provocative but principled polemic in some ways paralleled the stance of Breña within the SME, and it echoed international debates about art among leftist intellectuals in New York, Paris, and Valencia. It also anticipated the "Manifesto for an Independent Revolutionary Art" penned by André Breton and Trotsky and signed by Breton and Rivera in 1938, which advocated "an anarchist regime of individual liberty" for creation within "a socialist regime with centralized control."[69] In contrast to the LEAR debates of Siqueiros and Rivera in the summer of 1935, this debate was far less public and lacked that exchange's concrete outcome, the "Nine Points of Agreement." Cardoza later remembered the event as a public lynching. The LEAR refused to publish the debate as previously agreed, and the polemic was never addressed directly in the pages of *Frente a Frente*, much less in the Congress of Mexican Artists, Writers, and Intellectuals.[70] Reyes Palma calls Cardoza's challenge an "absent polemic," given that "the reigning politics tended to avoid disputes in order not to shatter the slogans of unity."[71]

Organizers of subsequent LEAR exhibitions were more careful to choose works based on their quality and to include works by artists not affiliated with the LEAR. Often the works that received the highest praise in the general press and even in *Frente a Frente* were by artists with limited or no ties to the LEAR and less obvious politics in their paintings, such as María Izquierdo and Julio Castellanos. But the LEAR continued to favor and promote art that was closely linked

thematically to the Popular Front politics of the epoch and in a style accessible to the working class. As a result, artists and writers like Rufino Tamayo, José Clemente Orozco, and Octavio Paz kept a skeptical distance. Cardoza later asserted that the LEAR "died from such disorientations."[72]

The LEAR faced a variety of organizational challenges that became insurmountable in the changing political context of 1937 and 1938. It had been created in 1934 as a vanguard organization with a small but cohesive membership with close ties to the PCM. As noted, with the Popular Front reorientation at the end of 1935, the organization grew exponentially, absorbing other organizations and new members with distinct goals and political orientations. A *Frente a Frente* article from January 1938 mentions 600 members. As the PCM and the LEAR worked ever more closely with the teachers unions and with the SEP, many looked to the LEAR primarily as a type of employment agency. The LEAR's archives include many requests to the SEP for employment, or for transfers of members closer to Mexico City and their LEAR duties.[73] Rivera, once denounced as the "house painter" of the government, wrote in *Novedades* in 1938 that the main purpose of the LEAR ("and related Stalinist organizations") was to gain government employment "through kinship and to recruit spies."[74]

Despite its numbers, the LEAR continued to rely on a small core of activists to fill its unremunerated leadership positions and to sustain daily functions. Conflicts existed within the leadership, but for most of its existence as a Popular Front organization the central challenge was mobilizing members to participate. LEAR meetings were filled with complaints about and threats to remove members who failed to pay dues, show up for meetings, or fulfill their regular responsibilities to volunteer and contribute works to the organization. An undated list shows that even the Plastic Arts division, the largest and most active in the LEAR, had seventy of roughly a hundred members behind on dues. Officers defensively insisted that their censures did not constitute "a regimentation of anyone, but rather a revolutionary, conscious and disciplined cooperation."[75]

For an organization dependent on a core of activists, the absence or turnover of leaders could be fatal. Helga Prignitz-Poda suggests that the participation of much of the LEAR leadership in the Congress of Anti-Fascist Writers in Spain created a vacuum in the organization. Within months of their February 1937 election, officers José Mancisidor, Maria Luisa Vera, Juan Marinello, and Fernando Gamboa all left for Spain, several of them staying on through the fall to visit the

Soviet Union.[76] The officers who replaced them, including the president, Luis Sandi, lacked the stature of previous committees and included none of the original founders.[77] It is unclear from the sparse activities and documentation of the period who the LEAR officers were in its final months.[78]

Similarly, the LEAR was always strapped for funds or relied on unreliable sources. Without regular dues and with minimal fees for artistic collaborations with working-class organizations, the LEAR depended in its early years on fundraising activities and appeals to different organizations for donations. For example, to send delegates to the American Writers Congress in 1935, the LEAR appealed widely for a "spontaneous contribution from anti-imperialist workers, students and intellectuals" and asked the Union of Restaurant Employees for their auditorium for a fundraiser, given the lack of space at their modest San Gerónimo headquarters.[79] But from 1936, the LEAR increasingly turned to a variety of government organizations for support, requesting access to the Palacio de Bellas Artes and the SEP for events, and received subsidies from different government institutions for publications, rent, and participation in the Anti-Fascist Writers conference in Spain.[80]

The increasing intimacy with the government brought benefits and risks. The executive committee decision in February 1937 to approach Cárdenas to request a new locale seems to have borne fruit, though apparently through the efforts of a lower official. *Frente a Frente* announced the opening of a new office and gallery on upscale Allende Street in the fall of 1937. But government ties and largesse could just as rapidly disappear, as Millan recounts:

The headquarters in Allende Street had been taken because General X, cabinet minister, was giving 100 pesos a month while politicians supplied the deficit. General X became piqued and cut off his allowance without a moment's notice; the politicians who had used the LEAR to build up a following decided that they no longer needed its help, and another source of financial support was cut off abruptly.

Millan is vague about "General X," and the archives and publications of the distressed organization are not forthcoming. Francisco Múgica, secretary of communications, was the cabinet member farthest to the left and the one who had most participated in LEAR activities.[81] The loss of the LEAR subsidy may have been a casualty of his failed campaign to become Mexico's next president.

The LEAR undoubtedly became tangled in conflicts over the CTM, the PCM, and the PRM. It was no longer identified exclusively with the PCM, but it suffered from the PCM's declining prestige and its latent rivalry with Lombardo Toledano, masked by its avowal of "Unity at all costs!" An anonymous article in the May 1937 issue of *Frente a Frente* hints at the LEAR's awkward balancing act. The writer cautions against recent conflicts within the growing labor movement. On the one hand, he praises the Communist Party for its new line of conciliation ("not putting conditions"), presumably in its initial differences with the CTM. On the other, he scolds the CTM for its suspicion of any "rigorously leftist groups" that tried to join its ranks.[82]

In the summer of 1937, the LEAR's council briefly debated whether to endorse members as PNR candidates for Congress in the midterm elections, in contradiction of LEAR statutes against intervening in politics. The debate was hardly acrimonious. How convenient, Secretary General Mancisidor noted, to have representatives in Congress "so that the interests of artists and writers are duly protected." The final decision is not clear.[83] A year later, the LEAR seems to have been too weak to attend or even merit an invitation to the founding of the PRM in March 1938, but it is not hard to imagine its endorsement of the party.

After 1937, the relative autonomy of the LEAR and its ties to the PCM may have made it less attractive to the more moderate Cárdenas administration as a way to advance government agendas. Through its Autonomous Department of Press and Publicity, created in 1937, the government was increasingly doing in-house promotion, with greater control and centralization. The department was best known for its work in film and radio and its international defense of the oil nationalization, but it did hire visual artists for its work in print media.[84] One of the LEAR's last projects, the *Libros de Lectura*, bore the department's imprimatur.

The moribund LEAR was forced to move to more modest headquarters on San Juan de Letrán Street some time in the first half of 1938. Soon after, the Talleres Gráficos, with its LEAR mural and LEAR director, ended its subsidy for the printing of *Frente a Frente*. The last three issues of *Frente a Frente* were half the size of the previous ten and contained far less graphic material. According to Millan, "The moment the LEAR's political power began to waver ever so little, all those members who had signed up in the hope of getting something out of it promptly took to their heels." The LEAR disappeared soon after.[85]

All these tensions played out among the visual artists who had been central to the LEAR's beginnings. Méndez and Arenal were founders and its first presidents, but they became somewhat marginalized as the organization expanded around its Popular Front position and diversified beyond prints. Still, the Plastic Arts division stood out in the last year of the LEAR as the only coordinated and efficient division or, as one report explained, "the shock troop of the organization." Part of its cohesion stemmed from its Workshop-School and ties to labor unions.

The cohesion facilitated its reformulation into a new organization by Méndez, Arenal, Raul Anguiano, O'Higgins, and Alfredo Zalce in June 1937, the Taller de Gráfica Popular.[86] The TGP coexisted with the LEAR for much of its first year of existence, and its members initially signed their works "LEAR y TGP," so its origins are not a formal break with the LEAR. But its tentative independence was implicit in the very use of both names. Méndez later explained the TGP's origins in the failures of the LEAR: "The LEAR died of the worst illness: opportunism. Many people joined because it was a way to get a little work. But some of us did not want to attend the funerals of the LEAR."[87] Declaring the same antifascist goals and the proletarian orientation of the LEAR, the TGP returned to the LEAR's initial vanguard organization, including only a small group of accomplished visual artists, privileging the print over painting and photography, insisting on careful craftsmanship and artistic freedom, and rejecting financial support from the state.[88] It did not try to sustain its own periodical.

As Francisco Reyes Palma suggests, the TGP may have been born out of the tensions between the CTM and the PCM.[89] LEAR visual artists had had the closest ties to unions in general and the CTM in particular, and many were pulled in the direction of Lombardo Toledano as tensions lingered and the PCM itself entered its deep crisis, reflected in the diminished size and circulation of *El Machete* and its successor, *La Voz del Pueblo*, as well as in the reduction in the number and richness of illustrations. Even within the PCM there was conflict between pro- and anti-Lombardo tendencies.[90] Similar tensions within the TGP continued through the 1950s, even as both Lombardo Toledano and the Communists were increasingly marginalized in national politics. Méndez himself was expelled from the PCM for his ties to Lombardo's tiny Partido Popular soon after it was formed in 1948.[91]

In this context, Lombardo Toledano, the CTM, and the government provided crucial support to the newly formed TGP. *Futuro* remained an important outlet for graphic art that fit within the patriotic leftism

EL

TALLER DE GRAFICA POPULAR

SALUDA A

Todos los Delegados
al Primer Congreso
de la

CONFEDERACION
D E
TRABAJADORES
DE MEXICO

Y

ofrece su contingente a to-
das las Organizaciones de
Trabajadores:

Carteles,

Hojas Populares,

Monografías,

Historias Gráficas de las lu-
chas de las Organizaciones de
Trabajadores,

Ilustraciones de la vida acti-
va de los Sindicatos,

Ilustraciones para Folletos,

Carátulas, etc., etc.

París Núm. 7 - L-87-38.

¡VIVA la UNIDAD del PROLETARIADO en provecho de la CULTURA del PUEBLO!

7.13. Leopoldo Méndez, TGP Flyer, side one, *Unidad*, 1938. Courtesy of Peter Schneider and Susan DeJarnatt. Permission of Pablo Méndez.

of its editor Lombardo Toledano and the CTM. So, too, did the Universidad Obrera that he had founded. From 1936, Méndez served on the faculty of the Universidad Obrera, an institution that provided direct links to CTM unions, lent the TGP a lithographic press, and provided its first formal commission, a series of calendars starting in 1938. The TGP also received an initial donation of fifty lithographic stones from the secretary of hacienda, portending the difficulty of avoiding a degree of reliance on the state, but facilitating the flurry of lithographs among early TGP prints.[92] In the 1940 presidential elections, the TGP produced graphic art supporting the candidacy of Avila Camacho and condemning the campaign of Almazán, and several times in the 1940s it unsuccessfully approached the SEP and the Federal District and national governments for subsidies.[93]

An early TGP flyer suggests the continuities of its outreach to working-class organizations, now largely centralized through the CTM. Produced on the occasion of the first full congress of the CTM in February 1938, the text on one side (fig. 7.13) welcomes delegates, celebrates proletarian unity and the "culture of the people," and offers unions the same variety of graphic services previously proposed

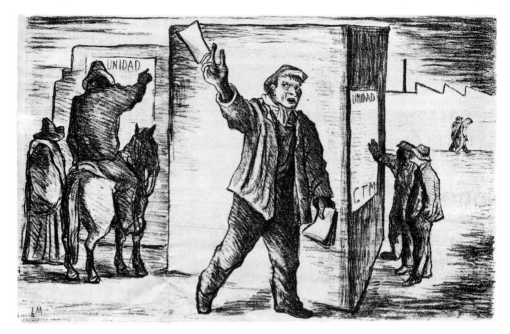

7.14. Leopoldo Méndez, TGP Flyer, side two, *Unidad*, 1938. Courtesy of Peter Schneider and Susan DeJarnatt. Permission of Pablo Méndez.

through the LEAR's Workshop-School. On the other side (fig. 7.14), a lithograph by Méndez visually narrates the ideal function of the TGP: a worker in the centerfold distributes propaganda, similar to the CTM flyer itself, while on each adjoining fold campesinos and workers peruse TGP posters with the CTM message of unity.

The TGP artists hardly broke with the Communist Party or suspended the use of their critical facilities in dealing with the CTM. Founding member Arenal produced graphic work for the PCM and its newspaper until his expulsion from the country in 1939 for his involvement in the first assassination attempt against Trotsky. His 1938 poster *Join the Communist Party* (fig. 7.15) echoes Méndez's flyer for the CTM. A working-class couple reads the broad, Popular Front justifications for joining the party on a poster plastered on a public wall: "For the unity of the people, for the complete triumph of the revolution, and for a happy Mexico." Like Méndez's CTM flyer, the poster is linked to the TGP.

A 1938 broadsheet by Ignacio Aguirre (fig. 7.16) titled *Divisionist Calaveras* uses sharp satire to critique the complicated CTM politics behind the unification of teacher unions. By 1936, Communists

had assumed the leadership in a majority of the many teacher unions nationally and, with the support of the LEAR, led the first attempt to create a national, unified teachers federation, the National Confederation of Educational Workers (CNTE). Lombardo Toledano and Velázquez instead supported a minority of conservative teachers unions such as the National Union of Technical Education Workers (Unión Nacional de Encauzadores Técnicos de la Enseñanza—UNETE) in order to undermine the CNTE and call for a new unification congress in 1937. But the new congress again elected communist leadership and the resulting federation was again rejected by the CTM. This is the moment when Aguirre joined the fray.[94]

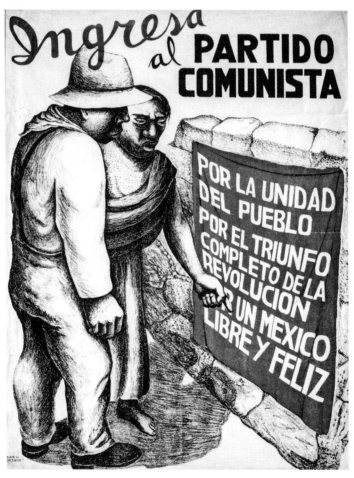

7.15. Luis Arenal, *Join the Communist Party, 1938.* Courtesy of Museo del Estanquillo, Mexico City. Permission of Graciela Castro Arenal.

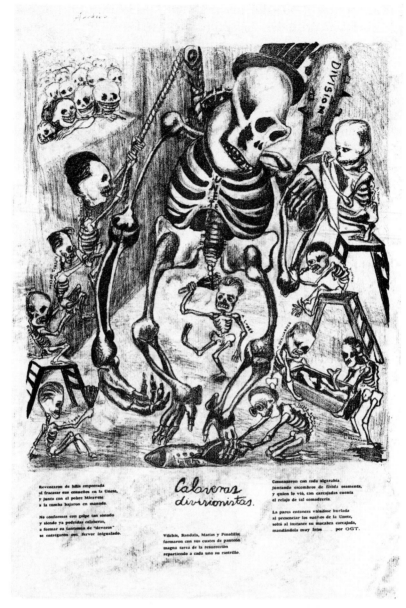

7.16. Ignacio Aguirre, lithograph, *Divisionist Calaveras*, 1938. Courtesy of Peter Schneider and Susan DeJarnatt.

Aguirre's lithograph and the verse below condemns the CTM's attempts to convene a third unification congress. Tiny CTM and SEP officials are portrayed as *calaveras* attempting "the great task of resurrection," leveraging with a rope and pulley a giant, ape-like *calavera* with a capitalist's top hat, labeled UNETE for the defunct union the CTM had previously used to undermine the first national confederation of teachers in 1936. At the top of a stepladder, the new CTM secretary of education, David Vilchis, who had replaced Miguel Velasco in the purge of Communists, reveals his giant club of "division." The verses below predict the failure of the CTM's divisionism.

As Peter Schneider suggests, the rather obscure meaning of the broadsheet limits its success as propaganda.[95] The various bureaucrats with their political intrigues give no hint of belonging to the working classes, which may ultimately be the satiric message, enforced by the amused crowd watching from the window. In the final verse, the Grim Reaper cackles at the futile attempt to revive the UNETE, but the CTM's strategy of division in the name of unity ultimately proved successful. It is significant that the poster in no way directly references the TGP, making the critique of the CTM Aguirre's alone.

TGP prints filled much of the visual vacuum left by the LEAR in the last two years of the Cárdenas government. Notable among its early collective and attributed production is a series of posters denouncing attacks on rural teachers; support for the dying Spanish Republic and its flow of refugees; and attacks on Franco's Spain and the emerging fascist axis, with a brief respite regarding the latter for the duration of the Nazi-Soviet pact (1939–1941).

With labor militancy discouraged and controlled, the TGP found few independent unions with which to collaborate. CTM and government commissions were important to the TGP's survival but gave both much more direct control over content than the indirect government subsidies received by the LEAR.

Commissions for the CTM favored representations of past labor conflicts or the importance of workers' patriotic sacrifice and participation in the present moment of national unity.[96] As early as the 1938 calendar for the Universidad Obrera, many TGP prints turned toward a commemoration of past labor conflicts and accomplishments, rather than current or future struggles. Méndez illustrated January with a lithograph that commemorated the violent prerevolutionary repression of the Rio Blanco strike of January 7, 1906. Pablo O'Higgins's print (fig. 7.17) of a violent confrontation on May Day 1933 between workers and soldiers reminded workers of the time before Cárdenas, "In the

7.17. Pablo O'Higgins, *In the Epoch of Repression, May 1, 1933*, from *Calendario de la Universidad Obrera de México, 1938*. Courtesy of Mercurio López Casillas. Author's photograph.

Epoch of Repression." For June, Jesús Bracho celebrated the 1937 nationalization of the railroads. For the following year, calendar images celebrated the formation of the CTM and the oil nationalization.

Both Méndez and Zalce created prints that commemorated the dramatic clash between communist workers and the fascist Gold Shirts in the 1935 Revolution Day parade in the Zócalo. Méndez's 1938 lithograph may have been part of a projected portfolio, *The Mexican People and Its Enemies from 1935-1939*. The prototype for the portfolio notes that the success of this and future TGP projects will depend on the "support of its chief consumers, its indispensable patrons,—the workers and their organizations." However, the prototype was written in English, suggesting that the TGP was already looking elsewhere for paying customers. The higher-quality images collected in portfolios became an obvious way to market previous and newer works and to reach a more affluent audience at home and abroad.[97]

As noted, the government had disbanded the Gold Shirts in 1936 soon after the clash, but the event was a useful reminder of the most dramatic expressions of fascism in Mexico and its ongoing threat. In his 1940 lithograph *Taxi Drivers Against the Gold Shirts* (fig. 7.18), Zalce followed Montes de Oca's iconic photograph of the event by making the main physical encounter between the taxi and a terrified and emaciated horse, hurled by the automobile onto its back haunches. The ideological clash is between the unionized taxi driver and the fascist Gold Shirt, thrown from the horse and sprawled on all fours. Other horses and riders lie in twisted heaps in a tangled background of semi-abstracted cars and bodies. The oversized face of a worker stares out the back window of the main taxi, while another leans out the passenger door and points accusingly. There is a touch of surrealism and an echo of Picasso's 1937 portrayal in *Guernica* of terrified humans and animals dismembered by German bombs. The image is a reminder of the variety of influences that shaped the print tradition in the 1930s, as well as the potential tensions between style and clarity of message. Indeed, in the same year a Soviet review of a TGP exhibition in Moscow scolded Zalce in particular and the TGP artists in general for their tendency toward "deformations" and "expressionist exaggerations." By contrast, the critic explained, Soviet artists had moved beyond such errors, depicting instead the beautiful workers and clear political messages of socialist realism.[98]

While Zalce's print is aesthetically fascinating, the basic political message of heroic workers against fascists, already opaque in Montes de Oca's photograph of a car slamming against a horse, is further ob-

7.18. Alfredo Zalce, *Taxi Drivers Against the Gold Shirts*, 1940. Courtesy of the Art Institute of Chicago. © Artists Rights Society (ARS), New York/SOMAAP, Mexico.

scured by his visual experimentation. The terrified Gold Shirts and their horses might just as easily invoke the helpless villagers of Guernica, and the modern taxis the German airplanes. Many in the TGP took the Soviet criticism to heart in the 1940s, veering more toward realism as a matter of both political clarity and marketability.[99] In its successful commercial collection of 1947, *Estampas de la Revolución*, the TGP featured Zalce's later relief print of the same scene in a more realist style that closely followed the original photograph.[100]

In his 1938 lithograph of the same event (fig. 7.19), Méndez ignores the dramatic confrontation between taxi and horse in favor of a much more Manichean encounter, similar to the perspective remembered by railroad worker Mario Gill. When the mounted Gold Shirts disrupted the procession, Gill later wrote, a group of "young Communists confronted the cavalry and hurled strings of firecrackers at the

feet of the horses . . . and threw themselves at the golden infantry with sticks, stones and, above all, hatred and determination."[101] In the Méndez print, the dark tangle of horses and armed Gold Shirts dominate the image. The venality of the thrown rider is obvious from his twisted face, his ARM badge, and the coins he clutches. By contrast, there is no doubt that the cornered workers and campesinos (rather than young Communists) who defend themselves with sticks and stones are not only the underdogs but ultimately the victors. The style of the Gold Shirts and horses is exaggerated, while the heroic hooded worker leading the crowd is drawn with a greater degree of realism. Of course, the heroic worker would not likely have attended the Revolution Day parade in a work apron and with bare feet, but by 1938 the event had entered the realm of historical myth.

Over the next decade, the TGP refined a distinctive and ever more sophisticated style rooted in the print tradition of the LEAR, with the mature Méndez being the TGP's most accomplished practitioner. The founding group was fortified by talented young printmakers such as

7.19. Leopold Méndez, untitled (Gold Shirts), 1938. Courtesy of Michael J. Ricker. Permission of Pablo Méndez.

Ignacio Aguirre, Isidoro Ocampo, Arturo García Bustos, and Alberto Beltrán, and it benefited from the organizational and business skills of European refugees like the Swiss architect and Bauhaus director Hannes Meyer. But the TGP faced a very different political environment, one that from its beginnings emphasized national unity around a more moderate social agenda and, by the 1940s, an economic agenda of industrialization and middle-class consumption over redistribution and the empowerment of workers and campesinos. A different public culture in turn broadened the TGP's thematic focus, format, patrons, and customer base.

Commissions included propaganda for Mexico's participation in World War II and Miguel Alemán's 1946 electoral campaign. Typical of Cold War commissions is the 1947 May Day poster by Alberto Beltrán and Arturo García Bustos done for the CTM, which in an even more realist style conveys the conservative and patriotic thrust of the dominant labor organization, now under Fidel Velázquez (plate 12). In descending importance, a worker, a bureaucrat, a campesino, and a woman (newly enfranchised in municipal elections) are sandwiched between the Mexican flag they hold and the petroleum towers of nationalized oil, demonstrating that the CTM stood for "UNITY OF ALL MEXICANS FOR THE AGGRANDIZEMENT OF THE NATION." The colors of the poster echo those of the national flag. Such images froze an image of a patriotic and sacrificing working class at a moment of sustained economic growth coupled with growing inequality.

Méndez in particular and the TGP in general were aware of the dangers of making art with an official perspective, even as they sought out government commissions to survive. Eventually the TGP diversified its income beyond commissions for the government and the official labor movement.[102] The worker remained a central figure in the visual repertoire of the TGP, with its frequent denunciations of urban sprawl and continued social injustice, as a symbol of the international solidarity of peace movements, or of the hemispheric solidarity against imperialism advocated by Lombardo Toledano's Confederation of Workers of Latin America (known as the CTAL). The TGP's distinct relations to a very different labor movement and a very different government hardly diminishes its accomplishments as Mexico's most coherent, long-lasting artists' collective or the consistent quality of much its artistic production.[103] But in a very different epoch, one where official incorporation and control diminished working-class militancy and mobilizations, visual representations of the worker lacked the immediacy and agency of the 1930s.

The dissolution of the LEAR and the small size and deliberate medium and aesthetic of the TGP left most artists to choose the style and subject of their art and to sell their art and talents to different domestic and international patrons. They continued to organize collectively, though never again on the scale or with the influence and relative unity of the LEAR. The limited organization of artists in turn reoriented artists' political expression. On the one hand, individual artists became more dependent on government criteria for work commissioned by the more conservative state, a trend forged during electoral campaigns and World War II. On the other, artists were freed from the explicit political positions shaped by earlier revolutionary processes and collective organizations such as the LEAR and the TGP. In the context of the Cold War, US cultural elites advocated abstract over figurative art as an expression of artistic freedom, and a generation of younger Mexican artists tired of the nationalist content and unchanging styles of the postwar period. As Mexico's growing wealthy and middle classes constituted a domestic market for art, often organized around private galleries, many artists, including LEAR veterans, pursued greater visual experimentation, often deliberately purified of explicit political messages.[104]

The trajectory of Santos Balmori is suggestive. His two provocative *Lux* covers denouncing CTM's leadership in April and May 1937 were the last he would do for the electricians union. From 1935, Balmori had also worked closely with Lombardo Toledano, and SME attacks on the CTM leader in *Lux* may have forced the artist to make a choice. He continued working with Lombardo's *Futuro* and the Universidad Obrera through the 1930s. Balmori never joined the TGP, instead moving between teaching and doing graphic work for Lombardo Toledano and the government. In 1939 he served as the primary artist in Ávila Camacho's presidential election campaign, and from the 1940s he taught drawing at the state art school La Esmeralda, mentoring a new generation of artists who would come of age in the newly politicized 1960s, while Balmori himself mostly avoided political themes and developed the female nudes for which he is best remembered today.[105]

In a 1940 image in *Futuro* (fig. 7.20), Balmori embellished the worker-state alliance consolidated in the PRM as part of the election cycle. A powerful Cárdenas stands ready to cede the steering wheel of the ship of state to Avila Camacho as a crowd of workers defends them with their tools in front. A massive worker with the eagle and serpent emblazoned on his chest embodies the national flag and official party as he navigates from behind. He bears the PRM emblem

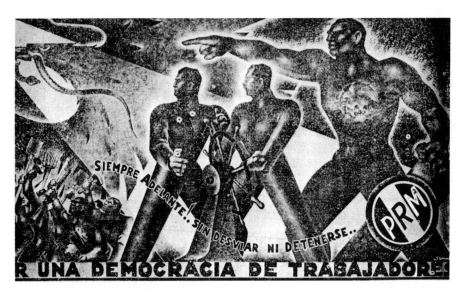

7.20. Santos Balmori, *Futuro*, December 1939. Centro de Estudios Lombardo Toledano, Mexico City, and the Fundación Santos Balmori.

on his leg, and his hand points all on board toward a future of continuity between Cárdenas and the official presidential candidate, "For a Democracy of Workers."

Another Balmori print served as the cover of *Cárdenas Habla!*, a collection of Cárdenas's speeches published in 1940, the last year of his presidency. The print (fig. 7.21) is striking on its own aesthetic and political terms as a visual commemoration of the outgoing and much beloved president, but it is even more suggestive as a reworking of his earlier *Lux* covers in 1936 and 1937 that featured labor leaders exhorting crowds, except that it is now the president who presides, and from the left side of the image rather than the right. Like the first *Lux* cover (fig. 6.8), the technique is probably wood or linoleum cut, with its dramatic contrasts and unequivocal message of unity, rather than the more ambiguous lines and message of the second *Lux* cover (fig. 7.1), perhaps a lithograph, of working-class divisions and betrayal.

Specific elements of each image differ according to the moment and purpose. Rather than extending his right hand to propel his spoken words, Cárdenas clasps the pages of his past speeches, which presumably speak for themselves in the volume. In fact, despite the title, Cárdenas doesn't seem to speak at all, instead surveying all he has wrought in his six years in office, and inviting his public and readers to do the same. The crowds surrounding Cárdenas are in a style simi-

lar to those in Balmori's earlier prints, though their banners are blank, to be filled in by the official party. The prominent sombrero in the first row and surrounding Stetsons suggest a broader pueblo that mixes campesinos, workers, and the middle class—three of the four sectors constituting the PRM, the publisher whose initials are emblazoned on the bottom strip.

The gathering commemorated in the print is no longer set in the all-purpose Zócalo, the prime site of both protest and official commemoration, but rather at the newly completed Monument of the Revo-

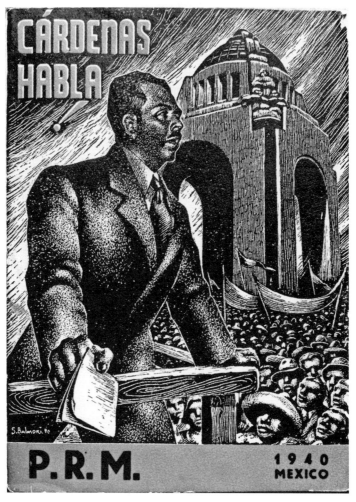

7.21. Santos Balmori, cover of *Cárdenas Habla!* (PRM, 1940). Courtesy of the Fundación Santos Balmori.

lution, started during the Maximato on the ruins of the unfinished congressional building begun before the Revolution. Carlos Obregón Santacilia, the monument's architect, imagined it as "the indispensable stage for the most emotional acts of the nation." At one corner of the monument's dome, a trilogy of workers was incorporated as one of the four allegorical sculpture groups, redeemed along with the nearby campesino family by the Revolution and its government, and mirrored in the crowds below. The monument was first incorporated into the official November 20 celebration of the Revolution in 1938. Thomas Benjamin argues that the monument was "the first official history of the Mexican Revolution" and served to legitimize the political system through its invocation of a myth of a popular, unified, and continuous revolution. The inclusion of the monument in Balmori's print for the official party publication fulfills a similar purpose.[106]

The print, like its predecessors, is a product of the moment as well as a collaboration between artist and patron—commemorating the end of Cárdenas's transformative administration, his shift to a more conservative stance in the face of internal opposition, the patriotic unity and fiscal strains of the oil nationalization, pending engagement with a Europe already at war, and the corporative structure of the new official party. Together with his two earlier covers, Balmori's distinct portrayals of leaders and the masses provide guideposts to both the working-class political mobilizations of the decade and the role that art and artists played in them.

The leader-speaker that Balmori places in the foreground evolves with circumstances and purpose, as does his public. Initially invoking Lenin, the January 1936 *Lux* (fig. 6.8) cover features the electricians' Breña Alvírez uniting the working class against Calles; in his April 1937 *Lux* cover (fig. 7.1), the image is recycled to show a corrupt and masked CTM leader manipulating the masses and thereby dividing the working class. In its final 1940 version, Cárdenas surveys his reconstructed Revolution and the loyalty of a united Mexican people, thereby legitimizing the new organization of the state and official party. The working class that was the essential actor as leader and audience in the first print has merged into a more generic pueblo.

Even so, campesinos and workers—including the electricians in their new headquarters just two blocks away—would periodically transform the Monument of the Revolution and reclaim symbols of the Revolution as elements of protest. And generations of politically engaged artists, taught or inspired by their predecessors, would be there to represent them.

CONCLUSION

n 1932, historian Frank Tannenbaum declared Diego Rivera the great-est prophet of the Mexican Revolution. "As long as his paintings are allowed to remain on the public walls so that the common people can rediscover themselves in them," he wrote, "the Mexican Revolution will remain safe, at least as an ideal—permanent, as a dream to be achieved."[1] Recent scholarship on Mexican muralism complicates Tannenbaum's assumptions. The extent to which common people saw the murals or identified with them is debatable. State sponsors at the time and over time tried to shape the messages of public murals to legitimize their rule. And the existence of revolutionary art, painted or posted on public walls, was hardly a guarantee of social transformation.[2]

But Tannenbaum's observation, in the midst of the repressive Maximato and on the verge of the dramatic mobilizations and reforms under the Cárdenas administration, still seems remarkably prescient. Those reforms, pushed by workers and campesinos and represented by artists at the time, fulfilled many of the social aspirations that were at the heart of Mexico's social upheaval from 1910–1920 and were still palpable in 1932. Just as Tannenbaum captured the tentative social dynamic of the period, his observations about Rivera point to the integral role of art in politics and in social transformation in the immediate postrevolutionary years.

The organized working class and artists played a fundamental role in constituting the postrevolutionary order. Despite their small numbers and limited role before and during the Revolution, each group was transformed by it and in turn seized on the opportunities of the 1920s and 1930s to organize themselves and broaden their publics. Labor organizations shaped the agenda and structure of the evolving state. Presidents, governors, and government bureaucrats could not long ignore an organized working class that in key moments proved a crucial ally for progressive reforms and helped legitimize the new political order. Similarly, artists inspired by the Revolution and avant-

garde movements won an outsized place for themselves in the new order, arguably more than any other group of progressive intellectuals. They challenged and allied with a state that needed their visual storytelling to mobilize support and create a nationalist iconography. Together with organized labor, they created a unique moment in national and international history.

Union leaders and artists on the left pursued parallel and intersecting paths. Labor leaders like Vicente Lombardo Toledano and the leaders of the Mexican Electricians Union appealed for solidarity and collaboration from artists in their publications and actions. Artists in turn made the worker a model for their own self-presentation and an essential character in their art. Through their collectives they reached out to unions and inserted their art into internal and public debates about the role of the worker in revolutionary Mexico.

This examination of prints and photographs, the periodicals and other media that contained them, and collective murals reveals the density and diversity of intersections between artists and labor unions. These media also indicate a variety of aesthetic influences in the representation of the worker, from Posada and Herrán around 1910 to advertisements and the international avant-gardes of the 1920s and 1930s. They also suggest a variety of political cultures at any given time and across time, from the dominant reformist nationalism of the 1920s to a radicalized and international class consciousness in the mid-1930s.

Organizations of workers and artists reached their greatest postrevolutionary influence and autonomy in the period 1934 to 1936. Labor leaders and artists played a fundamental role by shaping the policies and political culture of Cardenista Mexico. The Popular Front antifascism movement advocated by the Communist Party promoted working-class unity, heightened affinities between workers and artists, and facilitated an outpouring of graphic expression that infused Mexican art with transnational aesthetic influences. As state commissions for murals in government buildings virtually disappeared, alternative artistic projects thrived and reached a mass audience, with and without state support, though often in very ephemeral forms. For a brief moment in 1936, union leaders and artists on the left positioned themselves at the center of political struggle and constructed a shared image of the worker in terms of class, internationalism, and nation.

Tensions and contradictions were inevitable and many. One was an inevitable distance between middle-class artists who self-identified as workers and the workers they attempted to portray and reach. Similar

distances existed between skilled and unskilled workers and between union leaders and their rank and file. Many union leaders who constituted themselves as an "enlightened" vanguard of a developing working class compromised democratic rule within and between their unions, a pattern often justified in terms of moral superiority, masculinity, nationalist and communist imperatives, or political ambitions. The marginalization of women as workers in unions and in visual representations of the worker, despite their presence in the workforce, in Popular Front politics and the world of art, is today one of the most obvious contradictions.

Another was the reality that workers in many nonstrategic sectors needed state support in their mobilizations against employers, just as individual artists and their collectives ultimately relied on the state for jobs and commissions. In addition, artist collectives on the left alternately closed ranks to denounce apolitical artists, or they downplayed internal debates over quality, preferred styles, form, and content in the name of greater political purpose and cohesion.

From 1937, labor unions like the SME and artist collectives like the LEAR and the TGP struggled with the shifting politics of the CTM, the PCM, and the restructured official state party. Incorporation into Cárdenas's PRM, misconstrued as a Popular Front, imposed unity at too high a cost.

These contradictions and divisions, in the midst of shifts in domestic and international politics, ultimately gave the state greater control over the agendas of workers and artists in the last years of the Cárdenas administration, which in many ways constituted the end of the Revolution. In the new institutional order and distinct political climate after 1940, artists and organized labor preserved a prominent place, although with fading influence and autonomy. The dominant visual representation of the worker retained much of the vivid aesthetic developed over the previous decades, but the figure of the worker-citizen, rooted in the images of Herrán and *Revista CROM*, overshadowed that of the worker–victim in the tradition of Posada, or the worker–victim–militant in the tradition of *El Machete* and the LEAR.

Despite the institutionalization of the labor movement and art, the legacies of the 1920s and 1930s remain relevant, a constant reminder of that "dream to be achieved."[3] Murals on government walls have functioned primarily as museums; but the print and poster traditions of the SOTPE, the LEAR, and the TGP, once plastered clandestinely in the streets, have offered a more ready reminder of the ideals of the

1910 Revolution, as well as a greater challenge to its institutionalization after 1940 and to Mexico's neoliberal reconstruction from the last decades of the twentieth century.

Even in the altered political climate after 1940, when workplace conflicts exceeded the boundaries of state control, artists on the left often supported dissident labor. In 1950, the TGP produced various banners and prints in solidarity with the Nueva Rosita mining strike of 1950 and the miners' long march to Mexico City. In the 1950s, TGP members produced an array of art in support of Guatemala's revolution and against the 1954 US intervention there. By contrast, the 1959 railroad strike and the government's related censorship and jailing of Siqueiros bitterly divided the TGP and signaled its demise as an independent and creative force in Mexican art and politics.[4]

In the 1960s, the TGP survived thanks to a government subsidy and its sale of the archived works of an earlier generation. When the CTM denounced the 1968 student movement, the TGP proved its irrelevance by simply remaining silent.[5] Even so, its oppositional legacy was present, as student organizers appropriated images from the TGP's past. Their most visible poster placed Mexico's logo for the 1968 Olympics below Adolfo Mexiac's 1954 *¡Libertad de Expresión!*—the face of a man with his mouth chained and padlocked. Art students at the Academy of San Carlos and La Esmeralda, many of them accompanied by former TGP members like Mexiac and Arturo García Bustos, created relief prints of their own in support of the student movement.[6] Artists like Rina Lazo were jailed for their public support of the movement, while her husband García Bustos produced prints that captured the government repression that culminated in the massacre of hundreds of students at Plaza de Tlatelolco. In *Charge Against the People* (fig. 8.1), he incorporates elements of a famous Posada print—mounted police dispersing a protest against Porfirio Díaz—to portray the violence unleashed on student protestors at the foot of modern skyscrapers.

In the context of neoliberal reforms in the 1980s and 1990s, which gutted Mexico's traditional industries and further marginalized the labor movement, the graphic tradition rooted in Posada was revived, transformed, and supplemented. Deborah Caplow writes of the recent recycling of the art of Leopoldo Méndez by a variety of artist collectives involved in social protest: "His prints are used freely by political organizations, without attribution, in a sense acting as a kind of image base for contemporary political publicity."[7] New generations of artists and social activists cover community walls with print posters, alter-

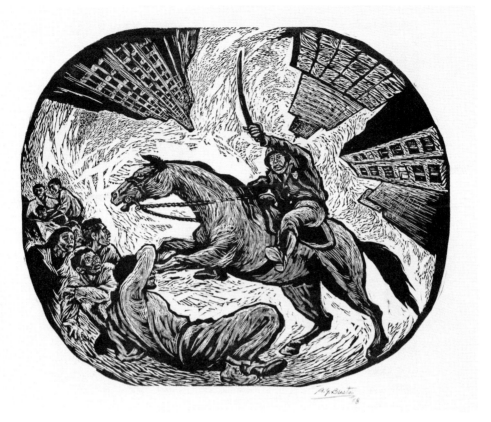

8.1. Arturo García Bustos, *The Charge Against the People*, 1968. Courtesy of Arturo García Bustos.

native murals, stencils, and graffiti in direct or indirect dialog with earlier artists on the left. Such movements and art forms include the murals supporting the neo-Zapatista uprising and autonomous *Caracol* communities in Chiapas, the relief prints, stencils, and graffiti of the "APPO" movement of teachers and indigenous groups in Oaxaca in 2006, and the alternative murals in border cities protesting the violence of *femicides*, drug gangs, and the militarized border itself. An example that suggests the continued relevance of the print as a form of protest are the street posters and a gallery exhibition of woodcuts by the "ASARO" collective of Oaxaca, formed in 2007 to denounce the government's violent repression of the APPO movement. One unsigned woodcut (fig. 8.2) portrays indigenous women demanding the ouster of the governor.[8]

When in 2009 the Mexican government liquidated the public electric company that employed the SME, effectively firing all the workers

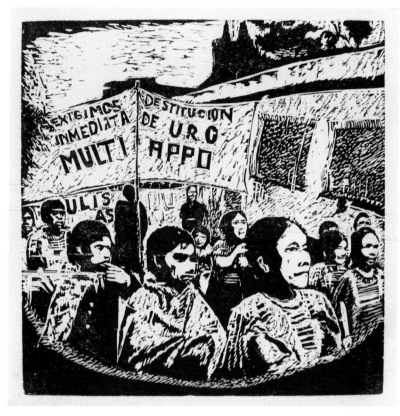

8.2. ASARO collective, *Indigenous Women Marching Against the Governor*, Oaxaca, Mexico, 2007. Photograph by Deborah Caplow.

of one of Mexico's oldest and most democratic unions, its mural *Portrait of the Bourgeoisie*, whose content was negotiated by collectives of artists and electricians, became a rallying point in defense of the union and political art.[9]

Increasingly rare in contemporary protest art is the essentialized male worker. The demise of the figure of the worker in overalls is not simply a change in working-class fashion. On the one hand, it is an acknowledgement that the universal symbol of the male worker was too narrowly constructed around the industrial workplace, Marxist-inflected representations of class, and hypermasculinized identities. New organizations and representations of popular movements are often rooted in community, in indigenous as well as middle-class identity, and in more complex constructions of gender and sexuality. But in the process, the centrality of work as an identity and place of organization has been lost.

One hundred years after the birth of Mexico's modern labor movement in the Revolution, globalization has transformed the locations, structures, gender, and organization of work. Under the North American Free Trade Agreement, foreign capital flows freely to new growth industries in Mexico. The greatest numbers of jobs are in the maquiladoras, borderland assembly plants worked primarily by women earning low wages with high turnover and limited labor rights. Others migrate north to the United States in search of work, where their labor rights are diminished and wages and protests are kept low by border walls, lack of documents, and fear of deportation.

In all of North America, structural changes and antilabor legislation since the 1980s have decimated organized labor as a percentage of the labor force and delegitimized it as a social actor. The unfettered movement of capital and the obstacles to both the movement of labor and the labor movement have led to a dramatic drop in labor's share of income and an ever greater gap between rich and poor.[10] Any renewed organization around work that grows out of such conditions will look different from that of the immediate postrevolutionary period. But the artists and labor leaders who picture the new worker in those movements can seek inspiration from those who represented workers after the Mexican Revolution—and learn from their mistakes.

NOTES

INTRODUCTION

1. Ortiz Hernán, *Chimeneas (Smokestacks)*, novela, 37.
2. Porter, *Working Women in Mexico City*, 40, 101.
3. Ortiz Hernán, *Chimeneas*, 38.
4. "Una Visita," *Frente a Frente*, July 1936, 23.
5. Knight, *The Mexican Revolution*; Vaughan, *Cultural Politics*.
6. Lear, *Workers*; Porter, *Working Women in Mexico City*.
7. Vaughan, et al., *The Eagle*; Craven, *Art and Revolution*; Folgarait, *Mural Painting*; Flores, *Mexico's Revolutionary Avant-Gardes*; Jolly, "Art of the Collective"; and Jolly, "Art for the Mexican Electricians' Syndicate."
8. Carr, "The Fate of the Vanguard"; Hemingway, *Artists on the Left*.
9. Vaughan, *Cultural Politics*.
10. Carr, "The Fate of the Vanguard," 327.
11. Hamilton, *The Limits of State Autonomy*; Knight, "The End of the Mexican Revolution?"
12. Porter, *Working Women in Mexico City*; see also essays by Fowler-Salamini, Gauss, and Fernández-Aceves in Olcott, et al., *Sex in Revolution*.
13. Serrano, *Imágen y representación*, 180.
14. Zavala, *Becoming Modern*.
15. Tenorio, *I Speak of the City*.

CHAPTER ONE

1. Victor Muñoz, "Saturnino Herrán," in Herrán, *Saturnino Herrán, instante subjetivo*.
2. The next paragraphs borrow from Lear, *Workers*, chap. 2.
3. Lear, *Workers*, 52–53.
4. Lear, *Workers*, 58–73.
5. On Salazar see *Nuestra Ciudad*, July 1930, 13; Salazar and Escobedo, *Las pugnas*; Huitrón, *Orígenes*, 73–84.
6. *Revista CROM*, March 22, 1925, 15–18.
7. Lear, *Workers*, 69–70.
8. Lear, *Workers*, 83.

9. Huitrón, *Orígenes*, 77, 226.

10. Basurto, *Vivencias*, 18, 54.

11. Lear, *Workers*, 84.

12. Illades, *Hacia la república*, 145–146.

13. Lear, *Workers*, 84.

14. Pérez Salas, "Genealogía," 192.

15. Oles, *Art and Architecture*, 181–187.

16. Ramírez, *Modernización*, 58; Museo Nacional de Arte, *1910, el arte*, 29.

17. El Spagoletto, in Moysseén, *La crítica de arte*, 588–590.

18. Muñoz, "Saturnino Herrán," 44; Ramírez, *Modernización*, 344–346.

19. Macías-González, "Apuntes"; Bleys, *Images of Ambiente*, 44.

20. Ramírez, *Modernización*, 58–60.

21. Doss, "Looking at Labor"; for an assertion of Herrán's possible homosexuality, see Bleys, *Images of Ambiente*, 43–44.

22. Museo Nacional de Arte, *1910*, 77.

23. Muñoz, "Saturnino Herrán," 44.

24. Museo Nacional de Arte, *1910*, 174.

25. Porter, *Working Women in Mexico City*, chap. 2.

26. Oles, "Industrial Landscapes," 133; Ramírez, *Modernización*, 71–99.

27. Museo Nacional de Arte, *1910*, 141.

28. Gómez Robelo, "Exposiciones," in *La crítica de arte*, editor Moysseén, vol. I, 471–473; Ramírez, *1910*, 79, 141.

29. Illades, *Hacia la república*; Lear, *Workers*, chap. 3; Diaz, "The Satiric Penny Press"; Leal, *Del mutualismo*, 86–87.

30. Archivo Electrónico Ricardo Flores Magón.

31. Ramírez, "La patria ilustrada," 53–73; Gretton, "The Cityscape," 214.

32. Ramírez, *Modernización*, 107, 116–118.

33. Gretton, "Posada," 32.

34. Antonio Rodríguez cited in Barajas, *Posada*, 111–113.

35. Frank, *Posada's Broadsheets*; Gretton, "Posada," 42.

36. Díaz, "The Satiric Penny Press," 515.

37. Buffington, *A Sentimental Education*, 31–32.

38. Díaz, "The Satiric Penny Press"; Barajas, *Posada*, 205–206; Buffington, "Toward a Modern Sacrificial Economy," 164.

39. Lear, *Workers*, 96–100; Barajas, *Posada*, 224, 239, 266, 337.

40. Gretton, "Posada," 40.

41. Barajas, *Posada*, 230, 234.

42. Ibid., 170, 334.

43. Ibid., 170–173.

44. Ibid., 282–285.

45. Ibid.

46. Ibid., 332–335.

47. Posada, "Un calvario moderno," *La Guacamaya*, April 20, 1905.

48. Díaz, "The Satiric Penny Press," 515; Barajas, *Posada*, 345–347.

49. Attributed by Barajas to Posada. Barajas, *Posada*, 347.

50. Barajas, *Posada*, 395.

51. Troconi, *Diseño gráfico en México*, 23.

52. See unsigned print *Servicio Militar Obligatorio* in *La Guacamaya*, April 11, 1907, and in *San Lunes* (October 4, 1909, January 31, 1910, February 14 and 21, May 10, 1910).

53. Barajas, *Posada*, 395–397.

54. Orozco, *Autobiography*, 30.

55. Lear, *Workers*, 201–202.

56. Buffington, "Homophobia," 212.

57. Posada, *Feminismo se impone*, in *La Guacamaya*, July 25, 1907.

58. Irwin, et al., *The Famous 41*, 2.

59. Barajas, *Posada*, 49, 268.

60. Anonymous, "Roberto Montenegro," in *La critica de arte*, vol. 1, 550; Nicolás Rangel, "El alma popular," in *La critica de arte*, vol. 2, 125; Ramírez, *Crónica*, 76.

61. Herrán's later paintings include "The Vendor of Bananas" (1912), "The Vendor of Oranges" (1913), and the drawing "Forge Workers" (1913). Ramírez, *Crónica*, 25–26.

CHAPTER TWO

1. Aguilar-Moreno and Cabrera, *Diego Rivera*, 20.

2. Ramírez, *Crónica*, 147–148.

3. González Matute, *Escuelas de pintura*, 22.

4. Orozco, *Autobiography*, 15–22, 28.

5. Knight, *The Mexican Revolution*; Hart, *Revolutionary Mexico*.

6. Lear, *Workers*; Snodgrass, *Deference and Defiance*; Bortz, *Revolution within the Revolution*.

7. Antliff, "Cubism, Futurism, Anarchism"; Leighten, *The Liberation of Painting*, 134.

8. Ortiz Gaitán, *Imágenes*, 17.

9. Charlot, *Mexican Mural Renaissance*, 44–46; Othon Quiroz Trejo, "La exposición de 1910"; Siqueiros, *Me llamaban*, 92.

10. Ramírez, *Crónica*, 49.

11. Ramírez, *Crónica*, 19, 38; González Matute, *Escuelas de pintura*, 47–68.

12. Ramírez, *Crónica*, 26.

13. Ibid., 28, 52–53.

14. See Ramírez, *Crónica*, figures 8–11, 22–25, 32–33, 39.

15. Lear, *Workers*, 139–140.

16. Ibid., chap. 4.

17. Huitrón, *Orígenes*, 242–254.

18. Lear, *Workers*, chap. 4.

19. Ibid., chap. 6.

20. Ibid., 171–172.

21. Casado Navarro, *Gerardo Murillo*, 31.

22. Quoted in Caplow, *Leopoldo Méndez*, 13.

23. Casado Navarro, *Gerardo Murillo*, 28–30; González Matute, *¡30-30!*, 29.

24. Ramírez, *Crónica*, 23.

25. Ibid., 22–23; Charlot, *Mexican Mural Renaissance*, 50.

26. Sáenz, *El símbolo*.

27. Rosendo Salazar, *El Demagogo*, 45–46.

28. Lear, *Workers*, 271–279; Orozco, *Autobiography*, 50.

29. Orozco, *Autobiography*, 50–53.

30. Salazar and Escobedo, *Las Pugnas*, 91.

31. Ibid., 93.

32. Carr, "The Casa del Obrero"; Lear, *Workers*, 276–283.

33. Troconi, *Diseño gráfico en México*, 50.

34. Ibid., 53–63.

35. CENIDIAP, Fondo Escuela de Pintura al Aire Libre, EC/E/10 vol. 1; Francisco Díaz de León, untitled manscript, 1965; Orozco, *Autobiography*, 50–53; Tibol, *Siqueiros*, 15–16; Museo Nacional de Arte, *1910*, 79; Siqueiros, *Me llamaban*, 86.

36. Fallaw, "The Seduction of Revolution," 91.

37. Sáenz, *El símbolo*, 242.

38. Azuela, *Arte y poder*, 41; González Matute, et al., *¡30-30!*, 30–31.

39. Gómez-Galvarriato, *Industry and Revolution*, 92–93.

40. Lear, *Workers*, 288–289, 315.

41. Moyssen Echeverría, *La Crítica*, vol. 2, 60; Ramírez, *Crónica*, 40–41.

42. Rosendo Salazar, in *Acción Mundial*, July 4 and 5, 1916.

43. *Acción Mundial*, February 12, 1916, vol. 1, no. 2, 12–13.

44. Lear, *Workers*, 280–295.

45. Ibid., 323–325.

46. Ibid., chap. 7.

47. See Zaldívar's caricature in the weekly *Acción Mundial*, February 19, 1916, and editorials of May 5, 22, 24, and 26 and July 22, 1916; Orozco's caricatures appear in the daily *Acción Mundial*, April 1, 1916.

48. On Atl's stencil technique, see Ittmann, "Dr. Atl," 89.

49. "Movimiento Obrero," *Acción Mundial*, July 23, 1916.

50. Lear, *Workers*, 333–338.

51. Castañeda, *Saturnino Herrán*, 14.

52. 1917 Constitution, Article 123, Section XVIII.

53. Clark, *Organized Labor*, 56.

54. Ramírez, *Crónica*, 53; Oles, *Art and Architecture*, 222.

55. Sáenz, *El símbolo*, 269–301; Casado Navarro, *Gerardo Murillo*, 165, 191.

56. Cited in Casado Navarro, *Gerardo Murillo*, 186.

57. Orozco, *Autobiography*, 81.

1. Casado Navarro, *Gerardo Murillo*, 182–183.
2. Craven, *Diego Rivera*, 72.
3. Clark, *Organized Labor*, 50–62.
4. Gauss, *Made in Mexico*, 25.
5. Aguirre and Buffington, *Reconstructing Criminality*, 119.
6. Susie Porter, "*Empleadas públicas*," 46–47.
7. Carr, *El Movimiento Obrero*, 163.
8. Clark, *Organized Labor*, 50–62.
9. Ibid., 56.
10. Lear, *Workers*, 341–354.
11. Tamayo, *En el interinato*; Clark, *Organized Labor*, 59, 62–68, 100; Middlebrook, *Paradox of Revolution*, 78; Rodríguez, "The Beginnings of a Movement," 67.
12. Alicia, *Arte y poder*, 116, 148–149.
13. Orozco, *Autobiography*, 74; Taibo, *Los Bolshevikis*, 369; "Las Juntas de Conciliación y Arbitraje," in *Vida Mexicana*, March 1923.
14. *Vida Mexicana*, March 1923, 13.
15. Caplow, *Leopoldo Méndez*, 59–60.
16. Charlot, *Mexican Mural Renaissance*, 242–243; Orozco, *Autobiography*, 66–67.
17. Charlot, *Mexican Mural Renaissance*, 241–244; Ramírez, "The Ideology," 291–325; Taibo, *Los Bolshevikis*, 204–205.
18. Orozco, *Autobiography*, 62–63; Siqueiros, *Me llamaban*, 215.
19. Charlot, *Mexican Mural Renaissance*, 244.
20. Rodríguez, "The Beginnings of a Movement," 69; Rivera Castro, *En la presidencia*, 142; Carr, *Marxism*, 30–31.
21. Taibo, *Los Bolshevikis*, 202; Charlot, *Mexican Mural Renaissance*, 280; Wolfe, *The Fabulous Life*, 151; Spenser, *Impossible Triangle*, 102, 110.
22. González Matute, "A New Spirit," 32–35.
23. Ittmann, "Open Air Schools," 90–91; Flores, *Mexico's Revolutionary Avant-Gardes*, 167–170.
24. Flores, *Mexico's Revolutionary Avant-Gardes*, 167–170.
25. See interview of Katherine Anne Porter with Rivera in *The Survey*, May 1, 1924, 52, no. 3; *Mexican Folkways*, no. 3, October–November, 1925.
26. Flores, *Mexico's Revolutionary Avant-Gardes*, 17, 24.
27. Charlot, Alva de la Canal, and Leal did receive mural commissions in the National Preparatory School.
28. Caplow, *Leopoldo Méndez*, 38–39.
29. Flores, *Mexico's Revolutionary Avant-Gardes*, 108.
30. Revueltas's *Workers' Wake* is included in ibid., 298–299.
31. Oles, *Agustín Lazo*, 35, 84.
32. Flores, *Mexico's Revolutionary Avant-Gardes*, 184.

33. Maples Arce, *La Urbe*. Translation taken from Brandon Holmquest, *City: Bolshevik Super-Poem in 5 Cantos*, 2010, 15, 19.

34. Flores, *Mexico's Revolutionary Avant-Gardes*, 107–108, 184–187.

35. Prieto González, "'El Estridentisimo mexicano y su construcción de la ciudad moderna a través de la poesía y la pintura.'"

36. Maples Arce, *Metropolis*.

37. Flores, *Mexico's Revolutionary Avant-Gardes*, 86–88.

38. Ibid., 118–119.

39. Poem translation in Charlot, *Mexican Mural Renaissance*, 262–263; Carranza, *Architecture*, 48.

40. Charlot, *Mexican Mural Renaissance*, 278–279.

41. Cardoza y Aragón, *Orozco*, 68; Folgarait, *Mural Painting*, 62.

42. González Mello, *La maquina de pintar*, 109.

43. Flores, *Mexico's Revolutionary Avant-Gardes*, 124–131.

44. Carr, *Marxism*, 36–37.

45. Orozco, *Autobiography*, 73.

46. Charlot contributed an article and woodcut, "Los Ricos en el Infierno," that was never published. "It is not political, but religious—the eye of the needle. It was a narrow point of contact with the political artists." Morse, *Jean Charlot's Prints*, 34.

47. Charlot, *Mexican Mural Renaissance*, 250–251. On distribution see *El Machete*, September 4, 1924; Siqueiros, *Me llamaban*, 217.

48. Carr, *Marxism*, 30–31.

49. For ads, see *El Machete*, March 15, 1924; see contributions and sales, June 15, 1924. On Rivera's considerable financial contribution, see Wolfe, *The Fabulous Life*, 154; Siqueiros, *Me llamaban*, 193.

50. *El Machete*, March 1, 1924.

51. Siqueiros, *Me llamaban*, 217.

52. Siqueiros, "Llamada," August 10, 1924.

53. Invitations to readers, *El Machete*, March 15, 1924, May 1, 1924, and "Concurso," March 5, 1925.

54. *El Machete*, June 1, 1924 and May 1, 1924.

55. Siqueiros, *Me llamaban*, 193.

56. *El Machete*, June 1 and 15, 1924.

57. *El Machete*, May 1, 1924.

58. "El Jurado," *El Machete*, June 1, 1924; "Los murciélagos," July 15, 1924; "Los Rorros Fascistas," August 28, 1924.

59. *El Machete*, June 15, 1924.

60. Azuela, "*Machete*," 82; Ramírez-García, "The Ideology," 337–339.

61. *El Machete*, October 30, 1924.

62. Ramírez-García, "The Ideology," 289–290.

63. Siqueiros, *Me llamaban*, 217.

64. Barajas, *Posada*, 27–29; Gretton, in Posada and Museo Nacional de Arte (Mexico), *Posada y la prensa ilustrada*, 121–149.

65. *El Machete*, August 3, 1924.

66. Azuela, *"Machete,"* 83.

67. *El Machete*, April 1–15, 1924, and March 1, 1924.

68. Carr, *Marxism*, 38.

69. *El Libertador*, May, June, and July 1925 (nos. 2–4).

70. *El Machete*, April 1 and May 15, 1924. See the attribution in Charlot, *Mexican Mural*.

71. *El Machete*, March 1 and April 15, 1924. Frank, *Posada's Broadsheets*, 135.

72. Charlot, *Mexican Mural Renaissance*, 248.

73. "Manifesto," *El Machete*, June 15, 1924; "Sigue," *El Machete*, May 1 and July 15, 1924.

74. Expediente personal, J. C. Orozco, Archivo Histórico de la SEP, O-2, ex 6, f80.

75. Azuela, "Vasconcelos," 153; Folgarait, *Mural Painting*, 280–293.

76. This tally and my identification of anonymous drawings as those of Orozco are confirmed by the curators of Museo de Arte Nacional in *Sainete, drama y barbarie*, 91–92. Orozco also published anonymously the following year in the periodical *L'ABC*.

77. *El Machete*, September 4, 1924.

78. *El Machete*, October 9 and 30 and December 11, 1924, and January 22 and March 12, 1925.

79. *El Machete*, September 25, 1924, and March 19, 1925.

80. Orozco, *Autobiography*, 30.

81. Alejandro Anreus, "José Clemente Orozco," *ArtNexus* no. 36, May–July 2000.

82. *El Machete*, October 30, 1924.

83. *El Machete*, October 23, 1924, and May 18, 1925.

84. *El Machete*, September 25 and October 16, 1924; Charlot, *Mexican*, 251.

85. González Mello, *Orozco: pintor revolucionario?*, 60.

86. Charlot, *Mexican Mural Renaissance*, 248.

87. Wolfe mentions two women in the Syndicate, Nahui Olín and Carmen Foncerrada, in Wolfe, *The Fabulous Life*, 157.

88. Irwin, "THE FAMOUS 41."

89. On Soviet subsidies see Spenser, *Impossible Triangle*, 100.

CHAPTER FOUR

1. *Revista CROM*, February 28, 1925.

2. Cited in Rodríguez, "Imágenes Colaterales," 158.

3. Middlebrook, *Paradox of Revolution*, 78; Buchenau, *Plutarco Elías Calles*, 115; Rivera Castro, *En la presidencia*, 30–31.

4. Quote from *Revista CROM*, March 1, 1927, 17.

5. Carr, *El Movimiento Obrero*, 135, 184; Clark, *Organized Labor*, 119.

6. On the printers' union see Gruening, *Mexico*, 365–366, 372–374.

7. *Revista CROM*, March 1, 1927, 37.

8. Directiva de la *Revista CROM*, May 1, 1925, 6; Loyo, "Gozos imaginados," 355, 372, 373.

9. The use of *"elementos trabajadores"* is noted in Loyo, "Gozos imaginados."

10. On strikes see *Revista CROM*, March 22, 1925, 1; August 1, 1925, 1; June 15, 1925, 2; July 15, 1926, 105; and May 1, 1927, 59.

11. *Revista CROM*, July 15, 1926, 4; August 31, 1926, 17.

12. *Revista CROM*, January 15 and June 1, 1928; March 22, 1925, 15–18.

13. Gaitán, *Imágenes*, 25–27.

14. Suplemento #5, also September 15, 1926, 74 2:35 and August 15, 1926, 69.

15. Exceptions are a photograph by Tina Modotti, cover, January 15, 1928, and a drawing by Gabriel Fernández Ledesma, *Revista CROM*, January 1, 1928, 67.

16. Dwyer, *Revista CROM*, December 1, 1927, 50; on Dwyer see Hooks, *Tina Modotti*, 142.

17. Hershfield, *Imagining*, 98.

18. Leal, *Agrupaciones*, 193; Cabral, *La vida en un volado*, 36.

19. Gaitán, *Imágenes*, 349.

20. See the supplement of *Revista CROM*, April 15, 1927.

21. *Revista CROM*, April 8, 1925.

22. Gaitán, *Imágenes*, 205.

23. Oles, *Industrial Landscapes*.

24. Doss, "Looking at Labor," 236–238.

25. *Revista CROM*, May 25, 1925, 14.

26. Buffington, *A Sentimental Education*, 141.

27. Buchenau, *Plutarco Elías Calles*, 125.

28. *Revista CROM*, March 1, 1927, 48; For Soto's cartoons, see *Revista CROM*, April 8, 1925, 65, 66; on the reorganization of the railroad, see Rodríguez, "The Beginnings of a Movement," 63, 64.

29. Hershfield, *Imagining*, 98.

30. *Revista CROM*, September 15, 1925, 57, and April 2, 1925, 27; Gaitán, *Imágenes*, 202.

31. French, "Progreso Forzado," 199–207.

32. Salazar cited in Córdova, *En una época*, 62.

33. Carlos Monsiváis, in *Estética socialista*, 27.

34. *Revista CROM*, May 1, 1927, 48–49, and January 1, 1928, 131–132.

35. Gaitán, *Imágenes*, 259–260.

36. Oles, *Industrial Landscapes*.

37. Lear, *Workers*, 351–352; Porter, *Working Women in Mexico City*, 39, 113–114; Guadarrama, *Los sindicatos*, 116–118.

38. Hershfield, *Imagining*, chap. 4.

39. Gauss, "Working Class Masculinity."

40. Ofelia Meza, "La Influencia," *Revista CROM*, May 1, 1925, 101; Hershfield, *Imagining*, 102–126.

41. Zavala, *Becoming Modern*; Rubenstein, "War on the Pelonas"; Hershfield, *Imagining*.

42. *Revista CROM*, January 15, 1927; February 15, 1927, 2; July 15, 1926, 55–56.

43. González Matute, "A New Spirit," 32–35.

44. Flores, *Mexico's Revolutionary Avant-Gardes*, 267; Reyes Palma, *Historia social*, 48.

45. Statistics for 1927 for all the Open Air and Centro Popular schools indicate that 1,105 of 1,616 male students were adults, and of a total of 1,753 students, only 137 were female, of whom 28 were children. "Informe general de la marcha de esta escuela, 1925–1928," Caja 6 #109. Archivo Facultad de Arquitectura—UNAM.

46. Azuela, *Arte y poder*, 81.

47. Reyes Palma, *Historia social*, 98.

48. Oles, "Industrial Landscapes," 129–159.

49. Ramírez, "El Centro Popular," *Forma* 7, 8.

50. Reyes Palma, *Historia social*, 62.

51. Cordero Reiman in Oles, *South of the Border*, 29–30.

52. Ramírez, "El Centro Popular," *Forma* 7, 8.

53. Fernández Ledesma, *Fernando Castillo*, 19; "Exposición del Centro Popular de Pintura Nonoalco," 1929, Biblioteca del Centro Nacional de las Artes.

54. González Matute, "A New Spirit," 42; Reyes Palma, *Historia social*, 65–67.

55. González Matute, *Escuelas de pintura*, 127.

56. González Matute, *¡30-30!*.

57. Actas de la Academia Mixta de Profesores y Alumnos. Archivo documental de la Academia de San Carlos, October 14, 1921.

58. Reyes Palma, *Historia social*, 47.

59. Rivera, "Exposición de Motivos," in Rivera and Tibol, *Arte y política*, 94.

60. González Mello, "La UNAM," 29–30.

61. Rivera, "Exposición de Motivos," in Rivera and Tibol, *Arte y política*, 91.

62. Ibid., 86.

63. González Mello, "La UNAM," 39, 41.

64. Wolfe, *Diego Rivera*, 291.

65. "Manifiesto a los obreros," in Tibol, *Arte y política*, 102.

66. Diego Rivera to Rector, "Contestaciones de los Cargos," no date. Caja 1; Expediente 33, Archivo de la Antigua Academia de San Carlos, Facultad de Arquitectura, Biblioteca Lazo, UNAM.

67. Abraham López to Diego Rivera, October 20, 1930, Bertram Wolfe archive, Folder 115, p. 3, Hoover Institute, Stanford University.

68. The enduring heir of the Centros Populares and Rivera's attempt to transform the Academy of San Carlos was most obviously the Escuela de Pintura y Escultora La Esmeralda, formed in 1943 as a successor to the Escuela Libre de Escultora y Talla Directa.

69. Mello, *La máquina*, 136.

70. For example, Arturo García Bustos (TGP), *La Huelga*, 1947.

71. Flores, *Mexico's Revolutionary Avant-Gardes*, 214.

72. Ibid., 206–210.

73. *Horizonte*, November 1926.

74. Méndez, *Horizonte*, May 1926, cover and 28.

75. Rivera Castro, *En la presidencia*, 94–96.

76. Flores, *Mexico's Revolutionary Avant-Gardes*, 214, 223.

77. Ramón Alva de la Canal, *Horizonte*, May 1926, 35.

78. Flores, *Mexico's Revolutionary Avant-Gardes*, 241.

79. The year 1927 is written on the back of the original of *Capitalism, the Clergy, and the Union Leader Against the Worker*, in the possession of the artist's son, Jorge Ramón Alva de la Canal. Some exhibitions have given both paintings the unlikely date of 1922. For example, see Museo Casa Estudio Diego Rivera y Frida Kahlo, *Misiones culturales*, 41, 44.

80. Rivera Castro, *En la presidencia*, 94–96.

81. Albiñana, et al., *México ilustrado*, 40.

82. Caplow, *Leopoldo Méndez*, 245–246.

83. O'Higgins and Híjar, *Apuntes y dibujos de trabajadores*.

84. Argenteri, *Tina Modotti*, 132; Caplow, *Leopoldo Méndez*, 70–71.

85. Mraz, *Looking for Mexico*, 76–85.

86. See the Modotti photographs in *Horizonte*, May 1926, 25, November 1926, 12, and April–May 1927, 36.

87. Folgarait, *Seeing Mexico Photographed*, 36–64.

88. Hooks, *Tina Modotti*, chap. 12.

89. *Horizonte*, April–May 1927, 36.

90. González Cruz Manjarrez, *Tina Modotti*.

91. Sarah M. Lowe, *Tina Modotti*.

92. Folgarait, *Seeing Mexico Photographed*, 110–112.

93. Argenteri, *Tina Modotti*, 131.

94. Rodríguez y Méndez de Lozada, "Imágenes colaterales," 168.

95. Ibid., 170–171.

96. Published July 28, 1928; see ibid., 171.

97. Thanks to John Mraz for pointing out that this is a railroad worker. On railroad strikes, see Carr, *El Movimiento Obrero*, 168–169, and Rodríguez, "The Beginnings of a Movement."

98. *El Machete*, April 6, 1929.

99. Orozco, *Autobiography*, 93–94.

100. Rivera cited in González Mello, "La UNAM," 45.

101. Azuela, "*Machete*," 85.

CHAPTER FIVE

1. Millan, *Mexico Reborn*, 171.

2. The Ferrocarril Mexicano railroad strike of December 1929 is a significant exception in this period of relative labor quiescence. Buchenau, *Plutarco*

Elías Calles and the Mexican Revolution, 149–150; Córdova, *En una época*, 56, 78, 87; Clark, *Organized Labor*, 174.

3. Carr, *Marxism*, 43–45.

4. Ibid., 47–56; Middlebrook, *Paradox of Revolution*, 186–188.

5. Casado Navarro, *Gerardo Murillo*.

6. Caricature by Arenal, *Machete*, November 30, 1934.

7. León and Marván, *En el cardenismo*, 65.

8. Ibid., 95.

9. Sosa Elízaga, *Los códigos ocultos*, 61.

10. R. Ortiz to Hernán Laborde, August 2, 1935, in Spenser, *Unidad a toda costa*, 68.

11. On membership figures, see Carr, *Marxism*, 51–53.

12. León and Marván, *En el cardenismo*, 33–39, 145–150.

13. Garza Toledo, *Historia*, 93.

14. Ibid., 92.

15. Millan, *Mexico Reborn*, 95–98; Ashby, *Organized Labor*, 26–27.

16. Middlebrook, *Paradox of Revolution*, 91.

17. Oles, *Art and Architecture*, 264–266.

18. Thanks to Bronwen Solyom for this connection.

19. Stein, *Siqueiros*, 54–73.

20. Oles, *Art and Architecture*, 268.

21. Stein, *Siqueiros*, 75; the mural has since been restored.

22. Lee, "Workers and Painters," 201–220.

23. Wolfe, *The Fabulous Life*, 339.

24. Folgarait, *Mural Painting*, chap. 4.

25. Craven, *Art and Revolution*, 55–57; for a very different interpretation, see Folgarait, *Mural Painting*, chap. 4.

26. Wolfe, *The Fabulous Life*, 238–239.

27. Casado Navarro, *Gerardo Murillo*, 139–140.

28. O'Higgins quotes in Oles, "Walls to Paint On," 244; Oles, *Art and Architecture*, 282–283.

29. Julio de la Fuente to C. Presidente de la República, March 1, 1936, Archivo Méndez, CENIDIAP/CAN C22 2971-D2485/12.8.2.

30. Plenn cited in Oles, *Walls to Paint On*, 310–311.

31. See microfilm copies of *Llamada*, *Golpe*, and *Choque* at the CENIDIAP, Centro Nacional de las Artes, Archivo Fernando Leal, Roll 2; on their militancy in the PNR, see Dafne Cruz Porchini, "Martillo," in *La arqueologia del régimen, 1910–1955*, 139.

32. Quote from *Choque*, March 1934, cited above. Oles, *Agustín Lazo*, 63–64.

33. García Molina, "De estridentópolis a la ciudad roja," 173.

34. Vargas, *Labor Rights*, 54.

35. On possible founding dates and members, see Reyes Palma, "La LEAR," 5 (footnote 3) and 6.

36. Ibid., 63–64.

37. "Síntesis de los principios," *Frente a Frente*, November 1934, 2.

38. Translation from Caplow, *Leopoldo Méndez*, 95.

39. Arturo Zepeda, "El plastodonte blanco," *Frente a Frente*, November 1934, 15.

40. Caplow, *Leopoldo Méndez*, 98.

41. Program, "Arte para el trabajador," Palacio Bellas Artes, December 1934, microfilm, Archivo Fernando Leal, CENIDIAP/CNA roll 2.

42. Leopoldo Méndez, "Programa de Trabajo del Teatro Guignol," March 18, 1933, Archivo Méndez, CENIDIAP/CAN D2117-D2120/12.3.2; Caplow, *Leopoldo Méndez*, 246.

43. LEAR, flyer, "4 Demandas de la Liga de Escritores y Artistas Revolucionarios ante el Presidente de la República," January 1935, CEMOS.

44. *Frente a Frente*, May 1935.

45. Vázquez Ramírez, "Acciones comunistas," 599–600.

46. Arenal, "Al Sindicato de Ferrocarrileros Mexicanos," November 19, 1934, Archivo Méndez, CENIDIAP/CAN C20 C914-D2420/12.8.1.

47. Reyes Palma, "La LEAR," 8; *Frente a Frente*, January 1935, 4–5.

48. "Detalle de Proyecto," *Frente a Frente*, January 1935, 4 and 10.

49. Prignitz-Poda, *El Taller*, 33–34.

50. Arenal, Letter to "Association des Ecrivains," January 25, 1935, Archivo Méndez, CENIDIAP/CAN C20 C957-D2423/12.8.1; Reyes Palma, "La LEAR," 7.

51. Reyes Palma, "La LEAR," 9.

52. The article "Derrotero de conferencias" complains that only 50 of 600 members attended a LEAR event. *Frente a Frente*, January 1938, 13.

53. Member list, "LEAR Artes Plásticas," no date, Archivo Méndez, CENIDIAP/CAN C20 E867-D2318/12.2.

54. Fuentes Rojas, *Liga De Escritores Y Artistas Revolucionarios*, 81–95.

55. Member list, "LEAR Artes Plásticas," no date, Archivo Méndez, CENIDIAP/CAN C20 E867-D2318/12.2; Izquierdo in *Frente a Frente*, November 1937, 12; Álvarez Bravo and Aurora Reyes in *Frente a Frente*, January 1938, cover and 13.

56. Zavala, *Becoming Modern*, 297.

57. Prignitz-Poda, *El Taller*, 39.

58. Juan de la Cabada to Cámara del Trabajo Unitaria, November 27, 1935, Archivo Méndez LM-C20-2949-D2456/12.8.2.

59. Letter, Juan de la Cabada to director "El Gráfico," February 1, 1936, Archivo Méndez, C21 E963 D2470/22.8.1; Fuentes Rojas, "Liga de Escritores," 58.

60. "E. Cruz to C. Ejecutivo de la LEAR," December 12, 1936, C23-E1269-D2831/12.8.2, Archivo Méndez, Day 3, p. 5.

61. Letter, Juan de la Cabada to director "El Gráfico," February 1, 1936, Archivo Méndez, C21 E963 D2470/22.8.1; ibid.

62. LEAR, *Declaración de Principios*, 1936, CEMOS, 3–4.

63. "Acuerdos tomados en la asamblea ordinaria," March 26, 1936, and July 18, 1936, Archivo Méndez, C20-C860-D2280/12.1 and C20-C862-D2293/12.1.

64. *Libro de lectura, 1er. Grado*, 88–89.

65. Prignitz-Poda, *El Taller*, 47.

66. Julio de la Fuente to C. Presidente de la República, March 1, 1936, Archivo Méndez, CENIDIAP/CAN C22 2971-D2485/12.8.2; Juan Marinello to Relaciones Exteriores, November 11, 1936, Archivo Méndez, LM C21 E986 D2503/12.8.1; LEAR to SEP, LM C21 E1000 D2518/12.8.2; on the headquarters subsidy, see Millan, *Mexico Reborn*, 195.

67. "Credencial a la Confederación Sindical Unitaria," February 20, 1936. Archivo Méndez, CNAP LM C21 E969 D2481/12.8.2.

68. "Objetivos y Organización Interna," Archivo Méndez, LM C20 E869 D2330/12.4. Caplow, *Leopoldo Méndez*, 112.

69. Reyes Palma, "La LEAR," 7; Prignitz-Poda, *El Taller*, 35–37; "Firma del pacto de frente unico," Archivo Méndez, C20 E859 D2279/12.1; "Acuerdos tomados," June 13, 1935, Archivo Méndez, C20-E862-D2291/12.1; *Frente a Frente*, August 1936, 23; "Taller de Pintura de la Liga," Archivo Méndez, LM C22 E977 D2492/12.8.2.

70. Siqueiros cited in Prignitz-Poda, *El Taller*, 36.

71. "Consciente de los postulados," 1933 or 1934 (date obscured). Courtesy of Peter Schneider.

72. In the collection of the Museo del Estanquillo.

73. Gaitán, *Imágenes*, 158.

74. See Fernández Ledesma comments on collective efforts in the exhibition flyer "Carteles de la U.R.S.S.," no date, Cenidiap/CAN, LEAL 7/20 #279.

75. Huerta, *El círculo que se cierra*, 73, 131.

76. Ortiz Gaitán, *Imágenes*, 158; *Choque*, March 1934; Troconi, *Diseño gráfico en México*, 70–76; "Panorama of the Poster Around the World," 1934; "Graphic Propaganda," 1936; and "Posters of the Spanish War," 1937.

77. Fernández Ledesma, "Exposición de propaganda tipográfica," *Frente a Frente*, July 1936, 22.

78. Dafne Cruz Porchini, "El Departamento de Bellas Artes."

79. Prignitz-Poda, *El Taller*, 44.

80. "Convenio para pintar," Archivo Méndez, LM, C22 E871 D2333/12/5.1.

81. On the reorganization of the Talleres Gráficos, see "Una Visita," *Frente a Frente*, July 1936, 23.

82. The collective publishing process of his novel is clear in the preface and back matter of his novel. Ortiz Hernán, *Chimeneas (Smokestacks)*.

83. O'Higgins, *Pablo O'Higgins*, 99–101.

84. Revueltas a C. General Lázaro Cárdenas, no date, Archivo Méndez, LM C22 E1105 D2660/12.8.2; Fuentes Rojas, "Murales de la Liga de Escritores y Artistas Revolucionarios en los Talleres Gráficos de la Nación: un Historial Accidentado," 33; Prignitz-Poda, *El Taller*, 42.

85. "Acuerdos tomados," March 6, 1936, Archivo Méndez, LM C20 E859 D2278/12.2.

86. "Discurso de Vicente Lombardo Toledano" and "Una Interpretación Marxista de Lázaro Cárdenas," *Frente a Frente*, March and July 1936, 4 and 2.

87. See also Lerner, *The Shock of Modernity*, 64–67; a crude early photomontage was used for the May 1935 cover of *Frente a Frente*. See Rodríguez, "El fotomontaje en México," 42–49; Prignitz-Poda, *El Taller*, 44.

88. Exhibition flyer, "Carteles de la U.R.S.S.," no date, Cenidiap/CAN, LEAL 7/20 #279; *Futuro*, February 1936, 216.

89. *Lux*, March 1936, 23.

90. *Lux*, March 1936, 44; a secretariat of women's affairs would eventually be created within the CTM in the 1940s. Olcott, *Revolutionary Women*, 242.

91. Olcott, *Revolutionary Women*, 117, 145.

92. Ibid., 16, 28, 48, 55–58, 111.

93. Spenser, *Unidad a toda costa*, 376–377, 485–486; Olcott, *Revolutionary Women*, 15–18.

94. "Convocatoria," December 1936, Archivo Méndez, CNAP FR LM C20 E910 D2413/12.7.

95. Olcott, "The Center Cannot Hold," 237.

96. Olcott, *Revolutionary Women*, 57.

97. *Libro de lectura. Segundo Grado*, 30, 33, 46, 47, 92, 93.

98. León and Marván, *En el Cardenismo*, 195.

CHAPTER SIX

1. Lear, *Workers*, 71, 266; Clark, *Organized Labor*, 166–170.

2. Thompson, *The Development*, 11–13.

3. Córdova, *En una época*, 11, 60; Clark, *Organized Labor*, 166–170.

4. Lear, *Workers*, 277, 336, 345.

5. Thompson, *The Development*, 89–90.

6. Garza Toledo, *Historia*, 61, 68; Thompson, *The Development*, 103–106, 141–147.

7. Clark, *Organized Labor*, 166, 170.

8. *Lux*, February 1935, 13; Garza Toledo, *Historia*, 75; Clark, *Organized Labor*, 137; Thompson, *The Development*, 93.

9. Statutes quoted in *Lux*, no. 338, 1994, 44.

10. Jolly, "David Alfaro Siqueiros," 35–37.

11. On the history of SME journals, see "La expresión periodística," *Lux*, December 1939, 53; see similar *Lux* covers for January 1929 (Aztec princess) and May 1931 (colonial church).

12. *Lux*, January 1929, 6–7; March 1929, 11.

13. Garza Toledo, *Historia*, 200; "Seis preguntas del mes," *Lux*, April 1932, 11–13.

14. *Lux*, back cover, February/March 1933.

15. Thompson, *The Development*, 80–86.

16. Vázquez Ramírez, "Acciones comunistas," 599–600.

17. Cartoon, "Participación de Utilidades," *Lux*, April 1932, 34; "La Herencia" and "El Sindicalismo," *Lux*, June 1932, 2, 6–8; *Lux*, July 1932, 13, 29.

18. "Discurso pronunciado," *Lux*, December 1933, 14; Thompson, *The Development*, 152; Jolly, "Art for the Mexican Electricians' Syndicate," 114–115.

19. Garza Toledo, *Historia*, 80.

20. On salaries, see "Huelga del SME," *Futuro*, July 1936.

21. "El SME y la década de los 30," *Lux*, July 2011, 53–56.

22. Asamblea General, March 22, 1934, Sindicato Mexicano de Electricistas, "Libro de Actas," vol. 6, 181.

23. On SME support of women's suffrage, see General Assembly, March 3, 1938, "Libro de Actas," 94; Breña, "Opiniones sobre los candidatos," *Lux*, October 1937, 43; see the lists of all SME officers for 1914–1984 in "70 años de democracia," *Lux*, no. 338, 1984.

24. "El nuevo contrato colectivo y el nuevo 'Lux,'" June 1934, *Lux*, 4–6.

25. See *Lux* (November 1936) on the SME visit to the Soviet Union. See complaints about Breña's Marxism, "Acusación," *Lux*, July–August 1935.

26. On Russian women, see *Lux*, September 1933, 29; *Lux*, October 1936, 26; the offending article is Amparo Poch y Gascón, "La Vida Sexual de la Mujer," *Lux*, September 1933, 25–26, and the journal's vague disavowal, *Lux*, October 1933, 4; for the subsequent discussion, see Asamblea General, November 9, 1933, and November 22, 1934, Sindicato Mexicano de Electricistas, "Libro de Actas," vol. 6, 128 and 134.

27. Circulation numbers from *Lux*, February 1935, 9.

28. Clark, *Organized Labor*, 170.

29. "Planillas electorales," *Lux*, October 1935, 11. For a discussion of the numbers and roles of Communists in the Mexican Electricians' Union, see Asamblea General, July 21, 1938, Sindicato Mexicano de Electricistas, "Libro de Actas," 422–423; Barry Carr, *Marxism and Communism*, 52–53.

30. Buchenau, *Plutarco Elías Calles*, 180; Chassen de López, *Lombardo Toledano*, 181.

31. Breña, *El sindicato*.

32. "El SME y la década de los 30," *Lux*, July 2011, 61.

33. Jolly, "David Alfaro Siqueiros," 41.

34. See similar borrowing in *Futuro*, edited by Lombardo Toledano.

35. Balmori, *Reflejo del ritmo*, 11; Balmori, *Remembranzas*, 49.

36. Balmori, *Remembranzas*, 45–51.

37. *Lux*, January 1936, 1.

38. Sosa Elízaga, *Los códigos ocultos*, 70–71; Garrido, *El Partido de la Revolución*, 199.

39. Cárdenas, *Ideario político*, 59; Sosa Elízaga, *Los códigos ocultos*, 81.

40. Breña's speech is in *Lux*, January 1936, 1–4; Garza Toledo, *Historia*, 92–93; Prignitz-Poda, *El Taller*, 36 and footnote 36.

41. *El Machete*, January 22, 1935.

42. "Huelga," *Lux*, September 1936, 3.

43. Thompson, *The Development*, 153–155.

44. Ibid., 164–174; Walter, "Lázaro Cárdenas," 94–99; León and Marván, *En el cardenismo*, 228.

45. Walter, "Lázaro Cárdenas," 99; Garza Toledo, *Historia*, 109.

46. "Boletín de Prensa," in *Lux*, September 1936, 66.

47. "Boletín de Prensa," in *Lux*, September 1936, 66.

48. Thompson, *The Development*, 152; Enrique de la Garza Toledo, et al., *Historia*, 109.

49. Enrique Gutmann, insert, *Lux*, September 1936.

50. González Flores, "Transito y mudanzas," 106.

51. Walter, "Lázaro Cárdenas," 97–98; Thompson, *The Development*, 176–178.

52. Matesanz, *Las raíces*, 54–55.

53. Filiberto Ortiz, November 8, 1936. "Sesión celebrada por los compañeros del sindicato de vaqueros." Archivo Diego Rivera-Frida Kahlo, 11600-02.

54. Graham, *The Spanish Civil War*, 66.

55. Ojeda Revah, *México y la guerra civil española*; Powell, *Mexico*; Matesanz, *Las raíces*.

56. Ibid., 124.

57. Ibid., 126–129; Matesanz, *Las raíces*, 69.

58. Sánchez, "Retrato de la burguesía," 44, 48; *Lux*, December 1938, 38.

59. Ojeda Revah, *México y la guerra civil española*, 194, 199, 211; Jackson, *Fallen Sparrows*, 79–81; Powell, *Mexico*, 73.

60. Artists accompanying Siqueiros as soldiers were LEAR member Antonio Pujol and inveterate drifter Barnabé Barrios. Powell, *Mexico*, 105; see Fernando Gamboa, "El soldado Antonio Pujol," in *Frente a Frente*, May 1937, 14.

61. Octavio Paz, "Elegía a un compañero muerto"; Millan, *Mexico Reborn*, 189; *Frente a Frente*, November 1937.

62. Ruipérez, "Renau-Fontseré," 15–16.

63. Jo Labanyi, "Propaganda Art," in Graham and Labanyi, *Spanish Cultural Studies*, 161–166; Jorge Volpi, "Octavio Paz en Valencia," 16; Ramírez Sánchez, "El muralismo mexicano," 63–64.

64. San Pedro, *El exilio español*, 42–45.

65. On "expressionist realism" see Nelson, *Shouts*, 28. See the photomontage by Lola Álvarez Bravo on the last cover of *Frente a Frente*, no. 13, January 1938. Labanyi, "Propaganda Art," 161.

66. *Lux*, January and March 1937.

67. Powell, *Mexico*, 67–68.

68. *El Popular* and *Futuro* quoted in Powell, *Mexico*, 129–132.

69. Ojeda Revah, *México y la guerra civil española*, 100–101; Sosa Elízaga, *Los códigos ocultos*, 110–112; Michaels, "Las elecciones de 1940," 98.

70. Jolly, "Art for the Mexican Electricians' Syndicate," 123.

71. Plenn, *Mexico Marches*, 273; SME, "Libro de Actas," March 3, 1938, 94, and March 24, 1938, 125–126; Balmori, *Remembranzas*, 53.

72. "Cárdenas pasa revista," *El Machete*, 8; cover of *Lux*, June 1938. Powell, *Mexico*, 131.

73. See Puyol's poster emphasizing this transition in Nelson, *Shouts*, 23.

74. Graham, *The Spanish Civil War*, 56; Lines, *Milicianas*, 169.

75. See the "Miliciana Española" photo of a CTM march, *Futuro*, September 1938, 37, and the participation of *miliciana* Caridad Mercader in a meeting of the LEAR in Guadalajara, *Frente a Frente*, January 1927, 13.

76. The photo of Mercader with Lombardo Toledano is reprinted in Costa-Amic, *León Trotsky y Andreu Nin*, 86.

77. Marinello, "Caridad Mercader," *Repertorio americano*, 40; Massón Sena, "Marinello," 139; Balmori, *Remembranzas*, 53.

78. *Lux*, back cover, August 1936, and poem, December 1937, 18.

79. Lines, *Milicianas*, 151–169.

80. O'Higgins, *Pablo O'Higgins*, 133.

81. Juan Alvarez Torres, "Subteniente de la Batería Antiaérea," *Lux*, May 1938, 21. On *milicianas*, see Graham, *The Spanish Civil War*, 54–57.

82. Spanish poster, "Adelante," back cover, *Lux*, July 1937.

83. Caplow, *Leopoldo Méndez*, 145.

84. *El Machete*, July 9, 1938, and May 7, 1938.

85. Caplow, *Leopoldo Méndez*, 143; O'Higgins, *Pablo O'Higgins*, 134.

86. Millan, *Mexico Reborn*, 197.

87. Sosa Elízaga, *Los códigos ocultos*, 454–455.

88. Powell, *Mexico*, 110; Snodgrass, "'We Are All Mexicans Here," 330; *Lux*, August 15, 1939, 17; Ojeda Revah, *México y la guerra civil española*, 262.

CHAPTER SEVEN

1. Knight, "The End of the Mexican Revolution?," 55–63; Hamilton, *The Limits of State Autonomy*; Sosa Elízaga, *Los códigos ocultos*.

2. Ojeda Revah, *México*, 276.

3. Sosa Elízaga, *Los códigos ocultos*, 453–457.

4. See "desobrerización" in Peláez Ramos, "La Federación Mexicana de Trabajadores."

5. Knight, "The End of the Mexican Revolution?," 55–63.

6. León and Marván, *En el cardenismo*, 182.

7. Breña, "Informe," *Lux*, March 1936, 6–10.

8. Garza Toledo, *Historia*, 94–97; León and Marván, *En el cardenismo*, 181.

9. Carr, *Marxism*, 54.

10. León and Marván, *En el cardenismo*, 212; Sosa Elízaga, *Los códigos ocultos*, 141–142; *Lux*, March 1937, 26–27; SME press statement quoted in Carr, *Marxism*, 54.

11. Caricatures by Arias Bernal, *Lux*, May 1937, 9, 13.

12. "El Sindicato Mexicano de Electricistas y la C.T.M.," *Lux*, March 1937, 26–29; "El Sindicato durante el año 1937," *Lux*, January 1938, 14–15; Sosa Elízaga, *Los códigos ocultos*, 270.

13. Peláez Ramos, "La Federación Mexicana de Trabajadores."

14. Sosa Elízaga, *Los códigos ocultos*, 145–150; Carr, *Marxism*, 55.

15. Report on the congreso, *Lux*, March 1936, 48, 53.

16. "El primer maestro rural," *Frente a Frente*, March 1937, 16.

17. MacGregor, "Elecciones federales"; León and Marván, *En el cardenismo*, 270–271; Garrido, *El Partido de la Revolución*, 219–225; Yucatan speech in Cárdenas, *Palabras y documentos públicos*, 260.

18. *El Machete*, August 1, 1938.

19. Ponte, *La ruptura de la nación*, 23; Sosa Elízaga, *Los códigos ocultos*, 277–280; Middlebrook, *Paradox of Revolution*, 93–95; Garrido, *El Partido de la Revolución*, 247; León and Marván, *En el cardenismo*, 299.

20. Knight, "La última fase de la Revolución: Cárdenas," 204, 250.

21. González Casanova, *El Estado y los partidos políticos en México*, 59.

22. León and Marván, *En el cardenismo*, 270; Garrido, *El Partido de la Revolución*, 247–248.

23. *El Machete*, April 16, 1938, 1.

24. *Lux*, March 1936, 48, 53; León and Marván, *En el cardenismo*, 232–234, 276–280.

25. Knight, "La última fase de la Revolución: Cárdenas," 50.

26. González Casanova, *La democracia en México*, 283.

27. Middlebrook, *Paradox of Revolution*, 94–95.

28. Sosa Elízaga, *Los códigos ocultos*, 453–457.

29. Plenn, *Mexico Marches*, 292.

30. SME Assembly meetings, "Libro de Actas," March 31, 1938 (137) and April 7, 1938 (147).

31. *Lux*, April 1938, 22–23.

32. Alvar D. Ross, "Una faceta . . . ," *Lux*, May 1938, 12–13.

33. Thompson, *The Development*, 197–199.

34. See Breña's report in "El Sindicato durante el año 1937," *Lux*, January 1938, 11–14; Breña, "Opiniones sobre los candidatos"; and a member's letter, *Lux*, October 1937, 43, 44, and July 26, 1934, Assembly, "Libro de Actas," 246.

35. "Dean Delgadillo se sigue exhibiendo," *Lux*, December 1937, 35–36. "El Sindicato durante el año 1937," *Lux*, January 1938, 14–15.

36. SME Assembly meetings, "Libro de Actas," March 31, 1938 (137) and April 7, 1938 (147).

37. SME Assembly meeting, "Libro de Actas," April 25, 1938, 177; "Informe Secretario Exterior," *Lux*, December 1940, 12.

38. Thompson, *The Development*, 187; Hernán Laborde to Volsky, February 4, 1937, in Spenser, *Unidad a toda costa*, 252.

39. "Apuntes," *Lux*, March 1938, 9.

40. Comments from three different SME Assembly meetings, "Libro de Actas," April 22, April 25, and August 18, 1938, 177, 185, 460.

41. SME Assembly meeting, "Libro de Actas," August 18, 1938, 449–460.

42. Thompson, *The Development*, 184–186; Jennifer Jolly, "Art for the Mexican Electricians' Syndicate," 116; *Lux*, January–February 1939, 29.

43. Editorial, *Lux*, September 1939; Spenser, *Unidad a toda costa*, 486.

44. Carr, *Marxism*, 62.

45. Editorial, *Lux*, August 1939, 8; "Sindicato y Lucha Electoral," *Lux*, September 1939, 8; "Informe Secretario General David Roldán," *Lux*, January 1940, 35; Contreras, *México 1940*, 81.

46. Editorial, *Lux*, October 1939, 7–9.

47. *Lux*, December 1984, 15, 38, 68; "La única verdad en la guerra europea," *Lux*, June 1940, 7–9.

48. "Informe," *Lux*, August 1939, 19.

49. Rangel, *Enrique Yáñez*, 63.

50. Jolly, "Art for the Mexican Electricians' Syndicate," 121–123; Folgarait, *Mural Painting*, 168.

51. Folgarait, *Mural Painting*, 142–147, 161–164; Jolly, "Art for the Mexican Electrician's Syndicate," 120.

52. Folgarait, *Mural Painting*, 141; Jolly, "Art for the Mexican Electricians' Syndicate," 125.

53. Translation from Folgarait, *Mural Painting*, 148, 170.

54. Folgarait reads the "revolutionary" as possibly middle class or "a man whose action and appearance blend class differences and assert solidarity in the face of a greater enemy." Ibid., 154, 172, 186.

55. Jolly, "Art for the Mexican Electricians' Syndicate," 126.

56. On the disputes within the collective, see Jolly, "Art of the Collective."

57. Jolly, "Art for the Mexican Electricians' Syndicate," 127–129.

58. Folgarait, *Mural Painting*, 184–190; Jolly, "Art for the Mexican Electricians' Syndicate," 130–132.

59. *Lux*, August 1939, 19.

60. "Informe," *Lux*, December 1940, 12.

61. Francisco Sánchez Garnica, "La Política en el Sindicato," *Lux*, September 15, 1941, 9–10.

62. Garza Toledo, *Historia*, 231–236.

63. A typical cover image of Rojas is December 1948; cited cover captions are from February and November 1949.

64. On the restoration of SME democracy in 1952, see "70 Años de democracia," *Lux*, December 1984, 78.

65. Millan, *Mexico Reborn*, 189–191; "Resumen del Congreso," *Frente a Frente*, March 1937, 24.

66. Plenn, *Mexico Marches*, 347.

67. Monsiváis, *Leopoldo Méndez y su tiempo*, 25.

68. Cardoza y Aragón, "Exposición de pintura," *El Machete*, May 23, 1936.

69. *Leon Trotsky on Literature and Art*, 117.

70. Cardoza y Aragón and González Mello, *La nube y el reloj*, 29–30; Reyes Palma, "La LEAR," 12–13; Cardoza y Aragón, *Orozco*, 185.

71. Reyes Palma, "La LEAR," 12–13.

72. Reyes Palma, "La LEAR," 12–13; Prignitz-Poda, *El Taller*, 44–45; Cardoza y Aragón, *Orozco*, 185–186, 251–252; Volpi, "Octavio Paz en Valencia."

73. Millan, *Mexico Reborn*, 193; Makedonio Garza, "Derrotero," *Frente a Frente*, January 1938, 13, 15; "Acuerdos," March 21, 1936, Méndez archive, CNAP-FR-LM C20 E860-D2281/12.1; "Acuerdos," July 18, 1936, Méndez archive, CNAP-FR-LM C20 E862-92213/12.1.

74. Diego Rivera, "Más Letras antes del Pan," *Novedades* (Mexico City), June 25, 1938. Reproduced online in the International Center for Arts of the Americas, Museum of Fine Arts of Houston, Record no. 794653.

75. Millan, *Mexico Reborn*, 178; "Sesión Ordinaria," January 9, 1937, Méndez archive, CNAP-FR-LM-C20-E836-D2296/12.1; "Reunión del Comité Directivo," Méndez archive, CNAP-FR-LM-C20-E864-D2306/12.1; quote from "El Comité Ejecutivo," March 1, 1937, CNAP-FR-LM-C20-E834-D2300/12.1; "Deudas," February 1936, Méndez archive, CNAP-FR-LM-C20 E872-D2336/12.6.1.

76. Prignitz-Poda, *El Taller*, 46; "Actividades," *Frente a Frente*, November 1937, 11.

77. "Delegados," *Frente a Frente*, July 1937, 22.

78. Fuentes Rojas, "Liga de Escritores," 91; Millan, *Mexico Reborn*, 195.

79. "Unión de Empleados," Méndez archive, CNAP-FR-LM-C20 C929 D2425/12.8.1.

80. "Asamblea," February 24, 1937, Méndez archive, CNAP-FR-LM-C20-E864-D2304; "Cuenta con Talleres," March 15, 1937, CNAP-FR-LM-C20-E873-D2352/12.6.1.

81. Sheridan, *Poeta con paisaje*, 194.

82. "30 dias," *Frente a Frente*, May 1937, 5.

83. "Reunion," February 25, 1937, Méndez archive, CNAP-FR-LM-C20-E864-D2305/12.1.

84. Aboites and Loyo, "'La construcción del nuevo estado," 1942.

85. Millan, *Mexico Reborn*, 195; for both moves, see Fuentes Rojas, "Liga de Escritores," 79.

86. "Balance," *Frente a Frente*, January 1937, 10; Prignitz-Poda, *El Taller*, 55–56.

87. Caplow, *Leopoldo Méndez*, 123.

88. Prignitz-Poda, *El Taller*, 55–56; Oles, *Art and Architecture*, 284–286.

89. Reyes Palma, "La LEAR," 14–15.

90. Carr, "La crisis del Partido Comunista Mexicano," 609.

91. Caplow, *Leopoldo Méndez*, 246–247.

92. "Méndez a Carrillo," January 15, 1938, Méndez archive, CNAP-FR-LM-C26-E1548-D3685/13.5.1; "Al Secretaria de Hacienda," February 25, 1938, Méndez archive, CNAP-FR-LM-C26-E1586-D3730/13.5.1.

93. Richards, "Imaging the Political," 62–63, 98–99.

94. Peláez Ramos, "La Federación Mexicana de Trabajadores."

95. I am grateful to Peter Schneider for our discussion of this print. See his description in Caplow, et al., *El Taller de Gráfica Popular*, 395.

96. Prignitz-Poda, *El Taller*, 103–104.

97. Thanks to Michael Ricker for sharing this print and his ideas. See Caplow, et al., *El Taller de Gráfica Popular*, 263.

98. *Taller de Gráfica Popular* (Mexico City), et al., Taller de Gráfica Popular records, Box 1, Folder 6.

99. Prignitz-Poda, *El Taller*, 73–74.

100. Taller de Gráfica Popular, *Estampas de la revolución mexicana*.

101. Peláez Ramos, "20 de Noviembre de 1935."

102. Prignitz-Poda, *El Taller*, 92, 103.

103. Ibid., 59, 104, 140, 175–181.

104. Oles, *Art and Architecture*, 334–340.

105. Chronology in Balmori, *Homenaje*; Vaughan, *Portrait of a Young Painter*, 141–151.

106. Benjamin, "From the Ruins," 170, 177.

CONCLUSION

1. Tannenbaum, *Peace by Revolution*, 181.

2. On Rivera and "official" muralism, see Folgarait, *Mural Painting*; Coffey, *How a Revolutionary Art Became Official Culture*; for an alternative view on Rivera's murals, see Craven and Rivera, *Diego Rivera*.

3. Tannenbaum, *Peace by Revolution*, 181.

4. Prignitz-Poda, *El Taller*, 59, 104, 140, 175–181.

5. Ibid., 201.

6. Dunn, "Mexico 68: The Graphic Production of a Movement: Santiago Armengod Interviews Felipe Hernandez Moreno."

7. Caplow, "Signal," 95.

8. Campbell, *Mexican Murals in Times of Crisis*; Bonansinga, *Curating at the Edge*.

9. Mónica Mateos-Vega, "Evoca *Retrato de la burguesía* la necesidad de arte contestatario," *La Jornada*, June 15, 2009.

10. Piketty, *Capital in the Twenty-First Century*, 2014.

SELECTED
BIBLIOGRAPHY

KEY PUBLICATION ACRONYMS

CENIDIAP: Centro Nacional de Investigación, Documentación e Información
de Artes Plásticas
FCE: Fondo de Cultura Económica
IIE: Instituto de Investigaciones Estéticas
INAH: Instituto Nacional de Antropología e Historia
INBA: Instituto Nacional de Bellas Artes
INEHRM: Instituto Nacional de Estudios Históricos de las Revoluciones
Mexicanas
SEP: Secretaria de Educación Pública
UNAM: Universidad Nacional Autónoma de México

ARCHIVES

Archivo de la Antigua Academia de San Carlos, Facultad de Arquitectura,
Biblioteca Lazo, UNAM, Mexico City, Mexico.
Archivo Diego Rivera-Frida Kahlo, Museo Frida Kahlo, Mexico City, Mexico.
Archivo Documental de la Academia de San Carlos, Mexico City, Mexico.
Archivo Histórico de la Secretaria de Educación Pública (SEP), Mexico City,
Mexico.
Centro de Estudios del Movimiento Obrero y Socialista (CEMOS), Mexico City,
Mexico.
Centro Nacional de Investigación, Documentación e Información de Artes
Plásticas (CENIDIAP), Mexico City, Mexico.
Hoover Institution Archives, Stanford, California.
Sindicato Mexicano de Electricistas (SME), Mexico City, Mexico.

PUBLICATIONS

Aboites, Luis, and Engracia Loyo. "La construcción del nuevo estado, 1920–
1945." In *Nueva historia general de México*, edited by Erik Velázquez
García. Mexico City: Colegio de México, 2010.

Aguirre, Carlos, and Robert Buffington. *Reconstructing Criminality in Latin America.* Wilmington, DE: Rowman & Littlefield, 2001.

Albiñana, Salvador. *México ilustrado: libros, revistas y carteles.* Mexico City: Editorial RM, 2010.

Antliff, Mark. "Cubism, Futurism, Anarchism." *Oxford Art Journal* 21, no. 2 (January 1, 1998): 101–120.

Argenteri, Letizia. *Tina Modotti: Between Art and Revolution.* New Haven: Yale University Press, 2003.

Ashby, Joe C. *Organized Labor and the Mexican Revolution.* Chapel Hill: University of North Carolina Press, 1967.

Azuela, Alicia. "*El Machete* and *Frente a Frente.*" *Art Journal* 52, no. 1 (1993): 82.

———. "Vasconcelos: Educación y artes. Un proyecto de cultura nacional." In *Antiguo Colegio de San Ildefonso,* edited by Elisa Vargas Lugo de Bosch. Mexico City: Nacional Financiera, 1997.

———. *Arte y poder.* Mexico City: Fondo de Cultura Económica, 2006.

Balmori, Helena Jordán de. *Remembranzas, silencios y charlas con Santos Balmori.* Mexico City: UNAM, 2003.

Balmori, Santos. *Reflejo del ritmo: antología de Santos Balmori.* Mexico City: UNAM, 1997.

———. *Homenaje a Santos Balmori.* Mexico City: INBA, 1989.

Barajas, Rafael. *Posada: mito y mitote: la caricatura política de José Guadalupe Posada.* Mexico City: FCE, 2009.

Basurto, Jorge. *Vivencias femeninas de la Revolución.* Mexico City: INEHRM, Secretaría de Gobernación, 1993.

Benito Vélez, Sandra. *Territorios de diálogo.* Mexico City: Museo Nacional de Arte, 2006.

Benjamin, Thomas. "From the Ruins of the Ancien Régime: Mexico's Monument to the Revolution." In *Latin American Popular Culture: An Introduction,* edited by William Beezley. Wilmington, DE: SR Books, 2000.

Bleys, Rudi. *Images of Ambiente: Homotextuality and Latin American Art.* London: Continuum, 2000.

Bonansinga, Kate. *Curating at the Edge: Artists Respond to the U.S./Mexico Border.* Austin: University of Texas Press, 2014.

Bortz, Jeff. *Revolution within the Revolution: Cotton Textile Workers and the Mexican Labor Regime, 1910–1923.* Stanford: Stanford University Press, 2008.

Buchenau, Jürgen. *Plutarco Elías Calles and the Mexican Revolution.* Lanham, MD: Rowman & Littlefield, 2007.

Buffington, Robert. "Homophobia and the Mexican Working Class, 1900–1910." In *The Famous 41: Sexuality and Social Control in Mexico, 1901,* edited by Robert McKee Irwin. New York: Palgrave Macmillan, 2003.

———. "Toward a Modern Sacrificial Economy: Violence Against Women and Male Subjectivity in Turn-of-the-Century Mexico City." In *Masculinity and Sexuality in Modern Mexico,* Albuquerque: University of New Mexico Press, 2012.

Buffington, Robert M. *A Sentimental Education for the Working Man: The Mexico City Penny Press*. Durham: Duke University Press, 2015.

Campbell, Bruce. *Mexican Murals in Times of Crisis*. Tucson: University of Arizona Press, 2003.

Caplow, Deborah. "Art of Rebellion." *Signal: 02: A Journal of International Political Graphics* (2012): 86–109.

———. *Leopoldo Méndez: Revolutionary Art and the Mexican Print*. Austin: University of Texas Press, 2007.

Caplow, Deborah, et al. *El Taller de Gráfica Popular: Vida Y Arte*. Athens: Georgia Museum of Art, 2015.

Cárdenas, Lázaro. *Ideario político*. Mexico City: Era, 1972.

Cardoza y Aragón, Luis. *Orozco*. Mexico City: FCE, 2005.

Cardoza y Aragón, Luis, and Renato González Mello. *La nube y el reloj: pintura mexicana contemporánea*. Mexico City: IIE-UNAM, 2003.

Carr, Barry. *El movimiento obrero y la política en México*. Mexico City: Era, 1981.

———. *Marxism and Communism in Twentieth-Century Mexico*. Lincoln: University of Nebraska Press, 1992.

———. "La crisis del Partido Comunista Mexicano y el caso Trotsky 1939–1940." In *El comunismo*, by Elvira Concheiro, et al., 605–614. Mexico City: UNAM, 2007.

———. "The Fate of the Vanguard under a Revolutionary State: Marxism's Contribution to the Construction of the Great Arch." In *Everyday Forms of State Formation*, edited by Gilbert Joseph. Durham: Duke University Press, 1994.

Carranza, Luis E. *Architecture as Revolution*. Austin: University of Texas Press, 2010.

Casado Navarro, Arturo. *Gerardo Murillo, el Dr. Atl*. Mexico City: UNAM, 1984.

Charlot, Jean. *The Mexican Mural Renaissance, 1920–1925*. New Haven: Yale University Press, 1967.

Chassen de López, Francie R. *Lombardo Toledano y el movimiento obrero mexicano*. Mexico City: Extemporáneos, 1977.

Clark, Marjorie Ruth. *Organized Labor in Mexico*. Chapel Hill: University of North Carolina Press, 1934.

Coffey, Mary K. *How a Revolutionary Art Became Official Culture*. Durham: Duke University Press, 2012.

Contreras, José. *México 1940: Industrialización y crisis política*. Mexico City: Siglo XXI, 1992.

Córdova, Arnaldo. *En una época de la crisis; (1928–1934)*. Mexico City. Siglo XXI, 1981.

Costa-Amic, Bartomeu. *León Trotsky y Andreu Nin: dos asesinatos del stalinismo*. Puebla, México: Altres-Costa-Amic, 1994.

Craven, David. *Art and Revolution in Latin America, 1910–1990*. New Haven: Yale University Press, 2006.

———. *Diego Rivera: As Epic Modernist*. New York: G. K. Hall, 1997.

Cruz Porchini, Dafne. "El Departamento de Bellas Artes y las exposiciones de carteles de 1934 y 1935." *Discurso Visual*, CENIDIAP (January–March 2005).

Díaz, María Elena. "The Satiric Penny Press for Workers in Mexico, 1900–1910." *Journal of Latin American Studies* 22, no. 3 (1990): 497–526.

Doss, Erika. "Looking at Labor: Images of Work in 1930s American Art." *Journal of Decorative and Propaganda Arts* 24 (January 1, 2002): 231–257.

Fallaw, Ben. "The Seduction of Revolution: Anticlerical Campaigns Against Confession in Mexico, 1914–1935." *Journal of Latin American Studies* 45, no. 1 (February 2013): 91–120.

Fernández Ledesma, Gabriel. *Fernando Castillo, pintor popular, 1895–1940.* Mexico City: UNAM, 1984.

Flores, Tatiana. *Mexico's Revolutionary Avant-Gardes: From Estridentismo to ¡30-30!*. New Haven: Yale University Press, 2013.

Folgarait, Leonard. *Mural Painting and Social Revolution in Mexico, 1920–1940.* New York: Cambridge University Press, 1998.

———. *Seeing Mexico Photographed: The Work of Horne, Casasola, Modotti, and Álvarez Bravo.* New Haven: Yale University Press, 2008.

Frank, Patrick. *Posada's Broadsheets: Mexican Popular Imagery, 1890–1910.* Albuquerque: University of New Mexico Press, 1998.

French, William E. "Progreso Forzado: Workers and the Inculcation of the Capitalist Work Ethic in the Parral Mining District." In *Rituals of Rule, Rituals of Resistance*, 199–207. Wilmington, DE: Scholarly Resources, 1994.

Fuentes Rojas, Elizabeth. "Liga de Escritores y Artistas Revolucionarios: una producción artística comprometida." Mexico City: UNAM, 1995.

———. "Murales de La Liga de Escritores y Artistas Revolucionarios en los Talleres Gráficos de La Nación: un historial accidentado." *Crónicas*, no. 3–4 (September 1998), 32–38.

Gaitán, Julieta Ortiz. *Imágenes del deseo: arte y publicidad en la prensa ilustrada mexicana, 1894–1939.* Mexico City: IIE-UNAM, 2010.

García Molina, Claudia. "De estridentópolis a la ciudad roja: la ruta hacia una literatura y una gráfica proletaria." In *Vanguardia en México 1915–1940*, edited by Renato González Mello, et al. Mexico City: Museo Nacional de Arte, 2013.

Garrido, Luis Javier. *El Partido de la Revolución Institucionalizada*. Mexico City: Siglo XXI, 1991.

Garza Toledo, Enrique de la. *Historia de la industria eléctrica en México*. Iztapalapa: Universidad Autónoma de México, 1994.

Gauss, Susan M. *Made in Mexico: Regions, Nation, and the State in the Rise of Mexican Industrialism, 1920s–1940s.* University Park: Pennsylvania State University Press, 2010.

———. "Working Class Masculinity and the Rationalized Sex: Gender and Industrial Modernization in the Textile Industry in Postrevolutionary Puebla." In *Sex in Revolution: Gender, Politics, and Power in Modern*

Mexico, edited by Jocelyn H. Olcott, et al. Durham: Duke University Press, 2006.

Gómez-Galvarriato, Aurora. *Industry and Revolution*. Cambridge: Harvard University Press, 2013.

González Casanova, Pablo. *El Estado y los partidos políticos en México*. Mexico City: Era, 1982.

———. *La democracia en México*. Mexico City: Era, 2003.

González Cruz Manjarrez, Maricela. *Tina Modotti y el muralismo mexicano*. Mexico City: UNAM, 1999.

González Flores, Laura. "Transito y mudanzas de la fotografia moderna en México." In *Territorios de diálogo*, edited by Benito Vélez. Mexico City: INBA, 2006.

González Marín, Silvia. *Prensa y poder político: la elección presidencial de 1940*. Mexico City: Siglo XXI, 2006.

González Matute, Laura. "A New Spirit in Post-Revolutionary Art." In *Mexican Modern Art, 1900–1950*, edited by Luis-Martin Lozano, 28–43. Ottawa: National Gallery of Canada, 1999.

———. *Escuelas de Pintura al Aire Libre y Centros Populares de Pintura*. Mexico City: INBA, 1987.

———. *Contra la academia de pintura, 1928*. Mexico City: INBA-CENIDIAP, 1993.

González Mello, Renato. "La UNAM y la escuela central de artes plásticas durante la dirección de Diego Rivera." *Anales Del Instituto de Investigaciones Estéticas*, no. 67 (1995): 21–68.

———. *Orozco: pintor revolucionario?* Mexico City: UNAM-IIE, 1995.

Graham, Helen. *The Spanish Civil War: A Very Short Introduction*. Oxford: Oxford University Press, 2005.

Graham, Helen, and Jo Labanyi. *Spanish Cultural Studies: An Introduction*. Oxford: Oxford University Press, 1995.

Gretton, Thomas. "The Cityscape and the 'People' in the Prints of José Guadalupe Posada." In *The Unknown City*, edited by J. Kerr and I. Borden, 212–227. Cambridge: MIT Press, 2001.

———. "Posada and the 'Popular.'" *Oxford Art Journal* 17, no. 2 (January 1, 1994): 32–47.

Gruening, Ernest. *Mexico and Its Heritage*. London: The Century Co., 1928.

Guadarrama, Rocío. *Los sindicatos y la política en México: La CROM*. Mexico City: Era, 1981.

Hamilton, Nora. *The Limits of State Autonomy: Post-Revolutionary Mexico*. Princeton: Princeton University Press, 2014.

Hart, Stephen M. *No Pasarán!: Art, Literature, and the Spanish Civil War*. London: Tamesis Books, 1988.

Hemingway, Andrew. *Artists on the Left: American Artists and the Communist Movement*. New Haven: Yale University Press, 2002.

Herrán, Saturnino. *Saturnino Herrán, instante subjetivo*. Aguascalientes, México: Instituto Cultural de Aguascalientes, 2010.

Hershfield, Joanne. *Imagining La Chica Moderna*. Durham: Duke University Press, 2008.

Hooks, Margaret. *Tina Modotti: Photographer and Revolutionary*. London: HarperCollins, 1993.

Huerta, Elena. *El círculo que se cierra: memorias*. Saltillo, México: Gobierno del Estado de Coahuila, 1999.

Huitrón, Jacinto. *Orígenes e historia del movimiento obrero en México*. Mexico City: Editores Mexicanos Unidos, 1974.

Illades, Carlos. *Hacia la república del trabajo*. Mexico City: Colegio de México, 1996.

Irwin, Robert McKee. "THE FAMOUS 41: The Scandalous Birth of Modern Mexican Homosexuality." *GLQ: A Journal of Lesbian & Gay Studies* 6, no. 3 (2000): 353.

Irwin, Robert McKee, et al. *The Famous 41: Sexuality and Social Control in Mexico, 1901*. New York: Palgrave Macmillan, 2003.

Ittmann, John. "Open Air Schools and Early Print Workshops." In *Mexico and Modern Printmaking*, 90–103. New Haven: Yale University Press, 2006.

Jackson, M. W. *Fallen Sparrows: The International Brigades in the Spanish Civil War*. Philadelphia: American Philosophical Society, 1994.

Jolly, Jennifer. "Art for the Mexican Electricians' Syndicate: Beyond Siqueiros." *Kunst Un Politik; Jahrbuch Der Guernica-Gesellschaft* 7 (2005): 111–139.

———. "Art of the Collective: David Alfaro Siqueiros, Josep Renau and Their Collaboration at the Mexican Electricians' Syndicate." *Oxford Art Journal* 31, no. 1 (2008): 129–151.

———. "David Alfaro Siqueiros, Josep Renau, the International Team of Plastic Artists, and Their mural for the Mexican Electricians' Syndicate, Mexico City, 1939–1949." Doctoral Thesis, Northwestern University, 2003.

Knight, Alan. "La última fase de la Revolución: Cárdenas." In *Lázaro Cárdenas: modelo y legado. 1*, edited by Lourdes Martínez Ocampo. Mexico City: INEHRM, 2009.

———. "The End of the Mexican Revolution? From Cárdenas to Avila Camacho, 1937–1941." In *Dictablanda: Politics, Work, and Culture in Mexico, 1938–1968*, edited by Paul Gillingham and Benjamin Smith, 47–69. Durham: Duke University Press, 2014.

Leal, Juan Felipe. *Agrupaciones y burocracias sindicales en México*. Mexico City: Juan Pablos editor, S.A., 2012.

———. *Del mutualismo al sindicalismo en México: 1843–1910*. Mexico City: Ediciones El Caballito, 1991.

Lear, John. *Workers, Neighbors, and Citizens: The Revolution in Mexico City*. Lincoln: University of Nebraska Press, 2001.

Lee, Anthony W. "Workers and Painters: Social Realism and Race in Diego Rivera's Detroit Murals." In *The Social and the Real*, edited by Alejandro Anreus, 201–220. University Park: Pennsylvania State University Press, 2006.

Leighten, Patricia. *The Liberation of Painting: Modernism and Anarchism in Avant-Guerre Paris*. Chicago: University of Chicago Press, 2013.

León, Samuel, and Ignacio Marván. *En el cardenismo (1934-1940)*. Mexico City: Siglo XXI, 1985.

Lerner, Jesse. *The Shock of Modernity: Crime Photography in Mexico City*, edited by Julio Patan. First ed. Mexico City, Turner-INAH, 2007.

Lines, Lisa Margaret. *Milicianas: Women in Combat in the Spanish Civil War*. Lanham, MD: Lexington Books, 2012.

Lowe, Sarah M. *Tina Modotti: Photographs*. New York: H. N. Abrams, 1995.

Loyo, Engracia. "Gozos imaginados, sufrimientos reales, la vida cotidiana en la *Revista Crom*." In *Tradiciones y conflictos. Historias de la vida cotidiana en México e Hispanoamerica*, edited by Pilar Gonzalbo Aizpuru and Mílada Bazant. Mexico City: Colegio de México, 2007.

MacGregor, Javier. "Elecciones federales intermedias en la ciudad de México." In *Lázaro Cárdenas: Modelo y Legado*, 397–399. Mexico City: INEHRM, 2009.

Macías-González, Víctor. "Apuntes sobre la construcción de la masculinidad en México a través del arte decimonónico." In *Hacia otra historia del arte en Mexico*, edited by Stacie Widdifield, 1:329–350. Mexico City: Conaculta, 2001.

Maples Arce, Manuel. *Metropolis*. New York: T. S. Book Company, 1929.

Maples Arce, Manuel. *Vrbe: Super-Poema Bolchevique en 5 Cantos*. Mexico City: Aandres Botas e hijo, 1924.

Massón Sena, Caridad. "Marinello y la república española." *Revista de la Biblioteca Nacional José Martí* (January 2007): 131–143.

Matesanz, José Antonio. *Las raíces del exilio: México ante la Guerra Civil Española, 1936-1939*. Mexico City: UNAM, 1999.

Mello, Renato González. *La maquina de pintar*. Mexico City: UNAM-IIE, 2008.

Méndez, Leopoldo, and Carlos Monsiváis. *Leopoldo Méndez y su tiempo*. Mexico City: INBA, 2002.

Michaels, Albert L. "Las elecciones de 1940." *Historia Mexicana* 21, no. 1 (1971): 80–134.

Middlebrook, Kevin J. *The Paradox of Revolution: Labor, the State, and Authoritarianism in Mexico*. Baltimore: Johns Hopkins University Press, 1995.

Millan, Verna Carleton. *Mexico Reborn*. New York: Houghton Mifflin, 1939.

Morse, Peter. *Jean Charlot's Prints: A Catalogue Raisonné*. Honolulu: University Press of Hawai'i, 1976.

Moysseén Echeverría, Xavier, ed. *La crítica de arte en México, 1896–1921*. Mexico City: UNAM, 1999.

Mraz, John. *Looking for Mexico: Modern Visual Culture and National Identity*. Durham: Duke University Press, 2009.

Muñoz, Víctor. "Saturnino Herrán: (1887–1918), el Instante Subjetivo." In Saturnino Herrán, *Saturnino Herrán, instante subjetivo*. Aguascalientes, México: Instituto Cultural de Aguascalientes, 2010.

Museo Casa Estudio Diego Rivera y Frida Kahlo. *Misiones culturales: los años utópicos 1920-1938*. Mexico City: Museo Casa Estudio Diego Rivera y Frida Kahlo, 1999.

Museo de Arte Carrillo Gil. *Estética socialista en México: Siglo XX*. Mexico City: INBA, 2003.

Museo Nacional de Arte (Mexico). *1910, el arte en un año decisivo: la exposición de artistas mexicanos*. Mexico City: Museo Nacional de Arte, 1991.

———. *La arqueología del regimen, 1910-1955*. Mexico City: Museo Nacional de Arte, 2003.

Nelson, Cary. *Shouts from the Wall: Posters and Photographs Brought Home from the Spanish Civil War*. Waltham, MA: Abraham Lincoln Brigade Archives, 1996.

O'Higgins, Pablo. *Pablo O'Higgins: voz de lucha y de arte*. Mexico City: UNAM, 2005.

O'Higgins, Pablo, and Alberto Híjar. *Apuntes y dibujos de trabajadores*. Monterrey, Nuevo León: Secretaría de Educación y Cultura, 1987.

O'Higgins, Pablo, Luis de Pablo, and Carlos Sansores San Román. *Pablo O'Higgins: los trabajadores de la construcción*. Mexico City: Instituto del Fondo Nacional de la Vivienda para los Trabajadores, 2000.

Ojeda Revah, Mario. *México y la Guerra Civil Española*. Madrid: Turner, 2004.

Olcott, Jocelyn. *Revolutionary Women in Postrevolutionary Mexico*. Durham: Duke University Press, 2005.

———. "The Center Cannot Hold: Women on Mexico's Popular Front." In *Sex in Revolution: Gender, Politics, and Power in Modern Mexico*, edited by Jocelyn Olcott, 223-240. Durham: Duke University Press, 2006.

Oles, James. *Art and Architecture in Mexico*. London: Thames & Hudson, 2013.

———. *Agustín Lazo*. Mexico City: UNAM, 2009.

———. "Industrial Landscapes in Modern Mexican Art." *Journal of Decorative and Propaganda Arts* (2010): 128-159.

———. *South of the Border: Mexico in the American Imagination, 1917-1947*. Washington, DC: Smithsonian Institution Press, 1993.

———. "Walls to Paint On: American Muralists in Mexico, 1933-1936." Doctoral Dissertation, Yale University, 1995.

Orozco, José Clemente. *An Autobiography*. Austin: University of Texas Press, 1962.

Ortiz Gaitán, Julieta. *Imágenes del deseo: arte y publicidad*. Mexico City: UNAM, 2003.

Ortiz Hernán, Gustavo. *Chimeneas, novela*. Mexico City: Editorial "México nuevo," 1937.

Othon Quiroz Trejo, José. "La exposición de 1910 y la huelga de 1911 en la Academia de San Carlos?" *Historia* 06 (2008) (available online at http://www.azc.uam.mx/publicaciones/tye/tye16/art_hist_06.html).

Peláez Ramos, Gerardo. "20 de noviembre de 1935: Batalla en el zócalo entre comunistas y fascistas." Lahaine.org (published April 12, 2010).

———. "La Federación Mexicana de Trabajadores de la Enseñanza en el LXXV aniversario de su fundación." *Rebanadas de La Realidad* (February 2, 2012) (available online at http://www.rebanadasderealidad.com.ar/ramos-12-06.htm).

Pérez Salas, María Esther. "Genealogía de 'Los mexicanos pintados por sí mismos.'" *Historia Mexicana* 48, no. 2 (1998): 167–207.

Philadelphia Museum of Art. *Mexico and Modern Printmaking: A Revolution in the Graphic Arts, 1920 to 1950*. New Haven: Yale University Press, 2006.

Piketty, Thomas. *Capital in the Twenty-First Century*. Cambridge, MA: Belknap Press, 2014.

Plenn, J. H. *Mexico Marches*. Indianapolis and New York: Bobbs-Merrill, 1939.

Ponte, Víctor Manuel Durand. *La ruptura de la nación: historia del Movimiento Obrero Mexicano desde 1938 hasta 1952*. Mexico City: UNAM, 1986.

Porter, Susie S. "Empleadas públicas: normas de feminidad, espacios burocráticos e identidad de la clase media en México durante la década de 1930." *Signos Históricos* (May 25, 2007): 41–63.

———. *Working Women in Mexico City: Public Discourses and Material Conditions, 1879–1931*. Tucson: University of Arizona Press, 2003.

Posada, José Guadalupe, and Museo Nacional de Arte (Mexico). *Posada y la prensa ilustrada: Signos de modernización y resistencias*. Mexico City: Museo Nacional de Arte, 1996.

Powell, T. G. *Mexico and the Spanish Civil War*. Albuquerque: University of New Mexico Press, 1981.

Prieto González, José Manuel. "El estridentismo mexicano y su construcción de la ciudad moderna a través de la poesía y la pintura." *Scripta Nova*, no. 398 (April 2012) (available online at http://www.ub.edu/geocrit/sn/sn-398.htm).

Prignitz-Poda, Helga. *El Taller de Gráfica Popular en México, 1937–1977*. Mexico City: INBA, 1992.

Ramírez, Fausto. *Crónica de las artes plásticas en los años de López Velarde, 1914–1921*. Mexico City: UNAM, 1990.

———. "La patria ilustrada y las colaboraciones de José Guadalupe Posada." In *Posada y la prensa ilustrada*. Mexico City: Museo Nacional de Arte, 1996.

———. *Modernización y modernismo en el arte mexicano*. Mexico City: UNAM, 2008.

Ramírez, Mari Carmen. "The Ideology and Politics of the Mexican Mural Movement: 1920–1925." Dissertation, University of Chicago, 1989.

Ramírez Sánchez, Mauricio César. "El muralismo mexicano y los artistas del exilio español." *Crónicas*, no. 14 (2010), 61–72.

Rangel, Rafael López. *Enrique Yáñez en la cultura arquitectónica mexicana*. Mexico City: Editorial Limusa, 1989.

Reyes Palma, Francisco. *Historia social de la educación artística en México*. Mexico City: SEP, 1984.

———. "La LEAR y su revista de frente cultural." *Frente a Frente* (Facsimile

ed.). Mexico City: Centro de Estudios del Movimiento Obrero y Socialista, 1994.

Richards, Susan Valerie. "Imaging the Political: El Taller de Gráfica Popular in Mexico, 1937–1949." Dissertation, University of New Mexico, 2001.

Rivera, Diego, and Raquel Tibol. *Arte y política*. Mexico City: Grijalbo, 1979.

Rivera Castro, José. *En la presidencia de Plutarco Elías Calles: 1924–1928*. Mexico City: Siglo XXI, 1983.

Rodríguez, José Antonio. "El fotomontaje en México." In *La arqueologia del regimen, 1910–1955*, 42–50. Mexico City: Museo Nacional de Arte, 2003.

Rodríguez, Miles. "The Beginnings of a Movement: Leagues of Agrarian Communities, Unions of Industrial Workers, and Their Struggles in Mexico, 1920–1929." Dissertation, Harvard University, 2010.

Rodríguez y Méndez de Lozada, María. "Imágenes colaterales: La influencia de la vanguardia soviética cn la obra de Tina Modotti." *Anales Del Instituto de Investigaciones Estéticas* 37, no. 106 (November 2014): 149–177.

Rubenstein, Ann. "The War on the Pelonas: Modern Women and Their Enemies, Mexico City, 1924." In *Sex in Revolution: Gender, Politics, and Power*, edited by Jocelyn Olcott, 57–80. Durham: Duke University Press, 2006.

Ruipérez, Maria. "Renau-Fontsere: Los carteles de la Guerra Civil." In *Tiempo de Historia* 5 (Madrid, December 1978): 10–25.

Sáenz, Olga. *El símbolo y la acción: Vida y obra de Gerardo Murillo*. Mexico City: Colegio Nacional, 2005.

Salazar, Rosendo, and José G. Escobedo. *Las pugnas de la gleba, 1907–1922*. Mexico City: Avante, 1923.

Sánchez, César. "Retrato de la burguesía, un mural colectivo." In Josep Renau, *Josep Renau (1907–1982): Compromiso y cultura; zum sobre el periodo mexicano*, 42–60. Madrid: Acción Cultural Exterior de España, 2009.

San Pedro, Abraham. *El exilio español en la Ciudad de México: legado cultural*. Madrid: Turner, 2011.

Serrano, Hector. *Imagen y representación de las mujeres en la plástica mexicana*. Mexico City: UAEMEX, 2005.

SEP, Comisión Editora Popular. *Libro de lectura para uso de las escuelas nocturnas para trabajadores*. Mexico City: SEP, 1938.

Sheridan, Guillermo. *Poeta con paisaje: ensayos sobre la vida de Octavio Paz*. Mexico City: Era, 2004.

Siegel, Paul, ed. *Leon Trotsky on Literature and Art*. New York: Pathfinder Press, 1970.

Siqueiros, David Alfaro. *Me llamaban el Coronelazo: memorias*. Mexico City: Grijalbo, 1977.

Snodgrass, Michael. *Deference and Defiance in Monterrey: Workers, Paternalism, and Revolution in Mexico, 1890–1950*. Cambridge, U.K.: Cambridge University Press, 2006.

———. "'We are all Mexicans Here': Workers, Patriotism, and Union Struggles in Monterrey." In *The Eagle and the Virgin: Nation and Cultural Revolu-*

tion in Mexico, 1920–1940, edited by Mary Kay Vaughan and Stephen E. Lewis, 314–334. Durham: Duke University Press, 2006.

Sosa Elízaga, Raquel. Los códigos ocultos del cardenismo. Mexico City: UNAM, 1996.

Spenser, Daniela. The Impossible Triangle: Mexico, Soviet Russia, and the United States in the 1920s. Durham: Duke University Press, 1999.

———. Unidad a toda costa: la tercera internacional en México durante la presidencia de Lázaro Cárdenas. Mexico City, CIESAS, 2007.

Stein, Philip. Siqueiros: His Life and Works. New York: International Publishers, 1994.

Taibo, Paco Ignacio. Los bolshevikis: historia narrativa de los oriígenes del comunismo en México. Mexico City: J. Mortiz, 1986.

Taller de Gráfica Popular, University of New Mexico, Center for Southwest Research. Taller de Gráfica Popular records. Mexico City: Taller de Gráfica Popular, 1999.

Tamayo, Jaime. En el interinato de Adolfo de la Huerta y el gobierno de Alvaro Obregón. Mexico City: Siglo XXI, 1987.

Tannenbaum, Frank. Peace by Revolution. New York: Columbia University Press, 1933.

Thompson, Mark Elliott. "The Development of Unionism among Mexican Electrical Workers." Dissertation, Cornell University, 1966.

Tibol, Raquel. José Clemente Orozco. Mexico City: Cultura/SEP, 1984.

———. Siqueiros, introductor de realidades. Mexico City: UNAM, 1966.

Troconi, Giovanni. Diseño gráfico en México: 100 años, 1900–2000. Mexico City: UNAM, 2010.

Vargas, Zaragosa. Labor Rights Are Civil Rights: Mexican American Workers in Twentieth-Century America. Princeton: Princeton University Press, 2013.

Vaughan, Mary Kay. Portrait of a Young Painter: Pepe Zuniga and Mexico City's Rebel Generation. Durham: Duke University Press, 2014.

Vaughan, Mary Kay, and Stephen E. Lewis, eds. The Eagle and the Virgin: Nation and Cultural Revolution in Mexico, 1920–1940. Durham: Duke University Press, 2006.

Vázquez Ramírez, Esther Martina. "Acciones comunistas: 1929–1935." In El comunismo: otras miradas desde América Latina, edited by Elvira Concheiro. Mexico City: UNAM, 2007.

Volpi, Jorge. "Octavio Paz en Valencia." Revista de La Universidad de México, no. 51 (May 2008): 13–20.

Walter, Jane. "Lázaro Cárdenas y la fuerza de trabajo: tres huelgas en 1936." Historias, no. 5 (1984): 67–108.

Williams, Lyle. "Evolution of a Revolution: A Brief History of Printmaking in Mexico." In Philadelphia Museum of Art, Mexico and Modern Printmaking: A Revolution in the Graphic Arts. New Haven: Yale University Press, 2006.

Wolfe, Bertram. *Diego Rivera: His Life and Times.* New York: Knopf, 1939.

———. *The Fabulous Life of Diego Rivera.* New York: Cooper Square Press, 2000.

Zavala, Adriana. *Becoming Modern, Becoming Tradition: Women, Gender, and Representation in Mexican Art.* University Park: Pennsylvania State University Press, 2010.

INDEX

Multiple titles are listed under individual artists in order of their appearance in the text. Page numbers in *italics* refer to illustrations.

Abelardo Rodríguez Market murals, 169–170, 181, 183

Academy of San Carlos, 31, 33, 61, 314; curriculum, 7, 18, 22, 23, 29, 52, 67, 77, 138; as Escuela Central de Artes Plásticas, 114, 137–139; and Open Air Schools, 52, 132, 137; reform efforts, 51, 56, 59, 75, 114

Accident in the Mines (Siqueiros), 166

Acción Mundial (Mexico City), 60, 62–65, 77

Actual, 87

After the Ball (Posada), 39

After the Strike (Domínguez Bello), 29, 67

Aguirre, Ignacio, 189, 288, 299; *Divisionist Calaveras*, 299

Ahuizote, El, 41

Alémán, Miguel, 271

Allegory of Construction and *Allegory of Work* (Herrán), 23–26, 124, 278, *plate 1*, *plate 2*

Allegory of Work (Izquierdo), 183

Almazán, Juan Andreu, 272, 282, 297

Alva de la Canal, Ramón: early muralism, 84; and *Horizonte*, 142–144; and Open Air Schools, 77; in the revolution, 51, 52, 60; works by: *Color Mill*, 80; *El Líder*, 144, *plate 6*; *Capitalism, the Clergy,* *and the Union Leader Against the Worker*, 144, *plate 7*

Alvarez Bravo, Lola, 183

Alvarez Bravo, Manuel, 188, 200; *Campesino Asesinado*, 200, 201

Amador, Graciela, and *El Machete*, 69, 88; *The Fall of the Rich*, 97

Ambush, The (Orozco), 86

And There We Have the People (Neve), 120, *122*

Anguiano, Raul, 204, 205, 296; drawing in *El Machete* (March 11, 1936), 204

Anti-Imperialist League, membership form, 190

Arango, Consuelo, 204

arbitration boards, 73, 115, 117, 189, 231, 232

Arenal, Luis: and LEAR, 176, 180–182, 184, 189, 209; and SME mural, 285, 286; and TGP, 292; works by: cover of *Frente a Frente* (January 1935), *179*, 204; *Gran Mitin*, *195*; *Ultramarino*, *258*; *Mexico will not be Spain!*, *260*; covers of *Futuro* (December 1937 and April 1938), *270*, *274*; *Portrait of the Bourgeoisie*, *287*; *Join the Communist Party*, 298, 299

Arias Bernal, Antonio, *Miliciana*, *252*

ARM. *See* Mexican Revolutionary Action

Arsenal, The (Rivera), 140

Art Deco, 113, 119, 120, 126, 214

Article 123 of the 1917 Constitution, and labor rights, 50, 66, 71, 142, 231

artists: and government, 6; as intellectual workers, 4, 9, 97, 111, 144, 209, 219, 244, 286; organizations of, 13–16, 58, 73–77, 119, 144, 182, 307; origins, 4; participation in the military revolution, 50–53; and working class, 4

Art Nouveau, 52, 67, 113, 119, 126, 214

ASARO printer collective, 315, 316; *Indigenous Women Marching Against the Governor, 316*

Assembly of the First of May (Rivera), 140

Atl, Dr. (Gerardo Murillo), 8, 12, 18, 22, 26, 48–49, 51, 56–67, 70, 73, 74, 89, 91, 121, 137, 169, 188; and printmaking, 64, 77–78; works by: cover of striking worker for *Acción Mundial*, 124, plate 3

Autonomous Department of Press and Publicity (DAPP), 295

Ávila Camacho, General Manuel, 273, 282, 290; representations of, 297, 307

Aztec Princess (Soto), *Revista CROM* cover, *114*, 119

Balmori, Santos, 8, 223–224; and LEAR, 224; and *Lux*, 224–230, 235, 240; post-LEAR career, 307–310; works by: *Lux* covers (November and December 1935, January, March, and September 1936, March 1937), 224, *225*, *226*, *230*, *236*, *255*, *308*; *Milicianas*, *251*; Avila Camacho campaign in *Futuro*, 307, *308*; *Cárdenas Habla!*, 308, *309*

Banquet of the Rich (Orozco), 86, 103

Barajas, Rafael, 37–40

Bassols, Narciso, 244

Bats and Mummies (Guerrero), *101*

Beltrán, Alberto, 306; works by: *Unity of All Mexicans*, 306, plate 12

Benjamin, Thomas, 310

Block of Intellectual Workers, 144

Bourgeois, The (Posada), 35

Bracho, Angel, 189, 303

Breña Alvirez, Francisco, 9, 219, 277; and the CNDP, 227; and Communism, 221, 279–281; and the CTM, 235, 263, 275; expulsion from the SME, 290; and 1936 SME strike, 231–235; representations of, 227, 228, 233, 265, 310; and SME divisions, 278–282, 289–290, 292; and Soviet Union, 221, 281

Breton, André, 292

Buffington, Robert, 32–33, 42

Burial of a Worker (Siqueiros), 84

Buy the May Issue (Peña), 191, *193*

Cabral, Ernesto García, 67, 119, 120, 125

Calaveras del Mausoleo Nacional (Méndez), *177*

Calles, Plutarco Elías: and artists, 120, 133, 140, 165–175; as Jefe Máximo, 145, 159–161; opposition to Cárdenas, 162–165, 182, 197, 209, 221, 226, 227; presidency, 72–74, 91, 100, 106, 113, 115, 118, 133, 144; representations of, 105, 108, 118, 125, 168, 172, 190, 200, 201, 205, 228, 265, 310; and unions, 104, 108, 115, 139

Campa, Valentín, 154

Campesino Asesinado (Alvarez Bravo, M), 200, *201*

campesinos (peasants): representations of, 9–10, 33; role of, 3

Campesinos Reading "El Machete" (Modotti), 155, *156*

Capitalism, the Clergy, and the Union Leader Against the Worker (Alva de la Canal), 144, plate 7

Caplow, Deborah, 314

Cárdenas, Lázaro: and Calles, 161, 165, 221, 227; and Communist Party, 267, 268; government of, 13–15, 159, 162–165, 168; and oil nationalization, 271–274; and Popular Front, 269; and PRM, 270–271; representations of, 199, 228, 273–275, 307, 308, 309; shift to moderation, 15, 261, 272, 282; and Spanish Civil War, 238, 244, 248; ties to artists, 2, 14, 137, 169–171, 178, 182, 186, 197, 291, 294–295; and unions, 164, 176, 205, 208–209, 227, 231–232, 235, 244, 245, 263–264, 269, 280, 313

Cárdenas Habla! (Balmori), 308, *309*

Cardoza y Aragón, Luis, 292, 293

Carr, Barry, 7, 264, 268

Carranza, Venustiano, 50, 55–56, 58–59, 61–63, 65–67, 70–71, 168, 212

Carrillo Puerto, Felipe, 76, 84

Casa del Obrero Mundial, 5, 22, 41, 48, 54–56, 58–59, 66, 142, 212; Constitutionalist Pact and "Red Battalions," 59–62; and general strike of 1916, 62–65, 120, 212; newspapers, 54, 55, 61–62

Casas en las Colonias (Negrete), 207

Castellanos, Julio, 188, 292

Castillo, Fernando, 136

Cedillo, General Saturnino, 257

Centennial of Mexican Independence (1910), 18; Exposition of Mexican Painters at, 23–29, 47

Centros Populares de Pintura, 113, 132–137, 146, 156

CGOCM. *See* General Confederation of Workers and Campesinos of Mexico

CGT. *See* General Confederation of Workers

Charge Against the People (García Bustos), 314, *315*

Charlot, Jean, 88; and early muralism, 84, 86, 100; and Estridentista movement, 79–82, 87; and printmaking, 77–79; works by: *The Way of the Cross*, 78; *Skyscrapers*, 81

Chávez, Carlos, "Proletarian Calls" concert, 177

Chávez Morado, José, 171, 240; *Week of Aid to Spain*, 254

Chimeneas (Ortiz Hernán), 1–3, 196

Choque (Mexico City), 171

Christ According to the Rich and Clergy (Orozco), 106

Christ Destroying his Cross (Orozco), 140

Clark, Marjorie Ruth, 211, 213, 220

CNDP. *See* National Committee of Proletarian Defense

Color Mill (Alva de la Canal), 80

Communist Party of Mexico (Partido Comunista de México, PCM), 5, 6; and artists, 5, 10, 12, 76, 84, 165–166; and Cárdenas government, 15, 159, 162–164, 271; changing strategies, 76, 161, 162–164, 181; and CSUM, 160, 214, 217, 263, 264; and CTM, 264, 267–268; legal status, 161, 165; and *El Machete*, 12, 60, 88–90; membership, 94, 96, 164; and Popular Front, 162–164; and SOTPE, 76; and "Unity at all costs," 267–268; and women, 203–205

Confederation of Mexican Workers (Confederación de Trabajadores de México, CTM), 8; and artists, 15, 189, 295–298, 301, 306, 313; cre-

ation, 165, 263–264; and Communist Party, 263, 264, 267–268, 272, 289; divisions within, 15, 234, 262, 213, 263–268, 298–301; and government, 257, 259, 262, 268–272, 273, 282; and militias, 245–248, 273; and mobilizations, 209, 231; representations of, 229; and SME, 234, 262, 264–268, 275, 277–278, 282; and Spanish Civil War, 238, 239, 243–244, 248, 254, 259; and women, 202–203. See also *Futuro*; Lombardo Toledano, Vicente; Universidad Obrera

Confederation of Workers of Latin America (CTAL), 306

Congress of Anti-Fascist Writers, Valencia, Spain, 183, 240, 242

Congress of Mexican Artists, Writers, and Intellectuals, 290–293

Constructivism, 14

Contemporaneos group, 81, 109, 172, 182, 183

Craven, David, 70

Creation (Rivera), 70

Crisol, 144

CROM. *See* Regional Confederation of Mexican Workers

CSUM. *See* Unitary Syndical Confederation of Mexico

CTM. *See* Confederation of Mexican Workers

de la Cabada, Juan, 171, 176, 184

de la Fuente, Julio, 171, 190; works by: covers of *ruta* (May and December 1933), *173*, *175*, 180; *Hoja Popular Anticallista*, 190

de la Huerta, Adolfo, revolt of, 76, 91, 100

Demonstration (Orozco), 256, 267

Detroit Industry (Rivera), 167

Díaz, María Elena, 32

Díaz, Porfirio, 18, 19, 32, 38, 41, 46, 49, 168, 314

Díaz de León, Francisco, 77

Divisionist Calaveras (Aguirre), 299

Domínguez Bello, Arnulfo, *After the Strike*, 29

Echauri, Manuel, *Have Some Respect*, 190, *191*

electricians, 54

Emancipación Obrera (Mexico City), 54, 55

Entering the Mine (Rivera), 84, *85*

Eppens, Francisco, *Lux* covers (July 1937, July 1938, June 1939, October 1939), 247, 273, 276, 282, *283*, *284*

Escobedo, Jesús, 136

Escobedo, José Guadalupe, 51, 60

Escuela Central de Artes Plásticas, 114, 137–139. *See also* Academy of San Carlos

Escuela de Escultura y Talla Directa, 133

Esmeralda, La, 307, 304

Espinosa Casanova, Luis, 219, 220–221, 281, 282, 289; as artist, 222, *223*

Estampas de la Revolución, 304

Estridentista movement, 12, 74; early phase, 78–83; later phase, 140–144, 156

Eternal Martyr (Romano Guillemín), 28–29, 40, 46

Exterior Scaffolding (Revueltas), 79

Fabrés, Antonio, 18, 23

Fábrica (Fábrica), 79

Fall of the Rich, The (Amador), 97–100

Fascist Babes (Orozco), *110*, 173

Feminism imposes itself (Posada), 44

Fernández Ledesma, Gabriel, 77, 142, 189; and the Centros Populares, 133, 136; and poster exhibitions, 191

Flores, Tatiana, 79, 81, 142, 143
Folgarait, Leonard, 149, 168, 286, 289
Forma (Mexico City), 134, 148
41 Faggots, The (Posada), 43, 44, 110, 173
41 Faggots for Yucatán (Posada), 43
Foundry, The (Rivera), *129*
Franco, General Francisco, 235, 238, 243, 244, 254, 259; representations of, 244, *245*, 254, *255*, *257*, *258*, 272
Frank, Waldo, 291
Fratricide! (Orozco), 103, *104*
Freeman, Joseph, 291
Frente a Frente (Mexico City), 11, 13, 16, 294, 295; art in, 176–183, 191, 194, 197, 199–202, 204, 234, 266; organization of, 176–183, 196, 197–200, 224, 291, 292, 293, 295; and Spanish Civil War, 241–243, 249, 254
Frías, Catalina, 237, 248
FROC. *See* Regional Federation of Workers and Campesinos
Fundidora de Monterrey (Martínez), advertisement in *Revista CROM*, *128*, 129
FUPDM. *See* Sole Front for Women's Rights
Futurists, 57
Futuro (Mexico City), 178, 189, 200, 201, 222, 224; art in, 233, 240, 244, 248, 250, 260, 269, 270, 273, 274, 296, 307, 308

Galeana, Benita, 151
Garay Molina, Claudia, 173
García Bustos, Arturo, 306, 314; works by: *Unity of All Mexicans*, 306, plate 12; *Charge Against the People*, 314, *315*
Gedovius, Antonio, 126
Gedovius, Germán, 23
General Confederation of Workers (Confederación General de Traba-

jadores, CGT), 72, 74, 76, 90, 117, 131, 278
General Confederation of Workers and Campesinos of Mexico (Confederación General de Obreros y Campesinos de México, CGOCM), 164, 263, 264, 268
Gill, Mario, 304
Glass Mill, The (Herrán), 23–24
Gold Shirts (Méndez, untitled), 305
Gold Shirts. *See* Mexican Revolutionary Action
Golpe (Mexico City), 171
González Mello, Renato, 140
Graham, Helen, 238, 248
Gran Mitin (Arenal), *195*
Greenwood, Grace and Marion, 170, 183
Grupo 30-30, 137
Guacamaya, La (Mexico City), 32, 34, 37, 41
Guerrero, Xavier, 8, 150; and Communist Party, 77; and *El Machete*, 69, 88, 94–97, 102, 111; and SEP murals, 86, 101; and SOTPE, 74; works by: *Zapata*, 93; *Land Distribution*, 93; *How one works . . .*, 94, *95*; *Judgment of the Intellectual Enemies*, 96; *Bats and Mummies*, *101*
Guerrero Galván, Jesús, 171; works by: *One of the Others*, 172, *173*, 183; International Women's Day cartoon in *El Machete*, 205, *206*
Gutiérrez Cruz, Carlos, 85
Gutmann, Enrique, 182, 199, 200, 269; works by: *Huelga del Sindicato Mexicano de Electricistas*, 233, *234*; *November 20, 1936 celebration*, 250

Hands Washing (Modotti), 150
Hanging Blacks (Orozco), 174
Harvest, The (Herrán), 52

Have Some Respect (Echauri), 190, *191*

Heartfield, John, 201, 240, 253; *¡No Pasarán! Pasaremos!*, 241

Herrán, Saturnino, 8, 11–12, 17–29, 45–46, 49, 52, 60, 66; posthumous influence of, 111, 119, 120, 124, 131, 133, 150, 156, 158, 278, 312, 313; and race, 26; representations of women, 14, 25; works by: *Labor*, 23; *The Glass Mill*, 23–24, 80; *Allegory of Construction* and *Allegory of Work* (diptych), 23–26, 278, *plate 1*, *plate 2*; *The Harvest*, 52; *The Offering*, 52

Hershfield, Joanne, 126

Hijo del Ahuizote (Mexico City), 30

Hojas Populares Anti-Callistas, 190–192

Horizonte (Jalapa), 139–145

How one works . . . (Guerrero), 94, *95*

Huelga del Sindicato Mexicano de Electricistas (Gutmann), 233, *234*

Huerta, Victoriano, 50, 52–56, 62, 63, 244

Huitrón, Jacinto, 20–22, 54

Indianilla (Revueltas), 79; first woodprint, 80

Indigenous Women Marching Against the Governor (ASARO), *316*

Inscríbase Taller-Escuela (Méndez), *188*

Institutional Revolutionary Party (PRI), 271

International Women's Day cartoon in *El Machete* (Guerrero Galván), 205, *206*

In the Cantina (O'Higgins), 146

In the Epoch of Repression (O'Higgins), 301, *302*

Irradiador (Mexico City), 87

Izquierdo, Maria, 8, 183, 292; *Allegory of Work*, 183

Jara, Heriberto, 56, 141–144

Jiménez, Luz, 151

Join the Communist Party (Arenal), 298, *299*

Jolly, Jennifer, 285, 286, 288, 289

Judas Morones (Orozco), 103, *105*

Judgment of the Intellectual Enemies (Guerrero), 96, 101

Justicia Proletaria (Orozco), 107

Kahlo, Frida, 8

Knight, Alan, 262

Kutsis, Gustav, 201

Labor (Herrán), 23

Laborde, Hernán, 154, 163, 182, 203, 227, 273, 281

Labor Department, 63

Labor Party, 71, 73, 115, 158, 168

Land Distribution (Guerrero), 93

Land Distribution (Rivera), 93

La Voz del Pueblo (Mexico City), 296

Lazo, Agustín, 81, 172; *Workers*, 81

Lazo, Rina, 314

League of Revolutionary Writers and Artists (LEAR), 2, 3, 8, 13–16, 159–160, 170; and Communist Party, 176, 178, 184, 293, 295; and CTM, 189, 295; and debates over art, 181–182, 292–293; demise, 290–295; exhibitions, 191, 194, 201, 224, 240, 292; formation, 171–176; and government, 184–186, 293–295; and *El Machete*, 176, 184; and murals, 170, 194–199; and photography, 199–201; and Popular Front, 182, 183; posters, 191, 194; and Spanish Civil War, 238, 241–242; and unions, 189, 199; Workshop-School of Plastic Arts, 187–189, 296, 298

Leal, Fernando, 52, 74, 133, 151; and early muralism, 84; works by: *Fábrica*, 79; print for poem *Metropolis*, 81–82

LEAR. *See* League of Revolutionary Writers and Artists

Leaving the Mine (Rivera), 85

Lenin, Vladimir, 90; representations of, 167, 228, 273, 310

Leyendecker, J. C., 124

Libertad de Expresión! (Mexiac), 314

Libertador, El (Mexico City), 94

Libros de Lectura (LEAR), 185–187, 205–208, 295

Líder, El (Alva de la Canal), 144, *plate 6*

List Arzubide, Germán, 75, 171; as editor of *Horizonte*, 142–144

Llamada (Mexico City), 171, 172

Lombardo Toledano, Vicente, 5, 9; and artists, 73, 100, 139, 197, 224, 296–297, 306, 307, 312; and CGOCM, 164; and CNDP, 165, 182, 227; and Communist Party, 164, 263–270, 272, 295–297; and CROM, 73, 74, 116; and CTM, 165, 203, 244, 245, 248, 249, 263–270, 273, 299; and *Futuro*, 222; representations of, 178, 197, 228, 233, 265; and Rivera, 139; and SME, 235, 244, 245, 248, 249, 263–270, 272, 273, 295–297, 298, 299, 306, 307, 312; and Universidad Obrera 199; and women, 203

López Vázquez, Rafael, *Sindicato de Costureras*, 205, *208*

Lucha Intelectual Proletaria, 171, 175

Lux (Mexico City), 13, 189, 200, 211, 213–217; art in, 222–230, 235, 236; and Communism, 217, 223; and feminism, 220; and in-house artist Sánchez, 216–217; and LEAR, 223; and Spanish Civil War, 243

Machete, El (Mexico City), 12–13, 16, 69, 76, 84, 221, 228, 245, 257, 263, 270, 271, 273, 276; and art, 92–111, 114, 209; and Communist Party, 88–90, 111, 150–156, 161; compared to *Revista CROM*, 113, 116, 117, 130, 131, 154–158; demise, 296; early organization under SOTPE, 87–92; influence of, 176, 313; and LEAR, 184, 292; legacy, 160, 171, 176, 180, 190, 313; legal status, 161, 163,171, 178; and Posada and the Penny Press, 88–93; representations of women, 109, 204–205, plate 10; and women, 109

Macías-González, Victor, 25

Madero, Francisco, 17, 22, 29, 39, 41, 49, 50, 51, 53, 56

Man at the Crossroads (Rivera), 167

Mancisidor, José, 171, 176, 240, 293, 295

Manilla, Manuel, 31

Maples Arce, Manuel, 78, 87; and government of Jara, 141; *Urbe*, 81–83

March, The (Méndez), 142, *143*

Marinello, Juan, 182, 249, 292

Martillo, El (Mexico City), 184

Martínez, Mariano, *Fundidora de Monterrey*, advertisement in *Revista CROM*, *128*, 129

Marx, Karl, 90; representations of, 168, 169, 173

Maternity (Orozco), 70

May Day (Neve), cover of *Revista CROM*, *123*

Méndez, Leopoldo, 8, 144–146, 178, 314; and the Communist Party, 145; and *Horizonte*, 142–144; and LEAR, 171–178, 195; and *El Machete*, 111; and Open Air Schools, 77, 134, 136; and Posada, 145, 146, 177; and TGP, 296; works by: *The Seamstress*, 79; *The March*, 142, *143*; *The Madman*, *145*; *The Workers Park Swimming Pool*, *146*; *Tierra y Libertad*, 155; *Pure Art vs. Workers*, 172; *Calaveras del Mausoleo Nacional*, 177; *Inscríbase Taller-Escuela*, *188*;

Workers Against War and Fascism, 196; Viva el Congreso de Unificación, 205, 206; Saludos al Congreso de Unidad, 205, 207; Viva México libre e independiente, 209, 210; The "Siege" of Madrid, 255, 257; Unidad, 298; Rio Blanco, 301; Gold Shirts (untitled), 305

Mercader, Caridad, 248–250

Mercader, Ramón, 250, 287

Mexiac, Adolfo, Libertad de Expresión!, 314

Mexican Electricians Union (Sindicato Mexicano de Electricistas, SME), 5, 8, 21, 58, 63, 65, 211–235, 315; and Communism, 217, 220–222, 233, 235, 279–282; and the CTM, 234, 264–266, 277; and engineers as leaders, 218–222; internal divisions, 275–284, 287; and LEAR, 233, 235; mural for, 197, 285–290, 316; and the nationalization of oil, 273–275; origins, 212–214; and the Spanish Civil War, 236, 239, 259, 288; and strike of 1936, 208–209, 211, 229–235; and women, 214–215, 220

Mexican Folkways, 78

Mexican Light and Power Company, 21, 63, 211–216, 219, 229, 232, 235, 290

Mexican Revolution, 2; historiography of, 3; military phase, 49–67

Mexican Revolutionary Action (Acción Revolucionaria Mexicana/ Camisas Doradas, ARM), 163, 169, 178, 190, 201, 205, 221, 244, 245, 249, 272, 303, 305; representations of, 197

Mexico City: as metropolis, 7, 19–22, 71; representations of, 133

Mexico Today and Tomorrow (Rivera), 168–169

Mexico will not be Spain! (Arenal), 260

Meyer, Hannes, 306

Michel, Concha, 202–203

Miliciana (Arias Bernal), 252

Milicianas (Balmori), 251

militias and workers: in Mexico, 245–248, 273; milicianas, 247–253; representations of, 245–253; in Spain, 237

Millan, Verna Carleton, 159, 259, 291, 294, 295

Modern Calvary (Posada), 35–36

Modotti, Tina, 8, 147–156, 161; and Horizonte, 142, 148; and El Machete, 12, 114, 150–156, 200; and photomontage, 152–154; representations of women, 15, 150–152; works by: Workers' March, 148, 149; Worker's Hands, 150; Hands Washing, 150; Workers, Mexico City, 150, 151; Woman with Flag, 151, 152; Those on Top and Those Below, 153; Worker Reading "El Machete," 154, 155; Campesinos Reading "El Machete," 155, 156

Moneda, Eduardo, 61, 116

Monsiváis, Carlos, 45, 291

Montenegro, Robert, 23, 45, 52, 67, 94, 119, 121; and Rivera, 118

Montes de Oca, Manuel, 163, 303

Montezuma Beer advertisements (anonymous), 130

Monument of the Revolution, 309, 310

Morones, Luis: corruption 5, 118; as CROM leader, 9, 71–74, 115, 118, 127; opposition to Cárdenas, 165; origins, 21, 59, 62, 212; relations with SME, 54, 59; representations of, 86, 97, 103–105, 118, 197, 273, 274

Mraz, John, 147

Múgica, Francisco, 282, 292

Muñoz, Victor, 26

Muñoz Hoffman, Esperanza, 183
Muralism, 10, 14; in Abelardo Rodrí-
guez market, 169–171; debates
over, 181–182; early portrayals of
workers, 84–87; in the Talleres
Gráficos de la Nación, 195–199; in
US, 166–167
Murillo, Gerardo. *See* Atl, Dr.
My owners, my masters (Siqueiros),
94, *plate 4*

Nacional, El (Mexico City), 236
National Committee of Proletarian
Defense (Comité Nacional de De-
fensa Proletaria, CNDP), 165, 182,
189, 190, 202, 227, 234
National Industry (Romano Guille-
mín), 27–28
National Preparatory School, 49,
70, 73–74, 77, 92, 100, 108, 140,
144; early muralism in, 84, 86–87,
101–102
National Union of Commercial Art-
ists, 119; *Revista CROM* cover by,
124, *Plate 5*
National University, 5, 91, 102, 109,
137, 138
Negrete, Ezequiel, *Casas en las
Colonias*, 207
Neve, Carlos, 51, 52, 67, 119, 120–
124, 126; works by: *And There
We Have the People*, 120, *122*;
The Pulse of the Proletariat, 121,
122; *May Day*, cover of *Revista
CROM*, *123*
New Masses, The (New York), 148,
184, 222, 224, 291
Night School for Workers, 191
Noguchi, Isumu, 170
North American Free Trade Agree-
ment, 317
November 20, 1936 celebration (Gut-
mann), *250*
Novo, Salvador, 91, 109

Obregón, Alvaro, 50, 55–56, 58–59,
61–62, 67, 70–76, 91, 100, 102, 106,
108, 115, 118, 158, 160, 212
Obregón Santacilia, Carlos, 310
Ocampo, Isidoro, 306
Offering, The (Herrán), 52
O'Higgins, Pablo, 146, 170; and
LEAR, 171, 176; and TGP, 296;
works by: *In the Cantina*, 146,
plate 8; *The Worker's Struggle
Against Monopolies*, 170, *plate 9*;
*Workers Against War and Fas-
cism, 196–199*; *Vultures over
Spain, 253*; *In the Epoch of Re-
pression, 301, 302*
oil workers strike and national-
ization (1937–1938), 6, 261, 269,
271–272
Oles, James, 134, 170
One of the Others (Guerrero Gal-
ván), 172, *173*, 183
Open Air Painting Schools, 46, 52,
57, 69, 74, 83, 165, 191; and Centros
Populares de Pintura, 132–134, 137,
138, 142, 165, 191; and printmak-
ing, 77–79
Orientalism, 119, 120
Orozco, José Clemente, 8, 12, 41,
48–49, 51, 67, 102, 142, 166; and
anticlericalism, 37, 60, 106; and
art during the 1910 Revolution,
60–64; and Communist Party,
105–106; and CROM, 73, 103–105,
108; and LEAR, 184, 293; and *El
Machete*, 69, 88, 102–111, 197; and
National Preparatory Murals, 70,
86–87, 102, 108, 140, 144, 197; on
proletarian art, 158; and Posada,
92, 103, 107, 110; representations
of homosexuality, 109; represen-
tations of women, 15, 109, 132; and
SOTPE, 75; works by: *Maternity*,
70; *Banquet of the Rich*, 86, 103;
The Ambush, 86; *Troops Defend-*

ing a Bank against Strikers, 87; Fratricide!, 103, 104; Judas Morones, 103, 105; Christ According to the Rich and Clergy, 106; Justicia Proletaria, 107, 125; Fascist Babes, 110, 173; The Strike, 140, 141; Christ Destroying his Cross, 140; Hanging Blacks, 174; Demonstration, 256, 267

Orozco Romero, Carlos, 188

Ortiz Hernán, Gustavo, 1–4, 196; work by: Chimeneas, 1–3, 196

Ortiz Rubio, Pascual, President, 161

Pacheco, Máximo, 90, 111, 171

Palacio de Bellas Artes, 25, 167, 176, 178, 191, 240, 290, 294

Party of the Mexican Revolution (Partido de la Revolución Mexicana, PRM), 262, 269; representations of, 269, 270, 307

Party of the National Revolution (Partido Nacional Revolucionario, PNR), 145, 161, 171, 182, 203, 269, 271, 295; representations of, 176, 178, 209

Paulín, Manuel, 219, 245, 277, 278, 280, 281, 289

Pavón Flores, Mario, 221, 232, 281

Paz, Ireneo, 30–31

Paz, Octavio, 239, 240, 293

PCM. See Communist Party of Mexico

peasants. See campesinos

Peláez Ramos, Gerardo, 268

Peña, Feliciano, Buy the May Issue, 191, 193

Penny Press, 30–44; broadsheets, 31–32, 41–46; for workers, 32–41

People's Graphic Art Workshop (Taller de Gráfica Popular Taller de Gráfica Popular, TGP), 15, 16, 254, 285, 290, 307, 314; Estampas de la Revolución, 304; for-

mation, 296–297; legacy, 313, 314; The Mexican People and its Enemies from 1935–1939 series proposal, 303; relation to organized labor, 298–301; representations of the past, 301–306; The Spain of Franco series, 254, 301

periodicals, 11

photography: as medium, 10; photomontage, 14, 152–154, 201, 202, 225, 233, 234, 248, 250, 273, 275, 285

Plenn, J. H., 170, 291

PNR. See Party of the National Revolution

Popular, El (Mexico City), 244

Popular Front strategy, 5, 13, 159, 182; and the PRM, 268–279

Porset, Clara, 182

Portes Gil, Emilio (president of Mexico), 161

Portrait of the Bourgeoisie (Siqueiros, Renau, Pujol, and Arenal), 211, 285–289, 287, 288, 316, plate 11

Posada, José Guadalupe, 8, 11, 12, 17, 29–46, 66; anti-clericalism, 37; influences of, 93–95, 96, 97, 100, 120, 121, 131, 145, 146, 156, 158, 176, 240, 313, 314; rediscovery of, 78, 92; representations of homosexuality, 15, 42–46; representations of women, 14, 37; works by: Seems like chia, but it's Horchata, 33–34; The Bourgeois, 35; Modern Calvary, 35, 36, 107; You, Great Friend of the Workers, 38; What happens and what will happen, 39; After the Ball, 39; Streetcar Strike, 41–42; The 41 Faggots, 43, 44, 173; 41 Faggots for Yucatán, 43; Feminism imposes itself, 44; Water Scarcity, 146, 148

PRI. See Institutional Revolutionary Party

Prignitz-Poda, Helga, 293

prints, as medium, 10

PRM. *See* Party of the Mexican Revolution

Pugnas de la Gleba, Las, (Salazar and Escobedo, drawings by Neve), 120

Pujol, Antonio, 170, 184, 188, 239, 285, 286

Pulse of the Proletariat, The (Neve), 121, *122*

Pure Art vs. Workers (Méndez), 172

Ramírez, Everardo, 209

Ramírez, Fausto, 31, 52

Ramos Martínez, Alfredo, 52, 77, 132

Regeneración, 30

Regional Confederation of Mexican Workers (Confederación Regional Obrera Mexicana, CROM), 5, 8, 212, 213, 278; decline of, 158, 160, 214, 245, 264, 268; dominance in the 1920s, 69, 71–77, 115–118, 142; and Grupo Acción, 5, 72, 118; and *El Machete*, 90, 103–111

Regional Federation of Workers and Campesinos (Federación Regional de Obreros y Campesinos, FROC), 234, 235, 263

Renau, Josep, 201, 240, 285, 286, 287, 288, 289; *Portrait of the Bourgeoisie*, *287*

Revista CROM (Mexico City), 13, 16, 69, 113, 116–132, 195, 213, 217; advertisements in, 125–130; art in, 118–132; compared to *El Machete*, 113, 116, 117, 130, 131, 154–158; influence of Herrán, 111; organization of, 116–118; representations of women, 15, 130–132

Revista de Revistas (Mexico City), 45, 52, 67

Revolución Social (Orizaba), 61

Revueltas, Fermín: and early muralism, 84; and Estridentista movement, 77, 87, 144; works by: *Exterior Scaffolding*, 79; *Indianilla*, 79

Revueltas, Silvestre, 176, 240

Reyes, Aurora, 183

Reyes Palma, Francisco, 292, 296

Reyes Pérez, Roberto, 171

Rigo, G., *untitled* (capitalist and worker), 135

Rio Blanco (Méndez), 301

Rivera, Diego, 8, 12, 47–48, 51, 67, 92, 142, 152, 158, 170, 311; and Communist Party, 77, 137, 166; critics of, 118, 169, 178, 181–182, 292; and CROM, 73–74, 100; as director of the Academy of San Carlos (the Escuela Central de Artes Plásticas), 114, 137–139; and Estridentista movement, 87; on LEAR, 293; and *El Machete*, 69, 88, 111; and National Palace murals, 168–169; and Posada, 92; and SEP murals, 84–86, 94, 100–101, 132, 140; and SOTPE, 75, 102; and the Spanish Civil War, 237, 261; works by: *Zapatista Landscape*, 47; *Creation*, 70; *Sugar Workers*, 81, 84; *Entering the Mine*, 84, *85*; *Leaving the Mine*, 85; *Land Distribution*, 93; *The Foundry*, *129*; *Assembly of the First of May*, 140; *The Arsenal*, 140; *Detroit Industry*, 167, 196; *Man at the Crossroads*, 167; *Mexico Today and Tomorrow*, 168–169

Rivera Rojas, Juan José, 281, 289, 290

Rodríguez, Antonio, 31

Rodríguez Lozano, Manuel, 81

Roldán, David, 219, 221, 232, 245, 281, 282, 285, 289

Romano Guillemín, Francisco, 27–29, 49, 51, 53, 60, 62; works by: *National Industry*, 27–28; *Eternal Martyr*, 28–29, 40

Ruelas, Julio, 77, 119, 120
Ruiz, Guillermo, 133
ruta (Jalapa), 173–175

Salazar, Rosendo, 21, 58, 120, 127; *Las Pugnas de la Gleba*, 120
Saludos al Congreso de Unidad (Méndez), 205, 207
Sandi, Luis, 294
San Lunes, (Mexico City), 39, 41
Schneider, Peter, 301
Seamstress, The (Méndez), 79
Secretariat of Public Education (Secretaria de Educación Publica, SEP), 6, 301; and artists, 91, 132, 166, 171, 178, 183, 184, 186, 191, 239, 293–294, 297; and murals, 75, 84–86, 93
Seems like chia, but it's horchata (Posada), 33–34
SEP. *See* Secretariat of Public Education
"Siege" of Madrid, The (Méndez), 255, 257
Sindicato de Costureras (López Vázquez), 205, 208
Sindicato de Pintores y Escultores, 139
Siqueiros, Davíd Alfaro, 8, 12, 48, 51, 52, 60, 67, 132; and the Communist Party, 77, 166; and LEAR, 171, 176, 181, 184, 189; and *El Machete*, 69, 88–90, 102, 111; and SME mural, 285, 286; and SOTPE, 75; and Spanish Civil War, 239, 240; and Trotsky, 286; works by: *Burial of a Worker*, 84, 100; *My owners, my masters*, 94, *plate 4*; *The Trinity of the Shameless*, 97, *98*; *We Three are Victims*, 97, *99*; *Accident in the Mines*, 166; *Workers' Meeting*, 166
Skyscrapers (Charlot), 81
SME. *See* Mexican Electricians Union

Sole Front for Women's Rights (Frente Único pro Derechos de la Mujer, FUPDM), 202, 203, 209, *plate 10*
Soto, W., house artist of *Aztec Princess* cover of *Revista CROM*, *114*, 119; *Tree of the Nation* cartoons, 125, *126*
Soto y Gama, Antonio, 54, 56
SOTPE. *See* Syndicate of Technical Workers, Painters, and Sculptors
Soviet Union, 5, 11, 137, 140, 150, 161, 162, 178, 203, 221, 238, 257, 261, 267, 272, 279, 281, 282, 284, 286, 287, 294, 301; influences of, 10, 11, 14, 90, 93, 129, 140, 152, 191, 197, 200, 222, 224, 240, 285, 303; representations of, 100, 164, 167, 201, 220
Spanish Civil War, 14, 210, 235–260, 286, 288
Streetcar Strike (Posada), 41–42
Strike, The (Orozco), 140, *141*
strikes, 12, 17, 18, 20, 29, 38, 41, 46, 51, 54, 58, 59, 61, 72, 74, 76, 90, 94, 108, 115–117, 125, 140, 154, 159, 161, 164–165, 182, 212–213, 217, 238, 314; general strike of 1916, 62–67, 71, 120–121, 212, 233; electricians' strike of 1936, 208–209, 211, 229–235; oil workers strike of 1937–1938, 208–209, 262, 272; representations of, 1, 28, 29, 39, 40, 41, 42, 64, 81, 87, 94, 103, 120–121, 140, 169–170, 173–74, 208, 230, 233–35, 273, 290, 301
Sugar Workers (Rivera), 81
Syndicate of Technical Workers, Painters, and Sculptors (Sindicato de Obreros Técnicos, Pintores y Escultores, SOTPE), 8, 74–77, 87, 102, 313; and *El Machete*, 87, 101

Talleres Gráficos de la Nación, 2, 116, 195, 295; mural in, 195

Tamayo, Rufino, 142, 182, 184, 188, 293

Tannenbaum, Frank, 311

Taxi Drivers Against the Gold Shirts (Zalce), 303, *304*

TGP. *See* People's Graphic Art Workshop

Those on Top and Those Below (Modotti), 153

Tierra y Libertad (Modotti), 155

Torres, Esther, 19–20, 22, 54, 65

Tree of the Nation (Soto), 125, *126*

Trinity of the Shameless, The (Siqueiros), 97, *98*

Troops Defending a Bank against Strikers (Orozco), 87

Trotsky, Leon, 169, 250, 272, 286, 287, 292, 298; Trotskyism, 237; representations of, 167, 228

Ultramarino (Arenal), *258*

Unidad (Méndez), 298

Unidad Nacional (LEAR), *El Machete*, 209, *plate 10*

union leaders, 5, 8–9; as "intellectual workers," 222, 286

Union of Revolutionary Artists, 58

unions, 9–16; cycles of mobilization, 71–72, 164–165; membership in, 54–56, 71–72, 164–165; relations with government, 6; role in military revolution, 3, 54–56

Unitary Syndical Confederation of Mexico (Confederación Sindical Unitaria de México, CSUM), 160, 214, 217, 263, 264

Unity of All Mexicans (García Bustos and Beltrán), 306, plate 12

Universidad Obrera, 189, 301, 307; calendar images for, 258, 301, 303

Urbe (Maples Arce), 81–83

Vanegas Arroyo, Antonio, 31, 41, 45, 78, 93

Vanguardia (Orizaba), 60, 61, 106

Vasconcelos, José, 6, 47–48, 67, 70, 73, 75–76, 85, 102; and the SEP murals, 85

Velasco, Ernesto, 212

Velasco, Miguel, 264, 301

Velázquez, Fidel, 164, 263–265, 290, 299, 306

Vera, Maria Luisa, 182, 293

Vida Americana (Barcelona), 87

Vilchis, David, 301

Villa, Francisco, 50, 55, 60, 62

Villaseñor, Isabel, 136, 183

Viva el Congreso de Unificación (Méndez), 205, 206

Viva México libre e independiente (Méndez), 209, *210*

Vultures over Spain (O'Higgins), *253*

Water Scarcity (Posada), 146, *148*

Way of the Cross, The (Charlot), 78

We Demand Bread or Work (anonymous), *Frente a Frente* (May 1935), *180*

Week of Aid to Spain (Chávez Morado), *254*

We Three are Victims (Siqueiros), 97, *99*

Weston, Edward, 13, 142, 147, 150

What happens and what will happen (Posada), 39

Wolfe, Bertram, 77, 88, 138, 164

Woman with Flag (Modotti), 151, *152*

Women: as artists, 8, 109, 182–183, 313; representations of, 2, 14, 25, 27–29, 37, 109–110, 130–132, 201–208, 247–255; and work, 2, 130–131, 313

Worker Reading "El Machete" (Modotti), 154, *155*

Workers (Lazo), 81

Workers, Mexico City (Modotti), 150, *151*

Workers Against War and Fascism (O'Higgins, Méndez, Zalce, Gamboa), *196–199*, 240

Worker's Hands (Modotti), 150
Workers' March (Modotti), 148, *149*
Workers' Meeting (Siqueiros), 166
Worker's Struggle Against Monopolies, The (O'Higgins), 170, *plate 9*

Yañez, Enrique, 285
You, Great Friend of the Workers (Posada), 38

Zalce, Alfredo, 296, 303; *Taxi Drivers Against the Gold Shirts*, 303, *304*
Zaldívar, Carlos, 29, 60
Zapata (Guerrero), 93
Zapata, Emiliano, 50, 55; as revolutionary icon, 1, 9, 93, 168
Zapatistas, 2, 50, 54, 58, 60; and neo-Zapatistas, 315